DIGITAL PHOTOGRAPHER'S HANDBOOK

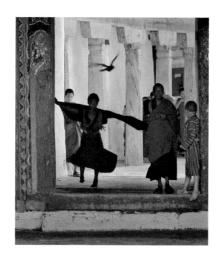

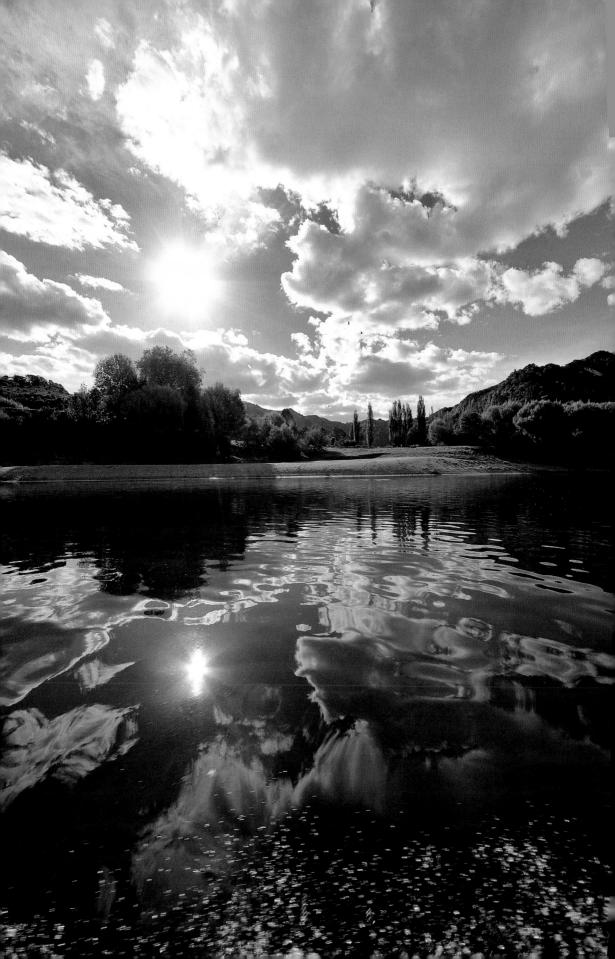

TOM ANG

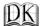

To Wendy

Project Editor Nicky Munro US Editor Margaret Parrish Senior Art Editor Gillian Andrews Production Controller Imogen Boase Senior Production Editor Luca Frassinetti

> Managing Editor Stephanie Farrow Managing Art Editor Lee Griffiths

> > Produced on behalf of Dorling Kindersley by

Sands Publishing Solutions

4 Jenner Way, Eccles, Aylesford, Kent ME20 7SQ, United Kingdom

Project Editors David & Sylvia Tombesi-Walton Project Art Editor Simon Murrell

> Original edition produced on behalf of Dorling Kindersley by

HILTON/SADLER

63 Greenham Road, London N10 1LN Editorial Director Jonathan Hilton Design Director Peggy Sadler

First published in the United States in 2002 by DK Publishing

Fourth edition published in 2008 by

DK Publishing

375 Hudson Street, New York, New York 10014

09 10 11 12 10 9 8 7 6 5 4 3 2 1

DD513-April 09

Copyright © 2002, 2004, 2006, 2008

Dorling Kindersley Limited

Text copyright © 2002, 2004, 2006, 2008 Tom Ang All rights reserved.

Without limiting the rights under copyright reserved above, no part of this publication may be reproduced, stored in or introduced into a retrieval system, or transmitted, in any form, or by any means (electronic, mechanical, photocopying, recording, or otherwise), without the prior written permission of both the copyright owner and the above publisher of this book.

> Published in Great Britain by Dorling Kindersley Limited.

A catalog record for this book is available from the Library of Congress.

ISBN: 978-0-7566-4310-2

DK books are available at special discounts when purchased in bulk for sales promotions, premiums, fund-raising, or educational use. For details, contact: DK Publishing Special Markets, 375 Hudson Street, New York, New York 10014 or SpecialSales@dk.com.

> Printed in China by Hung Hing Color reproduction by Colorscan, Singapore

> > Find out more at

www.dk.com

Contents

8 Introduction

Chapter 1 Total photography

- 12 Digital pathways
- 14 Legacy pathways
- 16 The technology
- 22 Digital camera features
- 24 Choosing a digital camera
- 32 Choosing lenses
- 36 Accessories
- 38 Digital accessories
- 40 Portable flash
- 42 Studio lighting
- 44 Studio equipment
- 48 Monitors
- 50 Scanners
- 52 Choosing software
- 54 Printers
- 58 Computers
- 60 Computer accessories
- 62 Setting up a workroom

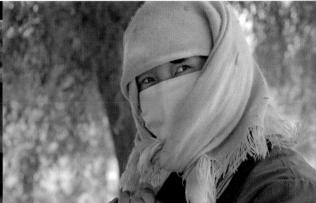

Chapter 2

112

114

116

118

121

124

126

128

Photography for the digital age

tile	uigitai aye
66	Handling cameras
68	Picture composition
74	Focusing and depth of field
78	Image orientation
80	Image proportions
82	Composition and zooms
84	Digital zooms
85	Camera movement
86	Digital close-ups
90	Extreme lenses
92	Quick fix Image distortion
93	Quick fix Lens problems
96	Influencing perspective
98	Changing viewpoints
100	Quick fix Leaning buildings
101	Quick fix Facial distortion
102	Color composition
104	Adjacent colors
106	Pastel colors
108	Strong color contrasts

Quick fix Color balance

Silhouettes/backlighting

High-key/low-key images

Quick fix Electronic flash

Advanced metering

Accessory flash

Studio flash

Exposure control

Chapter 3

A compendium of ideas

U	ucus
136	Starting projects
138	Abstract imagery
141	Buildings
144	Photographing clouds
146	Documentary photography
150	Ecotourism
153	Close-up photography
158	Vacations
161	Journeys and travel
166	At home
168	Children
171	Landscapes
176	Mirrors
178	Nudes
181	Bird's-eye views
186	Pets
189	Sports
192	Events
195	Urban views
198	Natural history
202	Panoramas
206	Zoos

Record-keeping

210

Contents continued

Chapter 4 Radical conversions

214	Scanning: The basics
216	Using flatbed scanners
218	Using film scanners
220	Quick fix Scan resolution
222	Using scanners as cameras
226	File formats
228	Quick fix Problems with scans
231	Quick fix Inaccurate
	printer colors
232	Color management
234	Image management

Chapter 5

All about image manipulation

M 6 6	i ii se seeps
240	Cropping and rotation
242	Quick fix Poor subject detail
243	Quick fix Poor subject color
244	Levels
246	Burning-in and dodging
250	Dust and noise
252	Sharpening
256	Blurring
258	Quick fix Image distractions
260	Image size and distortion
262	Quick fix Image framing
263	Quick fix Converging parallels
264	White balance
266	Color adjustments
268	Quick fix Manipulation
	"problems"
270	Curves
274	Bit-depth and color

276 282 286 287	Color into black and white Duotones Tritones and quadtones Sepia tones	The adv	pter 6 output enture
288	Sabattier effect	348	Proofing and printing
290	Gum dichromates	352	Output to paper
292	Split toning	354	Quick fix Printer problems
294	Sun prints	356	Art printing
296	Hand tinting	360	Publishing on the web
298	Cross-processing	362	Creating your own website
302	Tints from color originals	365	Going further
304	Quick fix Problem skies	369	Creating a portfolio
306	Filter effects	370	Building up your business
312	Multiplying filter effects	372	Mounting an exhibition
316	High dynamic range	374	Copyright concerns
318	Selecting pixels	376	Shopping for equipment
320	Quick fix Removing backgrounds	378	Disabilities
322	Layer blend modes	379	Survival guide
328	Masks	381	Glossary
330	Grayscale and color	392	Web resources
332	Text effects	395	Manufacturers
334	Cloning techniques	396	Software sources
338	Natural media cloning	398	Further reading
340	Image hose		
342	Photomosaics	400	Index
344	Image stitching	408	Acknowledgments

Introduction

Some 160 years after the invention of photography, an enemy rose above the horizon. Digital imaging threatened to sweep away film, make the darkroom redundant, and exile the hard-won craft skills of picture-making. In a short time, the threat grew as numerous new enemies appeared, in the shape of more and more digital cameras, scanners, image-manipulation software, and the Web, all banding together to raze conventional photography to the ground.

Photographers watched with steadily increasing apprehension, but the threat turned out to be the best friend photography could have hoped for. Instead of opposing conventional photography, digital technologies have in fact revitalized whole swaths of photographic practice. Traditional techniques in use of both the camera and lens, as well as darkroom manipulations fully retained their relevance as the foundation upon which many digital advances were based; this is reflected in references to film-based techniques throughout this book. Indeed, the union of conventional photography with digital technology has turned out to be incredibly fertile, providing us with new worlds of practical, creative, and enjoyable potentialities.

Digital Photographer's Handbook celebrates this union by bringing together, into one volume, all the best of classical photography techniques with a comprehensive survey of digital photography. So here you will find all the love and enthusiasm I have for conventional photography and its subtle craft skills for creating telling, effective, and rewarding images. At the same time, I hope to share with you my thrill and wonder at the flexibility, power, and economies that are possible with digital photography. By

learning how to bring out the power of digital photography, you will find—if you are already an avid photographer—that your enthusiasm and energy for photography will be increased tenfold; and if you are not experienced, you will find that photography has the power to reveal to you the richness and variety of the world that are second to none.

This book brings together a vast amount of technical information and practical advice and reveals numerous tips and tricks of the trade. It combines a complete account of professional picture-making skills with a thorough grounding in image-manipulation techniques. And it is all offered in order to help you improve, enjoy, and understand the medium of communication that is photography.

Since its first publication, Digital Photographer's Handbook has been translated into more than a dozen languages and sold half a million copies. It has been adopted by both beginners and experienced photographers and used as a course textbook. This latest edition responds to the profound changes in photographic practice, introducing much brand-new information to ensure it is fully up-to-date and continues to be perhaps the most comprehensive single resource for the modern photographer.

Total photography

The pathways through photography start with the digital capture of an image. Primarily you will capture, or "take," an image using your digital camera. But you may also obtain images downloaded from a website or sent wirelessly by cell phone. Images may be transferred from a video camera or copied from storage media such as a CD, DVD, or flash memory (see pp. 38–9).

Being digital, your image is similar to any word-processor document, spreadsheet, or other computer file. You can store it on your computer hard-disc, as well as on any removable medium; you can exchange the file between networked computers-wirelessly or through cables; and you can send it around the world via the internet. Like any computer file, however, it must be in a form that will be recognized by your chosen software before you can use it for image manipulation, combine it with text or other images, or print it out.

The digital journey

The image in digital form is versatile and flexible in the extreme. The degree of control

Digital cameras

Just like stills cameras, many video cameras and cell phones can capture images that you can use or share immediately.

Internet

Millions of images can be downloaded from the web. You may not even have to pay for them if they are not for business use.

Removable media

You may be able to source images from CDs or DVDs given away with magazines or donated by family and friends.

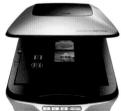

Scanner

Using a scanner, you can turn any of your existing photographs—whether prints or negatives-into digital image files with ease.

Computer

Digital image files and image-manipulation and management software meet in the computer. There you can perfect your images for their final use, combine images, and sort them for future use. From the computer you can also share them via networks or send them anywhere in the world.

One important feature that distinguishes image files from those produced by other computer applications is that most are in standard formats (*see pp. 226–7*) recognized by a very wide range of software. This include page- and graphic-design programs, web and presentation authoring, and even spreadsheets and databases. From this fact alone arises much of the versatility of the digital image. However,

raw (or RAW) formats produced by cameras may be specific to a manufacturer and recognized only by specialized raw-conversion software.

Sharing via the web

The more you discover about digital-image processes, the more their ease and convenience shine through. Beyond the simplicity with which we can now take and manipulate our pictures, there is also the ease of sharing them: modern software can fully automate the publication of your images as galleries on the web (*see pp. 360–3*).

economical, too.

Legacy pathways

Photographers who have made large investments in film-based photography in the past will wish to keep their legacy (film-based) work while, at the same time, keeping up with technological advances. Many lenses for 35 mm film cameras, such as those for Nikon, Minolta, Pentax, and Leica, can be used on appropriate digital cameras. However, the case for changing to digital is less compelling for those with medium- and largeformat equipment because of the high cost of medium-format digital cameras.

Developed films and prints can be scanned to create full-fledged digital images that can be manipulated, shared, emailed, put on the web, and printed to any size, just like any other digital image. Indeed, combining film-based and digital photography gives you the best of both worlds, opening up wonderful opportunities, with several ways to achieve nearly any end: from every fresh option arises yet more creative potential. Bringing legacy work into the digital domain can inspire as it empowers. The only limit is your imagination.

Digital route

film cameras.

Memory cards

A digital camera uses memory cards to store the digital representation of the subject.

Film camera

A film camera records an analog representation of the subject, with each image being recorded on an individual frame of film

Film

Once exposed to light from the subject, minute changes take place in the composition of the image-carrying emulsion layers of the film. At this stage the image is invisible and is known as a latent image.

Negative

Processing

Processing the film in special chemicals amplifies the latent image so that a recognizable image of the subject appears. Depending on the film used, you could have a positive image (or slide) or a negative, which requires printing, in color or black and white.

Analog and digital

We are most familiar with analog representations, since these are based on the perceptible and intuitive relationship between the representation (the movement of a clock's hands, say) and the reality itself (the passage of time). Similarly, locations on a map have relationships similar to those between the real places, so the map is an analog representation. In contrast, digital representation uses arbitrary signs whose

meanings may have no obvious relation to the thing. A digital watch could show the time in Chinese characters or Arabic numerals. Your zip code uses arbitrarily assigned numbers. To know what a code refers to, you need a code book—a way to interpret the signs. Similarly, computer files (strings of symbols) digitally represent the image, but a point in the negative image corresponds to —it is an analog of—a real thing in the original subject.

Images in the computer

Images are downloaded directly into your computer as digital files. Now, using image-manipulation and management software, the digital adventure can begin.

Storage

Once you are satisfied with the results of your work, you can store digital images on any of a range of removable media, including CDs, DVDs, USB drives and hard-disc drives.

Disseminate

You can share images on local networks or send your digital images anywhere in the world as an attachment to an email or by publishing them on picture-sharing sites or web pages, potentially reaching a enormous number of people.

Scanning

Taking a print or a film original as your starting point, you can use a scanner to create a digital representation of your analog image. Each scan is an individual digital file and you can work on it as if it had been taken with a digital camera.

Printing

In the time it takes to prepare darkroom chemicals, you could run off several prints from a desktop printer—all in normal room light. Even readily affordable printers can produce print quality equal to that of photographic papers.

The technology

Digital cameras record a scene using the energy of light to cause changes in a light-sensitive material. The light-sensitive electronic sensor absorbs light projected by the camera's lens. This light is turned into electricity, which is, in turn, converted into a form that the image processor a specialized computer—can handle. All the main phases of image recording take place within the body of the digital camera itself: image capture, image processing, and image storage. It is important to note that the principle of image capture is similar in both film and digital cameras: light is used to alter properties of a light-sensitive material. This initial capture is analog in nature in both cases.

Capturing the image

The image-recording sensor in a digital camera is built up of a grid, or array, of individual lightsensitive cells or photosensors. Each cell acts like an exposure meter by responding to different

amounts of light to generate a corresponding electrical signal. In most sensor-array designs, each cell is covered with a red, green, or blue filter so that each cell responds to just one of the primary colors of light (red, green, or blue). The filters are arranged in groups of four (see opposite), with two green filters for each pair of red and blue. The extra green filter is present to capture detail because the human eye is most sensitive to green light.

At this stage, the electrical output of each cell is proportional to the amount of light reaching it. It is next amplified, or made stronger, prior to quantization—that is, numbers are assigned to the signals being converted so that the digital processor can handle the information. This is done by the analog-to-digital converter (ADC).

Processing the image

The varying numbers from each cell are used by the image processor to create the individual

Pixels and film grain

The picture elements (pixels) of a digital image are arranged in a regular array of uniformly colored squares so small as to be individually invisible. In film-based images, picture elements are randomly arranged grains (in most black and white film) or clouds of dye, also commonly called grain, in the case of all color and some black and white films.

Film grain

A random distribution of varying-sized grains and just three colors characterize the composition of color film.

Pixel structure

The regular distribution of same-sized, uniformly colored picture elements from a wide range of colors are characteristic of digital images.

Sensor in the camera

The light-sensitive element, or photosensor, in a digital camera is positioned in the lens's focal plane. A photosensor is perfectly flat and is in precisely the same position for each exposure-something not guaranteed with film.

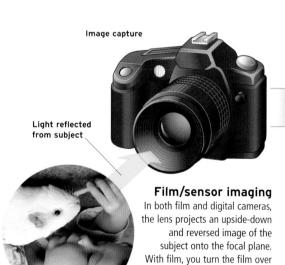

to view it correctly; in a digital

camera, this is done by software.

picture elements (pixels) in the image. In the majority of cameras, each pixel obtains its red, green, and blue values by calculation from the data of neighboring cells. This step (color filter interpolation or demosaicking) is crucial because the method of precise calculation determines the final image quality. This completes the imagecapture phase of the process.

The values for all the pixels are collected together to create the image file—in this process, other data, such as the camera (EXIF) data and format, are also determined. Some cameras will further process the image to improve its sharpness and compress the image. This phase is followed by the image being recorded (written to disc or to memory).

The first part of the process—image acquisition—can be very rapid, but processing and writing data to disc take longer. To speed things up, more advanced cameras use faster processors and large amounts of fast memory.

Color filter array

The image is separated into red, blue, and green components in an analog fashion by an array of colored filters lying over the photosensors.

Mosaic filter

The most common type of color filter array used in digital cameras is the Bayer pattern. In this, every other filter (and its corresponding pixel) is green, while one in four pixels is either red or blue.

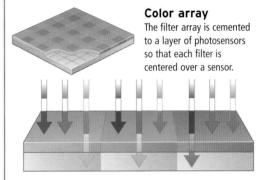

Color separation

Filters pass most of their own color but also some others: for example, blue passes mostly blue but some green, too.

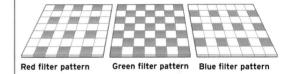

Color data before interpolation

To create an image, the camera software analyzes the three grids of color information to work out the intermediate color values—a process called color interpolation.

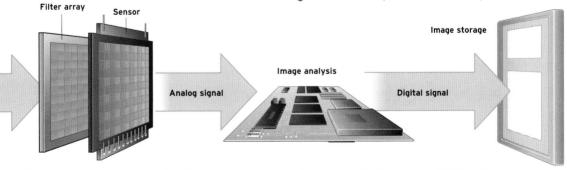

Sensor

The array of light-sensitive sensors turns the image into a mosaic of picture elements, or pixels, with luminance (brightness) and chrominance (color) information.

Analog signal

The photosensors produce streams of electrical signals that are amplified then converted into digital data by circuitry on the sensor or on a separate chip.

Image analysis

The digital data is next taken apart by powerful computer chips and software to extract the color and brightness data in order to construct the final image.

Writing to memory

The circuitry sends the image data to the electronic memory card, which is inserted in the camera, for storage. Some cameras use a temporary storage, which speeds up the picture-taking operation.

The technology continued

Digital camera technology

The modern digital camera bears only a superficial resemblance to its film-using predecessors. Freed from the need to accommodate a roll of film, digital cameras can be extremely compact, packing complex electronics, mechanics, and ultra-highprecision optics into a very small space. Cameras no larger than a cell phone can offer zoom lenses and an image quality equal to that of much larger 35 mm film cameras. By the same token, larger digital cameras can employ powerful batteries and even more electronics to improve their speed of At the same time, digital technology allows numerous functions to be provided. These range from the customization of camera features to suit the user, to groups of settings suited to different scenes or photographic situations. Some cameras even offer built-in image-manipulation features.

Built-in pop-up

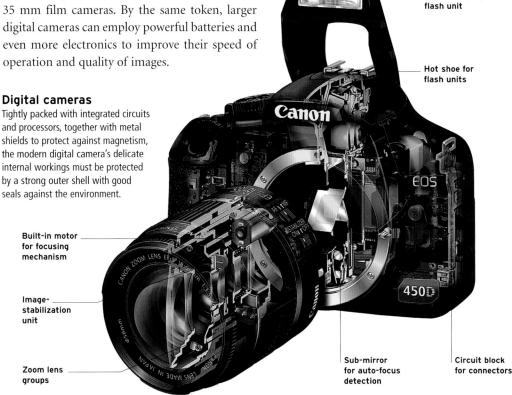

Differences between digital and film

Digital	Film
Same-sized sensor pixels arranged in a regular grid, or raster array.	Silver grains or dye clouds of varying size distributed in a random pattern.
Colors in the scene separated by a regular pattern of colored filters.	Colors in the scene separated by red-, green-, and blue-sensitive layers.
Interpolated from color filter array.	Dye clouds of cyan, magenta, and yellow.
Electronic and digital processes.	Development by chemical action.
Depends on sensor resolution and interpolation methods; also compression, if used.	Depends on film speed, grain structure, and processing regime.
Image stored temporarily on memory cards or hard-discs.	Image fixed by removing unexposed silver: black-and-white stable, color less so.
	Same-sized sensor pixels arranged in a regular grid, or raster array. Colors in the scene separated by a regular pattern of colored filters. Interpolated from color filter array. Electronic and digital processes. Depends on sensor resolution and interpolation methods; also compression, if used. Image stored temporarily on memory cards or

Sensor technology

Practically all microprocessor and memory chips are sensitive to light and so are normally protected by light-tight covers. There are several varieties of CCD (Charge Coupled Device) and CMOS (Complementary Metal Oxide Semiconductor) used in digital cameras, and although they do not differ in the basic principle of how they work, they do vary in the way in which the information captured by the sensors is used.

In CCDs, the charges built up in each sensor must be read off in one or more rows at a time. Thus, the image is effectively scanned over its whole area to retrieve the data. CMOS devices read out differently:

each sensor element can be sampled individually they are said to be X-Y addressable—and each one can be reached by giving its reference. As a result, a single CMOS sensor may be used not just for image capture but can also contribute to exposure metering and even autofocusing.

What CCDs lack in versatility they compensate for by being simpler and cheaper to make, while giving a clean signal that is easier to process than that from CMOS sensors. In digital cameras, however, CMOS has the advantage of working at a single, low voltage, compared with the high and varying voltages of CCD devices.

CCD sensor array Charges sent down row Individual sensors

Serial readout

Since charges need to be handed down each row, sensor by sensor, and then read off, there is a limit to how quickly the picture-taking process can be achieved.

CMOS sensor array

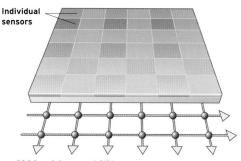

X-Y addressability

Each sensor on a CMOS chip has its own transistor and circuitry, so that nearly all can be read independently of the others, giving great versatility.

Triple-well sensors

In this type of CCD, each sensor measures all three colors of light using a design that exploits the phenomenon that each color penetrates the sensor to a different depth. In this way, there is no need for a separate color filter array, and in theory, the sensors can obtain at least three times more information than the equivalent using a Bayer pattern of colored filters through a much-reduced need for color interpolation. In addition, the integration of color separation into individual sensors means that pixels can be simply grouped—this lowers resolution but can increase sensitivity.

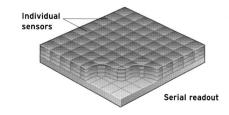

Each sensor measures blue, green, and red light

Digital camera features

Anyone who can operate a cell phone or MP3 player will also have the basic skills for setting up and using a digital camera. Don't be put off if there seem to be far more features than you need. No one expects you to use them all: the manufacturer is simply trying to make it easier to sell the camera by cramming as many features into it as possible in an attempt to cover all eventualities.

Before purchasing a camera, it is best to ensure that the model is comfortable for you to usesome are very small, which can make them awkward for people with large hands. Many cameras are smaller than they look in pictures, so check the actual physical dimensions. The placement of buttons and the grip will suit some people better than others.

Another consideration is the way the menus are designed. Make sure they are easy for you to read—some screens require very good eyesight and that the steps are easy to navigate.

Shutter control

The shutter button on a digital camera is, in fact, a switch that sets off a sequence of complicated electronic operations.

Flash

A built-in flash is handy in low-light conditions for subjects that are reasonably close by.

Viewfinder window

Observe the subject through the viewfinder to save power on the LCD screen or if you are unable to focus on close objects.

Zoom lens

Almost all cameras offer a zoom lens so you can readily change the field of view, but extreme wide-angle effects require accessory lenses.

Digital zoom

This feature takes the image produced by the lens's longest focal length setting and progressively enlarges the central portion. The camera appears to offers a zoom range that is longer than that of the lens alone but at the price of lower image quality.

Transferring images

Modern cameras can transfer files directly to a connected computer or some types of storage device to download images already shot—and sometimes even as images are captured. The connection may be via cable, Bluetooth, or wireless protocol.

Focusing in the dark

In one method, a beam of infrared (IR) light is projected from the camera or flash unit. The beam scans the scene and reflects back from any object it meets. A sensor on the camera measures the angle at which the beam returns, translates this into a subject distance, and sets the lens accordingly. This method is prone to interference from, say, an intervening pane of glass. Another method projects a light pattern from the camera or flash unit to provide the focus detectors with a target on which to focus.

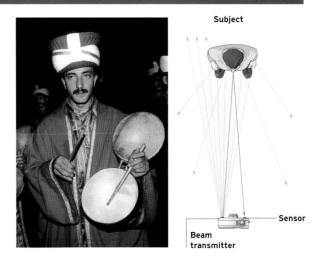

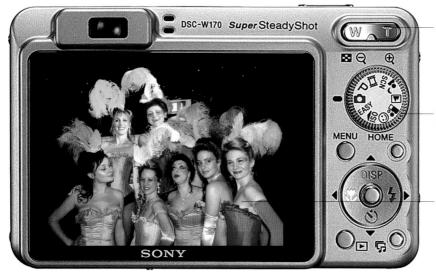

Zoom controls

This rocker switch sets different focal lengths but also zooms in and out of image previews.

Mode dial

Different modes of operation-such as movie, review, or scenes-may be set easily by turning a dial.

Display screen

Large and high-resolution screens can display an image accurately and show information clearly.

Viewfinder systems

A viewfinder system enables you to frame and focus an image before recording it. There are four types. The simplest uses an LCD or OLED (organic light emitting diode) screen on the back to present a low-resolution image. This is sufficient for framing but not effective for focusing. Some cameras also offer a direct-vision viewfinder, either built-in or as an accessory: you view the subject through a small lens system. This allows you to turn off the display and so save battery power, but since you are not viewing the subject through the imagetaking lens, framing of the subject is not precise.

The best system is the single lens reflex (SLR) arrangement in which you view the subject through the camera's lens itself. This gives you an accurate view of the subject and makes focusing very easy. An alternative is the EVF, or electronic viewfinder: with this you view an electronic display through an eyepiece. The camera handles like an SLR, but while the screen is sufficient for framing, resolution is not high enough for precise focusing.

Choosing a digital camera

Guidelines

The range of digital cameras available all but guarantees that any requirement can be met—from point-and-shoot needs, to specialized tasks such as astronomy and infrared photography.

One way to decide on a camera is by following the recommendation of a knowledgeable friend. You may also consult the numerous reviews available on the web: these range from the technically complete to superficial comments from unqualified, inexperienced testers. But it is easy to become confused when trying to balance many opinions. Thanks to unrelenting competition between reputable manufacturers, it is safe to say that all modern models will function well and reliably within their specifications.

The best way to avoid disappointment in your choice of camera is to handle it and obtain advice from a knowledgeable salesperson in a photography store. It is important to note that cameras with high resolution (the megapixel, or MP, figure) offer no guarantee of image quality: an 8 MP phone camera is likely to produce images markedly inferior to those from a 5 MP compact camera. High-megapixel cameras also tend to work more slowly than lower-specification cameras of similar cost. In general, cameras with larger sensor chips produce superior image quality. Zooms with modest zoom ratios—say, 24–60 mm, compared to 35–350 mm—will deliver much better images.

Autofocus compact

These small cameras offer a winning combination of high performance in a stylish and compact design. The trend is to rely entirely on a display screen on the back for viewfinding.

The shutter release is always sited for the right forefinger.

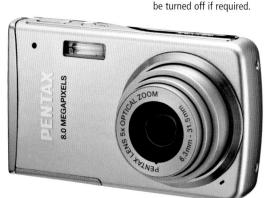

A high-quality 5x zoom makes for a versatile camera.

Sensor size and field of view

A camera lens projects a circular image. The sensor captures a rectangular area centered on this image. If the rectangle extends to the edge of the circle of light, the sensor captures the full field of view. But if the capture area falls short of the edge, the field of view is smaller. Many dSLR cameras accept conventional 35 mm format lenses but use sensors that are smaller than the 35 mm format (around APS, or about 24 x 16 mm). The result is that the field of view is reduced, which in turn means the focal length is effectively increased, usually by a factor of around 1.5x. This means that a 100 mm lens used on full-frame 35 mm is effectively a 150 mm lens when used with an APS-sized sensor. The convention is to relate the actual focal length to the 35 mm format equivalent.

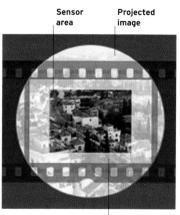

35 mm film area

Cell-phone cameras

Digital cameras in cell phones are the product of numerous engineering and cost compromises. In general, you sacrifice image quality, focusing and zoom range, speed of operation, and versatility of control for the convenience of a camera incorporated into your phone. The flash power, if available, is also limited. While a few use true zoom optics, the zoom function is generally obtained through digital zooming (see p. 22). However, the phone camera makes it easy to send images to friends and colleagues, and its importance in news gathering can only grow.

Entry-level compacts

With constant improvements in quality and the pressure of price competition, entry-level compacts offer good value for money. They don't necessarily have the lowest specification, but they may be less robust and not as compact, and offer inferior LCD screens and a limited set of features. They may also operate less quickly than high-quality cameras. But they can still deliver good image quality. Entry-level cameras from respected manufacturers offer an excellent ratio of quality to price.

Lifestyle and fashion compacts

Because the digital camera does not need to hold a roll of film, the form is flexible, so designers can create a stylish look and a level of compactness limited only by the necessity for a display and control buttons. This has led to the rise of the chic, ultra-slim, eminently pocketable "lifestyle" compact. Within this category you can find environment-proof models-sealed against dust and water splashes—that sacrifice little, if anything, in picture-making capability.

The performance of both the lifestyle compacts and the brightly colored "fashion" versions compares well with entry-level compacts, but their cost is somewhat higher, in return for which you obtain an attractive piece of modern technology. However, before parting with your money, handle the camera to ensure it is not too small for you to operate comfortably.

Resolution and quality

The word "resolution" is used in several different senses in photography. Applied to camera sensors, it measures the number of photo-sites used to capture the image. The resolution of the image itself is often equated with image size, or its number of pixels. In the context of lens performance or image quality, it is a measure of how well a system separates out fine detail.

These measures are related, but not directly. For example, the resolution of a sensor sets the upper limit of image quality, but not the lower limit: a highresolution sensor may deliver a poor-resolution image if the quality of capture, lens, or image processing is poor.

Lifestyle camera

In a bid to offer more than their competitors, some manufacturers seal their cameras against dust and water, while providing all the usual compact features. These models are excellent for taking everywhere with you.

Fashion camera

Compact cameras share so many features and are of such uniformly high quality that you may choose them simply on looks—and color is a large part of that. The range of colors goes from white to purple and everything in between.

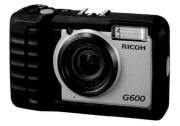

Rugged camera

A compact camera can be made very rugged by adding rubber bumpers all around, sealing against dust and water to allow underwater operation, and with oversized controls to allow for use with gloves in cold weather conditions.

Choosing a digital camera continued

Enthusiast compacts

For the avid photographer on a relatively tight budget, enthusiast digital compact cameras offer high performance, excellent versatility, and affordability. Cameras in this range may offer wider angles of view (24 mm), longer focal length zooms, the ability to record images in raw format, synchronization with accessory flash, sturdier construction, and a larger range of accessories than is available for simpler cameras.

Most importantly, these cameras offer a full range of photographic controls over exposure,

color balance, and focus. More attention is also given to lens and image processor design, with a significant improvement in picture quality compared to lifestyle compacts. Allied with typical pixel counts of 8 MP and more, these cameras are capable of tackling a wide range of photographic situations. You may also find cameras designed for special tasks, such as those capable of taking 60 frames per second and those adapted for infrared or astronomy.

When selecting a camera, try to ensure that the features you commonly use are easy to

Moiré patterns

One problem that can affect the quality of images recorded by a digital camera is known as "moiré." This occurs when the regular pattern of the sensor array in the camera interacts with some regular pattern in the image area, such as the weave of the cloth worn by your subject. The overlapping of two regular patterns, which are dissimilar and not perfectly aligned, leads to the creation of a new set of patterns—the moiré pattern—which is sometimes seen as bands of color or light and dark. Some digital SLR cameras (see pp. 28–9) offer a sophisticated optical solution—the so-called "anti-aliasing" filter—while

some other manufacturers use a filter—known as a "low-pass" filter—that very slightly softens the image by cutting out detail.

The appearance of the moiré pattern is readily discernible in the open weave of this fabric.

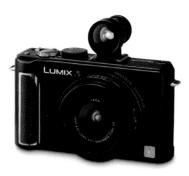

Wide-angle compact

Small digital cameras with a 24 mm equivalent focal length at the widest setting and a fast maximum aperture of f/2 offer real potential for documentary photography. An optical viewfinder can be fitted as an option.

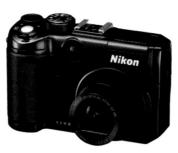

Enthusiast compact

Compact cameras aimed at the experienced photographer may pack numerous features—from GPS (Global Positioning System) geotagging, to raw recording with high sensitivity, a high-quality lens, and high pixel count.

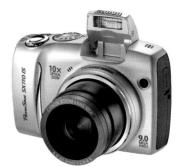

Wide-zoom-range compact

Modern compact cameras can carry zoom lenses with ratios of 10x or greater, along with relatively fast aperture at wide settings, high resolution, and other features such as video recording and image stabilization.

access, preferably with one click of a button. The size of a camera can be hard to gauge just by looking at pictures, so check the actual dimensions before you make a purchase. If speed of operation is important, test it on the camera itself, because some models operate very slowly, especially when recording in raw format.

Prosumer cameras

Prosumer cameras are models that are able to produce results to professional standards but may lack interchangeable lenses and are not built to professional standards of sturdiness and durability. There are two main types. Compact models—such as the top-of-the-line compacts from, for example, Ricoh, Panasonic/Leica, Canon, and Nikon—are excellent for photojournalism and candid street photography; and electronicviewfinder models (also called bridge cameras) with wide-range zooms—such as models from Fujifilm, Panasonic, and Olympus—are excellent for travel and out-and-about photography. For the serious nonprofessional photographer, these cameras offer superb quality at affordable prices.

Prosumer models

Easy to carry, but offering a zoom lens with 18x or greater ratio (that is, a 27-486 mm equivalent), cameras such as this can cover a wide range of subjects. The design, with permanently attached lens, is particularly useful for travel photography since it is relatively well sealed against dust.

A shutter button that "clicks" confirms when a shot is taken.

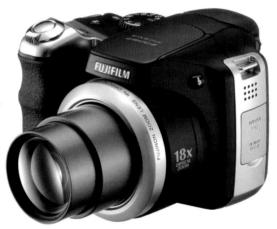

A click-stopped mode dial is the easiest type to use.

Conveniently located sockets make handling easier.

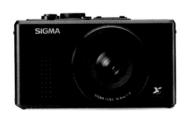

Prime-lens compact

For the enthusiast or purist who does not need a zoom lens, a compact such as this model, with a fixed zoom (28 mm or 35 mm equivalent), may be a good option. It is easy to operate and places an emphasis on quality of image capture.

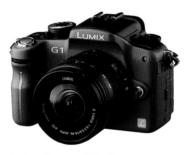

Interchangeable-lens compact

This type of camera (and similar ones from Olympus) take interchangeable lenses that fit onto a small body. It uses an LCOS (liquid crystal on silicon) display for a high-quality electronic viewfinder.

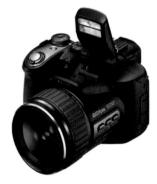

High-speed camera

Digital cameras offer increasingly powerful speed and video features. This model (and others similar) can shoot 6 MP still images at 60 frames per second and standard-definition video at up to 1,000 frames per second.

Choosing a digital camera continued

Entry-level dSLRs

The entry-level dSLR (digital single lens reflex camera) is another type of prosumer camera in that it is capable of professional-quality results but is built to offer many features at low cost. All dSLR manufacturers contribute to this sector, including Nikon, Canon, Sony, Pentax/Samsung, Panasonic/Leica, Olympus, and Sigma. These cameras will accept most, if not all, of the lenses and accessories that can be used on larger SLRs but are smaller, lighter, and generally offer lower specifications than their professional equivalents.

However, they may offer more modern features, such as live view (*see box, opposite*). These cameras make good backups to professional gear. The majority of cameras use APS-C–sized sensors, giving a focal length factor of around 1.5x the 35 mm equivalent.

Professional dSLRs

There is no clear line between entry-level dSLR and professional-level, as different models are used by both amateur and professional photographers. The larger cameras—such as the EOS-1 series

Digital SLR

Some fully interchangeable SLR cameras are significantly smaller than EVF cameras with fixed lenses. Models such as this offer good image quality with APS-sized chips of 10 or more megapixels, rapid response, and a versatility available only to cameras with interchangeable lenses.

Rapid-fire shutters help capture fleeting moments.

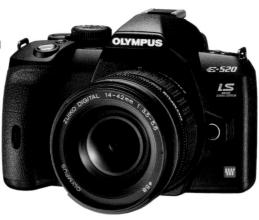

Pentaprism cover conceals a pop-up flash unit.

Interchangeable lenses give optimum versatility.

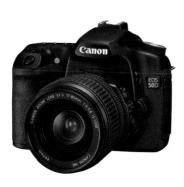

Enthusiast camera

Easily capable of professional-quality results and incredibly good value for money, these models offer 15 MP or greater resolution, 6 frames per second motor drive, live view on large displays, and sensitivities that reach ISO 12,800.

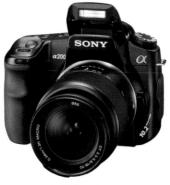

Image-stabilized camera

Some high-resolution cameras have image stabilization built into the body, rather than into the lens. The advantage of this is that any lens fitted to the body is image-stabilized, leading to a higher percentage of sharp images.

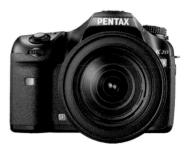

Semiprofessional camera

Affordable semipro models can be built to high standards, with dust sealing and solid construction. Some models may also offer built-in image stabilization and high-grade image processing, which makes them excellent value for money.

from Canon, the D3 series from Nikon, and certain models from Sony and Olympus-are designed for the professional. This involves highspecification shutters, a sturdy build, seals against dust and moisture, as well as a superior quality of viewfinder and features. Some cameras use a fullframe, 36 x 24 mm sensor; others use smaller ones, with resolutions ranging from 10 MP to 25 MP or more, depending on whether the emphasis is on quality or speed of operation. The Leica M8 is exceptional in offering professional-grade images using manual focusing through a rangefinder.

Top-level dSLRs

At the top of the digital photography world are the medium-format cameras, which combine a medium-format back with a large sensor—more than twice the size of a full-frame dSLR sensor. Resolutions range from 22 MP to extremely high figures of 60 MP and even greater. These cameras, from Sinar/Rollei/Leaf, Hasselblad, and Mamiya/ Phase One are built to extremely exacting standards and employ supremely high-quality lenses—some matched by software to the cameras—but they cost several times more than the most costly full-frame dSLRs.

Live view

The normal way to view through a dSLR is to examine the image reflected onto the focusing screen by the mirror. In some models, you can view the image via the LCD display, just like using a compact camera: this is called live view, and it gives you more viewing options. To enable this, either the mirror is raised and shutter opened to allow light to fall on the sensors, or the focusing screen image is reflected onto a sensor. Depending on the model, the LCD screen may be fixed in position or, as shown, can be tilted.

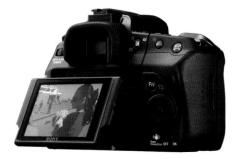

Live viewfinder

The most convenient displays are mounted on a flip-out panel that allows you to vary the angle and therefore hold the camera in different positions.

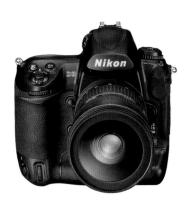

Professional camera

Models that are built for rigorous work are well sealed against dust and moisture, solidly constructed, and also respond very quickly with rapid motordrive and autofocusing. However, the end result is large, heavy cameras.

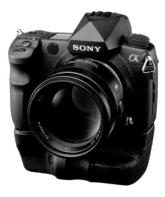

High-resolution, full-frame

Sensor sizes of 24 x 36 mm allow the widest-angle photography with 35 mm format lenses. Coupled with resolutions of 24 MP or more, image stabilization, and rapid responses, the package appeals to both enthusiasts and professionals.

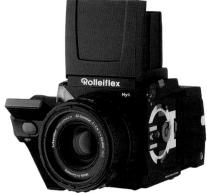

Medium-format digital

For the most demanding photography, medium-format lenses and large sensors with resolutions of 37 MP or greater are the solution. The results can be stunning, but they require great skill and high computing power to achieve.

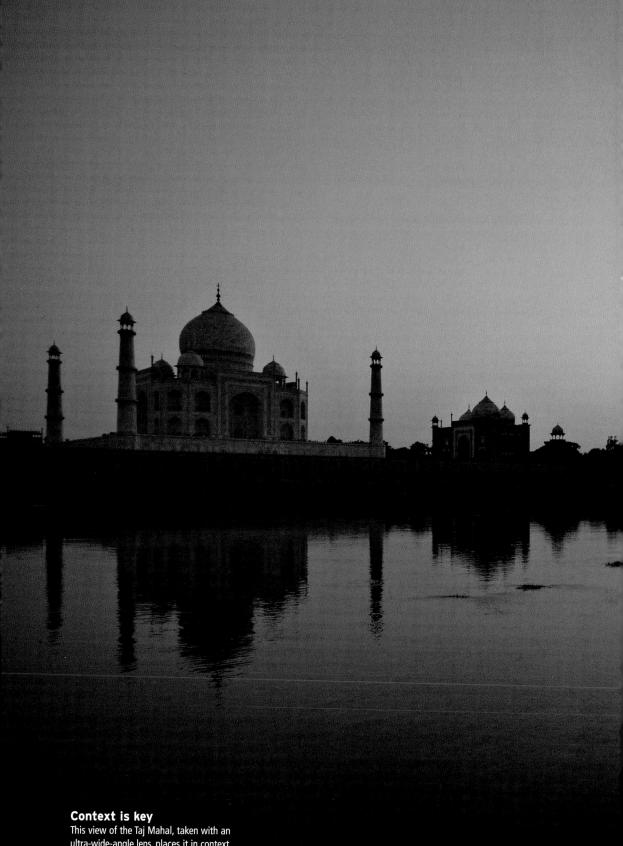

Context is key
This view of the Taj Mahal, taken with an
ultra-wide-angle lens, places it in context,
rather than making it dominant. The
natural light fall-off darkens the corners,
pulling the composition into shape.

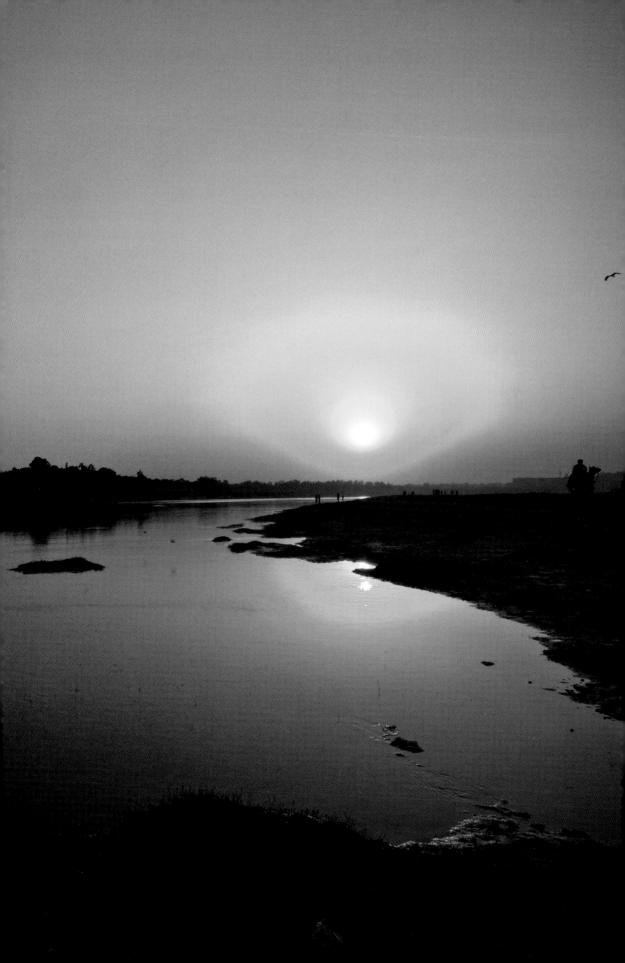

Choosing lenses

Modern camera lenses benefit from the adoption and merging of several technologies to deliver high performance with good quality in compact form and at low prices. Nonetheless, it remains as true now as ever that larger lenses with heavier construction, modest specifications, and built from costlier materials will perform better and more reliably than small, lightweight lenses or those with ambitious specifications. The most popular type of lenses are made to zoom—that is, to be able to vary their focal length (see opposite)

while remaining focused on the image. Lenses are also designed with fixed focal length (prime lenses), wide aperture, extreme focal length, or with an emphasis on specialized use.

Fixed lenses

Floating group

Compact cameras and many EVF (electronic viewfinder) cameras use a permanently mounted lens. This arrangement saves weight, allows a compact design, and virtually eliminates problems from dust on the sensor. While it is

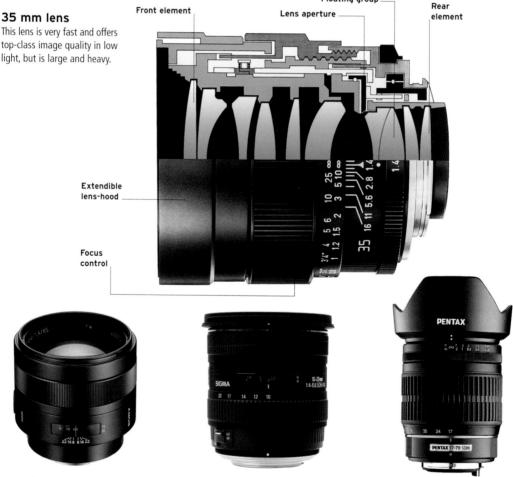

Ultra-fast telephoto

Fixed focal length lenses, such as this 85 mm optic offering an ultra-fast f/1.4 full aperture, can produce fine effects with superb quality but at premium costs.

Ultra-wide-angle

An ultra-wide-angle lens for APS-sized sensors must offer very short focal lengths, such as this 10-20 mm optic, but can be surprisingly bulky due to complicated construction.

Standard zoom

Lenses covering wide-angle to medium telephoto—such as this 17-70 mm model for APS-sized sensors—are versatile take-everywhere lenses, ideal for general photography.

tempting to opt for a fixed lens with a very large zoom range, such as 26-520 mm, bear in mind that more modest ratios are likely to give higher overall image quality, with less vignetting at long focal lengths (see p. 95) and less distortion at wide-angle settings.

Lens specifications

The main specification for a camera lens is its focal length, or range of focal lengths if a zoom. Focal length measures the distance between the point from which the image is projected by the lens to

the sharp image at the sensor, where the subject is very far away (at infinity). In practice, we use it to indicate the magnification and field of view of the lens: longer focal length lenses magnify a small portion of the view, whereas shorter focal lengths reduce a larger portion of the view.

Zoom lenses shift elements within the optics to change the focal length without changing the focus setting. From this we obtain the zoom range, or ratio, measuring the longest to shortest focal length, or vice versa. For example, a 70-210 mm lens offers a zoom ratio of 1:3.

Equivalent focal length

The focal length of a photographic optic tells you if a lens is wide-angle, normal, or telephoto. A "normal" lens is one in which focal length is about equal to the length of the diagonal of the format. With the 24 x 36 mm format, the diagonal is about 43 mm, which is usually rounded up to 50 mm. Because the sizes of sensors, and therefore format, of digital cameras vary so greatly, the accepted approach is to quote the equivalent focal length for the 35 mm format (35efl). For example, on one camera the 35efl of a 5.1 mm lens is 28 mm, but it may be 35 mm on another. The equivalence is only an approximation, because the proportions of picture rectangles also vary.

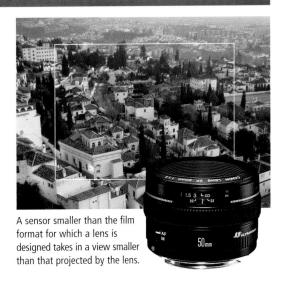

High-quality standard zoom For a standard lens—such as this zoom covering the 35 mm equivalent of

24-120 mm—you should buy the best quality you can afford, because you will use it extensively.

High-ratio zoom

A zoom lens that offers high ratios between wide and telephoto settings, such as the 15x of this model, is a tempting option, but performance may be compromised for convenience.

Telephoto zoom

A zoom limited to the telephoto range, such as this 70-300 mm model, can produce results almost equal to those of fixed focal length lenses but with greater versatility.

Choosing lenses (continued)

The other key measure is the maximum aperture. Lenses with a large maximum aperture—such as f/1.4, are said to be fast. They collect more light than lenses with small maximum aperture—for example, f/4—allowing for shorter exposure times or better-quality sensitivity settings.

Comparing focal lengths

As a result of the earlier dominance of, and familiarity with, the 35 mm format, the actual or physical focal length of a lens is usually related to that of the equivalent 35 mm format lens. For example, the 35 mm equivalent of a 10-22 mm lens for APS format (see p. 24) is 15–33 mm. Note that the maximum aperture of the lens does not change; only the field of view changes. Therefore, a 135 mm f/1.8 lens for 35 mm is effectively a 200 mm f/1.8 lens for APS-format sensors. (See also the box on p. 33.)

Match to format

The growth of dSLR cameras using APS-sized sensors (around 24 x 16 mm) has resulted in the development of two lines of interchangeable

What is lens aperture?

The terms lens aperture, f/number, and f/stop all mean roughly the same thing: they measure the size of the aperture sending light to the film or sensor. The actual size of the aperture depends on a control called a diaphragm—a circle of blades that open up to make a large hole (letting in lots of light) or overlap each other to reduce the aperture and restrict (stop down) the amount of incoming light. The maximum aperture is the setting of the diaphragm that lets in the most light. Lens aperture is measured as an f/number and is a ratio to the focal length of the lens. For example, with a lens of 50 mm focal length, an aperture of 25 mm gives f/2 and an aperture of 3.125 mm gives f/16.

POINTS TO CONSIDER

- Use a lens-hood: stray nonimage-forming light within the many internal lens elements can seriously degrade otherwise excellent image quality.
- Avoid using the maximum aperture or the minimum aperture. With most zoom lenses, at least one stop less than maximum is required to obtain the best image quality.
- Adjust focal length first and focus on the subject just before releasing the shutter. Avoid altering focal length after you have focused as this can cause slight focusing errors to occur.
- When using a wide-ranging zoom remember that a shutter setting that will ensure sharp results at the wide-angle setting may not be sufficiently short for the telephoto end of the range.

Macro lens

Invaluable not only for close-up work and copying flat originals, macro lenses offer the very best image quality, with high resolution, excellent contrast, and freedom from distortion.

Fish-eye lens

An ultra-wide-angle lens that distorts any line not running through the center of the lens, the fish-eye is excellent for special effects. The most useful type fills the frame with the image.

Converter lens

The focal length range of permanently attached lenses can be increased by using a coverter lens. The telephoto increases, and the wide type decreases, the basic focal length settings.

lenses. Generally, full-format (also called fullframe) lenses—that is, those designed for the 35 mm format—can be used on APS-sensor cameras, but not vice versa. Make sure you use the correct type of lens, and do not force a lens on if it does not fit easily. Some full-frame cameras automatically match the active sensor to the type of lens in use. The 4/3 format is a third line of interchangeable lens, and it uses its own unique mount.

Lens accessories

The zoom ranges of permanently attached lenses may be extended by using supplementary lenses. Those marked, for example, 1.7x will increase the zoom-set focal length by 1.7x to improve telephoto reach. Those marked 0.6x will decrease the zoom-set focal length by 0.6x, with the effect of increasing wide-angle views.

Interchangeable lenses accept accessories such as filters that mount on the front of the lens, as well as accessories that mount on the rear, between camera and lens. Converters, also called extenders, are rear-mounted accessories that multiply the focal length of lens. A 2x extender doubles the focal length of the lens to which it is attached-from 135 mm to 270 mm, for example, or giving a 100-300 mm zoom a 200-600 mm capability. But light transmission is reduced, and by the same factor: a 2x extender causes a 2-stop loss in aperture. Extension rings are just like converters but without a lens: they increase the focusing extension of the lens so that it can focus on very near subjects.

Specialty lenses

Lenses can be designed for specialty photographic tasks such as close-up dental photography, architectural or photogrammetric (measuring) work.

Lenses offering shift (see below) and tilt movements are very useful tools. Shifting allows you to reduce or increase, say, foreground coverage without moving the camera. Tilting the lens allows you to position the plane of best focus, to give very deep or shallow depth of field (see pp. 84-7), without adjusting the aperture—ideal for architectural and landscape work, and invaluable for still-lifes and portraiture.

The most popular specialty lens is the macro lens, designed for high-performance close-ups. A 50 mm macro lens is good for copying work; the 100 mm focal length is useful for general macro photography; and a 180-200 mm lens is essential for photographing wildlife from a distance.

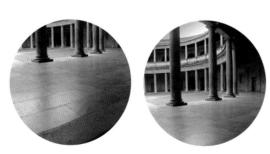

Shift views

With the camera held level, too much foreground is visible (above left). But with the lens shifted up, you can preserve the verticals while reducing the amount of foreground, and so allow more of the building to be seen (above right).

High-quality shift lens

This high-quality wide-angle lens is able to shift the image circle up, down, or across the center of the film format in order to reduce, say, the foreground without having to tilt the camera.

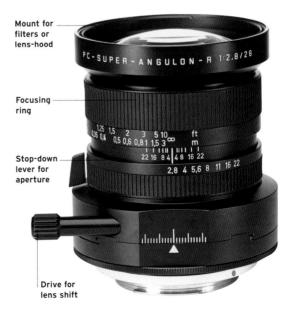

Accessories

Carefully chosen accessories can make a big difference to the quality and enjoyment of your photography. It is tempting to load up with numerous accessories, but too many items can slow you down more than they aid you.

Tripods

Tripods can make the biggest single contribution to improving the technical quality of your photography. The best are heavy, large, and rigid, while small, lightweight ones can be next to useless. As a rough guide, a tripod should weigh twice as much as the heaviest item you put on it.

For the best balance between weight and stability, look for a tripod made from carbon fiber. Those that telescope with three or more sections are more compact when folded but less rigid than those with fewer sections. Collars that twist to lock a section are compact but slower to use than lever locks. A good, less-expensive compromise is a tripod made from aluminum alloy. Very small tabletop tripods are handy for steadying the camera, and shoulder stocks, which enable you to brace the camera against your shoulder, can help reduce camera shake.

The choice of tripod head is as important as the choice of tripod itself. Choose one that is quick and easy to use but that holds the camera firmly. Ball-and-socket heads are quick to adjust but difficult to use with heavy equipment, while 3-D heads are easy to adjust with fair precision but are slower to operate than ball-and-socket heads. The slowest heads to operate are the geared type, but precision adjustment is very easy. For extremely heavy lenses, use center-of-gravity pivots such as the Wimberley head. Attach the camera to the head with a quick-release mount, as these are most convenient. However, when a mount is attached, it makes it more awkward to handle the camera.

Exposure meters

While almost all cameras made today have builtin exposure meters, handheld meters are still the best way to make incident-light readings (of the light falling on the subject). Some handheld

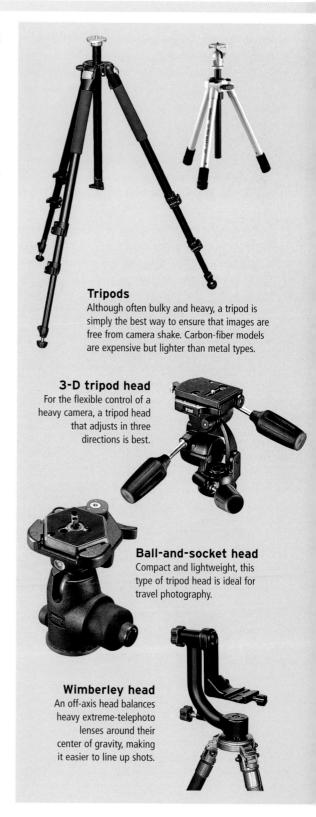

meters also offer far greater accuracy, especially in low-light conditions. And spot meters, which read reflected light from a very narrow field of view—commonly 1° or less—offer unsurpassed accuracy in tricky lighting.

Flash meters are designed to measure electronic flash exposures. Most modern handheld meters can measure flash exposures as well as ambient light and, indeed, indicate the balance between the two. A flash meter is an essential accessory for serious still-life and portrait work.

Bags

Modern, padded soft bags combine high levels of protection with lightweight construction: those from Lowepro, Think Tank, Tamrac, Tenba, Domke, and Billingham will all give excellent service for many years.

For carrying heavy loads over long distances, the backpack design puts the least stress on your back, but accessing equipment is slow. Bags slung over the shoulder are quick and easy to use but can strain the back. A good compromise is a shoulder bag with waist-strap, so that some weight is carried on the hips.

For work in highly challenging conditions, or if you fear your precious lenses and laptop might have to travel in cargo holds or be slung into the backs of overlander trucks, a hard case with waterproof and dustproof seal—such as a Pelican Case—is essential. However, even when empty they are heavy, so expect to have to pay excess-baggage charges.

Waterproofing

A waterproof camera housing is needed in situations such as shooting from a canoe or when sailing—not just if total immersion is likely. Camera housings are also ideal for particularly dusty conditions, such as industrial sites and deserts. Housings vary from flexible plastic cases for shallow water, to sturdy cases for deep water. They are available for compact cameras through to professional models, but they may cost at least as much as the camera they protect.

Digital accessories

The modern digital camera has to work with a retinue of digital accessories to ensure that it is powered and has the capacity to record images.

Memory cards

Memory cards use banks of memory registers that hold their state—on or off—without needing power. They can hold data indefinitely yet can easily write new or altered data. Their compact size, low power requirements, and large capacity make them ideal for image data. When an image is written to them, the registers are flipped on or off according to the data. To read the memory, the registers are turned into a stream of data. Modern cards can hold more than 16 GB of information and read or write 300x faster than a standard CD.

There are many card types in circulation: some are extra-compact for use in cell phones, others are optimized for speed or sturdiness. If you own more than one camera or want to use another device, try to ensure intercompatibility.

CompactFlash

The most widely used memory card for digital photography is the CompactFlash. All cards have to be slotted into the camera so that recorded

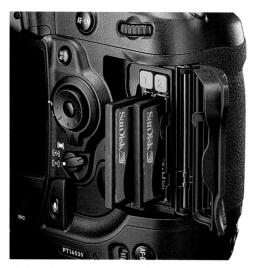

Using the memory card

Memory cards are easily replaced in a camera, but do not try to change cards when the camera is reading from or writing to the card—usually a light warns you when the card is in use.

images can be saved onto them. You can remove the card at any stage before it is full and slot it into a reader to transfer files to a computer, but do not remove it while the camera is trying to read the card, usually indicated by a red light. You can also erase images at any time to make room for more.

Digital image storage

When traveling with a digital camera it is often impractical, and always inconvenient, to carry a laptop computer for storing image files. One

CompactFlash

Very widely used in dSLR cameras and others, this is a sturdy card in a range of capacities, up to at least 32 GB, and speeds to suit different budgets.

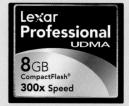

Secure Digital (SD)

Very widely used in compact and dSLR cameras, SD (and SDHC) cards are very small yet offer capacities as high as 32 GB with low draw on current. They are also sturdy, both electrostatically and physically.

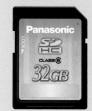

Micro SD

These cards are widely used in cellphone cameras and offer capacities up to 8 GB. Via an adaptor, they can also be used in devices that take the larger Mini SD and SD cards.

xD-Picture Card

These very small cards with capacities up to 8 GB offer good performance with low power consumption but are not widely supported. Proprietary to Olympus and Fujifilm.

MemoryStick

Proprietary to Sony, this family of cards is used in a variety of digital equipment, including Sony video cameras, allowing interchange with good capacities and performance.

option is what is essentially a portable hard-disc equipped with an LCD screen and card-reading slots. The screen may be color for reviewing images on the device, or it may simply show the copying status and basic file data. Some of these units can hold more than 100 GB of data and are equipped with slots for reading memory card devices. Data can be copied straight from the card devices onto the drive, then the drive can be connected to your computer to transfer your images once you are back at home.

Card care

- Keep memory cards far away from magnetic fields, such as television monitors, audio speakers, and so on.
- Keep cards dry.
- Keep cards dust-free.
- Keep cards in protective cases when not in use.
- Do not bend or flex cards.
- Avoid touching the contacts with your fingers.

Photo frame

These devices display a single image or a slide show of images downloaded from a memory card or picture store. Useful in store displays and gallery exhibitions.

Mobile storage

Freeing you from taking a back up photos and so continue

computer outdoors, these small hard-disc drives allow you to using your memory cards. They also allow you to review and show images as you shoot.

USB drive

quantities of files from one machine to another, USB drives are solid-state memory devices with impressive storage capacities.

Memory card readers

There are two ways of transferring images taken on your digital camera to your computer. You can connect the camera to your computer and instruct the camera's software to download images, or you can take the memory card out of the camera and read it to the computer. To do this, you need a memory card reader, a device with circuitry to take the data and send it to the computer, via a USB, USB 2.0, or FireWire cable—the latter two transmit data fastest. There are many card readers on the market that can read almost every type of memory card.

reader

Using a reader

When slotted in, the reader opens the card as a volume or disc. You can then copy images straight into the computer.

CompactFlash card reader

Portable flash

The invention of portable flash had a tremendous impact on photography: it opened the night world to the camera, with compact, easily carried equipment. Today, electronic flash is standard to all compact digital cameras, even to cell-phone cameras, and can even be found on most dSLR cameras. So what is the need for portable flash? (See also pp. 124–5 for use of flash.)

Power and recycling

Flash built into a camera relies on the camera's own batteries for power. To curb their hunger for energy, built-in flashes are designed to be lowpowered—usually sufficient to light to a distance of 3-7 ft(1-2 m) but little farther. In addition, the recycling rates—how quickly the flash can be fired in sequence—is also limited. Overenthusiastic use of built-in flash can render the camera literally powerless to work.

Flash power

Portable, or accessory, flash units overcome the limitations of built-in flash by carrying their own power and circuitry; this makes the units much larger than compact cameras. Accessory flash units also offer more control over flash power, direction of flash, and angle of coverage.

Accessory flashes fit onto the hot shoe, which combines electrical contacts with a slot that "mates" with a corresponding, locking part on the bottom of the flash unit. While the majority of cameras use a standard hot-shoe design, the contacts may be specific to the camera producer, and some manufacturers—such as Sony—use proprietary hot-shoe designs.

Adjustable angle

Many portable flash units place the flash on a swiveling turret so that it can be directed to the sides, or even backward, according to the nearest surface for bounce flash (see pp. 127 and 131–2). Some offer a tilting head so that you can point the flash upward, or downward for close-up work. A fully adjustable head increases flexibility, so is a must for wedding and paparazzi photography.

Adjustable coverage

On many flash units you can also adjust the coverage, or the angle over which light is spread. This ensures that when you use a wide-angle lens

Small supplementary flash

Units like this can augment the power of built-in flash units. It is triggered by the camera's own flash and adds its output to that of the camera's unit. It is an inexpensive solution to lighting problems, but control is limited.

Slave flash unit

Slave units can add to the power of builtin flash units. This unit synchs with the on-camera flash for the most accurate exposure, after which operation is fully automatic. Position it to one side of the camera to control lighting direction.

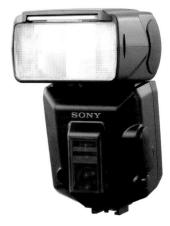

Powerful on-camera flash

Accessory flash mounted on a camera's hot shoe can be sufficiently powerful for all normal needs, offering a tiltand-swivel head for bounce, multipleexposure facilities, and focusing aids for working in complete darkness.

or setting, the flash coverage is sufficient to light the angle of view: this causes a lowering in the maximum power of the flash. When you make a telephoto setting or use a long focal length lens, the coverage is narrowed to match, approximately, the angle of view. This causes a gain in the maximum power of the flash, since the light is concentrated into a narrower beam.

Adjustment may be carried out automatically, with the camera instructing the flash according to the zoom setting on the lens, or it can be manually set. Zoomlike optics in the flash tube alter coverage, and a diffuser may be used for ultrawide-angle coverage.

Red-eve

The unsightly red dot in the middle of eyes lit by flash-commonly known as red-eye-is caused by two factors: the flash being so close to the optical axis that the light reflects off the bloodrich retina of the eye, while, at the same time, the eve's pupil is dilated in dark conditions. Accessory flash mounted on the hot shoe or to one side moves the source of flash relatively far from the optical axis, with the result that red-eye is avoided.

Guide Number

The light output of accessory flash units is usually measured by the Guide Number (GN). The figure is for a specific film/sensor speed—usually ISO 100 in either feet (ft) or meters (m), and for a specified angle of coverage. The GN for a unit will be higher for narrow coverage—suitable for medium-telephoto lenses—and lower for wide coverage—suitable for wide-angle lenses. A Guide Number may be quoted as, for example, GN45 (m), indicating the distance scale is meters. A typical small camera GN is 5-10 (m); accessory flash units offer 30-50 (m). The standard practice is that that the GN figure is quoted for the coverage of a standard lens but may be inflated in specifications by being quoted for a narrow coverage. The Guide Number scale is defined:

Guide Number = subject distance x f/number

The f/number for a correct exposure is the result of dividing the GN of your unit by the distance between the flash/camera and the subject. Using GN to set an f/number is generally more accurate than relying on automatic systems.

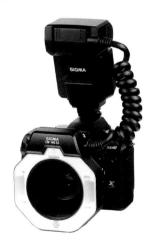

Macro ring-flash

For shadowless flash photography of insects, flowers, and other small objects, a ring-flash is ideal. The brief flash can stop inadvertent movement, and very small apertures can be set for maximum depth of field.

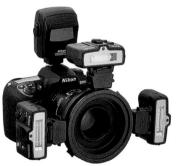

Adjustable macro flash

For controlled lighting in macro work, units with two or more small flash units that can be set to different positions around the lens give the most flexibility. They can be set to different power levels and point in different directions.

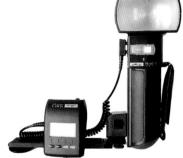

Powerful handle-bar unit

Units designed around a large handle offer great power output and high endurance. They also have many other functions, such as adaptors for dedicated operation, zoom reflector, and modeling light, as well as rapid firing rates.

Studio lighting

The photography studio allows you to control all elements of the lighting and background. Modern light-shapers and reflectors, as well as electronic control of light and color temperature, allow for unprecedented options-from the most subtle modeling for flattering portraits, to inventive, übercool looks for the sharpest of chic fashion.

How flash works

Studio flash units consist of a delicate, gas-filled glass tube with wire wrapped around it. When high-voltage electricity is discharged into the wire,

the gas emits a burst of intense light. A power unit is used to build up the necessary charge, and dials and other controls can vary the output of the flash. The light output is very reliable from flash to flash, color temperature does not vary significantly with change in power, and the short duration of the flash helps freeze subject movement.

Monobloc and power pack

Two different types of flash unit are available. The monobloc design combines the lamp, switches, power controls, and power supply in a single unit.

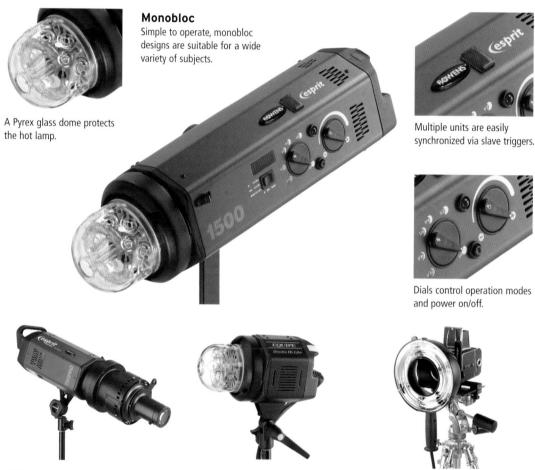

Universal spot

The light-shaper attached to the monobloc delivers a controllable and intense beam of light that is suitable for projecting images. Precision control of light power is especially important with spotlights.

Powerful flash

A very compact and lightweight head has the benefit of separating the power unit from the lamp. This unit packs a powerful flash output, as well as having a strong modeling light to allow you to preview the fall of shadows.

Ring-flash

The circular flash ring around the lens gives an unsurpassed softness of light, yet one that can model and shape through a fringe of balanced shadows. Available in various designs, from costly, powerful units to adaptors for existing flash.

This is the least expensive option, but when mounted on stands with a large light-shaper, these units are ungainly and top-heavy. You may also find yourself running from one side of the studio to the other to alter settings. But if more power is needed, you simply add another monobloc.

The other design uses a separate power pack connected by cables. These lamps are compact and lightweight compared to monoblocs, so they are easier to aim with precision. You can also place the power packs close to the camera for added convenience of control. However, power output is limited by the total capacity of the power pack.

On-location safety

Observe good practice to ensure safety when using high-powered electrical equipment out of doors.

- Ensure cables do not present trip hazards—tape or cover them, or fence them from passers-by.
- Ensure power cables are not live before connecting to equipment—turn off the power.
- Stop working immediately if it starts to rain and the equipment is not sheltered.
- Do not locate bare bulbs near objects of value or of which you do not know the composition. This will help avoid damage or fire risk.
- Allow only qualified persons to use the equipment.

Remote control

Many modern flash units are controlled digitally by push-buttons. These offer more precise control of functions (power can be varied by as small as 0.1-stop steps) and may be more reliable than dials and switches. A further advantage of the digital control of flash power and mode settings is that units can be set remotely, using radio or infrared. Typical handsets, working much like a television remote control, can operate eight or more different units-invaluable where units may, for example, be suspended from ceilings.

On location

Most units are designed for use in the studio, powered from an electrical outlet. For location work, you have a choice of power sources. In one, a battery pack powers normal studio lamp housings; these are compact but last only a limited time. Or you can power studio units from a dieselengined generator; these last as long as the generators run, but the generators can be very noisy and are not suitable in confined areas.

For regular location use, consider powerful portable flash units. These are much heavier accessory flash units but more maneuverable than studio flash; however, they lack the power of studio units. The range of light-shapers and softboxes may be smaller than for studio equipment.

Digital control

Modern, digitally controlled units offer the photographer finely tuned performance. Additionally, they allow for the possibility of being controlled by computer, making it easy to save and repeat power settings with precision.

Power pack

Floor-standing power packs allow the lamp housing to be lightweight and easy to set up or maneuver while capable of applying different power settings for up to four separate lamps. They are a good solution for small studios.

Remote control unit

A further advantage of the digital control of flash power and mode settings is that units can be set remotely. This handset, working much like a television remote, can control up to eight different units.

Studio equipment

In creating your ideal studio, you have four broad areas to design. Assuming you have a studio space, the first decision is whether the walls should be painted black (for minimum interference with lighting set-ups) or white (more pleasant to work in, but the walls bounce light into set-ups). A compromise is to hang black curtains on rails to hide or reveal white walls. The other areas are the type and number of lighting units; the lightshapers, diffusers, and reflectors to use; and the background system. Remember: even the bulkier modern flash units are still sufficiently compact to be used for indoor location shoots.

Lighting units

The minimum outfit for portraiture and still-life comprises two units of at least 500 W/s (Watts per second of power) offering variable power over at least a 2-f/stop range. It is possible, and sometimes easier, to photograph much still-life with just one unit plus inventive use of reflectors. Adding a

third lighting unit greatly increases the range of lighting possibilities, since two lights can be aimed at the subject and the third used to give variety to the background (see also pp. 128–33).

Light-shapers and soft-boxes

The light from a flash unit can be shaped to give many styles of illumination. A spotlight creates a concentrated, intense beam, while honeycombs give directional light favored in portraiture. For soft lighting and maximum output, use the largest reflector, often called a beauty dish.

The most useful of all is the soft-box, the light of which can be used for anything from food and still-life to portraiture, children, and fashion. Softboxes are constructed with a large reflector and diffusing screen hung on a frame with a central hole for the flash unit. With the diffuser attached, a soft-box provides soft, low-contrast light; with the diffuser removed, the unit produces a directional, though not harsh, light. The larger the soft-box, the softer the resulting light, but efficiency is lower—that is, light loss is greater.

Reflectors

Reflectors not only reflect light but can also alter its quality, so that the light quality is more or less

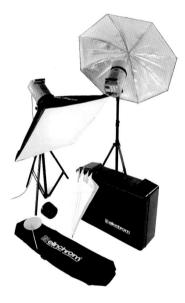

Versatile outfit

Two or three monoblocs with an umbrella reflector and a soft-box can tackle subjects from portraits to stilllifes and small interiors. With stands for the lamps and all cords, the outfit packs down to become fully portable.

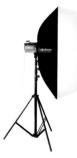

Soft-boxes

Made of lightweight frames and fabric, soft-boxes provide a very large light source for very soft light. With sizes reaching more than 7 ft (2 m) across, soft-boxes may be octagonal, tall, and thin, as well as square.

Light-shapers

Polished light-shapers are the most efficient way to control lighting quality as they make the most use of the flash output. However, the quality tends to be hard, so they are best used on backgrounds or with reflectors.

soft or diffused. They can also alter the color of the reflected light—usually to create a warmer or golden color. The closer the reflector is to the subject, the stronger the effect. The more polished its surface, the more the original light quality is retained: reflectors with dimpled or rough surfaces soften the light quality. With ingenuity, it is possible to light just about any subject using a single light source and lots of reflectors, but you will need many hands or clamps to hold the reflectors in place.

Slave units

In the usual set-up, the flash connected to the camera is the master light. When this unit fires, sensors, known as "slaves," attached to any other lights fire their flash units in synchronization. This removes the need for all flash units in a multilight set-up to be cabled to the camera.

Ring-flash

While most flash units are used at a distance from the lens, ring-flash is designed to light the subject from as close to the optical axis as possible. The flash tubes are arranged in a circle surrounding the front of the lens, producing nearly shadowfree light. Ring-flash is useful for lighting closeups of any small objects (as long as they are not shiny, flat, and taken directly face-on, since the light will bounce straight back into the lens), as well as portraiture and fashion subjects.

An alternative ring-flash technology uses the light from a normal flash but pipes the light around a ring-shaped diffuser to give effects identical to that of normal ring-flash. While there is a loss of efficiency, the cost is far lower. Moreover, some units, such as Enlight's Orbis, work with portable flash units.

Continuous light sources

Luminaires with continuous output are returning to the fore as a practical light source with digital cameras. The best of tungsten sources, such as those from Dedo, give a good output and are easily controlled, but color temperature is unstable. HMI lamps offer high output at lower operating temperatures, but they are very costly to purchase. Professional fluorescent lights are another solution for digital photography: the light is diffused, color temperature is stable, and they run cool compared with tungsten units.

Reflectors

Used to send fill-in light from the main light into unlit areas to relieve shadows, reflectors, when carefully placed, allow you to work with just a single light source. The colors of different surfaces tint the fill-in light.

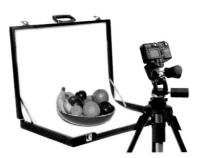

Tabletop set-up

Photography for online auctions is now well catered for with light-tents (for ultra-soft lighting) and tabletop backgrounds such as this. They are suitable for small objects and can be folded and packed away after use.

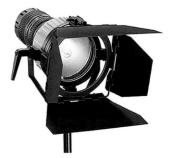

Continuous sources

The easiest way to control lighting is by using continuous sources, since you can see what you are doing at all times. Modern units provide high power and stability, while HMI types provide daylight-balanced light.

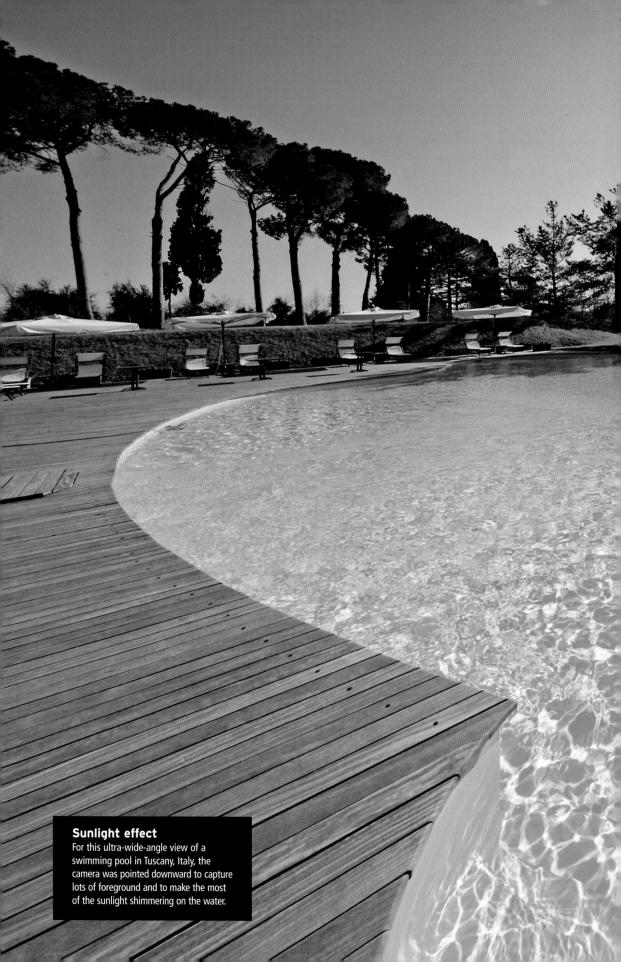

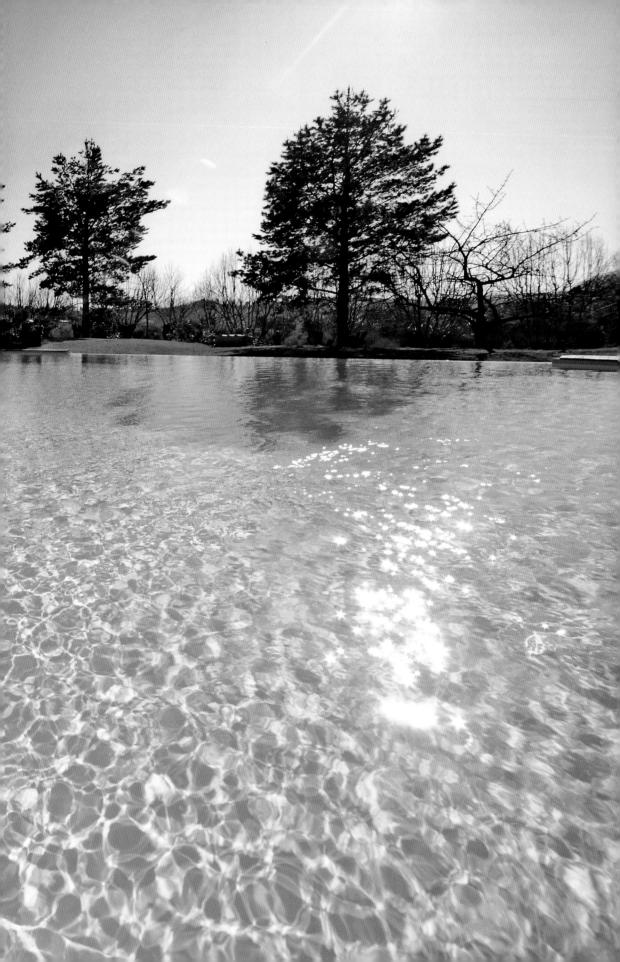

Monitors

The monitor is of central importance to digital photography. The likelihood is that you will spend at least as much time looking at the screen as through the camera lens, while you evaluate, sort, manage, and manipulate your images. In addition, the screen is the place you evaluate and correct image tone and color, and where you assess sharpness, so it is wise to purchase the very best and largest screen you can afford, appropriate to your photography.

Monitor technologies

There are two main methods of producing the computer monitor image. Both require extremely high levels of precision in manufacture and the utmost in sophisticated quality control. The technology used for cathode-ray tube, or CRT, monitors is essentially the same as that used in domestic televisions: an electron gun, the cathode, is heated up to produce electrons that are accelerated and focused onto a phosphor-coated screen, which glows when hit by the electrons. For color images, phosphors that glow red, green, and blue are used. To ensure that the correct color phosphor is stimulated to glow by the beam, a grid is placed between the electron beam and the phosphor.

CRT monitors continue to be used in specialty applications where the largest color gamut is required, such as in printing houses and highly color-critical industries. However, their enormous bulk, heavy power consumption, and need for

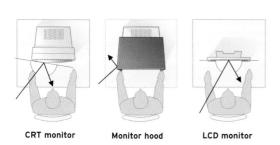

Controlling reflections

Sidelight reaching CRT or LCD monitors can reflect into the user's face, causing uncomfortable glare (above left and right). The use of a deep hood (above center) reduces this problem.

regular calibration have put them out of favor compared to LCD (liquid crystal display) screens.

In an LCD screen, the crucial element is the liquid crystal itself—a liquid or semiliquid material whose molecules behave like crystals when subjected to the influence of an electrical field. Due to their structure, some types of liquid crystal can polarize light—a property used either to allow or restrict its passage. LCDs consist of layers of liquid crystals sandwiched between a mosaic of very fine electrical plates covered by red, green, or blue filters. As a plate is turned on or off, the color of the picture element controlled by it appears bright or dark; taken together, this creates the colored image.

Modern LCDs are backlit (a panel of light shines through the LCD) to improve visibility and contrast. Screens using LEDs as the backlight are energy-efficient and provide excellent color reproduction. LCD screens can be extremely slim, consume little electricity, cause minimal eyestrain, and are suitable for all but the most colorcritical viewing.

Making a choice

For image manipulation, the minimum screen size recommended is 15-17 in (38-43 cm). The

General-purpose LCD monitor

High-quality modern LCD screens offer the best balance of ergonomic features and image quality, as well as minimizing eye-strain. Images are stable, geometry perfect, and color rendition sufficient for most color-checking needs.

screen resolution should be 1,280 x 768 pixels or better: for professional work the norm is 1,920 x 1,200 pixels. Note that two screens of different sizes may offer the same resolution: the icons on the smaller screen will be correspondingly smaller than on the larger screen. To obtain larger icons, you need to set a lower screen resolution.

All modern monitor screens can display millions of colors, but the accuracy and extent of the color gamut varies considerably. Broadly speaking, you need to spend more for colorcritical work. The main manufacturers—such as Apple, NEC, Eizo, Sony, and LaCie—all supply excellent screens.

The surface of LCD screens may be matte or glossy. Matte screens are less prone to stray reflections and display images similar to print reproduction. Glossy screens give much better image quality but are prone to stray reflections. Some modern screens also offer ports for USB or FireWire connectors, and this is an especially convenient feature.

The quality of the graphics processor card is at least as important as the monitor itself: the processor is fitted into the computer and may be upgraded to improve speed and quality. Some image-processing software applications use the

Specialized LCD monitor

Modern LCD and LCOS (Liquid Crystal on Silicon) technologies are improving color accuracy—in particular, by increasing color gamut. For the most color-critical work, the extra expense of color-accurate monitors is well worth the investment.

graphics processor for computation. Thanks to improvements driven by the computer games industry, the majority of graphics processor cards are amply powerful for digital photography.

Using two screens

Many computers will support two monitor screens, treating the screens as though they were one. This allows you to place, for example, the palettes and directory information on the lefthand screen, while the right-hand screen shows your image without any clutter. Using two screens greatly improves productivity, because you do not have to keep looking under the top window to see what is underneath.

Monitor calibration

As viewers, we are tolerant of quite wide variations in color balance in the image. However, to make the most of the superb images produced by today's digital cameras, you should work with a calibrated monitor.

Modern operating systems offer software calibration as part of the setting up. For Apple Mac, the calibration process is in the Displays section of System Preferences: select Color and click on the Calibrate button, then follow the instructions. There are different approaches for Windows users, according to the version installed. Windows Vista uses a new, powerful color-management system that addresses limitations of older systems. The best solution is to use a hardware calibrator. This

instructs the monitor to display standard colors, which are measured and compared with the target values: the differences between actual and target values enables a monitor profile to be created. (See also pp. 232-3 on color

management.)

Monitor calibrator

Scanners

With the dominance of digital cameras, scanners, which convert films or prints into digital form, have become less important. Nonetheless, much great photography remains locked up in film, and scanners enable medium-format and largeformat film users to share the advantages enjoyed by digital camera users. Additionally, modern scanners are so powerful and capable that professional-quality results are achievable even by those on a fairly modest budget.

Flatbed scanners

A flatbed scanner works in a similar way to a photocopier: you place an original print face down on the glass and a sensor runs the length of the original to scan it. If your print is large enough and of high quality, even inexpensive scanners can produce publication-quality images. These scanners can also be used as a close-up camera for taking images of flat subjects at full size or high magnification (see pp. 222-3). Opt for a flatbed scanner that can scan transparencies: a transparency adaptor may be built-in or an optional extra.

For scanning medium-format film, select scanners with resolutions of 2,000 ppi (points per inch) or better. If you intend to scan full-size flat originals of letter size (A4), an entry-level scanner offering resolutions in the region of 600 ppi will be fine. For scanning artwork up to tabloid size (A3), you will need a larger scanner, which is more costly. Scanning a large original in sections in order to blend the parts together in imagemanipulation software is not recommended with entry-level machines: unevenness around the edges will make it difficult to match the images.

Manufacturers such as Epson, Canon, and Microtek offer machines that cater to a range of needs, from the home-office worker upward. In general, it is true that the more you pay, the better performance you can expect—in terms of

Transparency adaptors

Should you need to scan medium- or large-format films, you need a scanner with a transparency adaptor. This is simply a light source that shines light through the transparency or film onto the scanner's sensor.

Transparencies require a higher scan resolution than prints. So-called repro-quality scanners offer resolutions of at least 1,200 ppi in one direction, and their maximum density ratings should equal or exceed 3.5.

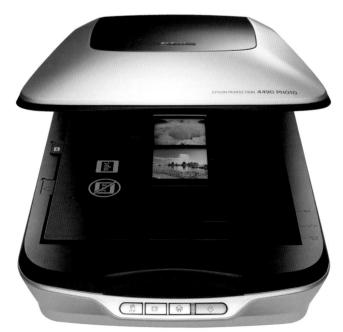

You can launch scanner-based applications and initiate scanning simply by pressing controls on the machine.

Easy, quick, reliable

Typical of numerous flatbed scanners, this model produces excellent results from prints, is easy and quick to operate, and is reliable. Use an adaptor, as here, to obtain good-quality scans from transparencies.

the scanner's mechanical operation, reliability, and quality of software interface.

Specialty film scanners

Where the primary source material is film— 35 mm or larger—a film scanner represents the best balance of features and quality. However, the market has shrunk, and the choice is now very limited. Nikon, of the major manufacturers, remains true to film with a range of professional scanners. Less costly options are offered by Plustek and Reflecta. The Hasselblad Flextight scanner uses a "virtual drum" in which the film is stretched over a cylinder prior to scanning. Very high quality and rapid scan rates, leading to professional-looking scans, are offered, with resolutions up to 8,000 ppi.

Points to consider

Resolution Choose a machine that offers an optical resolution of at least 2,700 ppi. This will create files of 20 MB in size from 35 mm format, which should be enough for fair-quality tabloid-size (A3) ink-jet prints or magazine-quality reproduction of letter (A4) size. Maximum density Look for a machine offering a d-max (maximum density) of at least 3.6—this will allow you to scan color transparencies to fair quality. Quality of film carriers Some carriers are flimsy, and you may find others awkward to use.

Driver interface On many scanners you have no choice but to use the manufacturer's driver, and some are far easier to use than others. VueScan drivers work with many machines and may be superior to the

manufacturer's own, while Silverfast works with the scanner's own driver for improved functionality. Film formats An APS (see p. 80) adaptor is usually an extra cost. For a panoramic-format 35 mm, you will need a medium-format scanner with suitable film carriers. Oversampling Some scanners can sample an original more than once, combining information so that differences are averaged. This has the effect of keeping genuine, repeatable information—and because unwanted data or noise is random, oversampling strips out image-degrading artifacts. Computer connection The best option is FireWire (which is also known as IEEE 1394 or iLink). USB is a low-cost option, while USB 2 is faster. SCSI is used by older equipment.

Medium-format scanner

A scanner suitable for medium-format film may also be able to scan panoramic formats on 35 mm film, giving results that can equal highresolution digital cameras.

35 mm scanner

A high-quality 35 mm scanner, such as this model, is excellent for turning legacy film-based material into digital form. This remains a cost-effective route to high-resolution photography.

Choosing software

Software is the lifeblood that enables your system to bring digital photography to life. Essentially a collection of instructions, software operates at several levels. Between machines, software instructs your equipment—camera, scanner, or computer—to communicate with other pieces of equipment in order to operate smoothly and free of error. At the system level, software enables you to copy your files, rename them, or back them up. And finally, at the application level, software enables you manage your images, manipulate them, and print them out. The good news is that the basic software you need to make a start in digital photography is usually provided with the digital camera that you purchase. In addition, your computer will offer software for viewing images and carrying out basic manipulations.

Workflow software

The best software to use for your digital photography is whatever best complements your digital-imaging workflow. Modern software development has concentrated on improving efficiencies on many fronts, with the most successful being those that image management with image manipulation. The leading examples are Adobe Lightroom (for Windows and Mac OS) and Apple Aperture (Mac only). These combine powerful management features with versatile handling of

metadata (captions and camera data), as well as image-enhancement functions such as color, tone, and sharpening controls. Furthermore, these applications automate export functions such as creation of web pages, slide shows, and printing of contact sheets, individual prints, and books.

Either Aperture or Lightroom may be all the software a digital photographer needs: the single solution is not only cost-effective, but you also need only one application open, where before you needed three or more. Note that before images can be handled by Aperture or Lightroom, they need first to be imported or referenced—a process akin to cataloging the images.

Adobe Photoshop

The most widely used software by both amateurs and professionals, Photoshop is one of the most powerful applications on the planet—let alone

Adobe Photoshop

Photoshop offers unrivaled flexibility of operation, the most versatile and capable manipulation of layers and masks, as well as the highestquality image processing. But it is not easy to use, nor is workflow obvious.

Checklist

When purchasing software, particularly the professional applications with more advanced feature sets, you should check the following:

Operating system required If you do not have the latest computer, check that your version of the operating system will run the software. You may need to download updates to your operating system first. Minimum RAM Check how much RAM the software needs to run efficiently. One advantage of entry-level software is its modest demands for RAM.

Minimum video Check the video requirements: some

software applications, such as Apple Aperture, use the video card for some of the image processing.

Minimum hard-disc space Check how much hard-disc space the software needs. In addition to the space for the software itself, it will need space to store temporary working files—the larger your files, the greater the amount of space that will be needed.

Drive type You will need at least a CD reader to install files, but some software is delivered on DVDs. An internet connection may be needed to unlock or register software and to download updates or fixes.

for digital photography. And therein lies its weakness: its range of features is so extensive and powerful that not even the busiest professionals could say they regularly use, and are familiar with, all of the tools and controls available to them. As a result of its piecemeal evolution, its collection of tools is not integrated into modern workflow practices, which ensures it is not easy to master. However, what experienced users most appreciate is the ease with which Photoshop may be customized, so that working with its numerous features can be highly streamlined and efficient. Photoshop is also fully supported with innumerable websites.

The power of Photoshop is also greatly increased by the myriad software plug-ins that are available for it. These can extend its every feature-from specialized saving of JPEG files, to lens-distortion correction. Its ability to manipulate numerous layers and masks is also unrivaled by any software.

Entry-level image editors

There are a great many software applications for image manipulation that are designed to be easy to use. They range in cost from inexpensive to free. However, the quality of results may vary: less expensive software may use less precise computation or use less rigorous techniques when manipulating images than professional software such as Photoshop. For PC only, PhotoImpact Roxio or consider Ulead PhotoSuite, both of which offer a lot of features at a very low cost, while Corel Paint Shop Pro has a very good suite of features that are broadly easy to use, although it costs slightly more than PhotoImpact or PhotoSuite. Adobe Photoshop Elements is easy to use and offers a feature set that will take you a long way; it also provides a good place from which to progress to the complexities of Photoshop.

In addition, there are many free software applications such as Picasa, Serif PhotoPlus, Pixla, Paint.NET (all for Windows), and GIMP (Windows and Mac).

Raw file conversion

Apple Aperture and Adobe Lightroom were originally created as raw conversion applications combined with management capabilities. As such, they remain the most powerful raw converters. However, they are extremely large applications that require considerable computing power. If you only occasionally convert raw files, you may opt to use other converters. All camera manufacturers provide raw converter software with their cameras that record in raw, but one of the most highly regarded is found in Adobe Photoshop-and it supports more cameras than most. There are also raw converters in Photoshop Elements and Paint Shop Pro. Favorites among professionals include DxO Optics and Capture One from Phase One (Mac and PC): both packages produce excellent images. Other commercial converters include SilkyPix, Bibble (Mac and PC), BreezeBrowser, and RawShooter (PC only), while RawTherapee, for PC only, is donation-ware (available for a donation).

Apple Aperture

This, together with Adobe Lightroom, is a leading example of a new type of application for photographic workflow, providing all the key tools for manipulation, management, and output in a single package.

Asset management

Where image collections number more than a few thousand pictures, you will be very grateful for software that helps you organize it by presenting each folder's contents as a series of thumbnail images. You will also be able to add captions, including camera details. Such applications will help you build web pages or display slide shows, too. The fastest and easiest to use is Camera Bits Photo Mechanic. While Extensis Portfolio and FotoWare FotoStation are large and powerful, they are fairly costly and much slower than Photo Mechanic. All work in Mac OS X and Windows XP. Lower-cost options include ACDSee, Adobe Album, and Corel Photo Album (PC only).

Printers

Digital printers place inks or pigments at precisely determined points on a substrate, such as paper or cardboard. The dominant printer technologies in use are the ink-jet and the laser; other types, such as dye-sublimation, are far less commonplace. Modern printers, in combination with high-quality papers, can deliver results that rival silver-gelatin prints for finesse of detail and tonal quality.

Ink-jet printers

Modern ink-jet printers produce excellent print quality at low prices. They work by squirting minute quantities of ink onto the substrate (by squeezing the ink droplet out with a piezoelectric element or by heating the ink). They are highly reliable and easy to use. The only downside is the cost of inks and good-quality paper. Features to consider when selecting an ink-jet printer include:

- Paper handling Some printers detect paper size and make settings to suit. Others take a large range of papers, from ordinary weight to cardboard. Some models also accept paper on a roll, allowing small posters to be printed (see pp. 352-3), while others allow printing right to the edge of the paper. Printers with a straight-through path for the paper, instead of curling it around a drum, will accept heavier papers or card stocks.
- Resolution In general, higher-resolution printers deliver better-quality results, but the issue is not simply about resolution. The difference between 2,000 dpi (dots per inch) and 2,880 dpi is of no practical significance: the precise way in which the printer software uses the dots available is far more important (see right). Looking at results when comparing printer quality is better than reading technical specifications.
- Four or more inks In general, printers using more colors for printing are more likely to produce photographic quality than those using only four. For black-and-white printing, specialized neutraltone inks may be used.
- Separate ink cartridges Modern desktop printers use separate cartridges for each ink. For

heavy-duty work, choose a printer with largecapacity cartridges. Kits are available for some printers to convert them to continuous flow, taking inks from easily filled and large-capacity bottles.

• Printers with card readers This is convenient for basic proof-printing—to check the quality of images from a shoot—or if you repeatedly need to make prints to order, since you can store prepared

Large-format desktop printer

Printers capable of working with tabloid size (A3) or rolls are ideal for the fine-art photographer. Using eight or more (readily changed) inks, very high quality can be achieved.

Self-calibrating printer

Large-format printers may incorporate color-checking devices that provide individual and convenient output profiling and ensure consistent, reliable color management with ink and paper changes.

files on a card and print them off as needed. The printer may be equipped with a small screen for viewing images.

• Direct printers Some printers can print direct from cameras compatible with PictBridge and offering DPOF (Digital Print Order Format), using a lead or connecting by Bluetooth, according to the model. You do not need a computer. Print controls may be built into the camera or on the printer, which may be equipped with a small screen for viewing images.

Other printers

Ink-jet technology creates relatively bulky machines. Dye-sublimation printers—which heat up colored ribbons to fuse color onto a receiving substrate—can be made very compact and are best for making small prints that are nonetheless near photographic in quality. The most compact printer extant is the Polaroid PoGo, which uses colored crystal activated by heat to create small color prints. Laser printers are best for graphicintensive images, but modern printers produce passably photographic results.

Half-tone cells

Printers can lay more than 2,000 dots of ink per inch (dpi) but since no printer can change the strength of the ink and not all can vary dot size, not all dots are available for defining detail. Thus, printers use groupings of dots—half-tone cells—to simulate a grayscale. At least 200 gray levels are needed to represent continuous tone. Therefore, a printer must control a large number of ink dots just to represent gray levels, reducing the detail that can be printed. In practice, detail resolution above 100 dpi meets most requirements. Now, if a printer can lay 1,400 dpi, it has some 14 dots to use for creating the effect of continuous tone. If you multiply together the four or more inks used, a good range of tones and colors are possible.

Filling in cells

Each cell accepts up to 16 dots-counting a cell with no dot, 17 grayscale levels are thus possible. Cells should be randomly filled. Here, they have a regular pattern, so when cells are combined a larger pattern emerges. The device resolution is used to place more dots in each cell.

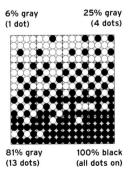

Dve-sublimation printer

Capable of producing extremely high-quality prints in little time, dye-sublimation printers are easy to use, require little or no maintenance-aside from feeding with new print packs-and take up little desk space.

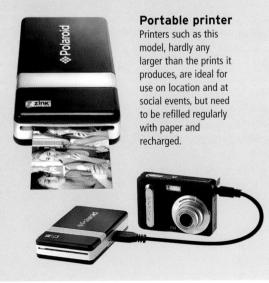

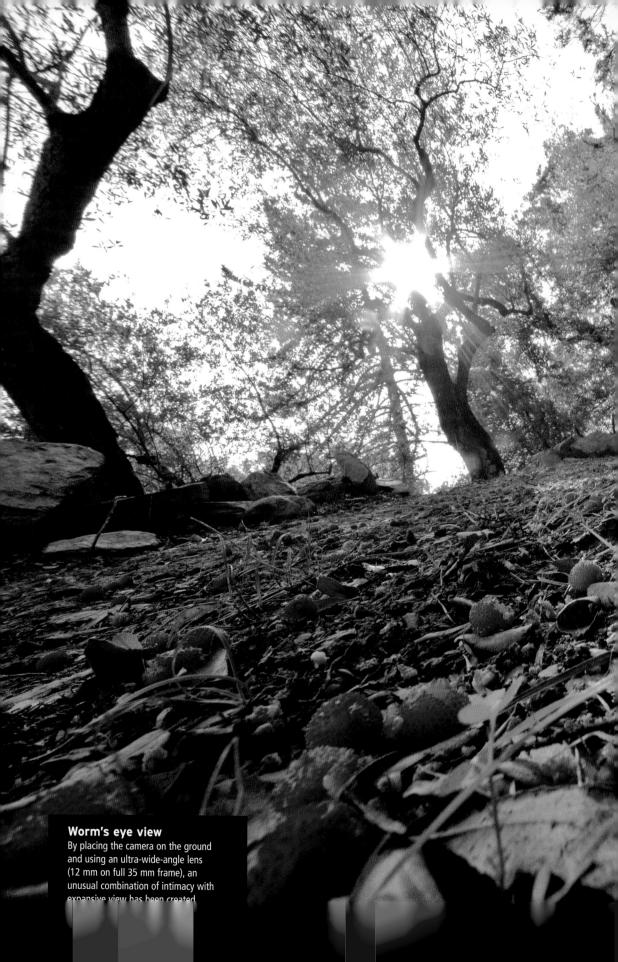

Computers

The serious digital photographer spends at least as much time at the computer as he or she does taking pictures. Not only has the computer replaced the darkroom, it is now effectively the photographer's print and slide library and the communication center for anyone interested in photographs. The computer will also drive the scanner, printer, and perhaps the camera, too.

What to look for

All modern computers can work with digital images. The differences lie in three main areas: the operating system, the system performance (which depends on processor, video graphics, and memory), and the storage capacity. The latest operating system may offer the most features, but software and hardware may need to be updated to work with them, and they may need extra RAM to run digital photography software. You should consider 256 MB to be the minimum

Mouse and keyboard

The quality of the mouse and keyboard can make a big difference to your enjoyment and comfort. If the keyboard is too small or you find the mouse uncomfortable to use, for example, change them. Such replacements are inexpensive, and if made at the time of purchase, they may even be cheaper.

Software packages

When budgeting, do not forget software costs. A full suite of software for image manipulation as well as desktop and web publishing can cost more than a computer, so use modest applications until your skills develop. Professional software can be very difficult to master, while simpler, cheaper packages still produce good results (see pp. 52–3).

Connections

When buying a computer, ensure its interfaces match those of the equipment you wish to use. Note that you may need to install some software to make a connector work.

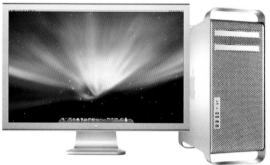

Desktop machines

Modern desktop machines easily handle large files and offer the immense computational power needed to process images. Hard discs can easily store thousands of images.

Computer care

Computers are usually built to run continuously for years in an office and so they should be very reliable when used in a domestic environment: most problems arrise with the software. You can safeguard your computer's useful life by following some simple rules:

- Connect your computer to a surge-protected block for power plugs. In areas with unreliable electrical power, install a UPS—uninterruptible power supply; this is a battery that gives you time to shut down in case of power failure (see p. 61).
- Do not jolt or attempt to move the computer while it is working.

- Once a year, open the computer and carefully vacuum away the accumulated dust-usually worst on the cooling fans and around the drives.
- Ground yourself before opening the computer and touching any internal part or before picking up a component for installation. Earthing wires that attach to your wrist are readily available.
- Use virus-checking software and keep it updated, particularly if you are a Windows user.
- Keep ample free space at the back of the computer for the air to circulate and keep the machine cool. Use a laptop cooler or riser to keep your laptop running efficiently, particularly in hot weather.

- Universal Serial Bus (USB) is easy to install and use, with data-transmission speeds adequate for printers, removable drives, and digital cameras. USB 2.0 is faster but generally not as fast as FireWire. Note that some peripherals, such as keyboards and screens, may offer USB connections: to be most useful, these should be powered; however, many are unpowered, which limits the accessories that can be used.
- FireWire (IEEE 1394), also known as iLink, is a high-speed standard suitable for professional work. It offers an excellent choice for removable drives, extra hard-discs, and digital cameras. There are two versions: FW400 is faster than USB but may be slower than USB 2.0; FW800 is comparable to USB 2.0.
- eSATA (External Serial Advanced Technology Attachment) connects external drives to computers and is up to twice as fast as USB 2.0 or FW800. Cable length is limited to 7 ft(2 m).
- Small Computer Systems Interface (SCSI) refers to numerous types of connectors used by older or specialty equipment.

Laptop or desktop?

Modern laptops have more than enough power for digital photography. Some, like the Apple MacBook, are not only more powerful than many desktop types, their screens are also of sufficient quality and large enough for serious work. The best Windows machines—such as models from Sony, Lenovo, and Hewlett-Packard—also make excellent workhorses for digital photography. Against the premium cost of miniaturizing is the convenience of a computer that takes up no more desk space than an open magazine. Laptops are essential for the digital photographer on the

Laptop for photographers

Wide-screen laptops with 17-in (43-cm) screens and powerful graphics are ideal for digital photography. More power may mean less compact, but they can easily replace a desktop machine.

Mac versus PC

A key question for anyone buying a computer is: "Do I buy a Mac or a PC?" In fact, you can work for your entire life on one machine or the other without being aware of any substantial differences between them. It is easy and natural to compensate for features that you find awkward, and you will make full use of features that suit you. There is no single difference between PCs and Macs that makes for a clear choice. Modern computers, if well built, are reliable and perform very well. Modern operating systems are superbly powerful and generally highly stable, with few of the crashes that used to be part of the computing experience.

However, independent surveys have shown that Apple Mac users are more productive and profitable than those who use Windows machines. In addition, virus attacks are rare on the Mac. For its first five years, Mac OS X was free of malicious viruses, while the number of Windows viruses ran to tens of thousands. However, now that Apple Macs can run Windows, they are equally vulnerable to attack. While nearly everyone in the world uses a PC, the majority of creative professionals producing content for web pages, magazines, books, and advertising are Mac OS users. Even so, Windows Vista operates a color-management system that is more flexible and advanced than that of Apple's ColorSync.

Computer accessories

As your expertise in digital photography increases and the quantity of images you produce grows, you will wish to invest in accessories that make life easier and increase your enjoyment.

Mobile storage

Digital photography produces vast amounts of data, and removable media provide the essential storage space you need. In general, the greater the capacity of the device, the cheaper is the cost per gigabyte of available space.

Portable hard-disc drives are, all around, the best solution for the digital photographer. Not only are their capacities ample for most workers—offering up to 250 GB—they are also very cost-effective and can transfer files rapidly. Models of about the size of electronic personal organizers are extremely portable and ideal for working on location with a laptop computer, since they can be powered from the laptop.

There are two types of hard-disc drives: those specifically designed for transferring and storing digital images, with their own card reader and controls (see also pp. 38–9); and drives that require the use of a computer. Drives use different interfaces, such as USB 2.0 or FireWire, so make sure you select the type that connects with and best suits your computer. The most versatile offer two ports-for example, one USB 2.0 and one FireWire; the second port enables you to connect another device while the drive is hooked up.

Larger, desktop hard-disc drives are the fastest and can offer capacities over 1 TB (1 terabyte, or 1,000 GB) yet, at the size and weight of this book, are still relatively portable; however, this type does need a separate plug-in power supply.

For heavy-duty work and the highest reliability, consider using RAID (Redundant Array of Inexpensive Discs), in which data is copied or striped over two or more discs so that if one should fail, data can be easily be recovered from the other drives. NAS (Network Attached Storage) is also invaluable when more than one person in a studio needs access to the image data.

Removable media

Optical disc media such as CD and DVD offer reliable storage that can be universally accessed. The CD, with its 650 MB capacity, is still used for small-scale transfer, while DVD, carrying up to about 7.5 GB in dual-layer form, is the current standard for large amounts of data. In 2008, Blu-ray Disc (BD) won the high-density format war with HD-DVD. A BD carries up to about

Graphics tablet

Graphic tablets come in a range of sizes—starting with models smaller than a mouse mat—to suit different ways of working. Large sizes can take up the entire desk area. The pen and mouse tools also cover a range, from simple devices to those sporting several buttons to access various functions.

Portable drives

Small portable hard disk drives are lightweight and offer a surprisingly high capacity for backups. Additionally, most can be powered from your laptop via its USB or FireWire port. This makes them ideal for location work, since you won't need to track down a power outlet.

48 GB in dual-layer form and will increasingly be the standard for archiving data. However, in comparison with hard-disc drives, optical media are slow to write and slow to access.

Graphics tablet

These input devices are an evolutionary step up from the mouse. Comprising a flat tablet, like a solid mouse mat, and a penlike stylus, graphics tablets give you excellent control over hand-drawn lines because of their high spatial resolution—

that is, they can detect tiny changes in position. They also allow you to increase the width of a line or the depth of a color by varying the pressure of the stroke—something that is impossible to do with a mouse. A tablet can be small, about the size of a mouse mat, or large enough to need a desk to itself. It is good practice to interchange the use of graphics tablet and mouse to help avoid repetitive strain injuries—or example, by using the graphics tablet for image manipulation and the mouse for the internet and word processing.

UPS, surge protectors, adapters, and cables

Computer systems are highly susceptible to even very small fluctuations in the amount of electrical current powering them. Because of this, you may want to consider protecting your equipment from power surges and outages—something that is even more worthwhile if you live in areas with uncertain power supplies. Saving your work frequently as you go ensures that, if the worst happens and your machine does crash, then at least not too much of it will be lost. However, apart from the frustration and wasted time involved in restarting your computer, an uncontrolled shut-down does carry with it the risk of damage to your hard drive. To safeguard against this, an uninterruptible power

supply (UPS) is essential, although it can be expensive to buy. This is a battery that powers the computer and monitor for a short period in case of a power loss, giving you time to quit the application and shut the computer down safely.

Another useful piece of equipment is a surge protector, which prevents sudden rises in power from damaging your delicate equipment. This is well worth its relatively low cost.

Other accessories that you will accumulate are cables to connect devices to your computer and to each other, and adapters that allow older equipment, such as those based on SCSI, to be used with newer systems, such as FireWire.

eSATA to USB adaptor

Adaptors

With the multiplicity of different standards, there is an accompanying proliferation of adaptors that convert one to another, such as eSATA to USB.

and connector

USB ports

USB (Universal Serial Bus) is a widespread protocol allowing devices to be plugged straight into a working computer and be recognized and connected.

FireWire 800

FireWire 400

FireWire cables

Second to USB in popularity, FireWire is equally easy to use and carries power, but connectors come in many different shapes and sizes.

eSATA cable

SATA drives are designed for high data throughput-up to three times that of FireWire 400, eSATA connectors are used to connect SATA drives to other devices but do not carry power.

Setting up a workroom

A workroom for digital photography has the huge advantage over the traditional darkroom used by film-based photographers in that it does not need to be light-tight—any spare room, or just a corner, is suitable.

You can work on your images at any desktop, or even any level surface, using a laptop computer. However, for the highest efficiency and throughput, a workroom designed for and dedicated to your needs is best.

The ideal environment

The key requirement of a digital workroom is comfort: you are likely to be spending long hours sitting in the same position, so don't allow the computer to become a source of ill health. Take note of the following points:

- Ensure adequate ventilation to dissipate the heat and ions produced by the computer.
- Subdue the lighting with heavy curtains or blinds to improve the screen image.
- Make sure there are sufficient electrical outlets to meet your equipment needs safely.

- The desk/chair should be at the correct height so that, when seated, your forearms are inclined slightly down when at the keyboard.
- There should be ample space underneath the desk for your legs.
- The chair should support your back and legs.
- Arrange desklamps so they do not shine onto the monitor screen. Some lamps are especially designed for computer use, illuminating the desk without spilling light onto the screen.
- Keep an area free for food and beverages. Make sure anything spillable is kept well away from the keyboard, electrical equipment, or discs.
- Arrange the monitor so the top of the screen is about level with your eyes, or slightly higher.
- Your monitor's screen should not face any light source, such as a window or a lamp.
- Arrange for a picture-editing area, containing a lightbox and your files, away from the computer and monitor.
- Set aside a safe storage area for data files. Any magnetic-based media should be stored at least 12 in (30 cm) away from the strong magnetic

Monitor

The digital photographer's desk

The ideal desk area has all the equipment within easy reach. The arrangement of equipment will vary, depending on precisely what you are doing and your own preferences, but everything should be conveniently close at hand. It is a good idea to locate the monitor in the middle, preferably in the inside corner of an L-shaped or curved desk.

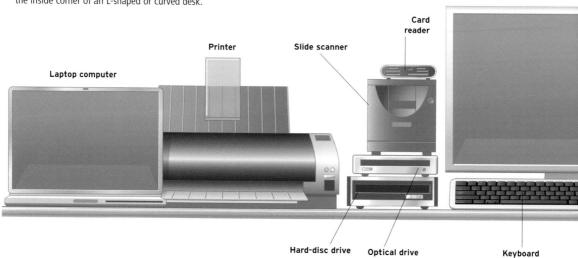

fields produced by audio speakers and electric motors. In addition, keep magnetic media away from direct sunlight and other heat sources.

- Turn off the computer, printer, and hard-disc drives overnight to reduce your use of electricity.
- Unplug battery chargers unless in use.

Electrical arrangements

Most computer peripherals draw low current at low voltages compared with domestic appliances. This is fortunate, since the peripherals for even a modest workroom could easily sprout a dozen power cords:

- If you are in any doubt about electrical safety, seek advice from a qualified inspector.
- Never overload extension cords—check the label for the maximum load.
- Don't stretch cords across walkways.
- Don't plug a device into a computer or a peripheral that is switched on unless you know it is safe to do so. Even then, never unplug a device that is halfway through an operation, usually shown by a flashing light.

Avoiding injury

It is unlikely that you will work the long hours at high levels of stress that lead to repetitive strain injury, but you should still take precautions:

- At least every hour, get up and walk around and take a few minutes away from the screen.
- After two hours in front of the screen, take a longer break—stretch your limbs and look out the window at distant objects to exercise your eyes.
- Listen to your body: if something starts to ache or is uncomfortable, it is time to make adjustments or to take a break.
- Keep your equipment clean and well maintained sticky mouse rollers or a streaky or dirty monitor screen or keyboard can all add, in more or less subtle ways, to stress levels.
- Install software that times how long you have been working and blanks the screen at regular intervalssay, every 15 minutes—to encourage you to take a short rest of 10 seconds or so. Every hour, it suggests you take an even longer rest.

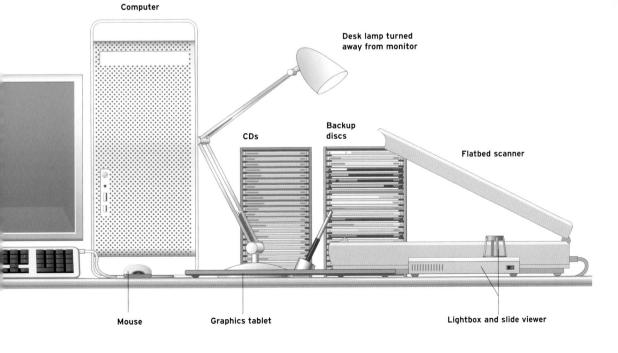

Photography for the digital age

Handling cameras

The least expensive way to "upgrade" your camera is by learning how to use it so that you are entirely comfortable with it. There is no single best way to use a camera, since you need to adapt your technique according to the type and model you have. While it is true that it is the photographer who makes the picture, not the camera, the most successful are those who work as a harmonious team with their equipment.

Digital quirks

The main operating difference between entrylevel and professional digital cameras is the response time. The best of modern cameras start up almost instantaneously, whereas less expensive models need a perceptible interval of time to start. However, for the majority of practical purposes, the speed of start-up of all modern cameras is more than adequate.

Shutter lag—the delay between the moment you press the shutter and the instant the image is recorded—should always be as brief as possible. Where the lag is perceptible, it is too long and can

Using a dSLR

The SLR-type camera is ideal for viewing and framing but is very bulky. It is best to hold it with your left hand cradling the lens.

make the timing of fast-action photography a tricky affair. Essentially, you get what you pay for: better-quality digital cameras power up quickly and have a shorter shutter lag. However, as the technology has moved on, the shutter lag on digital cameras has steadily reduced so that, on the majority of dSLR cameras, shutter lag is barely

LCD screen

Taking a picture by viewing the image on a digital camera's LCD screen is not ideal: for a start, it is difficult to hold the camera steady and, in addition, unless you have good close-up vision, you cannot see the image in any detail.

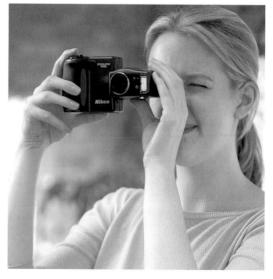

Viewfinder

The type of optical viewfinder on most digital cameras enables you to hold the camera close to your face. This helps to brace the camera and prevent movement during exposure. But the image you see is small and not accurately framed.

noticeable. Even so, if the precise timing of the exposure is a crucial factor for you, try out any digital camera carefully before deciding to buy.

Battery life

For some photography, such as documentary, news, and travel, it is important to keep your camera continuously on and be ready to respond instantly to any changing situation. The batteries on larger cameras will operate for a day or more continually, but it is good practice to carry a spare battery, and to recharge every day while working. Note that all modern batteries can be safely charged up even when only partially discharged, but some types last longer if fully discharged before being recharged.

Holding the camera

A firm and steady grip of your camera is one of the best ways to ensure your images are sharp. Holding the camera in both hands with it pressed against your forehead gives a stable, three-point support. Clearly this hold is impractical with compact cameras with LCD-screen viewing only: you have to hold the camera away from the face to view the screen. In this case, cameras with image stabilization are better than those without.

With dSLR cameras, support the lens with the left hand from below for the most stable hold. For portrait-format shots, hold the camera with the right hand uppermost; this requires no change of grip but may be uncomfortable for long periods. A vertical hand-grip, as on larger cameras or camera power packs, improves portrait-format handling.

Digital SLR and EVF cameras use adjustable optics for the viewfinder: change the setting so the image is sharply focused and the display is clear.

The right fit

When selecting a camera, ensure you find the controls intuitive and the layout of buttons and dials comfortable. Opt for a size that suits you: small cameras are a delight to carry around but their tiny buttons and dials may be a challenge to large fingers. If you are comfortable with your camera and are at ease using it, your photography will gain in fluidity and confidence.

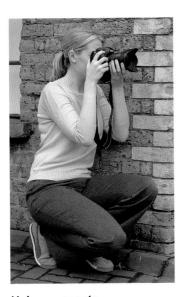

Using supports

Whenever you use long focal settings on a zoom or a long lens, take advantage of any support that is available—a tree, lamppost, or wall will help to steady the camera while you view and shoot.

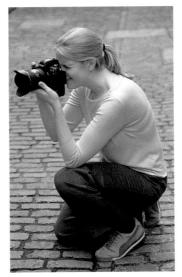

Body tripod

Use a half-kneeling position when there is no convenient support. Your knee and feet form a tripod, which is inherently stable, and your left arm can then be supported by your left knee.

TRY THIS

Rehearse taking pictures with your camera so that it becomes second nature. Learn how to adjust all the controls without looking at them—for example, there may two clicks to the left between the modes you use most often. Do you know-without looking-which way to turn the focusing ring to focus more closely? Or how to zoom in? Learn how to lock focus and hold the exposure entirely by feel. Hold the camera in a variety of positions to find the one that is most comfortable and stable. Only when you really know your way around your camera with your eyes closed can you concentrate fully on the subject.

Picture composition

Much advice on picture composition tends to be both prescriptive ("place the subject at the intersection of thirds") and proscriptive ("don't put the subject in the center"), as if the adherence to a few rules can guarantee satisfactory composition. It may be better to think of any rules simply as a distillation of ideas about the structure of images that artists have, over many generations of experimentation, trial, and success, found useful in making pleasing pictures.

Any photographic composition can be said to work if the arrangement of the subject elements communicates effectively to the image's intended viewers. Often, the most effective way to ensure a striking composition is to look for the key ingredients of a scene and then organize your

Symmetry

Symmetrical compositions are said to signify solidity, stability, and strength; they are also effective for organizing images containing elaborate detail. Yet another strategy offered by a symmetrical presentation of subject elements is simplicity. In this portrait of a Turkana man, there was no other way to

record the scene that would have worked as well. The figure was placed centrally because nothing in the image justified any other placement; likewise with the nearly central horizon. The subject's walking stick provides the essential counterpoint that prevents the image from appearing too contrived.

camera position and exposure controls to draw those elements out from the clutter of visual information that, if left cluttered, will ruin the photograph. Composition is therefore not only about how you frame the picture, but how you use aperture to control depth of field, how you focus to lead the viewer's attention, and how you expose to use light and shade to shape the image.

If you are new to photography, it may help to concentrate your attention on the scene's general structure, rather than thinking too hard about very specific details—these are sometimes of only superficial importance to the overall composition. Try squinting or half-closing your eyes when evaluating a scene; this helps eliminate details to reveal the scene's core structure.

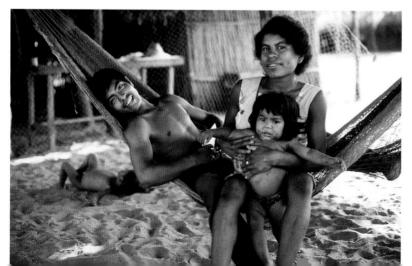

Radial compositions are those in which key elements spread out from the middle of the frame. This imparts a lively feeling, even if subjects are static. In this family portrait, taken in Mexico, the radial composition is consistent with the tension caused by the presence of a stranger (the photographer). The image suggests a modest wide-angle lens was used, but it was taken with a standard focal length.

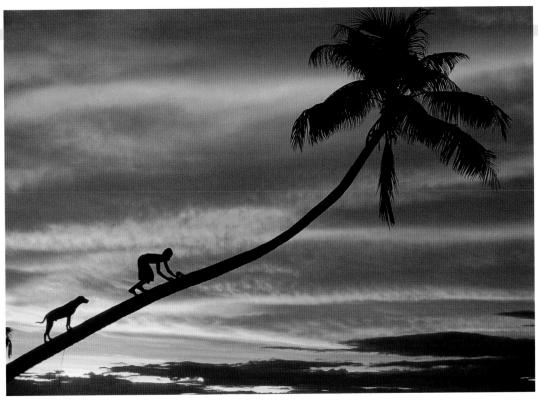

Diagonal

Diagonal lines lead the eye from one part of an image to another and impart far more energy than horizontals. In this example, it is not only the curve of the palm's trunk, but also the movement of the boy and his dog along it that encourage the viewer to scan the entire picture, sweeping naturally from the strongly backlit bottom left-hand corner to the top right of the frame.

Overlapping

When subject elements in a photograph overlap, not only does it indicate increasing depth perspective, but it also invites the viewer to observe subject contrasts. In the first instance, distance is indicated simply because one object can overlap another only if it is in front of it. In the second, the overlap forces two or more items, known to be separated by distance, to be perceived together, with the effect of making apparent any contrasts in shape, tone, or color. These dynamics are exploited in this low table view, aided by areas of bright and contrasting colors that fight for dominance.

The golden spiral, or "Rule of Thirds"

This image, overlaid with a golden spiral—a spiral based on the golden ratio—as well as with a grid dividing the picture area into thirds, shows that, as photographers, we almost instinctively compose to fit these harmonious proportions—the proportions that "look good."

Tall crop

The opposite of a letterbox composition (right) is a tall and narrow crop, which emphasizes an upwardsweeping panorama—a view that can be taken in only by lifting the head and looking up. As with all crops based on a high aspect ratio, it usefully removes a lot of unwanted detail around the edges.

Letterbox composition

A wide and narrow letterbox framing perfectly suits some subjects, such as these prayer flags in Bhutan. Such a crop concentrates the attention on the sweep of colors and detail, cutting out unwanted—and visually irrelevant—material at the top and bottom of the image.

Picture composition continued

Framing

The frame within a frame is a painterly device often exploited in photography. Not only does it concentrate the viewer's attention on the subject, but it often also hints at the wider context of the subject's setting. The colors of the frame may also give clues about where the photograph is set. In this image,

taken in Cannes, France, multiple frames divide the image up into compartments, which circle around the figure of a bistro chef taking a break from his duties. Without the figure, the image would be too symmetrical and dull; but without the rhythmic framing, the figure would be rather static.

Geometric patterns

Geometrical shapes, such as triangles and rectangles, lend themselves to photographic composition because of the way they interact with the rectangle of the picture frame. Here, in this corner of the great Ciudad de las Artes y las Ciencias in Valencia, Spain, shapes from narrow rectangles and acute triangles are all at work. In some parts they work harmoniously (the gaps between the slats); in others (the thin wedges created by diagonally crossing intersections), they create tension in the composition.

Symmetry

The glass of this window in Batsi, Andros, Greece, acts like a mirror to the beach scene, automatically giving a sense of symmetry to the image, but it is a partial symmetry. The subtle and notso-subtle differences between the reality and the reflection give energy and tension to the image, as well as providing visual puzzles such as being able to see more of the sun in the reflection, but without the sky.

Look for patterns whenever you have a camera handy. When you find an interesting example, take several shots, shifting your position slightly for each. Examine the pictures carefully and you may find that the shot you thought most promising does not produce the best result. Often, this is because our response to a scene is an entire experience, while photographs have to work within the proportions of the format.

Rhythmic elements

These regular columns of a courtyard in Sarzana, Italy, organize the haphazard groups of people, and together they create repeated lines and rectangles to form irregular

bands of light and dark. These in turn form the rhythmic framework for the distant mountains that contrast with the diagonals of sunlight finding its way between the clusters of people.

Focusing and depth of field

Depth of field is the space in front of and behind the plane of best focus, within which objects appear acceptably sharp (see opposite). Though accurate, this definition tells you nothing about the power that depth of field has in helping you communicate your visual ideas. You can, for example, use it to imply space, to suggest being inside the action, or to emphasize the separation between elements within the picture area.

Varying depth of field

Your chief control over depth of field is the lens aperture: as you set smaller apertures (using f/11 instead of f/8, for example), depth of field increases. This increase is greater the shorter the lens's focal length, so that the depth of field at f/11 on a 28 mm lens is greater than it would be at f/11 on a 300 mm lens. Depth of field also increases as the subject being focused on moves farther away from the camera. The corollary of this is that at close focusing distances, depth of field is very limited.

Using depth of field

An extensive depth of field (resulting from using a small lens aperture, a wide-angle lens, distant focusing, or a combination of these factors) is often used for the following types of subject:

- Landscapes, such as wide-angle, general views.
- Architecture, in which the foregrounds to buildings are important features.
- Interiors, including nearby furniture or other objects, and far windows and similar features.

As a by-product, smaller apertures tend to reduce lens flare and improve lens performance.

A shallow depth of field (resulting from a wide lens aperture, a long focal length lens, focusing close-up, or a combination of these) renders only a small portion of the image sharp, and is often used for:

- Portraiture, to help concentrate viewer attention.
- Reducing the distraction from elements that cannot be removed from the lens's field of view.
- Isolating a subject from the distracting visual clutter of its surroundings.

Lens focusing

Spreading light reflected from or emitted by every point of a subject radiates out, and those rays captured by the camera lens are projected onto the focal plane to produce an upside-down image. The subject appears sharp, however, only if these rays of light intersect precisely on the film plane (achieved by adjusting the lens's focus control). If not, the rays are recorded not as points, but rather as dots. If the image is reproduced small enough, then even dots may appear sharp, but as a subject's image diverges further from the film plane, so the dots recorded by the camera become larger and larger, until, at a certain point, the image appears out of focus—the dots have become large enough to be seen as blur.

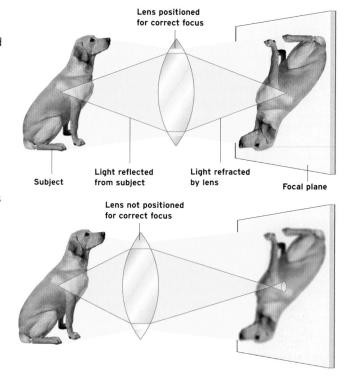

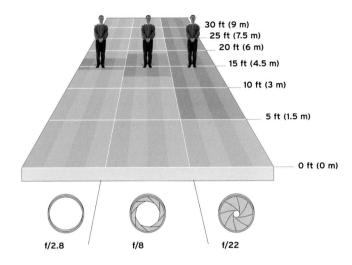

Effects of lens aperture

The main reason for changing lens aperture is to adjust camera exposure: a smaller aperture restricts the beam of light passing through the lens. However, the aperture also alters depth of field. As you set smaller apertures, the cone of light passing through the lens becomes slimmer and more needlelike. As a result, even when it is not perfectly focused, light from the subject is not as spread out as it would be if a larger aperture were used. Thus, more of the scene within the field of view appears sharp. In this illustration, lens focal length and focus distance remain the same, and depth of field at f/2.8 covers just the depth of a person, whereas at f/8 it increases to 6 ft (2 m) in extent. At f/22, depth of field extends from 5 ft (1.5 m) to infinity.

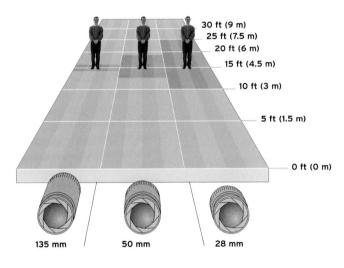

Effects of lens focal length

Variations in depth of field resulting from focal length alone are due to image magnification. With our figure at a constant distance from the camera, a long focal length (135 mm) will record him at a larger size than does a standard lens (50 mm), which, in turn, creates a larger image than the wide-angle (28 mm). To the eye, the figure is the same size, but on the sensor or film, the figure's size varies directly with focal length. Where details are rendered smaller in the image, it is more difficult to make out what is sharp and what is not. As a result, depth of field appears to increase. Conversely, longer focal length lenses magnify the image, so magnifying differences in focus. Thus, depth of field appears to be greatly reduced.

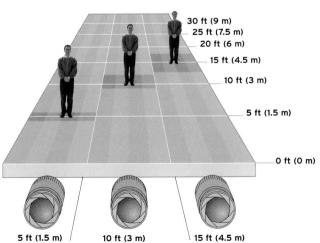

Effects of focus distance

Two effects contribute to the great reduction in depth of field as you focus closer and closer to the camera, even when there is no change in lens focal length or aperture. The main effect is due to the increased magnification of the image: as it looms larger in the viewfinder, small differences in the depth of the subject call for the lens to be focused at varying distances from the sensor or film. Notice that you must turn a lens more when it is focused on close-up subjects than when it is focused on distant ones. Another slight but important reason for the change in depth of field is that effective focal length increases slightly when the lens is set farther from the focal plane-in other words, when it is focused on subjects close-up.

Focusing and depth of field continued

Autofocusing

Two main methods of autofocus are used. In compact cameras, a beam of infrared (IR) light scans the scene when the shutter button is first pressed. The nearest and strongest IR reflections are read by a sensor, which calculates the subject distance and sets it on the camera a fraction of a second before the picture is taken.

The other main method is "passive." Part of the light from the subject is sampled and split up, but only when the lens is in focus do the parts of the image coincide (or are said to be "in phase"). The

Mimicking depth

While a narrow field of view usually yields a shallow depth of field. you can simulate a more generous zone of sharp focus linked with a narrow field of view by cropping a wide-angle image. Here, a 28-mm view has been cropped to that of a 200-mm lens, and the scene appears sharp from foreground to background.

crucial property of this system is that the phase differences vary, depending on whether the lens is focused in front of or behind the plane of best focus. Autofocus sensors analyze the pattern and can tell the lens in which direction to move in order to achieve best focus.

Though sophisticated, autofocus systems can be fooled. Beware of the following circumstances:

- The key autofocus sensor is in the center of the viewfinder image, so any off-center subjects may not be correctly focused. Aim the focusing area at your subject, "hold" the focus with a light pressure on the shutter-release button, and then return the viewfinder to the original view.
- When photographing through glass, reflections from the glass may confuse the IR sensor.
- Extremely bright objects in the focusing region—sparkling reflections on polished metal, say—could overload the sensor and mar accuracy.
- Photographing beyond objects that are close to the lens—say, through a bush or between the gaps in a fence—can confuse the autofocus system.
- Moving close-up subjects may be best kept in focus by setting a distance manually and then adjusting your position backward and forward in order to maintain focus.

Selective focus

A telephoto shot taken with the lens aperture wide open throws the girl in the foreground out of focus. One unwelcome consequence is that color from the background merges with the foreground, making color correction a tricky matter. It proved difficult to make a satisfactory duplicate of the original transparency, and the resulting scan also required a good deal of corrective work.

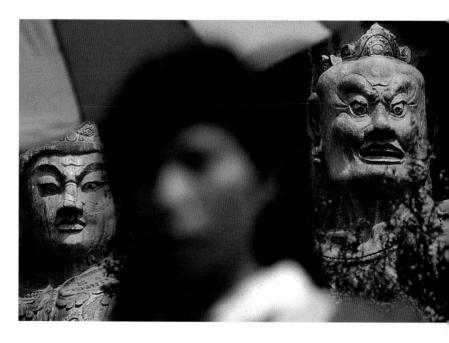

• With very fast-moving subjects, it may be better to focus on a set distance and then wait for the subject to reach that point before shooting.

Hyperfocal distance

The hyperfocal distance is the focus setting that provides maximum depth of field for any given aperture. It is the distance to the nearest point that is sharp when the lens is set at infinity and it is the nearest distance at which an object can be focused on while infinity appears sharp. The larger the aperture, the farther away this point is. With autofocus-only cameras, you cannot set the hyperfocal distance; however, with manual-focus cameras, you can set hyperfocal distance and then not worry about the clarity of any subject falling within the range of sharp focus.

When the subjects are offcenter, as here, you must not allow your camera to focus on the middle of the frame. To take this image, I simply focused on the boys, locked

the setting, and recomposed the shot. Even in bright conditions and focusing at a great distance—330 ft (100 m)—depth of field is limited because of the very long focal length of the lens.

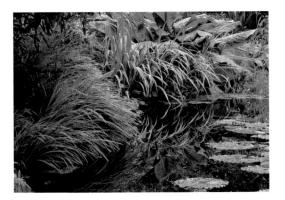

Right aperture

Medium-to-close-up pictures taken with a long lens will have a shallow depth of field unless a small aperture is set. In this shot, the charm of the scene would have been lost had unsharp

subject elements dominated. The smallest aperture on this lens was set to give maximum sharpness, but the long shutter time then needed to compensate meant that a tripod was necessary to prevent camera shake.

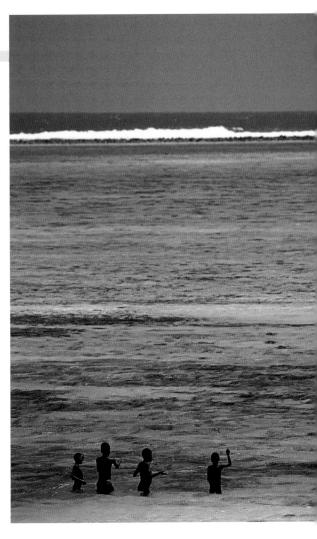

Perceived depth of field

Acceptable sharpness varies according to how much blur a viewer is prepared accept. This, in turn, depends on how much detail a viewer can discern in the image, which, in turn, depends on the final size of the image (as seen on a screen or as a paper print). As a small print, an image may display great depth of field; however, as the image is progressively enlarged, it then becomes more and more obvious where the unsharpness begins, thereby making the depth of field appear increasingly more limited.

Image orientation

Since most camera formats produce rectangular pictures, you can change the way you hold the camera to give either horizontal or vertical results. Image orientation produces different emphases and can alter the whole dynamic of a shot.

Picture shape should normally be dictated by the natural arrangement of subject elements—in other words, by the subject's own orientation. In portraits, for example, the subject will usually be sitting or standing, and so the camera most often is turned on its side to give vertical framing. As a consequence, vertical picture orientation is often called "portrait." Landscapes scenes, however, with their usually horizontal orientation, have given their name to horizontally framed pictures.

Landscape-shaped images tend to emphasize the relationship between subject elements on the left and right of the frame, while portrait-shaped pictures tend to relate foreground and background subject elements. And bear in mind that picture shape strongly influences what is included at the periphery of a scene, so you can use image orientation as a useful cropping device.

Breaking the "rules"

If you decide to move away from these accepted framing conventions, or "rules," you then have an opportunity to express more of an individual

vision. Simply by turning the camera on its side you could create a more striking picture perhaps by increasing the sense of energy and movement inherent in the scene, for example. Using an unconventional picture orientation may, therefore, reveal to the viewer that you are engaging more directly with the subject, rather than merely reacting to it.

Think ahead

Another factor to consider is that since most printed publications are vertical in format, pictures are more likely to be used at full size if they are vertically framed. As a safeguard, commercial photographers often take vertically framed versions of important views or events, even if an image's natural orientation is horizontal.

A potential problem with vertical framing occurs with cameras with swiveling LCD screens. Even if the camera has a viewfinder, if you attach any type of lens accessory, you then have to use the LCD screen exclusively for viewing and framing.

If, however, your images are intended for publication on the Web, bear in mind that the monitor's format is more horizontal in shape, and so appropriately framed images will then be easier to use at full size.

Reclining figure

The strong horizontal lines of both the bench and the metal siding on the wall behind, as well as the elegant, reclining pose of this Fijian woman, all suggest that horizontal framing is appropriate here.

Landscape scenery

A horizontal, or "landscape," view (above) is often an obvious choice for a landscape subject. However, vertical, or "portrait," framing (right) can effectively suggest space,

especially when some natural feature in the scenethe snaking crash barrier in this example—leads the eye right from the foreground through to the background.

Still-life

Different sets of lines that may be contained within a picture can be given additional prominence, depending on the framing you decide to adopt. Horizontal orientation (above) allows the strong, diagonally slanting plant stems to make

a visual statement, while the vertical image orientation (right) makes more of the parallel slats of the blind.

Image proportions

As you take more pictures, you may start to notice that the proportions of an image have a subtle effect on the picture's ability to communicate. A square image, for example, more often than not evokes a sense of stability and balance. However, an image that is just slightly rectangular can communicate a sense of indecision or make subject matter look uncomfortable within its frame. This type of framing is, therefore, best avoided unless you have clear reasons for it.

Panoramas

The "panoramic" picture was popularized most recently by the obsolescent APS (Advanced Photo System) cameras launched in 1996. In reality, this system simply cropped the top and bottom off an ordinary image, changing it into a narrow one, and so it is not a true panoramic image.

Digital cameras, however, can produce true panoramas (in which the camera swings through the scene, from side to side or up and down), so

True panorama

A true panoramic camera uses a swinging lens to project its image onto a curved piece of film. The movement of the lens

causes the typical curvature of lines away from the middle of the frame, as you can see in this example taken at an exhibition in a picture gallery.

Horizontal cropping

As you can see, the sofa pattern here competes strongly with the child and her collection of much-loved toys (left). A severe crop more clearly defines the image content (below).

that the field of view of the image is greater than the field of view of the lens. This is achieved by taking a number of pictures that overlap and "sewing" them together (see pp. 202-5).

To achieve best results, pivot the camera around a fixed point, such as a tripod, so that as you rotate the camera the image does not appear to move. To aid you, some digital cameras have a "panorama function," which indicates where the next pictures should be taken by showing you on the LCD screen the previous image as a guide.

Taking time to select just the right view to experiment with pays dividends with panoramic images. For example, you need to be aware that panoramas made up of individual pictures that include subjects positioned close to the camera, or even in the near middle-distance, will show a perspective distortion that makes the scene appear bow-shaped once images are combined.

Exposure is another consideration when taking panoramas. If you swing your camera across a scene, you will see that the exposure settings in the viewfinder readout alter as different areas of light and shade influence the changing picture area. If you were to take your panorama like this, you might find that, say, the foreground area fluctuates between dark and light from frame to frame. To prevent this, take the camera off automatic and set the exposure manually.

Vertical cropping An attractively framed, if conventional, shot of a lake in Scotland (above) has been transformed into a sharper, more challenging composition (right) simply by cropping it into a narrower, more vertical shape, in imitation of a traditional silk wall hanging.

Cropping

One of the simplest, and often one of the most effective, changes you can make to image proportions is to crop them—in other words, slicing portions from the sides, top, or bottom of the picture area. This can change the whole emphasis of a shot by, for example, removing unnecessary or unwanted subject matter, or changing the relationship between various subject elements and the borders of the frame. This can turn a mediocre picture into a truly arresting image.

Composition and zooms

Zoom lenses let you change the magnification of an image without switching lenses (see pp. 32-5). Zooms are designed to change the field of view of the lens while keeping the image in focus. When the field of view is widened (to take in more of the subject), the image must be reduced in order to fill the sensor or film area. This is the effect of using a short focal length lens or a wideangle setting on a zoom. Conversely, when the field of view is narrowed (to take in less of the subject), the image must be magnified, again in order to fill the sensor or film area. This is the effect of using a long focal length lens or a zoom's telephoto setting.

Working with zooms

The best way to use a zoom is to set it to the focal length you feel will produce the approximate effect you are aiming for. This method of working encourages you to think about the scene before ever raising the camera to your eye to compose the shot. It also makes you think ahead of the picture-taking process, rather than zooming in and out of a scene searching for any setting that seems to work. This is not only rather aimless, it is also time-consuming and can lead to missed photographic opportunities.

A professional approach

Many professional photographers use zooms almost as if they were fixed focal length, or prime, lenses, leaving them set to a favorite focal length most of the time. They then use the zoom control only to make fine adjustments to the framing. Zooms really are at their best when used like this—cutting out or taking in a little more of a scene. With a prime lens, you have to move the camera backward or forward to achieve the same effect. Depending on the type of subject you are trying to record, you could leave the zoom toward the wide-angle or telephoto end of its range. On some digital cameras, however, zooms are stepped rather than continuously variable, so they cannot be used for making small adjustments.

Zooms for framing

Zoom lenses come into their own when you find it difficult or time-consuming to change your camera position, since they allow you to introduce variety into what would otherwise be similarly framed images. In this large outdoor performance, one shot was taken at 80 mm (top), one at 135 mm (middle), and the other at 200 mm (above), all from approximately the same camera position.

Zoom movement

Color and movement literally seem to explode out from this photograph of a simple tulip—an effect achieved by reducing the zoom lens's focal length during a long, manually timed

exposure. And in order to emphasize the flower's blurred outlines, the image was also slightly defocused before the exposure was made.

Zooms for composition

Zooming from 80 mm (*above left*) to 200 mm (*above right*) produced an intriguing abstract image by allowing patterns of light and dark, color and non-color, to reveal themselves. But as the focal length increases, depth of field also diminishes (*pp. 74–7*), so select the lens apertures with care.

POINTS TO CONSIDER

Distortion Most zoom lenses distort the image by making straight lines look curved. This is especially the case at wide-angle settings.

Camera shake At the very long effective focal lengths some digital cameras offer—such as a 35efl of 350 mm—there is a great danger that camera shake during exposure will reduce image quality. Make sure you hold the camera steady, preferably supported or braced, and use a short shutter time. Lens speed As you set longer focal lengths, the widest available aperture becomes smaller. Even in bright conditions, it may then not be possible to set short shutter times with long focal lengths. Lens movement Some lenses may take a few seconds to zoom to their maximum or to retract to their minimum settings. Don't be tempted to rush the action by pushing or pulling at the lens.

Digital zooms

The term given to a computer-generated increase in apparent focal length is "digital zoom." Although the lens focal length does not increase, the image continues to be magnified.

It works by taking a central portion of an image and enlarging it to fill the format, using a process called "interpolation"—extra pixels are added, based on existing ones, to pad out the space (see pp. 260–1). This does not add information; indeed, it may even mask it. Clearly, you can obtain the same effect—sometimes even superior effects—by altering the picture using image-manipulation software, and this is very often a better option.

Long focal length settings on a zoom lens come into their own when you want to magnify a small part of a scene: a 35efl of 135 mm is ample for most purposes. This produces the characteristic "telephoto perspective," in which distant objects look compressed, or backgrounds in close-up shots are thrown strongly out of focus.

Nonetheless, many digital cameras now offer the equivalent of focal lengths of 300 mm and more. Some models reduce the effects of camera shake by using image-stabilization technology. Even so, it is worth making every effort to reduce unwanted camera-movement problems at source (*see pp.* 66–7).

Telephoto perspective

Even a modest telephoto shot of a distant scene depicts well-separated objects as if they are compressed and piled on top of each other. This is because the relative differences in distance within

the picture are small when compared with the distance between the subject and the camera. In this photograph, houses that were in fact hundreds of yards apart look squashed together, and depth of field extends throughout the image.

Image stabilization

Technology to reduce the effect of camera shake takes two forms. One uses a motion sensor to control a lens or thin prism that shifts the image to counter camera movement. This form, pioneered by Canon, is most suitable for still images and is available in several of their 35-mm format lenses. Olympus offers image-stabilized digital cameras and it is likely to become standard in more sophisticated, higher-end equipment. The other method analyzes the signals from the sensor and filters out the slight repetitions in image structure typical of camera shake. This system is used mostly in video cameras.

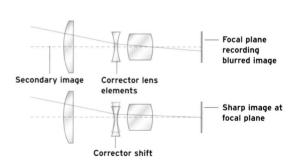

How it works

A blurred secondary image, represented by the dotted lines here, can result if the lens moves while the picture is being exposed (upper diagram). A corrector group of lens elements within the lens hangs from a frame, which allows these elements to move at rightangles to the lens axis. Motion sensors tell the frame which way to shift the corrector group to compensate for any movement of the lens (lower diagram).

Camera movement

While the accepted wisdom is that you should hold the camera completely steady when taking pictures, so that camera shake does not introduce unwanted movement that might spoil your image, there is a place for pictures that display a thoughtful or creative use of subject blur.

Experimentation

Since the effects of movement are unpredictable, it is essential that you experiment with this technique. They are, in fact, unique, and no other recording medium represents movement in quite the same way. However, in order to produce the occasional winning shot, you must be prepared to make a lot of exposures, and here the digital camera's ability to delete unwanted frames gives it a distinct advantage over film-based cameras.

While taking pictures from a moving vehicle is generally not recommended, it is nevertheless a technique that can produce interesting results. In a fast-moving car or train, for example, even a short shutter time will not be able to prevent motion blur, especially of foreground objects. But you can introduce blur in almost any situation simply by setting a long shutter time—at least ½ sec—and then deliberately moving the camera during the exposure. Another possibility is again to set a long shutter time and then zoom the lens during the exposure. This gives the resulting image a characteristic "explosive" appearance (see p. 83).

As a bonus, digitally produced motion-blur images compress to a very high degree with little additional noticeable loss in clarity because of their inherently lower image quality.

Moving camera

The blur produced by taking a photograph from a speeding car streaks and blends the rich evening light in a very evocative and painterly fashion in this example. To

the eye at the time of taking, the scene was much darker and less colorful than you can see here. It is always worth taking a chance in photography, since you never know what might come of it.

Digital close-ups

In the past, true close-up photography required specialty equipment and fiddly accessories. However, this situation has entirely changed thanks to the introduction of digital cameras. These cameras work at close-up subject distances as if they were designed for the job.

Digital's ability to handle close-ups is due to two related factors. First, because the sensor chips are small, lenses for digital cameras need only to have short focal lengths. Second, short-focallength lenses require little focusing movement in order to bring near subjects into focus. Another factor, applicable to digital cameras with zoom lenses, is that it is relatively easy to design lenses capable of close focusing by moving the internal groups of lens elements.

In addition to lens design, there is another feature common to digital cameras that also helps: the LCD screen. This provides you with a reliable way of framing close-ups with a high degree of accuracy, all without the complex viewing system that allows traditional SLRs to perform so well.

There will be occasions when you need to keep a good distance between yourself and the subject—a nervous dragonfly, perhaps, or a beehive. In such cases, first set the longest focal length on your zoom lens before focusing close up. In these situations, an SLR-type digital camera (one that accepts interchangeable lenses) is ideal, due to the inherent magnification given by the small sensor chip working in conjunction with lenses designed for normal film formats.

Simple subjects

Learning just what to include and what to leave out of a picture is a useful skill to master-not only is the image itself usually stronger for being simpler in visual content, as in the example shown here, but it is also often easier to use it for a range of purposes, such as compositing (pp. 320-7). Subject movement is always a problem with close-ups, especially plants outdoors.

where they can be affected by even the slightest breeze. If you cannot effectively shield the plant from air currents, then set the shortest shutter time possible, consistent with accurate exposure, to freeze any subject movement.

Avoiding highlights

One of the secrets underlying good close-up photography is avoiding unwanted highlights intruding on the image. These usually appear as insignificant out-of-focus bright spots when you frame the shot, but in the final image they can appear far more prominent and be very distracting. To take this shot, I moved slowly around the subject, watching the LCD screen continually, and released the shutter only when the brightest area was positioned just as I wanted.

Long close-up

A long-focal-length lens with close-focusing ability allows you to get close to small, nervous subjects, such as this dragonfly, and so obtain a useful image size. In addition, the extremely shallow depth of field with such a lens throws even nearby image elements well out of focus. The central bright spot is in fact a flower.

Safe distance

It was dangerous to get too near this constrictor, so a close-focusing long lens was the best way to obtain good magnification in this case.

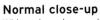

With static or slow-moving subjects, a normal focal length lens used at its macro setting will suffice.

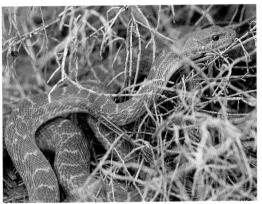

Digital depth of field

On one hand, the closer you approach your subject, the more rapidly depth of field diminishes, at any given lens aperture (see pp. 74-7). On the other, depth of field increases rapidly as focal length decreases. So the question is whether the increase in depth of field with the short focal lengths typical of digital cameras helps make close-up photography easier than with film-based equipment. The calculations are not straightforward, partly because in order for the shorter-focal-length lens to produce a given magnification, it must approach closer to the subject than a longer lens, which works

against the increase in depth of field. Another confusing factor is that digital cameras, with their regular array of relatively large pixels, cannot be treated in the same way as film-based cameras, whose images are based on a random collection of tiny grains of light-sensitive silver. With many digital cameras, you do not have the option of setting apertures at all, and, even when you do, the minimum aperture may be relatively large—say, f/8. Nonetheless, taking all these factors into account, depth of field often appears greater with digital photographic equipment than with conventional cameras.

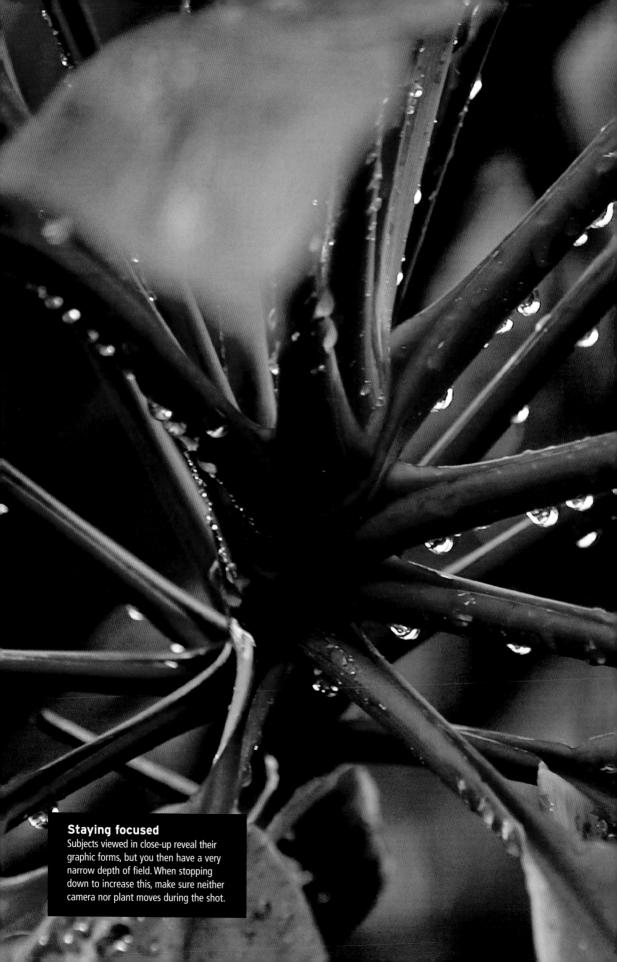

Extreme lenses

Some lenses have special capabilities—such as the ability to take ultra-wide-angle views or focus at very close subject distances—and these call for extra care when in use. And since they are often costly to buy, you need to know how to get the very best from them.

Ultra-wide-angles

Wide-angle lenses with a 35efl (equivalent focal length) of down to around 28 mm are easy to use, but when focal lengths become shorter than about 24 mm, successful results are less certain.

- To ensure that the image is evenly lit (all wideangle lenses project significantly more light onto the center of the image than the edges), avoid using the widest apertures available.
- To keep accessories such as filters from intruding into the lens's field of view, never use more than one filter at a time; also make sure lenshoods are designed for the focal length of the lens.
- With their extensive fields of view, ultra-wideangles can catch a bright source of light, such as the sun, within the picture area. These highlights can cause flare or strong reflections within the lens barrel. Using smaller apertures help control this.
- Avoid having very recognizable shapes—a face, say, or a glass—near the edges of the frame. It will

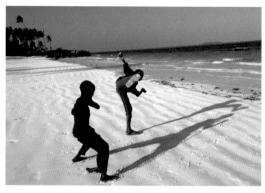

Problem horizons In the hurry to record this scene on a beach on Zanzibar, the slight tilt of the camera, which went unnoticed while using the 17-mm setting on the

lens, has produced an uncomfortable-looking horizon. Though far from a disaster, the picture would have benefited from a moment's extra thought before shooting.

appear obviously distorted if a small-sized image is then produced (see below).

- Line up wide-angle lenses very carefully with the horizon or some other prominent feature, since the broad sweep of view will exaggerate the slightest error in picture alignment.
- Avoid pointing the lens up or down unless you want to produce a distorted effect.

Wide-angle "distortion"

An ultra-wide-angle lens encompassed both the market vendor and her produce, but not only does she appear very distorted by being projected to the corner of the frame, so do the tomatoes in the bottom right-hand corner. If, however, you were to make a large print of this image and view it from close up, the apparent distortion would disappear.

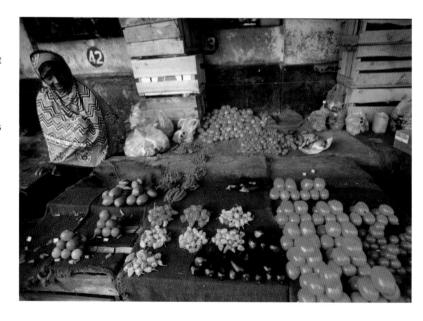

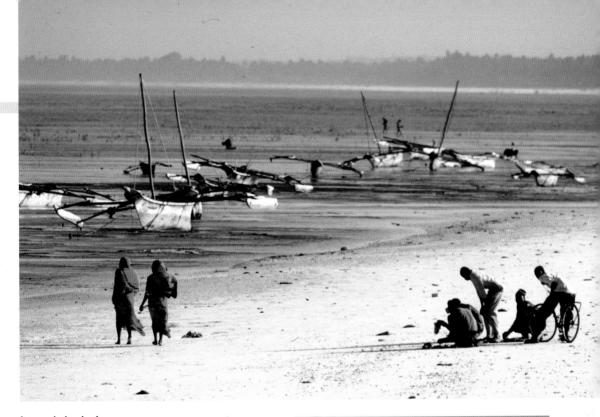

Long telephoto
In this version of the scene
shown on the right, the
zoom lens was set to 400 mm

and a 1.4x extender was also used, giving an effective focal length setting of 560 mm.

• Avoid using the minimum aperture: you rarely need the depth of field produced, and image quality is likely to be degraded. However, selecting a small aperture may improve image quality when focusing on very close subjects.

Wide-ranging zooms

Zooms that offer a wide range of focal-length settings, such as 35efl of 28–300 mm or 50–350 mm, are attractive in theory but, in practice, may require special handling.

- Zooms with a wide range of focal lengths are far bulkier than their single-focal-length counterparts. A 28-mm lens used on the street is inconspicuous; a 28–300 mm zoom set at 28 mm is definitely not.
- The wide-angle setting is likely to show considerable light fall-off, with the corners of the image recorded darker than the middle, so avoid images that demand even lighting to be effective.
- Image distortion is always the price you pay for a wide range of focal lengths, so avoid photographing buildings and items with clearly defined sides and straight lines. There will be a

Short telephoto
This view shows a beach
scene on Zanzibar as imaged
by a moderate 100 mm
telephoto setting. At this

magnification, the lens shows the general scene but not any of the activity or recognizable subject details (compare this with the top image).

setting, usually around the middle of the range, where distortion is minimized; but even here, straight lines may appear very slightly wavy.

• As you set longer and longer focal lengths on a zoom lens, the maximum available aperture becomes smaller and smaller. This can reduce the scope you have for setting short shutter times, and the need for brighter shooting conditions increases as lens apertures become smaller.

Quick fix Image distortion

Anybody whose photography involves taking accurate pictures of buildings or any other prominent architectural, or even some natural, eatures is likely at some stage to come up against he problems associated with image distortion.

Problem

When using an extreme wide-angle lens, or an accessory ens that produces a "fish-eye" effect, the straight lines of any subject elements—such as the sides of buildings, he horizon, or room interiors—appear to be bowed or curved in the image. With ordinary lenses, this effect known as distortion) is usually not obvious, though it s a feature of many zooms. Don't confuse this problem with converging verticals (see p. 263).

Analysis

Distortion is caused by slight changes in magnification of the image across the picture frame. Lenses that are not symmetrical in construction (in other words, the elements on either side of the aperture are not similar) are articularly prone to this type of imaging distortion, and the asymmetric construction of zoom lenses means that hey are highly susceptible.

Solution

Corrections using image-manipulation software may be ⇒ossible, but turning curves into straight lines is more difficult than adjusting straight lines. Try using the spherize distortion filter; the degree of flexibility in Photoshop is not very great, but some other software ackages offer more control and a better chance of correcting distortion. You could try applying a succession f filters—first, slight Perspective Distortion, then Spherize, then slight Shear—or apply filters to just ⇒ part of, rather than the entire, image.

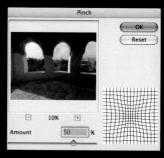

Barrel distortion

In the original shot (top), a wide-angle attachment led to barrel distortion. Using Pinch filter, to squeeze the image from all sides, with the Shear filter engaged has helped correct the problem.

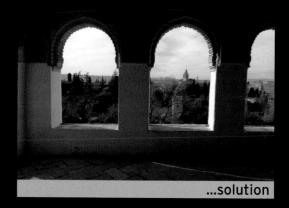

How to avoid the problem

- Don't place straight lines, such as the horizon or a junction of two walls, near the frame edges.
- Avoid using extreme focal lengths-either the ultra-wide or the ultra-long end of a zoom range
- Use a focal length setting that offers the least distortion, usually around the middle of the range.
- Place important straight lines in the middle of the this is where distortion is usually minimal

Quick fix Lens problems

Although many lens problems can be solved, or at least minimized, using appropriate software, prevention is always better than cure.

Problem: Lens blurring

The image looks unsharp, blurred, or smudged. Contrast is not high and the highlights are smeared.

Analysis

A dirty lens or lens filter, lack of sharp focus, damaged optics, camera shake, or subject movement may separately, or in combination, be the cause of blurred pictures.

Solution

You can increase contrast to improve image appearance using the Levels or Curves controls of image-manipulation software. Applying a Sharpen or Unsharp Mask filter is also likely to improve the image. The main subject can be made to appear adequately sharp if the background is made to look more blurred. To do this, select areas around the main subject and apply a Blur filter.

Camera movement

While trying to catch the light on the dust raised by a running zebra, the camera slipped a little, giving this blurred image-most evident in the highlights on the zebra's back and in the grass. However, blur can suggest mood and setting.

How to avoid the problem

Clean the lens or lens filter if it is marked: use a tripod to steady the camera for long shutter times or when using a telephoto lens or setting; if available, use an image-stabilization lens.

Problem: Lens flare

Bright spots of light, sometimes fringed with color, can be seen in the image. Spots can be single occurrences or appear in a row, and stretch away from a bright point source of light in the scene. Similarly, a bright, fuzzily edged patch of light, known as veiling flare, fills part of the image area.

Analysis

These types of faults are most likely the result of internal reflections within the lens. Stray light entering the lens from a bright light source has reflected around the lens and then been recorded on the film or picked up by the sensor of a digital camera.

Solution

Working with a digital file, small spots of light can easily be removed by cloning or rubber-stamping adjacent unaffected areas of the image onto them. Large areas of flare, however, are more difficult to correct, since they cover a significant area of the picture and contain no

Flare

An unobstructed sun in the frame causes light to reflect within the lens, resulting in flare. By changing camera position, it was possible to mask the sun with a column of the building, while allowing a little flare through to suggest the brilliance of the light. Some of the reflections may be removed, but probably not all of them.

How to avoid the problem

Use a correctly designed lens-hood to stop light from entering the periphery of the lens; and avoid pointing the lens directly toward bright light sources. If shot framing demands that you include an intense light source in the image, select a small aperture to aduce the cize of any reculting internal reflections

Quick fix Lens problems continued

Problem: Black skies

A blue sky is rendered almost black. This type of effect seldom looks realistic or believable.

Analysis

This is probably the result of a polarizing filter on the lens combined with underexposure. This can reduce the sky to the point where most, or even all, color is removed.

Solution

First, highlight the problem sky area and then use Replace Color in Photoshop, or a similar software package, to restore the color. The best way to work is by making small

changes repeatedly rather than a single, large change. Check that you do not introduce banding, or artificial borders, in the areas of color transition. You can also try using a graduated layer (see below).

How to avoid the problem

Don't set a polarizing filter to produce maximum darkness: in the viewfinder, you may still be able to see the blue of the sky, but the recording medium may not have sufficient latitude to retain color if the image is then underexposed.

Original image

The skies of Kenya seldom need a polarizing filter in order to emphasize their color—indeed, it may even cause a portion of the sky to turn too dark, as you can see here in the top left-hand corner of the image.

Gradient Fill

To correct this, you must remove the dark gradient while leaving the rest of the image unaffected. This calls for a transparent-to-solid gradient that runs counter to the darkness. Here a Gradient Fill of black-to-transparent, with its Blend mode set to Screen, was applied. The gradient was adjusted until the dark corner was neutralized.

Sky correction

Once the new layer was applied to the image, the carefully positioned Gradient Fill restored the natural color of the sky. Once you have made one adjustment, you may find the image needs more workfor example, the top right-hand corner may now seem too dark. With digital photography it is easy to create perfect tonal balance.

Problem: Dark image corners

Corners of the image are shadowed or darkened, with a blurred edge leading to blackness, or the middle of the image looks significantly brighter than the periphery.

Analysis

Images showing dark corners with a discernible shape have been vignetted. This is usually caused by using a filter with too deep a rim for use with a (usually) wideangle lens, by stacking too many filters on a lens, or by using an incorrectly aligned or overly deep lens-hood.

Solution

If the areas affected are small, vignetting can be corrected by cloning adjacent portions of the image. Light fall-off may be corrected using a Radial Graduate or Gradient Fill (see opposite)—experiment with different values of darkness and opacity.

Darkened corners

It is easy not to notice a lenshood interfering with the image. The shadows in the

corners here were not spotte until after film processing. Small apertures give deeper, sharper shadows.

How to avoid the problem

Vignetting is easy to avoid if you are careful with your filters and lens-hoods. Light fall-off, as an optical defect, can only be reduced, not eliminated altogether: use either smaller working apertures on a higher-quality lens.

improved with Levels or Curves. Try localized burning-in to improve contrast, which will also increase apparent

Problem: Poor-quality close-ups

Images taken at the closest focusing distances are not sharp or lack contrast.

Analysis

Lenses usually perform best at medium or long distances: the degree of close-up correction depends on lens design.

Solution

Poor image sharpness may be improved by applying Sharpness or Unsharp Mask filters. Contrast will be

How to avoid the problem

sharpness without increasing visual noise.

Small apertures are likely to improve sharpness. Try using different focus and zoom settings—there wil be a combination that gives the best possible quality An alternative solution is to attach a close-up lens to the main lens. This acts as a magnifying glass and can improve close-up performance.

Improving close-ups

The original image (right) shows the features characteristic of a low-quality close-up: poor sharpness and reduced contrast. Applying an Unsharp Mask filter and an increase in contrast significantly improves results (far right).

...solution

Influencing perspective

You can exercise control over the perspective of a photograph by changing your camera position. This is because perspective is the view that you have of the subject from wherever it is you decide to shoot. Perspective, however, is not affected by any changes in lens focal length—it may appear to be so, but in fact, all focal length does is determine how much of the view you record.

Professional photographers know perspective has a powerful effect on an image, yet it is one of the easiest things to control. This is why when you watch professionals at work, you often see them constantly moving around the subject-sometimes bending down to the ground or climbing onto the nearest perch; approaching very close and moving farther away again. Taking a lead from this, your work could be transformed if you

simply become more mobile, observing the world through the camera from a series of changing positions rather than a single, static viewpoint.

Bear in mind that with some subjects—stilllifes, for example, and interiors or portraits—the tiny change in perspective between observing the subject with your own eyes and seeing it through the camera lens, which is just a little lower than your eyes, can make a difference to the composition. This difference in perspective is far more pronounced if you are using a studio camera or waist-level finder on a medium-format camera.

Using zooms effectively

One way to approach changes in perspective is to appreciate the effect that lens focal length has on your photography. A short focal length gives a

Alternative views

This wide-angle view (above left), shows an unremarkable snapshot of a vacation beach, in Andros, Greece. It is a simple image of the place, but it lacks an engaging interpretation or inventive viewpoint of the scene. Once on the beach, the temptation is to take in a wide shot that summarizes the whole

scene. Instead, a low viewpoint that takes in the corner of a parasol gives a more intimate and involving feel: by using the parasol to balance the large rock, the picture is almost complete. Waiting for the right moment—a child runing into the foreground—brings the whole perspective to life.

perspective that allows you to approach a subject closely vet record much of the background. If you step back a little, you can take in much more of the scene, but then the generous depth of field of a wide-angle tends to make links between separate subject elements, since there is little, if any, difference in sharpness between them.

A long lens allows a more distant perspective. You can look closely at a face without being nearby. Long lenses tend to pull together disparate objects-in an urban scene viewed from a distance, buildings that are several blocks apart might appear to crowd in on top of each other. However, the shallow depth of field of a long lens used at close subject distances tends to separate out objects that may actually be close together (see p. 84) by showing some sharp and others blurred.

Telephoto perspective

Overlooking the action there is a sense of the crush of people at this festival in mountainous Tajikistan (above). Two children holding hands complete the scene. The long-focal-length

version (above right) focuses attention on the dancer, but excludes all sense of setting beyond the crowd watching the traditional performance.

Perspective effects

Wide-angle lenses

- Take in more background or foreground.
- Exaggerate the size of near subjects when used in close-up photography.
- Exaggerate any differences in distance or position between subjects.
- Give greater apparent depth of field and link the subject to its background.

Telephoto lenses

- Compress spatial separation.
- Magnify the main subject.
- Reduce depth of field to separate the subject from its background.

TRY THIS

For this exercise, leave your zoom lens at its shortest focal length setting. Look for pictures that work best with this focal length—ignore any others and don't be tempted to change the lens setting. This will help to sharpen your sense of what a wide-angle lens does. You may find yourself approaching subjects including people-more closely than you would normally dare. The lens is making you get closer because you cannot use the zoom to make the move for you. Next, repeat the exercise with the lens at its longest focal length setting.

Changing viewpoints

Always be on the lookout for viewpoints that give a new slant to your work. Don't ignore the simple devices, such as shooting down at a building instead of up at it, or trying to see a street scene from a child's viewpoint rather than an adult's.

Your choice of viewpoint communicates subtle messages that say as much about you as they do your subject. Take a picture of someone from a distance, for example, and the image carries a sense that you, too, were distant from that person. If you photograph a scene of poverty from the viewpoint of a bystander, the picture will again have that distant look of having been taken by an aloof observer. Lively markets are popular photographic subjects, but what do they look like from a merchant's position? If you enjoy sports, shoot from within the action, not from the sidelines.

Practical points

Higher viewpoints enable you to reduce the amount of foreground and increase the area of background recorded by a lens. From a high vantage point, a street or river scene lies at a less acute angle than when seen from street or water level. This reduces the amount of depth of field required to show the scene in sharp focus.

However, from a low camera position, subjects may be glimpsed through a sea of grass or legs. And if you look upward from a low position, you see less background and more sky, making it easier to separate your subject from its surroundings.

Less can say more At markets and similar types of locations, all the activity can be overwhelming-and the temptation is often to try to record the entire busy. colorful scene. However, if

you look around you, there could be images at your feet showing much less but saying so much more. In Uzbekistan I noticed next to a fruit stand a lady who had nothing to sell but these few sad tulips.

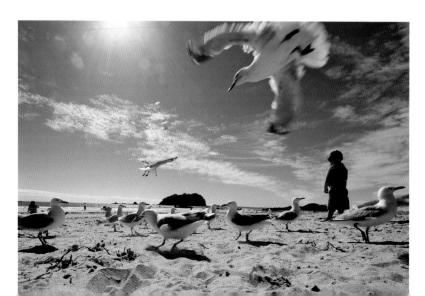

Child's-eye view

From almost ground level, the swooping gulls feel threatening and pull the viewer into the action. At the same time, looking upward gives the viewer a sense of open skies—this would be lost with the gaze directed downward.

HINTS AND TIPS

- In some parts of the world, it is a good idea to avoid drawing attention to your presence. Your search for an unusual camera viewpoint could attract the unwanted interest of officialdom. Even climbing onto a wall could get you in trouble in places where strangers are not a common sight or photographers are regarded with suspicion.
- As well as being discourteous, it might also be illegal to enter a private building without permission in order to take photographs. You may be surprised at how cooperative people generally are if you explain what you are doing and why, and then ask for their assistance.
- Try to be open and friendly with people you encounter—a pleasant smile or an acknowledging wave is often the easiest, and cheapest, way to elicit a helpful response from strangers.
- Prepare your equipment before making your move. Balancing on the top of a wall is not the best place to change lenses. With manual cameras, preset the approximately correct aperture and shutter time so that if you snatch a shot, exposure will be about right.

Changing viewpoint

This conventional view of the Mesquita of Cordoba, Spain (above), works well as a record shot, but it is not the product of careful observation. Looking down from the same shooting position, I noticed the tower of the building reflected in a puddle of water. Placing the

camera nearly in the water, a wholly more intriguing viewpoint was revealed (right). An advantage of using a digital camera with an LCD screen is that awkward shooting positions are not the impossibility they would be with a film-based camera.

Quick fix Leaning buildings

Buildings and architectural features are always opular photographic subjects, but they can ause annoying problems of distortion.

Problem

all structures, such as buildings, lampposts, or trees, or even people standing close by and above you, appear to ean backward or look as if they are about to topple over.

Analysis

his distortion occurs if you point the camera up to take the picture. This results in your taking in too much of the oreground and not enough of the height of the subject.

Solution

- Stand farther back and keep the camera level—you vill still take in too much of the foreground, but you can ater crop the image.
- Use a wider-angle lens or zoom setting, but then emember to hold the camera precisely level—wide-■ ingle lenses tend to exaggerate projection distortion.
- Take the picture anyway and try to correct the distortion by manipulating the image.
- Use a shift lens or a camera with movements. This quipment is specialized and expensive, but technically t is the best solution.
- Exaggerate the leaning or toppling effect to mphasize the height and bulk of the subject.

Tilting the camera

An upward-looking view of the spires of Cambridge, England, makes the buildings lean alarmingly backward.

Using the foreground

By choosing the right camera position, you can keep the camera level and include foreground elements that add to the shot.

osing the foreground

o record the red flags against the contrasting blue of the building, there was no option but to point the camera upward. hus dismissing much of the foreground. As a result, the nearest wilding annears to lean hackward

...solution

Alternative view

Keeping the camera level, a shift lens was used, set to maximum upward movement. This avoided the problem of converging verticals. Although this is the best solution to optimize image quality it does require a costly professional lons

Quick fix Facial distortion

Distorted facial features can be a problem with portraits. To make the subject's face as large as possible, the temptation is to move in too close.

Problem

Portraits of people taken close-up exaggerate certain facial features, such as noses, cheeks, or foreheads.

Analysis

The cause is a perspective distortion. When a print is viewed from too far away for the magnification of the print, the impression of perspective is not correctly formed (see also p. 90). This is why at the time you took the photograph, your subject's nose appeared fine, but in the print it looks disproportionately large.

Solution

• Use a longer lens setting—a 35efl of at least 80 mm is about right, so that for a normal-sized print viewed from a normal viewing distance, perspective looks correct.

- Use the longest end of your zoom lens. For many, this is a 35efl of 70 mm, which is just about enough.
- If you have to work close-up, try taking a profile instead of a full face.
- Avoid using wide-angle lenses close to a face, unless you want a distorted view.
- Don't fill the frame with a face at the time of shooting. Instead, rely on cropping at a later stage if you need the frame filled (see pp. 80-1).
- Don't assume you will be able to correct facial distortions later on with image-manipulation software. It is hard to produce convincing results.
- If you have a digital camera with a swiveling lens, it is fun to include yourself in the picture by holding the camera at arm's length—but your facial features will then be so close they will look exaggerated.
- Make larger prints. With modern inkjet printers, it is easy to make letter-size images (substantially larger than the usual photographic snapshot), and at normal viewing distances they are far less prone to perspective distortion.

Full-frontal

To emphasize the friendly character of this man, several "rules" were broken: a wide-angle lens was used close-up; the shot was taken looking upward; and the face was placed off in one corner, thus exaggerating the distortion already present. But the total effect is amiable rather than unpleasant.

Profile

Taking portraits in profile avoids many of the problems associated with facial distortion in full-frontal shots. Make sure you focus carefully on the (visible) eye-other parts of the face may appear unsharp yet be acceptable to the viewer.

Color composition

Successful color photography means learning to use color as a compositional tool—as a form of visual communication in its own right—rather than just reproducing a scene or subject that happens to be in color.

The importance of color

Color is far from being merely incidental, any more than is the surface texture of a subject or, indeed, the quality of the light illuminating it. Color is an integral part of our experience of the subject, helping to determine both the mood and the atmosphere of the scene and our emotional responses to it. One way to come to terms with this is to record colors as if they were distinct entities, separate from the things displaying them.

Mental focus

Once you have made this change in mental focus, you could, for example, start evaluating scenes not in terms of vistas or panoramas, but in terms of color content. Look at, say, the greens—are they as intense as you want? Is the light too contrasty for them to have real depth? Is your shooting position right in relation to the light in order to give the color impact you want to record? Look at a city scene not because it is full of activity but because there, among the drabness, are flashes of red, or blue, or green. And if a neighboring color is distracting, change focal length or crop the final image to exclude it.

Working digitally

An advantage digital photographers have over their traditional counterparts is that it is easy, using image-manipulation software, to alter the colors of the recorded image. Not only are broadstroke changes possible—such as whole areas of sky or foreground—but you can also select very precise parts of a scene for the software to work on. And if radical changes are not appropriate, then it is just as easy to alter color contrast, saturation, or brightness to emphasize one particular part of the image or suppress another.

Color saturation

Red is such a strong color that it inevitably draws attention to itself. In this image (right), the reds coupled with the green reflections in the water are so strong that the fish almost seem to blur before your eyes. Using the imagemanipulation software's Color Picker option, however, all manner of color adaptations become possible (far right).

Bright/pale contrast

A simple subject—floral table decorations in a restaurant (below)—has been transformed by an overhead camera angle and the contrast provided by the bright colors of the flowers with the far subtler tones contained in the rest of the image.

Color wheel

Strictly speaking, the color wheel displays only hue and saturation: in the middle are the desaturated colors (those containing a lot of white); on the perimeter of

the wheel are the most saturated colors. The colors are organized in the order familiar from the spectrum, with the degree marks around the rim being used to help locate different hues.

Perception of color

If a pale subject is seen against a complementarycolored background, its saturation seems to increase. Similarly, a neutral gray changes its appearance according to its background color, appearing slightly bluish green against red, and magenta against green. If you compare the gray patches in the two colored panels here (below right) you can see this at work. If you cut small holes in a piece of white paper, so that only the four patches are visible, you can see that the blues are, in fact, identical, as are the grays.

Adjacent colors

Colors that lie immediately next to each other on the color wheel (see p. 103) are said to be analogous, or adjacent, colors. Examples of these include light green and yellow, dark green and blue, purple and cyan, and so on.

Color and harmony

Although it is difficult to generalize about what are essentially subjective reactions to the inclusion of particular colors, as a general rule, if you include combinations of adjacent colors in an image, you create a more harmonious effect. This is especially true if the colors are approximately equal to each other in brightness and saturation. As well as being pleasing to the eye, color harmony also helps to bind together what could perhaps be disparate subject elements within a composition.

Color and mood

There is much to be said for learning to work with a carefully conceived and restrained palette of colors. A favorite trick of landscape photographers at some times of the year, for example, is to select

a camera viewpoint that creates a color scheme that is composed predominantly of browns and reds—the hues redolent of fall. Thus, not only does a harmonious color composition result, but all of the mood and atmosphere associated with the seasonal change from summer to winter are brought to bear within the image.

Depending on how the photographer wants a picture to communicate with its intended audience, images that feature gardens as the principal subject might be dominated by colors such as various shades of green or blues and purples.

Monochromatic color

Another type of picture harmony results when the colors are all of a similar hue. The subtle tonal variations can impart a sense of quiet tranquillity or reinforce the drama of the scene. Duotone or sepia-toned effects (see pp. 282-7) are highly monochromatic, as are views of the sea and sky containing a range of different blues. Red and orange sunsets may be lively or serene, while flower close-ups are often beautiful because of their delicate shifts in color.

Monochrome landscape

As the French painter Paul Cézanne taught us, every color of the rainbow can be seen in any scene if you look hard enough, especially in a landscape. However, the dominance of yellows and browns in this image encourages the viewer to admire the chiaroscuro and shape of the slopes without the distraction of color contrasts.

Emotional content

Even though all the main colors in this photograph are tonally very close, the image lacks impact when it is rendered in black and white. The emotional content of the warm reds, pinks, and purples is essential to the success of the study.

Blue on blue

Although the strong and adjacent blues, which have been given extra depth by the bright sunlight illuminating them, are what this picture is all about, a total absence of some form of contrastprovided here by the small red label and the subject's flesh tones-would have left the picture unbalanced and overstated.

TRY THIS

First, choose a color. It could be your favorite oneblue, yellow, orange—or any other. Next, set out to photograph anything that is largely or wholly composed of that particular hue. Allow only variations of that color within each picture. If any other colors are present, don't take the picture—unless you can get in close enough, or change your camera viewpoint, to exclude them. When you are done, put your collection of pictures together. The assembly of similar colors in different shades will have an impact that may surprise and delight you.

Red and purple

When I first noticed this painted wall, it appeared to have promise, but it was not until it was strongly lit by oblique sunlight that the picture really came together, the dominance of the red and the strongly graphic crack both being powerful visual elements. A little postprocessing work served to heighten the colors and strengthen the shadows.

Pastel colors

Referring to pastels as watered-down versions of colors does them a disservice. Certainly, they are paler and less saturated than full-strength hues, but they are nevertheless a vital part of the photographic palette.

Evoking mood

Within the photographic image, pastels tend to generate a sense of calm and an atmosphere of softness. They are gentle and refined, whereas strong colors tend to be more strident; they are

soothing as opposed to invigorating; subtle rather than obvious. Pastels, therefore, evoke emotional responses that are simply not possible where bright colors dominate. And, as a result, they are often chosen as the principal color theme in home interiors, especially where a calm, relaxed, or soothing environment is the aim.

Appropriate exposure

In portrait photography, the accurate exposure of pastel shades is often a crucial factor in the success

Creating harmony

The soft light and gentle colors, together with the smooth curves of the plates and glasses, have all combined in this image to create a sense of calm and repose. Anything other than pastel colors would disturb the composition and mood of this table setting. The scene was carefully exposed and a small aperture set to produce maximum depth of field.

Skin tones

The most natural way to articulate the softness and vulnerability of the naked human figure is with pastel colors illuminated by a gentle form of lighting. In this image, water has further softened subject details, while the wide-angle view has exaggerated her form. A slight reduction in color saturation was given in order to soften the original image even further.

of an image. Many skin tones, for example, are essentially desaturated hues—pinks being pale versions of reds, and East Asian skin tones being light versions of golds or yellow-browns.

Pictures that are composed predominantly of pastel colors are often associated with "high-key" imagery (see pp. 118-19). An exposure reading taking in areas of dark shadow is likely to result in the camera controls being set to record shadow detail. This has the obvious effect of overexposing all the brighter parts of the scene, turning colors

into pastel-like hues. This high-key technique can be effective in nature and landscape photography when you are trying to achieve a more interpretative, less descriptive effect.

However, if you are working with digital image files, you have the advantage of being able to tone down and lighten colors deliberately in order to create pastels from more strident hues (see p. 302). Another way to achieve a similar type of effect is to introduce pale colors into a black and white image (see pp. 296-7).

Color variety

A scene that utilizes pastel shades is not one in which all the colors have to be similar. In this selective view of a Scottish moor, a whole spectrum of different colors is on display, but the soft light has toned them all down so that they blend gently together to create a harmonious composition.

Color restraint

It is easy to be overwhelmed by strong colors and brilliant light. But there are times when a subtle color palette works far better-as in this near-abstract impression photographed during Holy Week in Mexico City. An overly strong color rendition, by using slight underexposure, would have recorded the bare heads as being too black, while the slight overexposure employed here has given a pastel effect and better detail in the shadow areas.

Strong color contrasts

Color contrasts result when you include hues within an image that are well separated from each other on the color wheel (see p. 103). While it is true that strongly colored picture elements may have initial visual impact, they are not all that easy to organize into successful images. Often, it is better to look for a simple color scheme as part of a clear compositional structure—too many subject elements can so easily lead to disjointed and chaotic pictures.

Digital results

Modern digital cameras are able to capture very vibrant colors that look compelling on your computer's monitor screen. Because of the way the screen projects color, these are, in fact, brighter and more saturated than those film can produce. However, one of the advantages of using computer technology is that the color range offered by film can be enhanced with image-manipulation software, giving you the opportunity, first to create, and then to exploit, an enormous range of vibrant colors.

Distracting composition

Combine strong colors with an unusual and an appealing subject, and you would think that you have all the important elements for a striking photograph (above). In fact, there is far too much going on in this picture for it to be a successful

composition. The painting in the background distracts attention from the manhimself an artist, from Papua New Guinea-while the white edge on the right disturbs the composition. A severe crop, to concentrate attention on the face alone, would be necessary to save the image.

Lighting for color

The unbelievably strong colors seen in this image, taken on an isolated Scottish shoreline, are the result of shooting in the bright yet diffused light from an overcast sky, which has had the effect of making all the colors particularly intense. The palette of contrasting dark reds and blues not only looks good on screen, it also reproduces well on paper. This is because the particular range of colors in this image happen to be those that print well. A range containing, say, bright purples or sky blues would not be so successful.

Simple composition

Bright colors are attractive in themselves, but they tend to be most effective when they are arranged in some type of pattern or sequence. This arrangement imposes a structure on them and thus suggests a meaning or order beyond the mere presence of

the color itself. The main problem I encountered when taking this photograph of brightly colored umbrellas was avoiding the reflections from the store window in front of them.

Color gamut

The intensity of computer-enhanced colors gives them real appeal, but it is in this strength that problems lie. Strong colors on the page of a book or website will compete with any text that is included; they are also likely to conflict with any other softer image elements. In addition, you need to bear in mind that even if you can see intense, strong colors on the screen, you may not be able to reproduce them on paper. Purples, sky blue, oranges, and brilliant greens all reproduce poorly on paper, looking duller than they do on screen. This is because the color gamut, or range of reproducible colors, of print is smaller than that of the monitor.

Of the many ways to represent a range of colors, this diagram is the most widely accepted. The rounded triangle encloses all colors that can be perceived. Areas drawn within this, the visual gamut, represent the colors that can be accurately reproduced by specific devices. The triangle encloses the colors

(the color gamut) of a typical RGB color monitor. The quadrilateral shows the colors reproduced by the fourcolor printing process. Notice how some printable colors cannot be reproduced on screen, and vice versa.

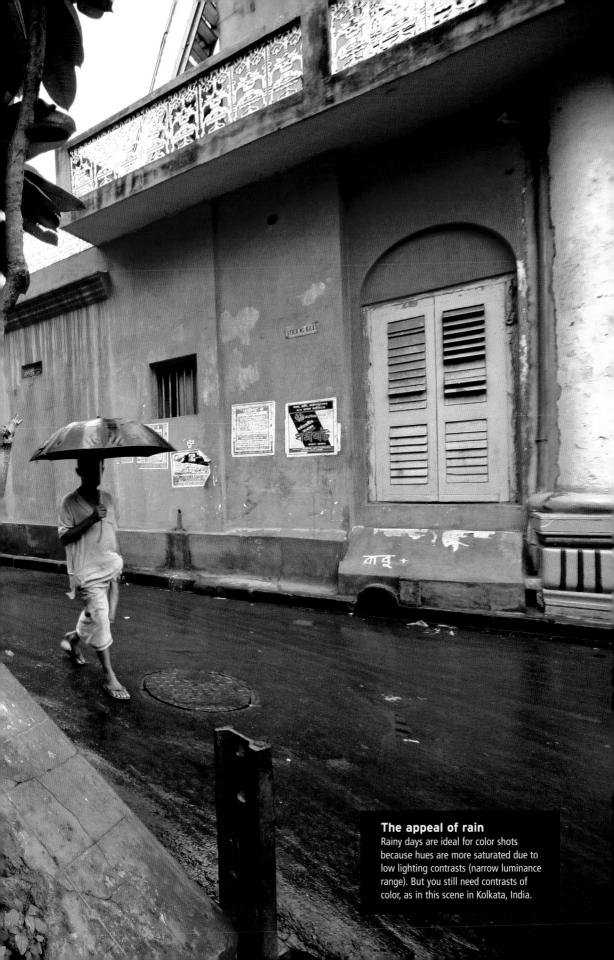

Quick fix Color balance

Correct color rendition depends on many different factors, one of which is ensuring that the recording media and light sources match.

Problem

Pictures taken indoors have a distinct color cast-either orange or yellow—and images appear unnaturally warmtoned. A related problem occurs in outdoor shots—there is a blue cast and images appear unnaturally cold. In other situations, pictures taken under fluorescent lamps appear greenish overall. Problems are compounded if you work in mixed lighting, such as daylight from a window and light from a table lamp. If you correct for the orange cast of the lamp, the window light looks too blue; if you correct for the window light, the lamp looks too orange.

Orange domestic tungsten

Photographs taken of rooms by domestic tungsten light often display an orange cast because the film used is intended to be exposed by daylight, which has a higher color temperature.

Analysis

All imaging systems, whether film-based or digital, assume that the light falling on a scene contains the full spectrum of colors. This produces the "white" light of daylight, often called 6,500 K light—a reference to its color temperature (see p. 266). If, however, the light is deficient in a specific band of colors, or is dominated by certain color wavelengths, then everything illuminated by it will tend to take on the strongest color component. We do not experience indoor light, for example, as being unduly orange because our eyes adapt to the dominant color and our brains "filter" it out. Likewise, we seldom notice the blue color cast that is often present in the shadows on sunny days because our eyes and brains compensate for the color cast—and so we see the colors we expect to be there.

Solution

There are various solutions, depending on whether you are using a film-based system or digital technology.

Film-based systems

• Use the correct film type for the principal source of illumination in the scene. For indoor photography, shooting under incandescent lights, use tungstenbalanced film. This advice, and that following, applies principally to slide film, as the film image is usually the final result. With color negatives, however, at least some

Color Balance screen shot Tones lighter than midtone are strongly yellow-red. To correct for this, "Highlights" was selected in Color Balance, and blue increased using the lowest slider.

Corrected color Notice that the corrected image has retained a hint —removing it completely would have of the orange cast-

• Attach a color-balancing filter to your lens so that the light reaching the film corresponds to that film's color balance. Use an 85B for daylight-balanced film exposed indoors under tungsten light; an 80B for tungsten-balanced film exposed in daylight. Pink or light magenta filters help to correct the color casts produced by fluorescent lamps.

Scanned images

- Scanner software can make corrections while it is scanning. If you have many images to correct, apply the settings that give the best results to all of them.
- Or make corrections using image-manipulation software. This may be more accurate, since you will then be working with the full image data.

Digital cameras

- Most digital cameras automatically correct for the white balance—they analyze the colors of the light and remove the color cast. In some situations, however, you will obtain more accurate results if you present the camera with a neutral color and set white balance manually.
- Images recorded by a digital camera showing an unwanted color cast can be corrected using image-manipulation software (see pp. 264–7).

It is worth bearing in mind that you may not always want to correct a color imbalance, or at least not fully correct it. In some situations, the color cast may be helping to set the atmosphere of a scene or providing the viewer with additional information about the subject.

How to avoid the problem

- Don't choose to photograph in mixed lighting conditions unless you specifically want the image to display unpredictable colors.
- Don't take color-critical shots under fluorescent lamps—it is very difficult to correct precisely the resulting cast.
- Don't rely on color-balancing filters—they make only approximate corrections. But partial correction does make later refinements—when printing or

Blue dawn light

Taken at dawn, this shot displays a distinct blue b suppressing the warm colors I perceived at the time. film, the blue cast would have been more pronounced but, as you can see, even the digital camera's white balance did not fully compensate for the distortion.

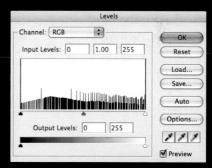

Levels screen shot

The quickest way to correct the image was to Levels. The Highlight Dropper (far right tool) was appete to the area to be rendered a neutral white (the whit walls of the foreground building). The Shadow Droppe was then selected and a deep shadow chosen.

Corrected color

The finished result shows greatly improved co overall, but note that the blue hills in the far distant

Exposure control

The process of determining the amount of light that is needed by the film or sensor for the required results is called exposure control. Unlike in film photography, many digital cameras can change sensitivities to maintain practical camera settings. For example, in low light, sensor sensitivity increases (just as faster film might be used in film-based photography) to allow you to set shorter shutter times or smaller apertures.

It is important to control exposure accurately and carefully, as it not only ensures that you obtain the best from whatever system you are using, but also saves you the time and effort of manipulating the image unnecessarily at a later stage.

Measuring systems

To determine exposure, the camera measures the light reflecting from a scene. The simplest system measures light from the entire field of view, treating all of it equally. This system is found in some handheld meters and some early SLR cameras.

Many cameras, including digital ones, use a center-weighted system, in which light from the entire field of view is registered, but more account is taken of that coming from the central portion of the image (often indicated on the focusing screen). This can be taken further, so that the light from most of the image is ignored, except that

from a central part. This can vary from a central 25 percent of the whole area to less than 5 percent. For critical work, this selective area, or spotmetering, system is the most accurate.

A far more elaborate exposure system divides the entire image area into a patchwork of zones, each of which is separately evaluated. This system, commonly referred to as evaluative or matrix metering, is extremely successful at delivering consistently accurate exposures over a wide range of unusual or demanding lighting conditions.

As good as they are, the exposure systems found in modern cameras are not perfect. There will be times when you have to give the automation a helping hand—usually when the lighting is most interesting or challenging. This is why it is so crucially important to understand exactly what constitutes "optimum exposure."

Optimized dynamics

Every photographic medium has a range over which it can make accurate records-beyond that, representation is less precise. This accuracy range is represented by a scale of grays on either side of the midtone-from dark tones with detail (say, dark hair with some individual strands distinguishable) to light tones showing

What is "correct"?

To the eye, this scene was brighter and less colorful than seen here. A technically correct exposure would have produced a lighter imagethus failing to record the sunset colors. Although it looks like this might challenge a basic exposuremeasuring system, by placing the sun center frame you guarantee underexposure, resulting, as in this example, in a visually better image than a "correct" exposure would produce.

Narrow luminance range

Scenes that contain a narrow range of luminance and large areas of fairly even, regular tone do not represent a great problem for exposuremeasuring systems, but you still need to proceed with care for optimum results. The original of this image was correctly exposed yet

appeared too light because, pictorially, the scene acquires more impact from being darker, almost low-key (pp. 118-20). The adjustments that were made to darken the image also had the effect of increasing color saturation, which is another pictorial improvement.

Wide luminance range

The range of luminance in this scene is large—from the brilliant glare of the sky to deep foreground shadows. Exposure control must, therefore, be precise to make the most of the film's ability to record the scene. In these situations, the best exposure system is a spot meter, with

the sensor positioned over a key tone—here, the brightly lit area of grass on the right of the frame. Evaluative metering may also produce the same result, but if you are using a film camera, you will not know until you develop the film.

texture (perhaps paper showing crinkles and fibers). If you locate your exposure so that the most important tone of your image falls in the middle of this range, the recording medium has the best possible chance of capturing a full range of tones.

Exposure control is, therefore, a process of choosing settings that ensure that the middle tone

of an image falls within the middle part of the sensor's or film's recording range in order to make the most of the available dynamic range.

The easiest method for achieving precision in exposure control is to use a spot-metering system to obtain a reading from a carefully selected tone within a scene. This may be a person's face or, in a landscape, the sunlit portion of a valley wall.

Sensitivity patterns

Cameras use a variety of light-measuring systems, and the representations shown here illustrate two of the most common arrangements. With a center-weighted averaging system, most of the field of view is assessed by the meter, but preference is given to light coming from the middle of the frame. This produces the correct exposure in most situations. However, the optics of a light meter can be arranged so that all its sensitivity is concentrated into a small spot in the very middle of the field of view. This spot-metering system gives a precision of control, which, if used with care and knowledge, produces the best reliability.

Metering systems

Center-weighted metering (above left) takes in all of the view but gives more weight, or emphasis, to the light level around the center of the image, tailing off to little response at the edge.

So a bright light at the very edge of the image will have no effect on the reading. A spot-metering system (above right) reads solely from a clearly defined central areausually just 2-3 percent of the total image area.

Silhouettes/backlighting

Although the results may look different, silhouetted and backlit shots are variations on the same theme. In terms of exposure, they differ only in how much light is given to the main subject.

Silhouetted subjects

To create a silhouette, expose for the background alone—whether the sky or, say, a brightly lit wall so that foreground objects are recorded as very dark, or even black. Make sure the exposure takes no account of the foreground. For this technique to be most effective, minimal light should fall on the subject, otherwise surface details start to

record and the form loses impact. Your aim is to exploit outline and shape, and to help this, a plain background is usually best.

When taking pictures into the light, you need to be aware of bright light flaring into the lens. As a rule, try to position yourself so that the subject itself obscures the light source, though it can be effective to allow the sun to peep around the subject to cause a little flare. Using a small aperture helps reduce unwanted reflections inside the lens.

Backlit subjects

The classic backlit subject is a portrait taken with a window or the sky filling the background, or figures on a bright, sandy beach or a ski slope.

The challenge in terms of exposure in these types of situations is to prevent the meter from being overinfluenced by the high levels of background illumination. If you don't, you will end up with a silhouette. To prevent this, either override the automatics or manually set the controls to "overexpose" by some 1½–2 f/stops.

Another approach is to set your camera to take a selective meter reading (see pp. 114–15). Alternatively, with a center-weighted averaging meter reading, fill the viewfinder with the shadowy side of your subject, note the reading, or lock it in, move back, and recompose the image.

Backlit scenes are prone to veiling flare—nonimage-forming light—which is aggravated by the need to increase exposure for the subject. In strong backlighting, however, it is hard to prevent light from spilling around the subject edges, blurring sharpness and reducing contrast.

Conflicting needs

In this strongly backlit portrait of a Kyrgyz shepherd (which has been cropped from a wide-angle shot), I positioned myself so that the subject shielded the lens from the direct rays of a bright sun. It is very difficult to achieve the right balance of exposure—if the horse is fully exposed, the sheep will be too light. This is

clearly the type of situation that would benefit from a little fill-in flash (pp. 124-5). However, there was just enough light to pick out the color of the horse when the sheep were correctly exposed.

Dealing with flare

As the sun sets on a market in Tashkent, Uzbekistan, the dust raised by street cleaners fills the air, catching and spreading the still-bright sunlight. The lower the sun is in the sky, the more likely is it to become a feature in your composition. In the example here, the flare has been caused as much by the atmospheric dust as by any internal reflections within the lens

itself. A normal averaging light reading taken in these conditions would be massively overinfluenced by the general brightness of the scene, and so render the backlit subject as featureless silhouettes. Therefore, what may seem like a gross overexposure—an additional 2 f/stops—is needed to deal with this type of lighting situation.

Sky exposure

Strong light from the front and a symmetrical foreground shape immediately suggest the potential for a silhouette. A passing windsurfer, in the Penang Straits of Malaysia, completes the picture. Simply by exposing for the sky, all the other elements fall into their correct place—the

black, shadowy palm, the sparkling water, and the surfer are transformed. Using a catadioptric (mirror) lens produces the characteristic "hollow" look of the out-offocus palm.

Virtue of necessity

When shooting into a fierce tropical sun, you may have no choice other than to produce a silhouette. If so. the strategy then becomes a search for the right type of subject. Here, on Zanzibar, dhows and beachcombers are complementary in terms of tone, yet contrasting in

shape. Notice how the central figure seems diminished in size as his outline is blurred by the light flaring all around his body.

High-key/low-key images

The key tone in the majority of images lies at or near the midpoint between darkest or black tones and the brightest or white ones. The visual effect of deliberately shifting the key tone is not merely to make an image lighter or darker overall, but to signal a mood or feeling to the viewer; it is to use the tonality of the image to convey meaning. In this sense, the exposure is "incorrect," or not compliant with the standard, since you are deliberately causing under- or overexposure.

Visually, it seems that when the key tone is shifted, it is best to alter the other values further to suit. Thus, with high-key images there are generally few, if any, truly black areas, while in low-key images, white-bright areas are minimized.

High-key owl

High-key images may result not only from exposure control or the nature of a subject, but also from the treatment given to an image after it has been captured. The original portrait of this eagle owl was full of dark

tones, but manipulation of the image concentrated on bringing out the bird's strong features by turning unnecessary details into pure white or a few hints of color.

Bright and high

High-key overcomes shadows and signals a mood full of light and air. But making a high-key image is not just a matter of increasing exposure; it means ensuring that as many tones as possible are lighter than midtone. You can do this by lighting your subject evenly from both sides, using fill-in flash or reflectors to reduce shadows, or shooting from a position that minimizes shadows. However, if you are working in low-contrast conditions, you may indeed have to increase exposure.

Snow scene

Both snow and white sand seen in full sun reflect back a lot of light, which can, if not corrected, lead to dark, underexposed images. To retain the character of snow or sand, the exposure must be greater than normal by between 1 and 2 stops. In this snow scene, taken in Uzbekistan, exposure was measured from a nearby object (not visible) that contained midtone colors. Compared with that meter reading, the snow called for 1½ stops less exposure. The resulting deliberate overexposure lightens the snow to produce a high-key tonal rendering.

With digital cameras, you can easily see the effect of setting non-standard exposures as soon as you take an image. However, it may be easier to record the image normally and then create the high-key effect using image-manipulation software.

The easiest way to create a high-key picture is to base exposure on the shadow areas by ensuring that your meter reads light values in these areas alone. If your camera has a spot or selective-area meter, point it at a shadow that still retains some subject detail, lock the reading in, and recompose the shot. If you don't have this facility, you may need to move close enough to a suitable shadow so that it fills the sensor area. If you place the darkest area with detail as your midtone, all the other tones in the image will be lighter and you should have very little in the image that is darker than midtone.

Deliberate overexposure with a digital camera can cause electronic artefacts as photosensors become overloaded. If this occurs, the best option is to record the images using normal exposure settings and create the high-key effects later, via your image-manipulation software.

TRY THIS

Look for subjects that have a narrow range of luminances—those with relatively small differences between their brightest and darkest parts—such as flatly lit subjects on an overcast day. Take a series of exposures, starting with the metered correct exposure, and steadily increase exposure to overexpose the subject. You will find that overexposure of 1 stop or more is sufficient to fill the colors with light to create a relatively pastel image, provided there are not any black or very dark areas. This is a high-key image. At the same time, look for scenes with a broad subject-luminance range—say, a building with one side brightly lit and the other in deep shadow. Take a series of exposures, starting with the correct exposure, and steadily decrease exposure to underexpose the subject. You will find that while the midtones deepen to black, the highlights simply become smaller until the image consists of sharply drawn highlights. This is a low-key image.

Shadow scene

The exposure you give a scene determines the placing of the midtones: less exposure places midtones toward the dark end; more exposure places them toward the light end. This in turn places all the other tones either higher or lower than normal. In this still-life of tulips placed in front of a curtain, deliberate overexposure ensures that there are virtually no tones that are lower than midtone, thus creating a high-key effect. An equally valid image would result from a much darker picture, but its mood would then be very different.

High-key/low-key images continued

Moody landscape

In reality, this scene was a pale landscape with swirling clouds occasionally pierced by shafts of sunlight. By forcing most of the tones to be darker than midtone, while allowing the relatively small, light areas to remain bright, the drama of the light has greatly increased. You can darken the image with the burning-in tool (part of image-manipulation software) or, since this image was taken on black and white film, you can burn in the print in the darkroom. Then, after scanning, you can make any further tonal refinements.

Dark and low

The mood of low-key images is in sharp contrast to that of high-key: with darkness comes a more somber and metaphorically darker mood, perhaps with more drama implied.

Technically, low-key images are easier to create than high-key ones, since less light, exposure, and somewhat less control are required. However, you must be aware that when it comes to outputting the images, inkjet prints with large areas of dark tone easily become overloaded with ink.

In a similar approach to high-key imaging, the most flexible technique for determining the exposure for low-key pictures is to concentrate your exposure reading on the light values that still retain subject detail. If you point your spot or selective-area meter at such a region of your subject, that tone will be rendered as a midtone gray. This means that everything darker than the light area (most of the image) will be darker than midtone gray. Shadows with detail will, therefore, become featureless black.

Note that underexposure with digital cameras can introduce unwanted visual noise, so it may be best to create a low-key effect from a normally exposed image via image-manipulation software.

Dramatic portrait For a low-key portrait, all that is often required is low-angle

sidelighting, as here, and enough underexposure to shift midtones into shadow areas. The absence of real highlights has the effect of darkening

mood and concealing all sorts of defects. The very dark tone also makes it easy to burn in any distracting highlights.

Advanced metering

Determining correct exposure with precision is a challenge to any automated system. For experienced photographers, there is no substitute for taking more or less full control of the process. Unfortunately, this not only requires skill, but takes time and careful attention to detail. However, not all work is hurried and, even with digital photography, precisely correct exposure always saves time and work later.

Incident-light metering

For much studio photography, taking an incidentlight reading is a much-favored technique for determining exposure. The light-sensitive cell of a handheld meter is covered with a translucent white hemisphere that collects light from a very large area. The meter is held at the subject position with the hemisphere pointing toward the camera. Thus, the meter integrates all light falling on the subject to arrive at a cumulative average.

Deciding which method to use

Bright, contrasty lighting from behind the camera or from the side, as in this scene, is ideally measured using an incident-light meter. The key tones in the image are the fish and chair, and if you get those correct, then the rest of the scene falls into place. It would have been

easy to underexpose this scene, since a normal reflectedlight reading could be misled by the light-toned foreground and middle ground, and so set a smaller aperture or shorter shutter time.

The meter cannot distinguish between one side of the subject being in shadow while another is in bright light; it simply adds the two together. It also takes no account of the nature of the subject itself, which could be dark and absorbent or bright and reflective. The meter reading would be exactly the same.

The advantage that this method has over a reflected light reading is simplicity; and it always provides a good basis for bracketing exposures (see below). However, you do need to move from the shooting position to the subject position, which may sometimes be difficult. In addition, small differences in the meter position can make a big difference to the reading, facing you with the problem of deciding which is the "correct" reading. Incident-light metering is, therefore, most useful where bright light is falling on the subject from the side or from behind the camera position; it is tricky to use in backlit situations.

Bracketing exposures

Since correct exposure is central to good image and reproduction quality, many techniques have evolved to ensure that pictures are properly exposed. The simplest is to take several bracketed exposures, using slightly different settings each time, so that they run from having more exposure than the metered "correct" setting through to having less exposure. It is then likely that one of the images will have just the qualities of exposure you want to see.

Some cameras offer an automatic bracketing mode: they take several exposures in quick succession all at different settings. Alternatively, you can take a series of manual exposures yourself, each time setting a different value on the override—for example, + 0.5, +1, -0.5, -1 (in addition to the meter's recommended exposure)—in order to produce a bracketed set. Steps of ½ stop are generally recommended: steps of 1 stop are too large except for color negative film, while steps finer than ½ stop are needed by professionals working with color transparency material.

Advanced metering continued

Spot metering

Many SLR cameras and some handheld meters enable you to take a reading from a very small area of the subject—typically from some 5 percent of the total field of view, down to just 1 percent (with professional-grade cameras). For work on location, spot metering has two major advantages: first, it allows you to be highly selective in choosing the key tone; and, second, even when you cannot approach your subject, it allows you to take a reading as if you were close up.

The easiest way to use a spot-meter is to decide which patch of color or tone in the subject should be exposed normally—which should be the midtone, in other words. Then you simply take a light reading from that area and ignore the rest of the image (as far as exposure is concerned). Some authorities suggest taking several readings—of highlight, shadow, and midtones—to determine the midpoint. Indeed, some cameras will automatically make the calculations for you. However, not only is this time-consuming, multiple readings do not deliver results that are any more reliable than those from a single reading.

However, multiple spot metering is useful for determining the luminance range of the scene its span of brightness values. You can take a reading from a shadow area with detail and from a highlight area with detail and see by how many stops they differ. If this difference is less than 2 stops, you can comfortably record the entire

scene. If, though, the subject luminance range is greater than 3 stops, then because of the film's or sensor's recording limitations, you will need to decide to sacrifice some subject details in the shadows or in the highlight values of the scene. The only other option is to adjust the lighting ratios (see pp. 116-17 and 124-5) to reduce the luminance range, if lighting is under your control.

Technical readings

One technique for dealing with variable lighting conditions is to present your exposure meter with a standard target, such as a gray card. This target is printed in a neutral gray color with 18 percent reflectance: in other words, it reflects back 18 percent of the light falling on it. Instead of measuring the light reflecting from the subject or scene, you take your reading from the card instead.

Not only is this a cumbersome method, there are also variations in readings when the card is illuminated by directional light depending on the angle at which the card is held (even though the card has a matte surface).

However, the gray card is an excellent control where image density or color accuracy is crucial, since it provides a standard patch whose density and color neutrality is a known quantity, and this allows an image to be calibrated to a standard. This degree of accuracy is important for technical imaging, such as copying artwork, clothing, or certain types of products for catalogs.

Preset metering

With fast-moving clouds, Nelson's Column in London was bathed in changing light, while the blue sky behind remained relatively constant. I wanted to catch the sun just bursting through the rim of a cloud—too much sun created excessive flare, while too little lost the attractive burst of rays. If the meter had been left on automatic, the instant the sun appeared the exposure settings would compensate for the extra light and so

render the sky almost black. In anticipation of this, I set the camera controls according to a manual meter reading of the sky, which included some bright cloud—thus ensuring that the sky was a deep blue. The rest simply consisted of waiting for the sun to emerge, resisting the urge to respond when the meter reading shot up to indicate massive overexposure.

Taking a spot reading

Light from in front of the camera, as in this late afternoon scene, is best measured using the camera's spot-metering option (if available). You can then select the precise area of the scene that you want correctly exposed. In this shot, the reading was taken

from the men's shadowy faces and bodies. The crucial goal is to ensure that the brighter areas of the scene are not rendered too light while retaining details in the shadows. Here, shadow detail has been helped by the reflective qualities of the sand.

Color accuracy

You can use a gray cardone printed with a midtone grey-as a standard target for the exposure meter when faced with subjects that are very dark or very light. However, gray cards are also useful when you need objective accuracy—as in this shot of a rare embroidery from Afghanistan. If you include the gray card, as you can see here, it provides a known standard for accurate color reproduction. The colored tabs also included with the object are useful for comparison with any paper print, again to help ensure color accuracy.

Averaging metering

This view of silver birches is the ideal subject for meters that average light values throughout a scene. Indeed, it demonstrates how rare it is that this method of metering is applicable, since not many scenes have such a small dynamic range and even tone distribution. This scene is such that every method of metering should produce the same result—one that ensures the blues are rendered to midtone while the narrow tree trunks retain both highlights and shadows.

Accessory flash

Digital cameras, almost without exception, are equipped with a built-in electronic flash. What makes the modern flash so universal is that it is both highly miniaturized and "intelligent." Most units, for example, deliver extremely accurate computer-controlled dosages of light that suit the amount of available, or ambient, light in the scene.

Making flash work for you

Whatever you might gain in terms of convenience by having a ready source of extra light built into the camera, you lose in terms of lighting subtlety. To make flash work for you, you need to exploit what limited control facilities your camera offers.

First, use the "slow-synch" mode if your camera offers it. This allows the ambient exposure to be relatively long, so that areas beyond the range of the flash can be recorded as well as possible, while the flash illuminates the foreground (see below). This not only softens the effect of the flash, it can also give mixed color temperatures—the

cool color of the flash and the often warmer color of the ambient light—which can be eye-catching.

Second, try using a reflector on the shadow side of the subject. If angled correctly, it will pick up some light from the flash and bounce it into the shadows. Any light-colored material can be used as a reflector—a white sheet of paper, a white sheet, or a shirt. Professional photographers like to use a round, flexible reflector that can be twisted to a third of its full size. It is very compact, lightweight, and efficient, and it usually has two different surfaces—a gold side for warm-colored light and a matte side for softly diffused effects.

Third, an advanced option is to use slave flash. These are separate flash units equipped with sensors that trigger the flash when the master flash (built into or cabled directly to the camera) is detected. If you have a flash unit, then adding a slave unit is not expensive. However, you need to experiment with your camera to check if the synchronization of the multiple flash units is correct.

Flash limitations

Dusk in Istanbul, Turkey, and traditional musicians gather. The standard flash exposure used for this image lights only the foreground subjects, and the rapid light fall-off, characteristic of small light sources, fails to reach even a short distance behind the first musician. Adding to the problems, camera exposure is not long enough for the low ambient, or available, light levels prevailing at the time. As a consequence, the background has been rendered black. This type of result is seldom attractive, nor does it display any sound photographic technique.

Effective technique

When illumination is low. make the most of what light is available rather than relying on electronic flash. Here. exposure was set for the sky: this required a shutter of 1/4 sec, giving rise to the blurred parts of the image. At the same time, the flash was brief enough to "freeze" the soldier in the foreground, so

he appears sharp. Utilizing all ambient light ensures that the distant part of the scene is not wholly underexposed some color can even be seen in the background building. Compare this with the image in which flash provided all the illumination (above left).

Using any setup with more than one flash means trying out different levels of flash output to discover the best results. Start by setting the slave to its lowest power output, bearing in mind that the task of this unit is to relieve subject shadows, not act as the main light. Some models of camera are designed for multiple-flash photography.

Flash synchronization

Because the pulse of light from electronic flash is extremely brief, even compared with the shortest shutter time, it is crucial that the shutter is fully open when the flash fires. Only then will the entire film area be exposed to the flash light reflected back from the subject. There is usually a limit to the shortest shutter time that synchronizes with the flash, often known as "x-synch." For most SLRs, this is between 1/60 and 1/250 sec. In some cameras, x-synch corresponds to the shortest available shutter time, which may be 1/8,000 sec. To obtain this, however, you must use flash units made for that particular camera model.

Without flash

Bright, contrasty sunshine streaming in through large windows behind the subjects—a troupe of young singers dressed in traditional costume from Kyrgyzstan produced a strongly backlit effect. Without the use of flash, the shadows would appear very dark, but in this case a wall behind the

camera position reflected back some light from the windows to relieve the contrast a little, and so retain some subject details.

Flash exposure

All flash exposures consist of two separate processes occurring simultaneously. While the shutter is open, or the light sensor is receptive, light from the overall scene—the ambient light—produces one exposure. This ambient exposure takes on the color of the prevailing light, it exposes the background if sufficient, and it is longer than that of the flash itself.

The second exposure is in addition to the ambient one. The burst of light from a flash is extremely brief, possibly less than 1/10,000 sec (though studio flash may be as long as 1/200 sec) and its color is determined by the characteristics of the flash tube (which can be filtered for special effects).

The fact that there are two exposures means that it is necessary to balance them in order to produce good results. But it also allows you to make creative use of the process by, for example, allowing the flash exposure to freeze subject movement, while the longer ambient exposure produces blurred results.

With flash

In this interpretation of the previous scene (above left), flash has been used. This produced enough light to fill most of the shadows. Now we can clearly see the girls' costumes, but note the shadows that still remain on the carpet. It is important to set the camera to expose the background correctly: since in this example it was very bright, a shutter time of 1/250 sec was needed. The f/number dictated by the exposure meter was set on the lens, and the flash was set to underexpose by 11/2 stops. This ensured that the foreground was exposed by both the flash and by the available window light.

Quick fix Electronic flash

Modern electronic flash units are versatile and convenient light sources, ideal for use when light evels are low (and the subject is relatively nearby), or when image contrast is high and you vant to add a little fill-in illumination to the hadow areas. However, due to the intensity of heir output as well as their limited range and covering power, obtaining naturalistic lighting effects and correct exposure can be problematic.

Problem

common types of problems that are encountered when using electronic flash include overexposed results—carticularly of the foreground parts of the image—and underexposed results—particularly of the image cackground. In addition, general underexposure of ong-distance subject matter is very common, as is uneven lighting, in which the corners or foreground are less bright than the center of the image.

Analysis

Modern electronic flash units have their own lightsensitive sensor to measure automatically the light
output from the flash or the amount of light reflecting
oack from the subject and reaching the film or camera
sensor. As a result, they are as prone to error as any
camera exposure meter. Furthermore, the light produced
by a flash unit falls off very rapidly with distance (see

Overexposed flash-illuminated pictures are usually caused by positioning the flash too close to the subject or when the subject is the only element in an otherwise argely empty space.

Flash underexposure is caused by the unit's having nsufficient power to cover adequately the flash-to-subject distance. For example, no small flash unit can ight an object that is more than about 30 ft (10 m) away, and even quite powerful flash units cannot adequately light an object that is more than about 00 ft (30 m) distant.

Uneven lighting is caused when the flash is unable

o cover the angle of view of the lens—a problem most

often experienced with wide-angles. And another

oroblem occurs when an attached lens or lens accessory

locks the light from a camera-mounted flash

Light fall-off

Light from a flash unit mounted on the camera falls off, or loses its effectiveness, very rapidly as distance increases. This is evident in this close-up image of a bride holding a posy of flowers. The subject's hands and the roses nearest the flash are brightly illuminated, but even just a little bit farther back, the image is visibly darker. This

is evident if you look at the back edge of the wedding dress, for example. The effects of this light fall-off can be greatly minimized by using a light source that covers a larger area—hence the very different lighting effect you get when using bounced flash (opposite).

Solution

For close-up work, reduce the power of the flash if possible. When photographing distant subjects in the dark—landscapes, for example, or the stage at a concert—a flash is usually a waste of time and is best turned off. A better option is to use a long exposure and support the camera on a tripod or rest it on something stable, such as a wall or fence. With accessory flash units—not built-in types—you can place a diffuser over the flash window to help spread the light and prevent darkened corners when using a wide-angle lens

Bounced flash

Direct flash used at this close distance would produce a harshly lit subject and a shadowy background. In this shot, the flash was aimed at the wall opposite the child. In effect, the light source then becomes the wall, which reflects back a wide spread of light. Not only does this soften the quality of the light, it also reduces the rapid light fall-off characteristic of a small-sized

source of light. But bounced flash is possible only if you use an auxiliary flash unit. Note, however, that the background is rather darker than ideal—to overcome this. there must be sufficient ambient light to mix with the flash illumination to provide correct exposure overall (above right).

How to avoid the problem

The best way to obtain reliable results with flash is to experiment in different picture-taking situations. With a digital camera, you can make exposures at different settings in a variety of situations to learn the effects of flash without wasting any film. Some flash units feature a modeling light, which flashes briefly to show you the effect of the light—this is a useful preview, but it can consume a good deal of nower and is likely to disturb your subject

Mixed lighting

The result of balancing flash with an exposure sufficient to register the ambient light indoors delivers results like this. The lighting is soft but the color balance is warmed by the ambient light. Also, the background is bright enough for it to appear

guite natural. If a greater exposure had been given to the background, there would have been an increased risk that subject movement woulc spoil the image.

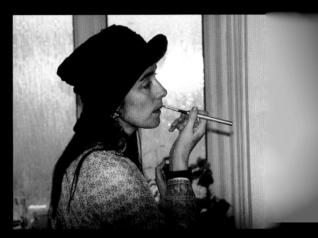

Uneven light

On-camera flash typically delivers these unsatisfactory results. The lighting is uneven, the shapes the flash has illuminated look flat, and there are hard, harsh reflections on all shiny surfaces. In addition, the flash has created unpleasant shadows (note the shadow

of the lip-brush on the background woodwork) Always be aware of any flat surfaces positioned behind your subject when using flash from the camera position.

Studio flash

AC-powered studio flash offers an unbeatable combination of high power, flexibility, and convenience. Moreover, modern flash units are extremely controllable, with small adjustments in light output being easily achieved. In addition, lighting effects are repeatable and color temperature is constant (see p. 266). However, the cost of these flash units is high, as are all the accessories you need to shape and modify the quality of the light output. Worse, many photographers are discouraged from using studio flash units because they perceive them as being difficult to use. In fact, the basics are easily mastered, as long as a few techniques are applied.

Digital advantages

Digital photographers are at a great advantage compared with their film-based counterparts in being able to assess the result of a flash exposure immediately after it is made—by observing the image either on the camera's LCD screen or on a computer monitor. It can be a difficult task, however, to assess image quality on the type of small LCD screen found on the back of a typical digital camera. If possible, it is always preferable to download the image onto a computer for

assessment via a full-sized monitor. With many digital cameras, you can view images on the computer screen at the same time you take them.

Types of equipment

For a range of photographic tasks—from still-life to portraiture—a single flash unit will suffice, if it is combined with a large diffuser or soft-box. Therefore, a starter kit comprising a single unit is a practical proposition. A second lighting unit is useful for adding highlights—a halo of light from behind, for example, or controlling background lighting or increasing overall light levels. You need to ensure, however, that the shutter of your digital camera will synchronize with the firing of the flash units-beware, since not all models do. In addition, you will need a cable to connect the camera and flash, perhaps via an adaptor.

If you are using more than one flash, they can be—and usually are—synchronized via "slave" sensors—units that detect the flash output from the cabled flash unit and trigger their own lights in response. You also need a camera model with an adjustable lens aperture, since this is your principal means of control over the quantity of flash exposure reaching the camera sensors.

Broad lighting

Young children can be demanding subjects if you have too fixed an end result in mind. Often, they are curious about all the equipment in a studio, they are very mobile, their concentration span is short, and they are difficult to direct. One approach is to position them against a plain background and set a broad lighting schemeperhaps two soft-boxes, one either side of the set. The wide spread of soft light allows your subjects to move around without your worrying where shadows will fall.

Building a lighting scheme

The following sequence of photographs (see below and pp. 130–3) illustrates the dramatic differences you can achieve by working with an extremely simple lighting arrangement and minimal equipment. A studio setup such as that used for these pictures could easily fit in any spare room in your home, or you could set up the equipment and dismantle it in a matter of minutes if you don't have the space for a full-time studio.

For all of the pictures, a single electronic flash head was used, fitted either with a bowl-shaped reflector or with a 3-ft- (1-m-) square soft-box (a tentlike enclosure made of two layers of white nylon to diffuse and spread the light from the flash and so soften its quality).

In some shots, a reflector, made of material coated with a metallic finish, was used to bounce light from the flash into subject shadows. And a cream-colored backing was used throughout to help make comparisons easier.

Carefully analyze the images below and those following by looking not only at where shadows fall but also by examining the quality of light making up the highlights. Note, too, the varying depth of color and changes in apparent contrast.

Bowl: front

The flash was fitted with a simple bowl reflector, which provides a broad beam of fairly harsh light. The flash, placed next to the camera position, provides a flat light so there are few unsightly shadows on the girl's face. However, the hard light has created shiny highlights on her forehead and under her eyes. In addition, there is an untidy shadow behind the subject-a sure sign of carelessly applied lighting. In this lighting configuration it is very difficult to eliminate the shadow.

Bowl: 45° to side

When the flash is placed diagonally in front of the subject, the light can model the contours of the face. Here, a strong shadow is thrown from the nose, mouth, and cheeks. The highlight has moved to one side of the subject's face, which is a lessdistracting position than its central position in the first picture. However, the shadows are perhaps too strong and provide too much contrast with the subtle tones of the face for this to be an entirely satisfactory way to light this type of portrait.

Studio flash continued

Inverse square law

If you double the distance between a light source and the surface that light falls on, brightness at the surface is not just halved. For a small, or "point," light source, without a reflector or lens for focusing output, doubling the distance reduces intensity by four times (by a factor of two squared). This is the inverse square law. Although commonly applied to studio and accessory flash lighting, the inverse square law gives inaccurate results, since nearly all luminaires (sources of light) use reflectors or lenses, so light distribution is not even and equal in all directions.

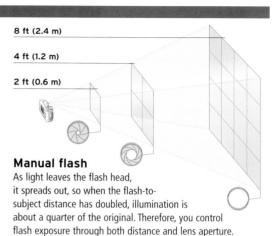

Bowl: 45° to side plus reflector

The addition of a reflector on the side of the subject's face, opposite the lamp, fills in the shadows, though not fully. Notice how the shadow under the chin is still visible, though it is not so dense that you cannot see full skin tone, and the clothes retain their shape. As a result, there is a good balance between shadows, which help define the form of the face, and midtones. However, look closely at the forehead and you will see two reflections—one caused by the reflector being placed too far forward of the face; the other caused by the lamp itself.

Bowl: 90° to side

With the lamp placed directly to one side of the subject, the shadows on the opposite side of her face become so deep that practically no detail is visible. As a result, the effect is dramatic and visually arresting. And notice how the texture of her clothes is beautifully rendered, with every fold visible. However, in conjunction with the lack of detail in the shadows, note that the highlights are also lacking in detail. This is due to the fact that the light-reading sensor in the camera is unable to retain information with the high dynamic range produced by the lighting.

Bowl: 90° to side plus reflector

A reflector should always be used with care. Here, it was introduced to bounce light back into the deep shadows thrown by the flash positioned directly to one side. However, the fill-in has only partially done its job, leaving a dark strip down the middle of the face due to the fact that it was placed directly opposite the lamp: a position farther in front of the face would have improved the lighting effect. Other approaches include using a reflector that diffuses the light more strongly as well as varying the distance between the reflector and the subject.

Harsh shadows

Using a single camera-mounted flash is by far the most convenient lighting arrangement. However, effects are often harsh and unattractive. Here, a flash on the left of the camera has provided adequate illumination, but it has also cast hard shadows behind the subject and from the pen she is holding. At the same time, the modeling effect on the face is flat, while the background appears too dark due to the rapid fall-off of light. To avoid these problems, you will either have to bounce the flash off an intervening surface or, better, use more than one lighting unit.

f/22

This pair of images illustrates how a simple change in exposure setting can produce radically different lighting effects. In the darker image (above right), the flash was placed directly behind the subject: this creates an attractive halo of bright hair framing the head, but the sitter's face is all but obscured by heavy shadow. The lens aperture used for this image, like that of all the others in this set, was f/22. In the next image (above left), the lighting remained exactly the same, but the lens was opened up to f/8, which is a full 3 f/stops brighter than f/22. Note now that the face is correctly exposed. Increasing the level of exposure reveals the face because the wider aperture exploits indirect light from the flash that which has been reflected from the studio's light-colored walls. You can refine this result further by using a black background, which would show up the halo of light around the model's hair to a much greater degree.

Soft-box: front

Compare this image with the first in the sequence (p. 129). The greater diffusion of light from a flash inside a soft-box placed as near the camera as possible has produced an altogether more attractive lighting scheme. The shadow behind is diffused almost to the point of being a positive asset, and facial features are softer yet still clearly delineated. Note, too, that the catch-lights in the eyes are much larger than with the first bowl/ reflector set-up.

Studio flash continued

HINTS AND TIPS

If you are new to working with studio flash and accessories (see pp. 42-5), you might find it useful to bear the following points in mind:

- As a general rule, always use as few units as possible to achieve the desired lighting effects. Start with one light only and use reflectors to control the quality of the illumination reaching your subject. Only if this is insufficient should you consider adding extra lighting units to the scheme.
- Remember that it is easier to remove light than to add light. Using accessories, such as barn doors or snoots, you can easily control the fall of light and any

- shadows that are created as a result. However, an additional light immediately casts a set of new shadows.
- A reflector placed facing the main light, angled so that it bounces light into subject shadows, is usually a more effective solution than using another light source to reduce shadows.
- A large light source, such as an umbrella reflector or soft-box, produces softer light and more diffused shadows than a small light source.
- A small light source, such as a spotlight with a small bowl, produces harder light and sharper shadows than a large, diffuse light source.

Soft-box: 45° side

It is at once clear that lighting from diagonally in front from a large, diffused source is a most versatile scheme. This arrangement is easy to control, with just small changes in the angle of the light producing a subtly differing feel to the quality of the illumination. The form of the face is clearly shown, shadows are not harsh, there is an attractively large catch-light, and the textures in the girl's top are well defined. There is also little problem with shadows falling behind the subject as the diagonal placement of the light throws them out of view of the lens. As a result, you can place the subject close to the background if required.

Soft-box: 45° side plus reflector

Here, the reflector bounces light from the large source into the shadow region to create almost too soft a result. The lighting lacks drama and contrast and is somewhat similar to lighting directly from in front. The shadows from the lock of hair on the subject's right gives away the fact that light is reaching the face from both sides. Note that the fill light from the reflector has almost completely removed the shadow under the chin—which is close to merging with the neck, thereby losing its shape—and is generally an effect to be avoided.

An aim of studio lighting can be to mimic the quality of daylight. In this scene, it was important that the table light appeared to be the main light source. The levels of daylight were inadequate to illuminate the dark-colored interior of the room, so a studio flash was directed at the ceiling behind the table. The reflected light was just enough to bring out important details in the setting without creating telltale hot spots in the glassfronted pictures.

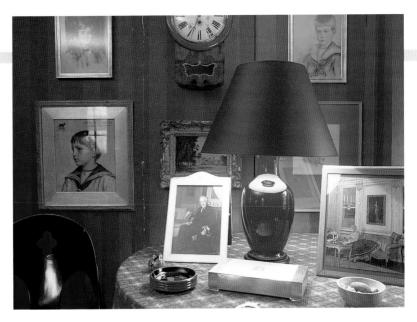

Soft-box: 90° side

A large light source placed to the side of the face provides a strongly chiaroscuro effect, in which the distribution of light and dark areas defines the image. So, in this scheme, form is clearly molded yet details in the shadows are not wholly lost in the dark; nor are highlights "blown out," or featureless. This is a favorite arrangement for dramatic portraiture and mimics the effect of placing a portrait subject next to a window admitting bright yet diffused light. A dark background—instead of the light one used here—would help ensure that the viewer's attention is focused on the lighter side of the subject's face.

Overhead view

Soft-box: behind

Placing a soft-box directly behind the subject pointing back at the lens gives a camera image that looks unpromising. The light floods into the lens, making it very hard to discern the face. In addition, the veiling glare appears to destroy any image that you can see. In this situation, a lens-hood—which stops sidelighting from entering the lens—will not help at all. However, as a digital photographer, you should take the image even if it looks unpromising. It could be a revelation—highly unusual lighting schemes could make you look at your subject in new ways. Besides, you can always manipulate the image to reduce the worse effects of the glare.

A compendium of ideas

Starting projects

A project gives you something to concentrate on, something on which you can focus your ideas or around which you can define a goal. Committing yourself to a specific project can give you a purpose and help you develop your observational and technical skills. In addition, a project provides you with a measure against which you can determine your progress as a photographer.

One of the most frequently asked questions is how you come up with project ideas—and a common mistake is to think that some concept of global interest is needed. In fact, the most mundane subjects can be just as rewarding and—even more important—achievable.

An action plan

• It could be that your skills as a photographer could be put to use by some local community group. So, instead of giving money, you could provide photographs—perhaps with the idea of holding a local exhibition to raise funds.

- If you try to do too much, too quickly, you are heading for disappointment. For example, you want to digitize all the pictures in your family albums. Fine; but don't try to complete the project in a month.
- You have to be realistic about the money involved in carrying through a project, but preoccupation with cost can freeze your enthusiasm, kill the sense of fun, and become, in itself, the cause of the waste of money.
- Nurturing a project idea is more about cooperation than coercion. You have to learn to work with the idiosyncrasies and character of the subject you have set your sights on. And doubts and misgivings are very common. If you find yourself inhibited or you are afraid to look silly, or if you think it's all been done before, then you may start to wonder what the point is. If so, then just bear in mind that you are doing this for yourself, for the fun of it. As long as you think it is worthwhile, why care what anyone else thinks?

Illuminating domesticity

This is the type of domestic scene that could easily pass unnoticed at home, unless your concentration is sharpened by having a project in mind. Yet if you were to see the exact same scene on your travels, the simple fact

that you were not in your familiar surroundings may make the light and balance of the complementary colors and the rhythm of the vertical or near-vertical lines immediately striking.

Shadows

Strong light casting deep, well-defined shadows and the warm colors of the floor make for an abstract image. To ensure that the lit area was properly exposed, I took a spot reading from the bright area of floor, entirely ignoring the shadows.

Interior arrangements

The paraphernalia of a restaurant under construction produced a complex of lines and tones that caught my eye. The picture benefited

from having the left-hand side slightly darkened to balance the darkness toward the top right of the image.

Juxtaposition

A monument to three wartime commandos in Scotland reflects the three benches erected for visitors to sit and enjoy the view.

A long wait in a bitingly cold wind was rewarded when a spectacular burst of sunlight broke through a gap in the cloud-laden sky.

TRY THIS

Make a list of objects you are familiar with. These can be as simple and ordinary as you like—dinner plates, for example, or bus stops, drying clothes, or chairs. Do not prejudge the subject. If the idea comes to you, there is probably a good reason for it. Choose one subject and take some pictures on the theme: again, do not prejudge the results, just let the subject lead you. Be ready to be surprised. Don't think about what others will think of what you are doing. Don't worry about taking "great" pictures. Just respond to the subject—if it is not an obviously visual idea, then you might have to try a bit harder to make it work as an image. Don't abandon the subject just because it initially seems unpromising.

Abstract imagery

Photography has the power to isolate a fragment of a scene and turn it into art, or to freeze shapes that momentarily take on a meaning far removed from their original intention. Or chance juxtapositions can be given significance as a result of your perception and the way you decide to frame and photograph the scene.

Close-ups and lighting

The easiest approach to abstracts is the close-up, since it emphasizes the graphic and removes the context. To achieve this, it is usually best to shoot square-on to the subject, as this frees the content from such distractions as receding space or shape changes due to projection distortion.

Longer focal length settings help to concentrate the visual field, but be careful not to remove too much. It is advisable to take a variety of shots with differing compositions and from slightly different distances, as images used on screen or in print often have different demands made on them. For example, fine detail and texture are engrossing, but if the image is to be used small on a webpage, then a broad sweep may work better. And since you will usually be shooting straight onto flat or two-dimensional subjects, you do not need great depth of field (see pp. 74–7). This is useful, since it is often crucial to keep images sharp throughout.

Complicated abstract

Abstract images do not need to be simple in either execution or vision. Try working with reflections and differential focus (focusing through an object to something farther away). Here, in Udaipur, India, a complex of mirrors, colored glass, and highlights from window shutters battle for attention-and bemuse the viewer. Control of depth of field is critical: if too much of the image is very sharp, the dreamy abstract effect may be lost.

Found abstract

Here (below), the decaying roof surface at a busy train station must have been glanced at by thousands of commuters every day but seldom seen. Perhaps it is a simple expression of the process of aging, the origins of which can only be guessed.

Abstract imagery continued

Modern forms

Contemporary architectural details are rich sources of abstract imagery. Their strong graphic design invites you to take—and delight in—small elements and examine their interaction with other, equally graphic elements. Here, the

frosted glass of an apartment building gives a partially obscured view of the courtyard beyond. To increase the abstract look of the image, I simply turned it on its side.

Light play

Observe shadows closely and you will find a challenging and constantly changing source of images. Clear, clean light, such as in New Zealand (above), helps give welldefined shadows that contrast sharply with man-made

textures and surfaces. Take care not to overexpose, because that will cause you to lose highlight textures. Images often benefit from increased contrast and saturation, as seen here.

Copyright concerns

You may think that because a poster or other subject is on public view, you can photograph it with impunity. The chances are, however, that you will be infringing someone's copyright. However, if you are taking the photograph for research or study, then perhaps not. To illustrate a school essay on advertising—you are probably in the clear. But if you use a recognizable and sizable portion of an image on public view as a significant part of another image that you go on to

exhibit, publish, or sell, then in many countries you would be in breach of copyright. If you really want the image, then at least be aware of the potential legal situation. Note that sculptures, buildings, logos such as McDonald's arches, cars such as the Rolls-Royce, the French TGV train, certain toys and, say, Disney characters—even the Lone Cypress tree at Pebble Beach, CA-all enjoy a measure of copyright protection. You may never be pursued in court... but you could be (see pp. 374–5).

Buildings

The built environment provides endless photographic opportunities—the problem is not in finding subject matter, but in reducing it to a manageable scale.

Technical considerations

Although it is natural to reach for a wide-angle lens to photograph buildings, a wide-angle view is not always best. A carefully chosen narrower field of view can reveal more of a building and its surroundings. Working digitally, you can always stitch several shots to create a panorama (*see pp. 202–5*). Bear in mind, however, that this technique works best when the camera is tripod-mounted, and that in many public buildings you need permission to use a tripod.

Avoid using lens attachments that are intended to increase the wide-angle or telephoto ability of the prime lens—these always worsen a lens's optical ability. Rather than use lens attachments, look for positions and angles that make best use of the focal lengths of your prime lens: if you need a larger image, try moving closer; for a broader view, shoot from farther back.

Privacy in public places

When shooting in a public space, such as the street, train station, or market-place, you are not likely to be invading people's privacy if they are included in the frame. However, you need to be sensitive to the fact that if you are photographing in a public place and you include people who happen to be in their private spaces—indoors by a window, say, or in their garden—the situation may be different. And people may be more suspicious of your motives if you are using a long lens. The whole notion of privacy varies from culture to culture; in some, photographing people in any circumstance—whether they are in a private or a public place—must be approached with tact.

High vantage point

A Hindu temple in Singapore, with its colorful depictions of deities, offers many photographic opportunities. By climbing up to a high vantage point, the temple could be photographed

without pointing the camera upward. This shooting position also provided a contrasting background of modern office buildings.

Buildings continued

Golden light

A street scene such as this (above) can be found in many cities, but the golden glow from a setting sun would flatter any view. These lighting effects are transient, and you need to be at the right place at the right time. The best advice is always to carry a camera and be ready to take advantage of the unexpected.

Shifting perspective

Tiny differences in perspective can make a huge difference to images of buildings. In this view of a mirror-clad building (right) in Leeds, England, every slight shift in the camera position produced a different set of reflections, and with each change a different impression of the building was presented.

Ideal conditions

Good weather and bright light are the best friends of architectural photographers. Architects enjoy working with light and shadow, and modern buildings, in particular, come alive in good light. There will be moments at specific times of the year when light and shadow just seem to fall in all the most perfect places (left).

Photographing clouds

Flying affords you an entirely novel perspective on the Earth below. So instead of watching the usual selection of in-flight movies, why not spend some of your time photographing the constantly changing pattern of clouds? Of course, shooting digitally means you can check your exposures instantly, deleting any that are substandard.

The ideal seat is by a window with a clear view unobstructed by the aircraft's wing. The best position is ahead of the engines; a view more from the rear is likely to suffer from the turbulence of gases ejected by the engines. On high-altitude flights it is not uncommon for windows to frost over for part of the time, so you will just have to wait for them to clear. You will need only a modest wideangle or standard focal length to capture cloud effects: too wide a focal length and you will catch the sides of the windows; too long a focal length and the degradation in image quality due to the thickness of the window becomes apparent.

Wide-angle imagery

One disadvantage of working from an aircraft is the difficulty in using ultra wideangle lenses to capture views like this one (below), which was seen from ground level. A setting sun tries to break through a high layer of cloud

while, lower down in the sky, heaped clouds sweeping around in lines are indicative of short-lived fine weather. The use of an inferior-quality wideangle lens is apparent by the the appearance of slightly darkened corners, which are the result of light fall-off.

Health warning

Take care to avoid looking directly at the sun—even at sunset when the sun is low—while waiting for it to burst through cloud cover. This is particularly the case if you are shooting in equatorial regions, where sunlight is often very strong. Even a fraction of a second's unprotected direct exposure can damage your eyes—especially if you are using a traditional single-lens reflex viewfinder. For sun-watching, a digital camera is ideal, since you can safely observe the fiery glow on its LCD screen. However, too long an exposure to the full effects of the sun can cause irreparable damage to a camera's photosensor.

Global view

Dawn is one of the best times to look for cloud images, whether you are on the ground or in the air. Here, high above the Earth, somewhere over the Pacific, a rain cloud (lower half of the picture) is building up, while the sun, just over the horizon, casts long shadows and mixes its pink tints with the blue to create shades of purple and mauve.

Awkward angle

For this shot, I found an unoccupied seat at the very rear of the aircraft—from here, however, the hot gases and turbulence streaming out from the rear of the engines distorted part of the view. To avoid this, I tilted the camera to one side, causing the view to be at a somewhat awkward angle. Fortunately, aerial views, with no points of visual reference, are tolerant of this approach.

Documentary photography

The documentary uses of photography range from the most prosaic and practical—progress reports on building projects, for example—to the most altruistic and idealistic—such as recording the plight of endangered species or the effects of environmental pollution.

Useful digital features

Using even the most basic digital camera, you can take a picture of, say, damage to property for insurance purposes or an item for auction, and confirm instantly that it accurately documents the features required for its purpose. Another advantage is that many digital cameras are nearly silent and inconspicuous in operation. This means that if you are an accepted part of an event, photography can proceed without anybody really noticing. This is further helped if your model has a swiveling lens or LCD screen, since you don't have to hold the camera up to your eye in order to shoot. If you use this technique, however, you will be holding the camera lower than usual, so you should therefore try to photograph from a higher viewpoint in order to compensate.

For formal documentary work, it is important that the digital image is not altered. Although a digital image is far easier than an analog one to change, it is also easier to build into an image a feature that will prove this has happened. There are systems that conceal a code in the image that changes if the image is altered in even the minutest or most innocent of ways, such as a change in brightness or resolution. In addition, each image can be tagged with information about the date and time it was taken, increasing its value as a piece of documentary evidence. Various systems are available, and when a validation system is in operation, you should expect the reading and writing of files to take longer than usual.

Potential digital drawbacks

Two major disadvantages experienced by digital photographers working in the field of social documentary are that many models have a slow response time when first turned on (*see p. 66*),

Photographs © John Curno

and that those with LCD screens, especially, consume battery power at a very rapid rate.

In general, social documentary photography is characterized by long waits punctuated by short and sudden bursts of activity. Because of this, use the viewfinder—not the LCD screen—whenever possible in order to conserve battery power. This may give you enough power to keep the camera turned on and ready to respond instantly. You may also need to account for shutter lag

Technical notes

John Curno took all the photographs shown on these pages using a Nikon digital camera with center-weighted metering. This metering system produces better results for black and white than fully automatic matrix or evaluative metering (pp. 114-15 and 121-3). Curno chose not to use his usual large- and medium-format, film-based cameras, opting instead for a digital camera to produce small, uncropped prints from a desktop inkjet printer.

with digital cameras. This is the delay between pressing the shutter and the picture actually being recorded. By anticipating the action, rather than responding to it, you can at least minimize this annoying drawback.

One man's vision

The affectionate and intimate images shown here and on the following two pages are part of John Curno's documentary work on the rural parish of Drewsteignton, Devon, in southwestern England, where he lives. Curno is a much-exhibited photographer, and his aim is to show through his images how the villagers are coping with the changes associated with the arrival of newcomers to the village. An aspect of this evolutionary change in the parish that particularly interests him is how modern technology allows the newcomers to choose a rural lifestyle, commuting only when necessary.

Documentary photography continued

Technical notes

Habitually using a wide-angle attachment on his digital camera means that Curno has to move in close to his subjects to achieve many of the portraits seen here. At times, he also uses a yellow-green filter over the camera lens. This type of filter is commonly used with black and white film cameras to help tonal rendition, and old habits die hard.

Photographs © John Curno

Model release form

If you take pictures of people and intend to use them in commercial ventures, this legally binding agreement between subject and photographer allows you to use the pictures without any further financial obligation or reference to the person depicted.

For the personal use of a photograph, it is generally not necessary to obtain the model's release; however, if an image is intended for commercial use, it is advisable to obtain signed consent. A simple form of words is: "I permit the photos taken of me (subject's name) by (photographer's name) to be printed and published in any manner anywhere and at any time without limit." The consent form should also note the date the pictures were taken, the location, and carry the signature and contact details for both the subject (or parent/guardian) and the photographer. Both parties should sign two copies—one is kept by the photographer, the other by the subject. In some countries, a consideration (the payment of a sum of money or the giving of a print) is required to make the contract binding.

Ecotourism

Every publicly funded animal reserve, national park, or nature preserve welcomes the type of activity that results in positive publicity of its aims. Thus, when you are a digital photographer, the technology at your command can turn you from a passive observer into an active contributor.

Aims and objectives

The likelihood is that you will have only limited time when you visit—a day probably, maybe two-so it is up to you to make the most of the opportunity. First, determine what the main attractions of the place are, and how you can best record them. Next, a little research beforehand will inform you of any recent developments that have taken place so you can decide whether or not they should be on your list of things to see. And don't neglect the people who work or live there they may be rewarding subjects for your camera.

Digital photography usually wins over its film-based counterpart due to its versatility. You can use digital images in emails to illustrate a publicity campaign; for brochures within minutes of their being taken; and, of course, you can place them on a website publicizing the park or its work. In addition, many digital cameras allow you to include a sound bite from the person you have photographed.

However, a manual 35-mm camera may have the advantge over a digital type in extremely remote or testing locations, since they tend to be more robust and less dependent on batteries.

Candid shot

The Himba take great care with their appearance. Lost in conversation with other women of her tribe, this woman idly rearranges her intricate hairstyle, unaware of the camera's presence. Taken from relatively close-up, the very long focal length threw a great deal of the background out of focus.

An outside eye

Mundane activity can appear exotic to outside eyes. For these women (above), a long walk is required just to fetch water. The day I took this shot there had been a lion attack on a cow near the village. In light of this, they decided it would be too dangerous to wait and make the trip at their preferred time of dusk.

Careful framing

The cool of dawn is the best time to milk the cows. An early start gave me a chance to combine portraiture with a record of an aspect of daily life. A wide-angle lens brought the subject elements together, but I took care not to place the woman's face too close to the edge of the frame, in order to avoid any distortion.

Ecotourism continued

Close framing

At the water hole, the girls of the village take a moment to relax and joke with each other. Framing the shot tightly cut out the glaring white light of the desert landscape.

Lighting contrast

Long shadows from the distant hills darken the foreground while the sun turns the background a flaming orange.

A professional approach

Even if the pictures you take are simply for your own enjoyment, a professional approach helps to ensure that you do not neglect to record some vital aspect of your visit or run out of film or memory cards.

- Bear in mind the basic story-telling elements of a picture story: the roads leading to and from the park help give your other images a context.
- Vary perspective and viewpoints as much as possible. Take close-ups as well as long views; wideangle and telephoto shots.
- A choice of landscape- or portrait-format images gives you design flexibility if you ever want to produce publicity material.
- Take plenty of photographs whatever the conditions: you may be able improve the images (on the computer) even if the lighting or weather was less than perfect.
- If your digital camera can take short video sequences or voice recordings, don't neglect to use the facility.
- Take ample spare batteries and memory cards for a digital camera.

Close-up photography

Close-up photography used to require special equipment, but digital cameras have changed this. Not only is it common to be able to focus with the lens nearly touching the subject, the use of LCD screens giving a "through-the-lens" view allows all but the simplest models to focus close-up.

Points to consider

The main technical points to take into account when shooting close-up are:

- Depth of field is limited (see pp. 74–7), and it is all but impossible to include all of a subject within sharp focus. The best strategy is to focus critically on the most important part of the subject.
- Subject or camera movement is greatly magnified when working close-up. You will need to steady the camera and the subject to prevent blurred imagery. Flash, which delivers an extremely brief burst of light, can be used to reduce the effect of camera or subject movement.
- A reasonable working distance is needed with subjects such as birds or butterflies to avoid disturbing them. This requires the use of a long focal length—ideally, a 35efl of 180-200 mm.
- Automatic flash may be unable to respond quickly enough to light reflecting back from the subject, resulting in overexposure. To combat this, reduce flash exposure via the flash controls, set the flash to manual (see right), or cover the flash head with translucent material.

Close-up photography needs more care than when working at normal subject distances. To achieve the best results, you need a digital camera that allows apertures to be manually set and that has close-up focusing at the long end of the focal length range. Generally speaking, the cameras that feature these close-up-friendly facilities are good-quality digital SLRs.

Manual flash exposure

Using flash set to manual delivers the most accurate and reliable results when dealing with close-up subjects. You need to take four variables into account: the power of your flash; the working distance; the speed of your film (or sensitivity of your photosensor); and the effective lens aperture at the working distance. First, set your flash unit manually to low power say, to 1/2 of maximum. Next, focus on an averagely reflective subject at a fixed distance from the camera—for example, 10 in (25 cm) away. Now make a series of exposures, changing the lens aperture each time, and carefully note all the settings used. Repeat this procedure at different subject distances and flashoutput settings. Review the results on your LCD screen or after the film has been processed. You can then draw up a set of figures for different situations—such as 1/2 power at 10 in (25 cm) at a lens aperture of f/5.6, or $\frac{1}{2}$ power at $\frac{1}{2}$ in (1 cm) at f/8, and so on.

Safety first

Although this seal looks relaxed, I did not care to take the shot with an ordinary lens. In fact, I used a zoom set to 400 mm, and note how the shallow depth of field limits the zone of sharp focus. I decided that the snout and whiskers were the elements I wanted sharp and so focused specifically on them.

Close-up photography continued

Approaching butterflies

Butterflies (left) have excellent vision and easily spot your approach. Using a long-focal-length lens will help—here the equivalent of 180 mm for 35 mm because you obtain higher magnification from a greater working distance compared to a shorter focal length. Using an image-stabilized lens or camera helps ensure sharp images, but you always need to focus critically.

Photomicrography

Extreme close-ups, as in this view of animal tissue (right), require a microscope. Modern, lightweight digital cameras are easy to link to laboratory microscopes as long as you have an adapter tube and mounting system, which are readily available from many camera stores.

Natural history

The most common subject for close-ups is plant life. Here, it is the droplets of moisture clinging to the foliage that make the picture. By observing the subject from various positions, it was possible to see the reflected sparkles in the droplets change. But take care not to disturb the plants and disperse the water droplets by approaching too close.

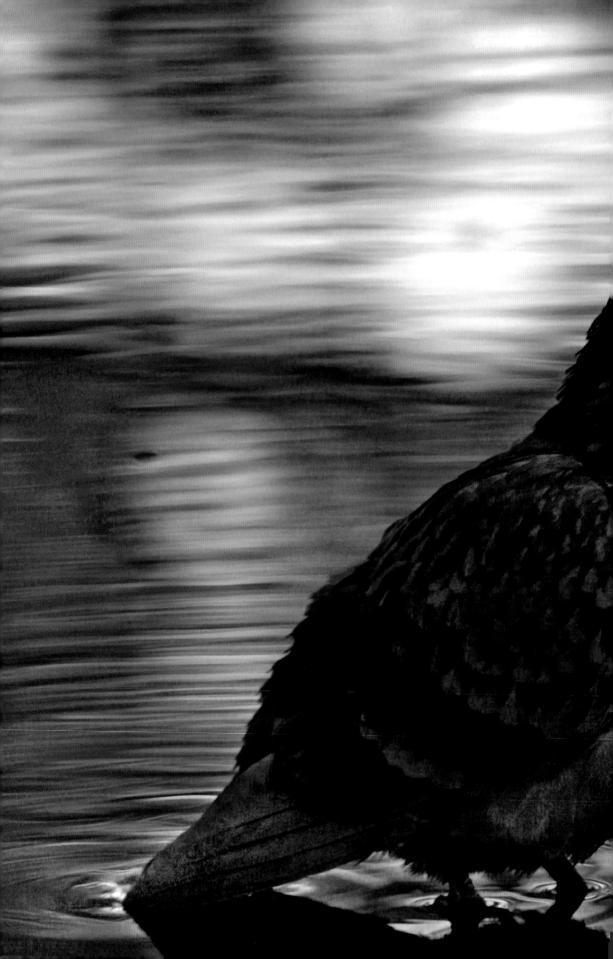

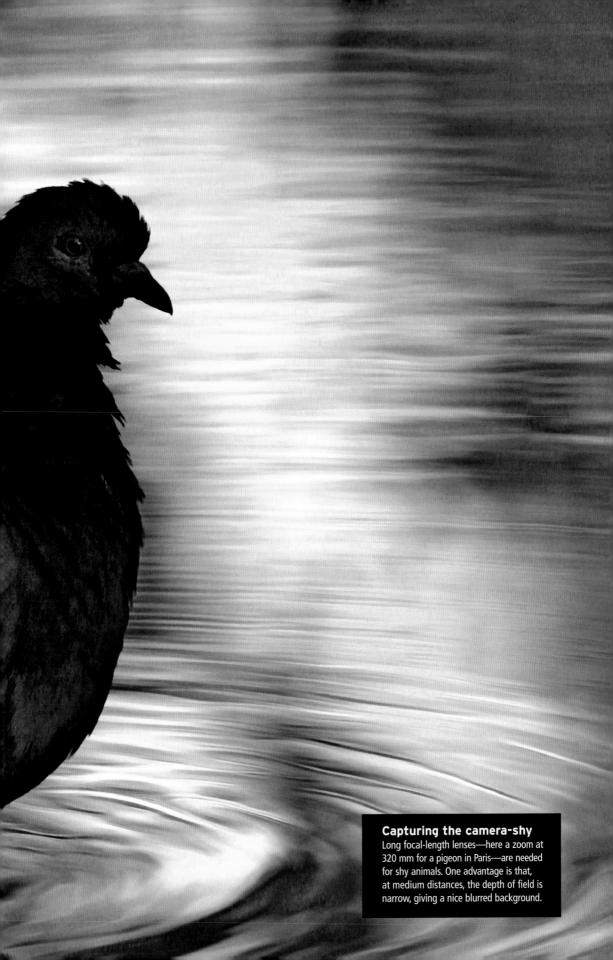

Vacations

The challenge when photographing a vacation is to avoid the obvious while making a record of the events you may wish to remember in the years to come. Another challenge is to lift your images from the strictly personal—snaps that are of interest only to friends and family-to a level where they have a wider appeal.

Themes and subjects

One project idea that takes you away from the obvious monuments or museums could be something along the lines of street traders or local cuisine. Depending on your own interests, you might find that pictures of street food bring back the memories of a place far more vividly than, say, the facade of some neoclassical public building. And by working digitally, you have the ability to review an image as soon as you have taken it and decide whether or not another shot is needed.

Attitudes and approaches

It is simply good manners to take into account the sensitivities of the people in whose country you are traveling. It is their religion, customs, and attitudes to which you will be exposed, so treat your hosts' country with the same respect you would expect of tourists in your country. As a start, dress in a style that is appropriate to the cultural or social expectations of the country you are in. And don't insist on taking pictures of people if they wave you away or seem unhappy about it.

Local culture

Food shots can be colorful and memorable—food is an essential part of any vacation, and negotiating a purchase can be part of the fun. But don't record only the food or some artistic arrangement of produce-including the vendors in the shot increases the challenge and can give rise to more interesting and livelier pictures.

Changing emphasis

Even when the weather is less than perfect, the observant can always find picture opportunities. In this view of downtown Auckland. New Zealand, rain from a storm beats on the windows of an observation tower. It is usual to focus on the distant view, but by concentrating on the raindrops the scene shifts, and suddenly there is a picture to be made.

Securing your equipment

A potential problem on vacation is the tension that can exist between the vigilance necessary to take care of your equipment and the desire to relax and enjoy yourself. These points may help:

- In a hotel, make full use of any safe or security boxes that may be available. Sometimes these are provided in your room, sometimes at reception.
- Make sure you lock your luggage while you are out of your room.
- If you have to sleep during a long wait in a train

or bus station or airport lounge, set a battery-powered alarm (that beeps if it is moved) on your bags.

- Stay in the best-quality accommodation you can afford—you are generally more at risk from theft in cheaper hotels or apartments.
- Use physical restraints (bolts or chains, if provided) to secure your door when you are in.
- Insure all your camera equipment and accessories before departure for their full replacement amount. Rates vary, so obtain two or three quotes.

Vacations continued

Ever ready

You may find interesting or strange images being created for you if you stay alert. When some villagers in Turkey borrowed my sunglasses, a child on his mother's arms wanted to try them on-and suddenly there was an image to be had (above). Tight framing left out the clues that would make the picture easier to read, making the image a little more intriguing.

As the photographer, you may find yourself slightly apart as your search for pictures takes you away from the group. Here, walking up a hill from this beach in New Zealand rewarded me with a fine view of reflections of figures in the ebbing waters and wet sand.

Journeys and travel

What distinguishes a journey from a vacation is that on a journey it is the total trip, from beginning to end, that counts: in other words, the entire traveling experience supplies the challenge, and the fun, rather than just the destination.

Moving platforms

Photography from a car, bus, or train does not offer much opportunity for sharp, wellconsidered images. Nevertheless, it is worth taking the odd shot showing the countryside passing in a blur in order to record something of the experience of being there. It is better to try for a shot of a marvelous view than spend the rest of the journey wondering if you missed something special. And if it does not work, with a digital camera you can always delete the image.

For the best results when shooting from a moving platform, use a wide-angle lens, but avoid including too much of the foreground. The phenomenon of movement parallax means that the foreground appears to move much faster than objects in the distance, and it is impossible to render the foreground sharp—even at moderate road speeds. The use of an image-stabilized lens (see p. 84) can be of considerable help.

Remember that the windows in buses are often tinted—even if the view looks neutral in color, if it is slightly darker than clear glass it will surely tint your images. Digital cameras may fare better than film-based ones in this respect, since the automatically adjusted electronic white balance may be able to compensate for any tint.

Traveling companions

If you are traveling in a small group, you will almost certainly want to stop the vehicle whenever you see something promising. If your traveling companions are not sympathetic to your photography objectives—and even if they are continually stopping and starting can become tiresome. You will, therefore, need to develop a sense of when something is really worth screeching to a halt in order to photograph.

Watch the changing views as you progress through the countryside to anticipate where a good viewpoint might be. However, bear in mind that what you see from, say, a bus or a four-wheeldrive vehicle is from a higher viewpoint than road level: this difference, though small, can introduce an obstruction or cut off important foreground information.

Evocative imagery

Few things are more evocative of long distances than seeing the receding parallel lines of railroad tracks. With the foothills of the Tian Shan range in the background, these tracks offer a shortcut to the local people in Uzbekistan. You have to balance the need to show a long stretch of track with the size of the people on the line. Other pictures I took at about the same time showed the figures as being far too small to have much of an impact.

Journeys and travel continued

Vehicular interest

When you reach important stages in your journey, don't forget to include your most important companion—your means of transport. Here, after two months on the road, on a beautiful day we reached Mount Ararat in Turkey. A wide-angle lens at minimum aperture captures the car on the road as well as the not-so-distant snow-capped mountain.

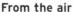

Photographers travel the greatest distances by air, yet they rarely photograph the landscape from this unique perspective. By staying alert, you can catch fleeting moments such as this—as the aircraft banked for its final approach, it caught a flash of sunlight reflected from a car down below. This brings the scene to lifeand it could be a road you will be traveling on after touchdown.

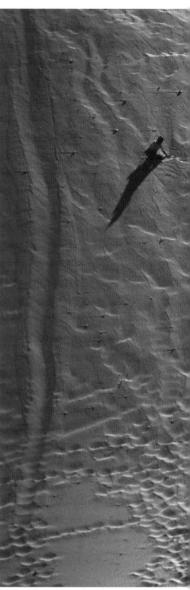

First things first

A large spring in the middle of nowhere (right) is irresistible after a hot, dusty day bumping along on the dirt roads that crisscross the Kenyan savanna But you have to resist the urge to jump in with all your clothes on-first, you must grab your picture, remembering to get your transport in view... then you can join the others.

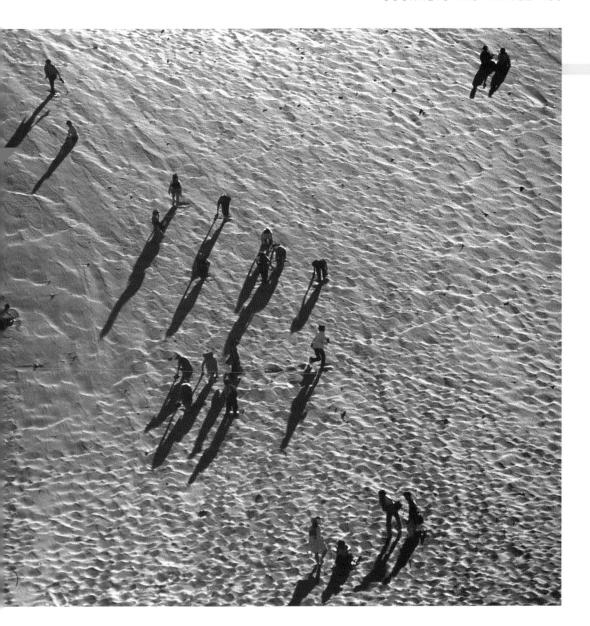

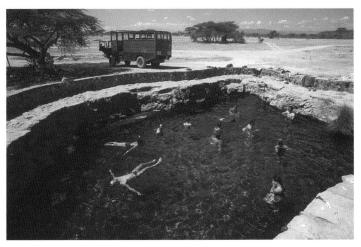

Dunhuang dunes

A favorite spot for tourists visiting Dunhuang in eastern China (after viewing the great grotto art) is to climb the giant sand dunes, from where a great sweep of countryside is visible. Rather than climb the dunes with everybody else, you should look for a different angle: only then will you be rewarded with a shot that is unique.

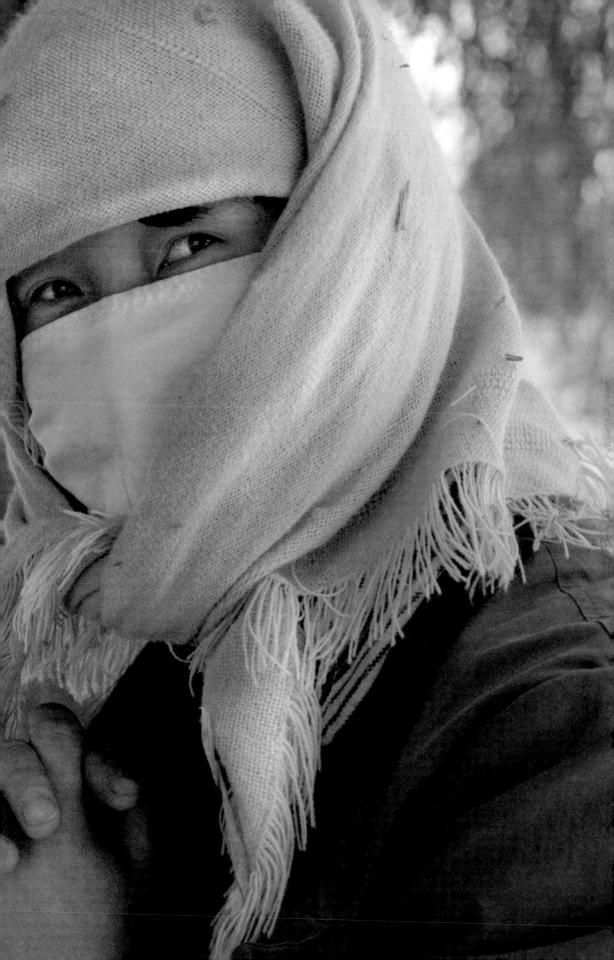

At home

It is a mistake to think you have to travel to foreign lands to find subject matter for your camera, when one of the richest veins of photography is in your own home. The secret lies in opening your eyes to the possibilities all around you.

Approaching the familiar

The trick is to carry a camera as you move around at home. The camera will remind you to keep alert, to look for a fresh approach to the ordinary and the familiar. For example, one day the sun may shine from precisely the right angle to light up a particular corner of your kitchen, or there may be one time of day when a reflection from a neighbor's window spotlights your bedroom dresser. Resist the temptation to straighten up: cluttered table tops, ruffled cushions, or discarded clothing can all help to evoke a specific mood.

Whether you work in color or in black and white affects the character of your images. Color can impart a documentary, objective tone, while black and white may mask some of the chaos most of us tend to live in, transforming clashing colors into harmonious monotones.

Indoors, light levels may be low, so think about using a tripod to steady the camera during long exposures—especially if you wish to set a small aperture to maximize depth of field (see pp. 74–7). With digital cameras, bear in mind that long exposures result in "noisy" pictures, though some models have a setting for removing this interference. Some cameras set a higher sensor "speed" when they detect low light levels: this also tends to increase noise (see pp. 250–1). But turn off the automatic flash unless you specifically want this type of lighting effect.

Once you begin to realize the potential that surrounds you, you may start to see your immediate neighborhood in a different light, perhaps appreciating better the nature and character of your area. And this is excellent training for travel photography (*see pp. 161–3*).

Chance lighting

Only at rare times did the sun catch this chest of drawers at precisely the right angle—fortunately, just after the children had added their personal decorative touches. Working in black and white helps to control the high subject contrast that often results from this type of directional lighting.

Garden still-life

A week of summer growth between the coils of a hose and a child's beads create a riot of texture and contrasting shapes. But the coils of the hose and plants also organize the image into a satisfying, rhythmic composition.

Chair

This image was captured one morning before I had to rush off for an appointment. It was the only shot I took, and it is not about precision of composition or arranging subject elements—it is simply an exercise in responding to the moment.

Children

The photography of children falls into two main areas of interest—images of family and friends, or pictures taken when traveling abroad. We tend to photograph our own children, or children with whom we have some sort of relationship, in a very different way from children living in other cultures. The prime reason for this is that our approach to the "exotic" is one we are reluctant to apply to the familiar. For example, when overseas, the fact that a child is dirty or is wearing ragged clothing may be the very features that attract our photographic interest. We may be proud to show this imagery highlighting the different and unfamiliar to friends or colleagues, yet we would be reluctant to show our own children in anything but a favorable, "sanitized" light.

A change of attitude

So the challenge is clear: we must find a way to bring the two approaches together, to show more honesty in the photography of our own children while showing more respect in our representation of children from other cultures. For example, when you are traveling, you could try to learn about the games that children play: do they have rhyming games in Mongolia; do the children of the Philippines play "catch"; which version of soccer do they play on the beaches of Zanzibar? Another approach could be to show children from other cultures in roles that might be largely alien to our own-such as working in the fields or factories or active in religious observance.

In the end, by deepening our involvement, we increase our understanding and enjoyment of our subject, thereby giving our photography a most exciting and rewarding edge.

Selective view

Ostensibly, this is a study of contrasts-between the baby's hands and those of his grandmother; of colorful clothes against tanned skinbut this selective view also removes the viewer's gaze from the child's grubby face.

An even closer approach, to concentrate attention on, for example, the lower part of the image, might have been even more effective.

Trust reveals personality

A child needs to trust you before you can enter his or her personal space. The close-up is the best way to record a sense of the child's personality and world. There is no need to capture the entire face: concentrate on the expressive eyes and mouth to create a concisely evocative image.

A candid approach

A large fountain in hot weather is irresistible to children anywhere in the world. The problem here was trying to photograph the boys without their realizing it—otherwise they would start playing to the camera. I mingled with the crowds, enjoying the sun, and waited for a suitable grouping and rare moment of relaxation. Then I raised my camera at the last moment and grabbed the shot.

Children continued

Suitable framing

Without the stark framing, this would be a well-lit, uninteresting image. But the frame not only helps the composition, it also gives us clues about where these boys live. With the hay just

visible, this must be a farm. A second before shooting, the standing boy's face was lost in shadow, but I could not focus and shoot quickly enough.

HINTS AND TIPS

Children can be a challenge in technical terms, since they are small, low down, and move quickly. They require stamina and fitness on the part of the photographer, as well as quick reflexes. You can help yourself by trying out these techniques:

- With very small children, work at a fixed distance: focus your lens manually to, say, 18 in (0.5 m) and keep your subjects in focus by leaning backward or forward as they move. Small children move very quickly but usually only over short distances. This method requires little effort and can be superior to relying on autofocus.
- When you first photograph a group of children, fire
 off a few shots in the first minute—they need to get
 used to the sound of the camera or light from the
 electronic flash, while you need to exploit their short
 attention span. Once they have heard the camera

working, they will soon lose interest and ignore you. If, however, you wait for them to settle down before taking your first picture, they will be distracted by the noise.

- For professional photography of children, the best cameras to use are digital SLRs or manual film-based cameras. These give you more flexibility than ordinary digital cameras or autofocus compact types. You need the shortest possible shutter lag (the time interval between pressing the shutter and actually recording the picture) if you are not to miss out on the really spontaneous images.
- In low light, try using faster film or increasing the photosensor's sensitivity rather than setting the lens's maximum aperture. With non-professional lenses, you lose more image quality through using large apertures than from the grain given by higher-speed recording.

Landscapes

The natural landscape is one of the most accommodating and challenging areas of photography. The land simply lets you photograph it from any angle, at any time, and in any weather, but you must work to find the ideal viewpoint.

There are three essentials of landscape photography—place, time, and means—but the most crucial of all is place. And it will do you no good at all if you have an original approach to landscape in mind, but have not learned how to find just the right position from which to depict the place. To discover the perfect position, you cannot rush at it, hoping it will be obvious once you get there. Once you see a view that is promising, you need to slow down completelyeven put your camera away. Then just walk and look, walk a little more and look a little harder. That is all there is to it.

Foreground interest

One of the most effective techniques in landscape photography is to make confident use of features in the foreground. Here, in New Zealand, a spider's dew-laden web catches the early morning sun, and so frames the landscape beyond. By using a large aperture (small f/number) the depth of field was limited, so even in this wide-angle view the background is blurred and soft to blend into the mist.

Polarizing filter

The hallmarks of a picture made through a polarizing filter are the deep blue of the skies and, if any water is visible, a lack of reflections. In this image of Samburu, Kenya, the dark stones at the bottom of the pool are clearly visible because the polarizing filter has removed reflections of the sky. Also, colors in the reeds were intensified because the filter removed the partial reflections that degrade color saturation.

Landscapes continued

Leading the eye

A landscape photograph does not need to feature the sky or be shot with a wide-angle lens. This scene in New Zealand was taken with a zoom lens set to a 35efl of 600 mm in order to lead the eye to the masses of variegated greens and the patterns of tree trunks. It is a scene that could easily be turned into a painting.

Selective emphasis

The scene was simple enough and its promise was clear, but finding the right position to photograph this half-empty reservoir in Hong Kong took many minutes, thanks to restrictions on access. Since the day was dull, there was little choice about lighting, so I had to shift my attention to shape and the balancing of tonal masses.

Polarizing filters

One of the most popular (some would say essential) accessories for the landscape photographer is the polarizing filter. This is a neutrally dark glass filter on a rotating mount. When fixed on the front of a lens pointing away from the sun, then rotated to a certain angle, the filter has the effect of making blue skies appear dark. This is because most of the light from a clear sky vibrates in a narrow range of angles: however, a polarizer passes light that is vibrating in one direction only and blocks all the others. The polarizing filter is an

effective way to reduce the luminance range of a scene, but it works most effectively when the sky is already blue (and so is darker than sky with diffused cloud), when it can cause over-darkening. This filter is best used on an SLR, where you can see any changes through the viewfinder. Modern polarizers should be of the circular polarizing type. Don't be tempted to use linear polarizing filters—although they are less expensive, they cannot be recommended for most modern cameras since they render autofocus and some metering systems inaccurate.

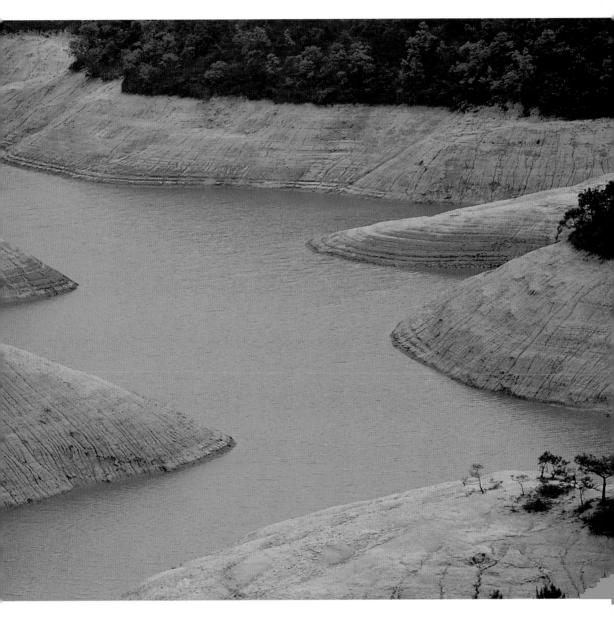

Dawn mist

Landscape photography may seem leisurely, but often you have to act quickly. Driving out of Auckland airport,
New Zealand, just after dawn, this mist-shrouded scene presented itself. I knew that it would evaporate quickly, so I jumped out of the car and raced back down the road to record it. Just seconds later, the rising sun masked the delicate hues in the sky and the mist thinned.

Seizing opportunities It is easy to give up on rainy days and miss the 2 minutes of sunshine. To capture this image in the Zerafshan of Tajikistan, I needed to move quickly; a few seconds later, the rainbow was gone.

Mirrors

Reflective materials are wonderful for photography. As well as mirrors themselves, any shiny surface—metalwork in buildings, glass windows, the shiny parts of cars, or a body of still water will reflect the surrounding scene and add a new dimension to your work.

Practical concerns

One problem when photographing mirrors is that you can find yourself included in the image. Unless you are prepared to buy a special, and very expensive, shift lens (see p. 35) —which allows you to stand to one side and then shift the lens to produce a "head-on" view—you will have to adopt an angled shooting position.

Another problem is that the depth of field required may need to extend from the near foreground to any distant view visible in the mirror. You could use the smallest lens aperture available, but on digital cameras this is often very limited. In addition, lens performance at the smallest aperture may fall below acceptable levels.

A digital approach is to take two images and fuse them later: take one of, say, the foreground and mirror frame at one focus setting; then take another, altering focus to obtain a sharp reflection. You may have to enlarge the reflected image slightly to make it fit perfectly in the mirror frame.

Making reflections disappear

You can make some reflections disappear by exploiting the fact that light reflected from most surfaces—but not metallic ones—becomes polarized. By attaching a polarizing filter to the lens and rotating the front element, some, if not all, reflections from, say, windows or wate, will be removed. This technique is very valuable when photographing water when you want to see any fish that may be near the surface. Polarizing filters are also handy for improving the color saturation in a scene, since they remove many of the partial reflections that reduce color brilliance.

Urban farm

A backyard in Tokyo has taken on an esoteric appearance by including a mirror, which seems like the entrance to a parallel world. A short wait

for the animals to arrange themselves was needed to complete the image.

Traffic mirror

The traffic mirrors used to help car drivers see around blind spots make an interesting subject. This example, in Cambridge, England, was ringed with red spots, which glowed brightly when illuminated by the camera's flash.

Mirror mall

One of the disadvantages of digital cameras is their inability to take truly wideangle shots. In this image of a shopping mall in New Zealand, I felt even the 17-mm lens, with its 104° field of view on a 35-mm camera, was insufficient to convey the sense of unending virtual space caused by the narrow gap between precisely aligned mirror walls.

Repeated imagery

The reflections of offices in the mirror-windows of another building offer many possibilities for the digital photographer—the image looks manipulated even before you have worked on it in the computer. Here, in Leeds, England, the new and the old in architecture come together, but-apart from the photographer—it is not entirely clear who benefits from the union (see also p. 142 for another treatment of this image).

The naked body has been a favorite subject with photographers from the very beginning, and all the techniques applicable to film-based photography apply equally when you are working digitally.

Technical considerations

The main objective is to control lighting contrast to ensure that the subtle transitions in tone that guide our perception of the human form are not lost in heavy shadows or empty highlights. The best way to ensure this is to use a single, simple light source—preferably one that is large and diffused. For example, hang a sheet over a window to diffuse incoming daylight, or direct studio flash into an umbrella reflector. To lighten shadows, use a reflector, such as a white card, to direct extra light where it is needed.

Another approach is to soften the image. Generally, the rule is, the sharper the better. Too much sharp detail in images of the human form, however, tends to brings out minor skin features. Working digitally, you can always soften detail using filters and other techniques. Another softening technique is to throw the subject out of focus. However, in many digital cameras, manual focus adjustment is limited.

Observing local laws

One of the most rewarding ways of photographing the nude is in the natural environment and in exotic locations. But while that beach in some far-off land may look empty, or that carefully selected desert oasis may seem private and secluded, you still need to take all reasonable precautions to ensure that you are not observed by casual passers-by and that you do not fall foul of local laws or upset local sensibilities.

If you are shooting in a country you do not know well, it is advisable to consult local tourist offices, local guides, or prominent local officials to find out what the law is and what reactions are likely to be.

Do not keep a memory card containing nude pictures in your camera when traveling through Customs or other inspection points. If anyone checks the camera's operation—routine when security levels are high—they may inadvertently see the pictures. At best this will be embarrassing; at worst you could face delays and questioning.

Camera as observer

Formal posing sessions are not always necessary or even the best ways to work with a nude subject. You might ask the model to perform an everyday activity, such as bathing, drying, or dressing; the natural gestures that result can be far more intimate, revealing, and real than the most carefully constructed pose. Here, the model, seen through a gauze of netting, is simply pinning her hair on top of her head.

Dawn light

A simple setup of mosquito netting and a bed lit by a rising sun provides a range of photographic opportunities. The warm-colored light from the early morning sun has bathed the subject's body in a golden glow, while the light-diffusing quality of the intervening window keeps image contrast under control.

Diffused imagery

By focusing on the mosquito netting, the form of the figure was not only softened, but skin tones have also blended with the color of the netting to produce an image in which texture and shape work harmoniously together. Since the zoom was set to wideangle, the widest aperture was needed to limit depth of field so that it did not extend to the figure. For this style of work, an SLR-type camera is invaluable, as you can make an approximate check on the depth of field in the viewfinder before shooting.

Nudes continued

Shifting viewpoint

The easiest place for nude photography is in the privacy of your own home, but bear in mind that too much clutter and detail in the surroundings will take attention away from your subject. You can reduce the effect of these distractions by your careful choice of viewpoint. A low viewpoint (above left and left) explores a composition dominated by lines resulting from the walls, blind, and the subject's own body. A high viewpoint (above right) ignores the room altogether and works with the body on the bed-here, a pattern of light adds vital contrast without which this shot would lack tension.

Bird's-eye views

It is still a novelty to see pictures of familiar landmarks taken from the air or from the tops of tall buildings. The bird's eye view afforded by an elevated shooting position often produces images with no clear orientation – turning your head one way or another gives more or less the same view. However, choosing how to orientate the camera, so that the resulting hard-edges of the picture frame relate to the picture content, is vital.

Technical considerations

The most effective focal lengths are in the midto wide-angle range - it is rare to use a long focal length, particularly from an aircraft due to the effects of vibrations through the airframe and the problems associated with shooting through the thick windows.

A large aperture is the preferred setting, as this allows you to set the brief shutter times needed to prevent camera shake. However, the contrastlowering effect of shooting through a large volume of air means that you will want to use your lens at its optimum aperture, to give the most contrasty image. Another measure for improving image contrast is to use a haze or UV (ultraviolet) filter. Exposure is generally straightforward as most scenes resolve into an average range of brightness. Slight underexposure with color transparency film helps increase color saturation and reduce the impact of haze.

Ideal times for aerial photography are early morning and early evening, when the sun is low and shadows long. When arranging a flight, ask for a pilot experienced in working with photographers. A good pilot knows how to bank at the right point to give you the best downward view.

Aerial spectacular

On long-haul flights, you can catch some breathtaking sights. Look out for views such as this-a river emptying into the sea while plumes of smoke are caught in the light of a setting sun. In this situation, when, because of the speed at which you are traveling, you

have mere seconds before the lighting changes, measure exposure by taking a spotreading of, say, the cloud of smoke. If your digital camera does not have this facility, try bracketing exposures instead.

Bird's-eye views continued

Appropriate view

Large-scale events—such as the massed runners in the Paris marathon (right)—make an interesting composition when seen from a high viewpoint. I experimented with a view that showed the competitors running alongside the Seine River, but I prefer this shot, in which each runner has his or her own space and is easily distinguished from the others.

Proper context

Rather than aiming their boat straight downstream, which would have produced a boring image from my viewpoint, this young crew was rowing at an angle to the current. Their inexperience allowed me to frame the shot to show a distant slice of riverside development, and so give their boat a proper context.

Optimum aperture

If you examine very carefully the quality of enlarged photographs from different lenses as you change the aperture from maximum (widest) to minimum (smallest), you will see a common pattern emerging. As you close the aperture down from maximum, lens performance improves, with images displaying more contrast and sharper and clearer details. Then, at a certain point, image quality drops off as you set yet smaller and smaller apertures. In other words, there is an aperture setting that gives optimum performance. Lower-quality lenses produce acceptable images only at this optimum aperture, while high-quality lenses produce acceptable images even at maximum aperture. The optimum aperture is commonly two or three stops smaller than maximum—in top-quality lenses, the optimum aperture may be as little as half a stop smaller than maximum.

Balcony view

Nearly overawed by the privilege of being invited into an ancient synagogue in Uzbekistan-a secular Muslim country—I almost failed to notice the balcony above my head (right). But having seen it, I knew I had to go up and view the service from above. Thus, I obtained this panoramic view of a holy place, but it is also a view that, sadly, makes obvious the diminished number of worshipers.

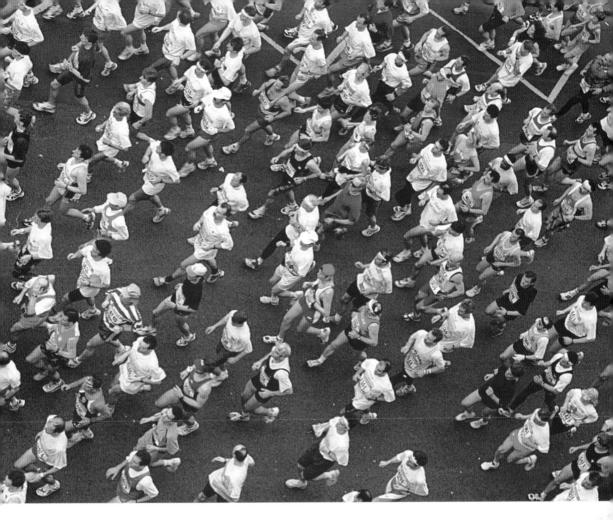

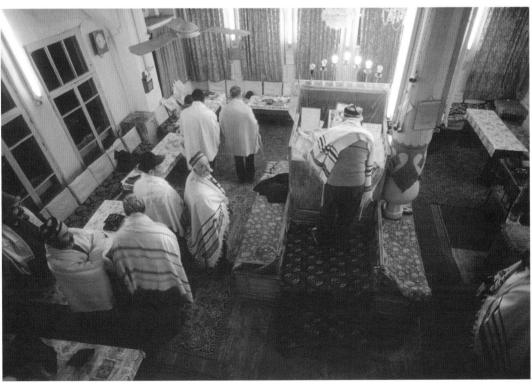

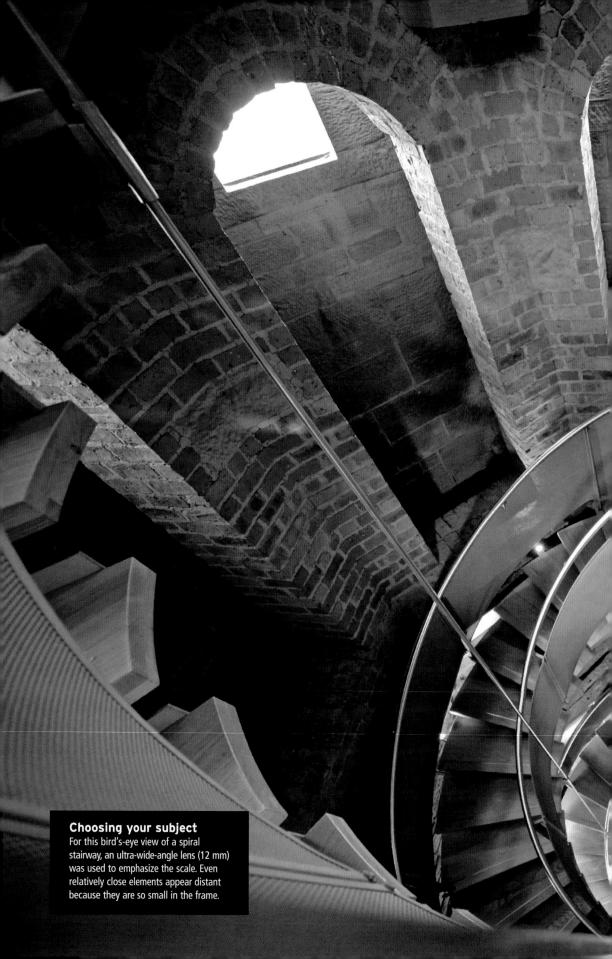

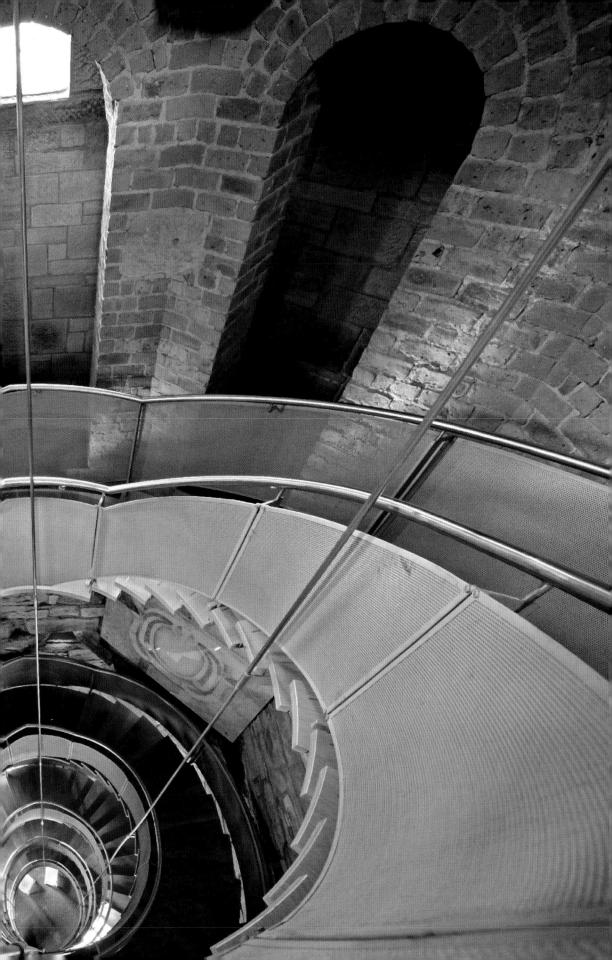

Pets

A common error in pet photography is to concentrate on an animal's face or depict it by itself, without any context. If you can detach yourself from the situation, evaluating it in terms of its visual interest, any resulting image is likely to be more successful. If, however, you produce images very personal to you, don't then be surprised if they fail to engage a wider audience.

What to look for

Broadening out this area of interest to include the study of relationships between people and their pets can make a fascinating subject for the camera. The challenge lies in finding original or illuminating approaches to the subject.

A straightforward portrait of a pet and its owner is rarely likely to be of interest to anyone but the owner and his or her family. However, through the careful choice of lighting and selecting the right moment to shoot, you can produce an expressive image with wider appeal.

Pets are notoriously tricky subjects for the photographer to deal with. They certainly do not respect your wishes—in fact, it often seems that they know precisely what you don't want them to do, and then willfully do it. Above all, successful pet photography requires endless patience and quick reflexes.

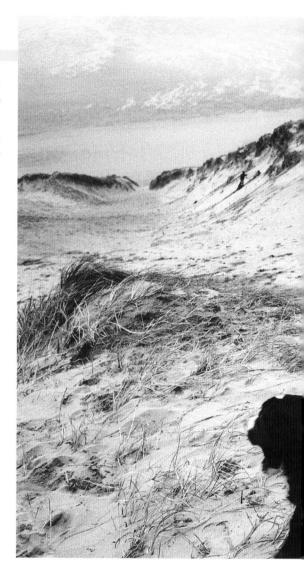

Sociable cat

Harmony of tone and hue come together in this image with contrasts in texture and line. But it is only a friend's cat being sociable and wanting to sit between us. As a digital photographer, you can take as many shots as you like and simply discard the unsuccessful ones. You can tidy them up, too: here, the boards could be straightened a little and the object near the tip of the cat's tail could easily be removed.

Quick reflexes

A cold, windswept walk on the beach may not seem to be the most promising subject for photography, but for a split second a picture opportunity presents itselfand you need to stay alert to record it. Here, the dogs not only appear to blend with the tones of the beach, but also seem to be responding to the contours of the landscape. The original color image was turned to black and white, then tints were added to suggest the natural colors.

Animal friend

Not only is a pet's favorite person ideal for keeping the animal still, but, as in this example, she can be the subject of the portrait, too. In this image, all the colors are soft and muted, so there is nothing to conflict with the delicate shades of the guinea pig.

Professional service

Pet owners wanting professional portraits of their animals can provide a good source of work for the digital photographer. The advantage of working digitally is that you can not only offer unaltered, "straight" images, but also easily supply any of the huge number of variations available via your imagemanipulation software. Another advantage of digital technology is that you can shoot a number of images and then show them immediately to clients on a television screen or computer monitor. This allows them to select the ones they want on the spot, thus saving you the time and expense of processing films and printing proof sheets.

Project ideas

Exploring the relationship between this horse and its field could be a project in itself. Imagine this scene with blue sky or at sunset—already you have three very different images.

Simple shapes like this make excellent greeting cards, or the clear area of sky of this version could also feature advertising copy.

HINTS AND TIPS

- Find out at which time of the day the animal is normally at its quietest. Consult the owner about when it is best to photograph the animal—it may be just after feeding time, for example. However, cold-blooded animals, such as snakes, frogs, and lizards, are quietest when the surrounding temperature is low—so dawn may be a good time.
- Find out what the animal likes. It may be calmed down by music or by being allowed to play first and let off steam. A hungry animal may be bad-tempered, but one that has been recently fed may be frisky and want to play. Again, consult the animal's owner.
- Is it likely to be startled by flash or the sound of the camera? Check with test firings of the flash at a distance before you approach within striking distance. Some animals may also be disturbed by the high-pitched noise of autofocus mechanisms—which you may not be able to hear—or by the sound of a motordrive.

- Always move smoothly and steadily and make no sudden noises. Avoid positioning yourself behind an animal, where it cannot see you.
- To keep your distance, use a longer focal length than usual. An extension tube (a ring of metal that sits between the lens and camera) or a close-up lens added to a long focal length lens enables you to focus much closer, but you will then have to work within a limited depth of field.
- Let the animal be handled by its favorite person: it will be calmer and less likely to behave erratically or in an unpredictable fashion.
- To keep the animal in focus as it moves around, try manual focusing. Keep the animal within the depth of field by changing your position as it moves, thus keeping a constant distance between yourself and the subject. This is often easier and less tiring than constantly making small focusing adjustments.

Sports

Sports photographers were among the first to recognize the competitive edge digital technology could give them in the race to get pictures of dramatic sporting moments into newspapers and magazines. With no film to process, images could be transmitted down the phone line directly to the picture desk. Minutes after a home run is hit, the image can be with a picture editor on the other side of the world.

Digital photography also offers advantages for the more casual sports photographer. You may, for example, be asked to make prints of winners and team lineups for friends or relatives—an easy task for digital cameras and inkjet printers. Many sporting clubs have their own website to attract new members and to keep supporters informed of events, and images for these—from the Christmas party to the regional tournament—are always needed; digital photography offers the easiest and least expensive way to provide them.

TRY THIS

Sports photography does not have to be confined to the sporting activity itself. A less literal approach to the subject could lead you to document the fans—their faces and what they wear—or you could try making a record of behind-the-scenes activities—preparation for games, the lives of the support staff, or what the event is like from a referee's perspective. By applying your imagination and knowledge of the sport, digital photography can open avenues of discovery about your favorite sport that might be closed to ordinary fans.

Behind the scenes

Photography of sporting activity can not only include the highlights of the action, but also give some sense of the hours of instruction needed to learn a skill. Here, a sensei, or teacher, demonstrates an arm lock in the repertoire of Goju-ryustyle karate.

Sports continued

Concentration

One of the difficulties with sports is that with so much happening in the background. it can be hard to concentrate on the foreground action. Here, a busy background did not intrude into the main subject-a karate student being tested for tension—due to the exposure difference that allowed the background to be underexposed. In addition, the use of a large aperture limited depth of field to the foreground figures.

Know your sport

The better you know a sport, the better able you will be to anticipate the action—you have to be almost as alert as those involved in the freestyle sparring taking place here. A blow can be delivered and retracted in a split second: not only do you have to respond, so does the camera—so you need to anticipate the action by small fractions of a second.

Shoot what you need

Here, during freestyle sparring, the attacker has succeeded in momentarily trapping the right hand of his opponent. Unfortunately, in the next instant, the duelists turned and obscured the action. One advantage of a digital camera is that you can shoot as many action sequences as you need and later discard those that are useless, without worrying about wasted film.

Creative blur

Great sports photography is not just about showing the game. Only those who have taken part in a sport really know what it feels like, but we can use whatever photographic techniques are available to us to show something of the spirit. A relatively long exposure-1/4 sec-blurs the action, but it takes many attempts to find an image that balances blur with discernible shape.

HINTS AND TIPS

The essence of the sports photograph lies in choosing the right moment to press the shutter. A split second represents the moment one tennis ace turns the tables on another, or one misjudged tack separates the winner of the America's Cup from the also-rans. The strategy for sports photography is, therefore, constant vigilance to make sure you are in the right place at the right time.

- Allow for shutter lag: the time interval between pressing the shutter and actually capturing the image is usually at least 1/10 sec but can be as long as 1/20 sec.
- Keep safety in mind. In covering motor sports, there is always an element of risk for anyone involved—particularly photographers, who are often given vantage points that are close to the action. Don't

place yourself at risk unnecessarily, and be guided by the track or event officials.

- Position yourself carefully. Try to view the event from a point at which you not only have a good view of the action, but also from where your target is not moving impossibly swiftly.
- "Know your sport" is the best advice. Use your expert knowledge to aid your photography. As a race track becomes worn down, for example, do the riders take a slightly different route around it? As the sun moves across the sky, do the players pass the ball from a different direction to avoid the glare? In dry conditions, do race-car drivers take a corner faster than in the rain? Are you prepared for the changes?

Events

The key to successful photography at events such as carnivals, parades, or religious festivals is to undertake a little research beforehand.

Preparing for an event

If you are preparing to cover an outdoor event, get out and look over the route a day or two beforehand, if you can, to find likely shooting positions—in particular, look at where you might gain some extra height to allow you to shoot over the heads of the crowds that will be there on the day. A well-built, easily accessible brick wall might serve your needs; so might the first-floor window of a building overlooking the route (assuming you have permission to enter the property).

Preparation for an indoor event follows much the same routine. If possible, get to the venue in advance to familiarize yourself with the layout, bearing in mind that on the day, the vast empty space before you now could be a seething mass of enthusiastic participants. It could be that there is a gallery, which would give you a vital height advantage. If so, check with an official if that area

will be accessible and, if so, whether or not permission is required to enter it. In addition, pay special attention to where the windows are located—it is often better to shoot with the light coming from behind you so that the maximum possible illumination falls on the camera-facing side of your subjects.

Clearly, you need to prepare your photographic resources carefully—the middle of a festival is not the best time to find that you must return to your hotel room for extra batteries. You will need to bring ample supplies of film or memory cards so you do not have to return to base for top-offs or to download images. An advantage of digital photography is that all images have the time they were taken embedded in the file, which makes it easy to reconstruct a sequence of events.

Position is key

To avoid only a back view of these "Roman soldiers" at the Holy Week festivities in Mexico City, I managed to secure a grandstand seat. For low-light shots, don't spoil the ambient lighting with flash: set a digital camera to high sensitivity, or use fast film.

Plain background

Here, a white-washed wall in Mexico City provides a neutral background for the strong linear shape of the subject. This composition is, however, a little tight: it would have been better if the man's hand had not been cut off, but my fixed focal length lens did not allow fine tuning.

Amused onlookers

Sometimes it is worth getting the crowd, as well as the main event, into the shot. Here, the normally stern-faced police could not help being amused by the parade of "criminals" in the Passion Play reenactment.

Events continued

Camera viewpoint

In any large-scale festivity, there are often periods of waiting around and lining up—here, to receive a blessing. The difficulty lies in catching a momentamusing or revealing-or trying to obtain a strong composition. This shot (left), although striking, would have benefited from a slightly higher camera viewpoint or a greater concentration on a face.

Patience

Even in extremely poor lighting conditions, there is always a chance something interesting will happen. For a brief time, this line of junior "penitents" (above) in the Passion Play is well-lit by weak sunlight. To catch such a moment, it is essential to be able to move around freely to take advantage of the situation. It is also important to stay alert: this moment occurred toward the end of 12 hours under a hot sun.

Urban views

The urban environment sets challenges for the photographer that are similar to those encountered by landscape photographers (see pp. 171–3). There is, for example, the overriding need to find the ideal viewpoint, sifting through a multiplicity of visual experiences to arrive at that single one that stands for them all. Then there is the importance of timing and lighting. In addition, whether you are working in a town or in the country, you have to choose between the wide vistas or recording a more detailed view of your subject.

Technical considerations

Technically, there are differences between town and country photography. Pointing the lens a long way below or above the horizon in a landscape seldom causes obvious distortion effects, such as converging verticals, unless very upright trees are in view. In an urban setting, converging verticals are a constant challenge—whether to use them (easiest option), ignore them (seldom advisable), or correct them (requiring expensive equipment).

Depth of field is often a problem, too (see pp. 84-7). While country views may stretch from the medium distance into infinity, and so easily fall within normal depths of field, town views often stretch from very close to very distant.

Shooting at night

The tendency of all autoexposure systems is to overexpose urban nighttime shots. As a result, street lights become too bright and the essential "feel" of a night scene is lost. It is best to first turn off the flash, and then set your camera to manual and bracket a number of exposures, starting with a shutter speed of 1 sec. You will need to support your camera firmly, preferably on a tripod, to prevent camera shake. Note that digital cameras may produce "noisy" images with long exposures, in which blacks are degraded by lighter pixels. Some cameras offer a noise-reduction mode on long exposure, which you should turn on.

Points of law

In most developed countries you will encounter few problems photographing in major cities, but you may need to exercise some care when working in some other parts of the world. It may be illegal to photograph certain government buildings, and railroad stations and bridges may also be out of bounds. In addition, some buildings may be protected by copyright or design rights: this is unlikely to cause a problem unless you wish to make commercial use of your photographs.

London Eye

Shooting at night and using London's slowly turning ferris wheel, the London Eye, as my platform posed a challenge. The simple strategy in a

situation such as this is to take as many pictures as possible and then review and edit them later.

Urban views continued

Working around a subject

A simple exercise is to take an obvious landmark and then shoot as varied a set of views of it as possible. These images of the Sky Tower in Auckland, New Zealand, were all taken as I went about my business in that city. This shot (above), taken from a car, was very nearly missed—it is of such an ordinary scene, yet there is a rhythm in the multiple framing, a sense of a hidden story. In addition, its crisp colors make it a surprisingly rich picture. The passenger seat of a car makes a wonderful moving platform from which to work.

Noticing these flowers first, I went over to photograph them, only to find the tower unexpectedly in view. The flash on the camera illuminated the foreground flowers but not those a little farther away. The shadow visible on the bottom edge of the image was caused by the lens obstructing the light from the flash.

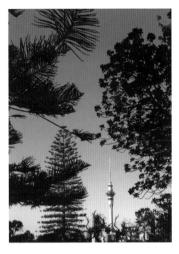

Silhouette lighting

The silhouettes of a variety of trees serve to frame the sleek, industrial lines of the distant tower (*above*). As the trees are represented by shape alone, they look very sharp—although depth of field in such views appears extensive, it is, in reality, an illusion of perception.

Converging lines

Generally, you would want to avoid pointing the camera steeply upward at buildings, as the strong convergence of normally parallel lines causes distortion. However, this can be exploited to create the sense of disorientation or of being loomed over. Its effectiveness is increased in this view by avoiding any alignment between the picture frame and the sides of any buildings.

Distant view

The Sky Tower is visible even an hour's ride away by hydrofoil. A strong telephoto perspective—produced by the 35efl of a 560-mm lens—leaps over the distance and appears to compress the space between the intervening islands. The haze has desaturated colors to give a nearly neutral gray.

Natural history

Digital photography could have been designed for those interested in natural history. Of the many features that make this technology ideal for record-keeping, chief among them must be its automatic indexing of all images. At the very least, all digital cameras give a unique file name to every image captured, thus allowing pictures to be tied in to notes taken in the field. But many cameras record far more information: date, time, shutter and aperture setting, zoom lens setting, exposure compensation used, and so on. Some systems are even able to link in with GPS (Global Positioning System) instruments so that picture coordinates are automatically recorded.

Digital advantages

The sheer ease with which large amounts of data can be collected, downloaded onto a computer system, and cataloged is a huge bonus for digital camera users. For field work that does not call for first-class image detail, digital photography offers considerable advantages over film-based cameras. As long as you have the power to run a portable computer and your camera, you can produce as many images as you like without ever buying film or visiting a processing laboratory.

Digital cameras are, by their nature, easy to control electronically. You could, for example, set a camera to take images at relatively long intervals—say, once an hour—to reveal the transformation of a chrysalis into a butterfly or the opening of a flower. For this, however, you need AC, not battery, power, and will probably need to set up a flash to ensure adequate and consistent lighting. Some cameras even charge the flash in advance so that it is fully powered in time for the exposure.

Afternoon light

Although your primary aim may be to document a scene or detailed feature, be aware that good lighting not only improves the visual qualities of any image, but may also bring out important new

information. Earlier in the day, overhead lighting on this hill made the grass appear smooth and featureless.

Toward evening, however, ridges caused by generations of sheep runs became evident in the low-angle light.

TRY THIS

Choose a natural history subject to photograph—any aspect of this wide area of study that interests you—and aim to document it as thoroughly as possible. It will be best if you approach this exercise methodically. Try to imagine you are documenting a new discovery of some type, and need to record every scrap of evidence. Start with overall views showing the subject and surroundings, depicted from a variety of angles. Then move in close to record each detail. Remember, you are not using up any film, so just take as many pictures as you need. You may surprise yourself by discovering any number of things you had never known or noticed before.

Looking at a single tree

For many, one of the most satisfying areas of photographic interest is the natural world, and one of the easiest subjects is plant life. Discipline and a systematic approach can bring you great satisfaction, deepening your pleasure both in photography and in the world around you. Here, a beautiful fir tree in New Zealand has been studied and recorded so

that any expert could readily identify it—the cone, the organization of its branches, its bark, and its leaves are all unmissable clues. You could also add its habit (spreading, weeping, and so on) by recording the entire tree. For rigorous work you need to include some indication of scale by, for example, including a ruler with the cone and bark.

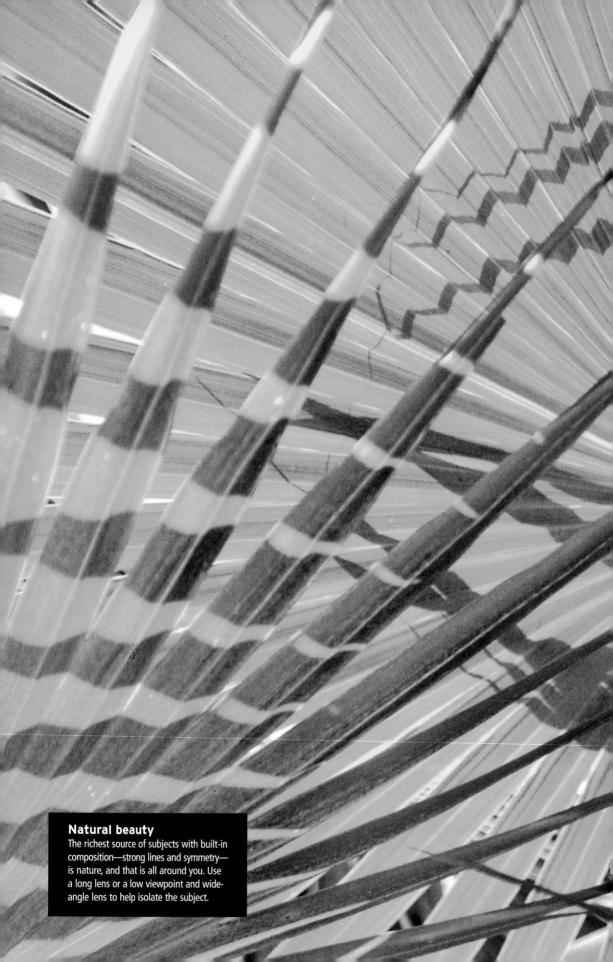

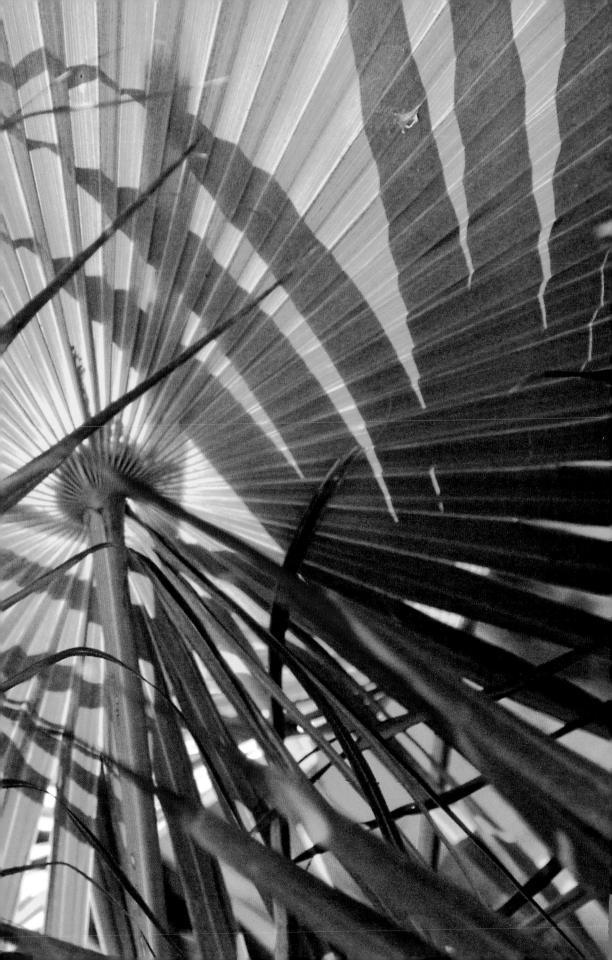

Panoramas

The basic concept of a panorama is that the recorded image encompasses more of a scene than you could see at the time without having to turn your head from one side to the other. In fact, to obtain a true panoramic view, the camera's lens must swing its view from one side to the other.

Visual clues

The giveaway visual clue to a panorama is that there is necessarily some distortion—if the panorama is taken with the camera pointing slightly upward or downward, then the horizon, or any other horizontal line, appears curved. Alternatively, if the camera is held parallel with the ground, objects positioned near the camera—usually those at the middle of the image—appear significantly larger than any objects that are more distant from the camera.

Landscape view

The landscape is the natural subject area for the panorama, and it also presents the fewest technical problems. In addition, it can transform a dull day's photography into a breathtaking expanse of quiet tones and subtle shifts of color. Here, in Scotland, a still day creates a mirrorlike expanse of water to reflect the fringing mountain, thus adding interest to an otherwise blank part of the scene. This image consists of six adjacent shots, and it was created using Photoshop Elements.

Digital options

In recent times, the concept of panoramas has been enlarged (confusingly) to include wide-angle shots that have had their top and bottom portions trimmed or cropped into a letterbox shape. As a result, images have a very long aspect ratio—which means that the width is much greater than the depth of the image. These pseudo-panoramas do not show the curvature of horizon or exaggerated distortion of image scale of true panoramas.

The digital photographer has a choice. Pseudopanoramas can be created simply by cropping any wide-angle image—all you have to do is ensure that the image has a sufficient reserve of detail to present credible sharpness after you have cropped it. Don't forget that a panorama can be oriented vertically as well as horizontally (*see pp. 78–9*).

True panoramas are almost as easy to create digitally. First, you take a number of overlapping images of a scene from, say, right to left or from top to bottom. Then, back at the computer, you can join all these individual views together using readily available software such as Spin Panorama, PhotoStitch, or Photoshop Elements. These software packages produce a final, new panoramic image without altering your original image files in any way (see pp. 344–5).

Unlikely subjects

You can experiment with component images (*left*) that deliberately do not match, in order to create a view of a scene with a rather puzzling perspective. The software may produce results you could not predict (*above*), which you can then crop to form a

normal panoramic shape. While the final picture is by no means an accurate record of the building, in Granada, Spain, it may give the viewer more of the sense of the architecture—of the neverending curves and columns. This image was created using the PhotoStitch application.

Panoramas continued

Canal scene

The distortions in scale that are caused by swinging the view from one side to another, so that near objects are reproduced as being much larger than distant ones, can produce spectacular results. In this view, taken under a railroad bridge crossing a canal in Leeds, England, one end is reproduced as if it is the entire width of the image, while the other end takes up only a small portion of the center. The mirror calm of the canal water helps to produce a strong sense of symmetry, which is in opposition to the powerful shape of the wildly distorted bridge.

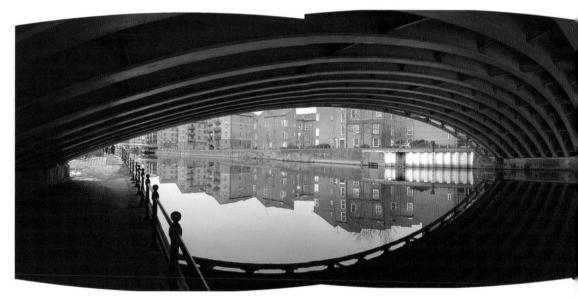

Rear nodal point

The image projected by a lens appears to come from a point in space: this is the rear nodal point. Rotate a lens horizontally around an axis through this point and features in the scene remain static even though the views change. A virtual reality head (see opposite) allows the axis of rotation to be set to that of the rear nodal point to give perfect overlaps between successive shots.

HINTS AND TIPS

In order to obtain the best-quality panoramic images, you might find the following suggestions helpful:

- Secure the camera on a tripod and level it carefully.
- Use a so-called "virtual reality head": this allows you to adjust the center of rotation of the camera so that the image does not move when you turn the camera. If you simply turn the camera for each shot, the edges of the images will not match properly.
- Set the camera to manual exposure and expose all the images using the same aperture and shutter speed settings. As far as you can, select an average exposure, one that will be suitable for the complete scene.

- Allow for an ample overlap between frames at least a guarter of the image width to be safe.
- Set your lens's zoom to the middle of its range, between wide-angle and telephoto. This setting is likely to produce the most even illumination of the whole image field and also the least distortion.
- If possible, set the lens to a small (but not the smallest) aperture—say, f/11. Larger apertures result in unevenness of illumination, in which the image is fractionally darker away from the middle.
- Ensure that important detail—a distinctive building, for example—is in the middle of a shot, not an overlap.

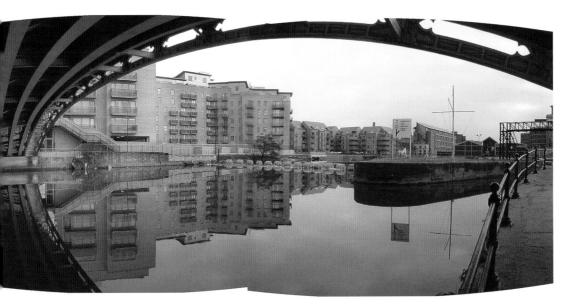

Table setting

It can be fun to create panoramas of close-up views: here, a collection of views were blended together, playing with the pastel colors and repeated elliptical shapes (see also pp. 106-7).

Zoos

For most people, zoos offer the very best chance to get up close to wild or exotic animals. Modern zoos in major cities are becoming less like animal theme parks and are taking on the role of important centers for the study and preservation of wildlife and the development of models of animal care. You can see well-fed animals in something like their natural habitat, though generally with little room to roam or play.

A learning experience

For the photographer, zoos are useful places to practice some elements of wildlife photography before venturing into the field. You soon learn that you have to stay still and wait, sometimes for hours, for something to happen. After a while, you discover that if you set up at the right place at the right time, your wait for the right shot can be greatly shortened—and from this you learn the importance of knowing your animal, its habits, and its relationship with its environment. You also learn how most visitors to zoos, like tourists in nature reserves, are wholly insensitive to their surroundings, moving noisily, talking loudly, and failing to use their eyes. So the best times for your visit might be midweek, when zoos tend to be quiet, rather than on weekends. If you travel a lot, you might want to consider a photographic project on zoo architecture—which is virtually an art form in its own right-in addition to concentrating on the animals.

You can approach animal photography in zoos in various ways: the images shown here (see right and overleaf) mimic photography in the wild, with no signs of enclosures, cages, or members of the public allowed to intrude. An equally valid approach, however, is to emphasize the captivity and the isolation of the animals through your photography—it all depends on what you are trying to convey through your work.

It may be possible to gain privileged access to at least some of the animals by approaching the relevant keepers or the zoo director and offering free photographs for use in the zoo's publicity material or on its website.

The right moment

The ease of taking pictures of animals in zoos should not lull you into thinking it is easy to take effective images. As with animal photography in the wild, wait for the right moment, for a revealing insight in the animals' lives, or when the animals' features are clearly shown.

The depth of field available when you are focusing on a nearby subject with a long focal length lens is limited. The advice for people pictures applies to animals, too: if you focus on the eyes, then unsharpness elsewhere is acceptable. In this portrait of a red panda, the eyes and whiskers are sharp but little else is, yet the image overall gives the impression of being extremely crisp.

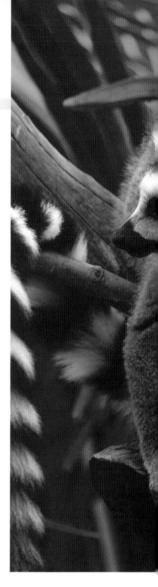

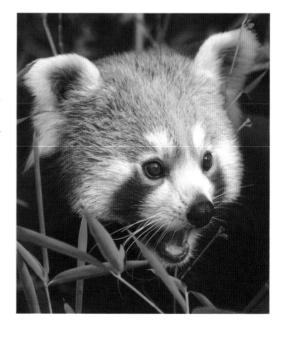

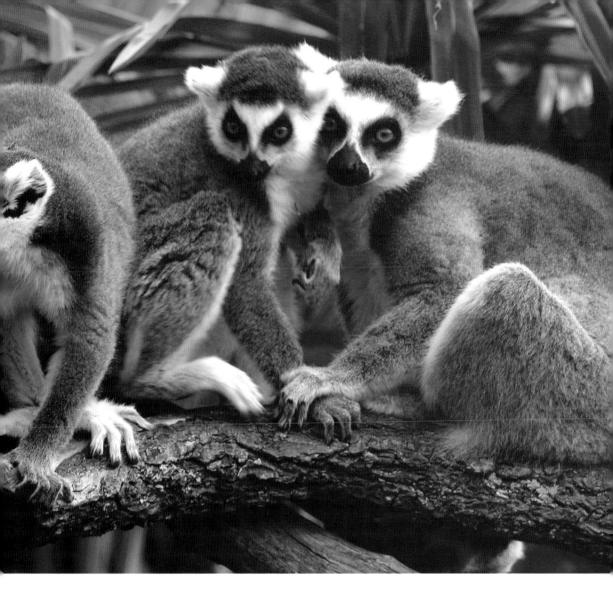

The truth behind the image

You could explore the field of unconventional portraits: views of animals you could never expect to see in the wild—such as this polar bear swimming, apparently soaking up the sunshine with some degree of pleasure. Beware, however, of the mistake of attributing human emotions to animals—it is widely accepted that polar bears are very distressed by captivity in zoos.

Zoos continued

HINTS AND TIPS

Zoo photography is technically straightforward, but these points may be worth noting:

- To minimize the appearance of wire barriers when photographing, use your longest focal length lens very close to the wire, and with the lens set at its maximum (widest) aperture. If you stop down the lens, any obstacle in view will be sharper and darker. However, be aware that even if a wire is not visible in the viewfinder or the preview screen, it may still result in softened subject detail overall.
- Check with an animal keeper before using flash in dark conditions to ensure that the animals will not be disturbed. Some cameras emit an infrared light to aid focusing in dim light—this may also disturb some animals. If so, turn this off or switch to manual focus.
- When using flash through a wire barrier, remember that the wires may cast unsightly shadows.
- When shooting through glass, place yourself at an angle to it. If you stand directly in front of the glass, the flash will bounce straight back at the camera.

Careful observation

Fast-moving and constantly on the go, animals such as otters are very hard work to photograph, and you have to watch constantly with the camera ready at all times. Here, a digital camera puts you somewhat at a disadvantage compared with film-based cameras, as its high consumption of battery power limits its working time. Furthermore, shutter lag can present problems. The best solution is to observe the animals carefully and concentrate on the spot that seems to be a favorite with them—in the example here (above), it was these rocks where the otters regularly rested and sunned themselves. Focus the camera on this spot, set to manual—exposure and focusing-if possible.

An eve for detail

Zoos allow you to obtain animal portraits that would be difficult to take in the wild. However, to any knowledgeable eye, signs of captivity will be evident, even if the bars of the cage cannot be seen. Forests of tall trees are not typical of a lion's natural habitat, for example, nor is the fern at this lion's feet native to Africa.

Record-keeping

Digital cameras have revolutionized recordkeeping. Not only are they unencumbered by the need to process film, but the amount of equipment required can be minimal (see pp. 153-5), and little or no physical material is consumed. And once the information is recorded, you can send it around the world in an instant.

Applications

The everyday applications of digital technology are numerous. If you want to sell your car, just take a picture and email it to the newspaper with your details. For insurance, take images of your valuables and possessions, room by room, but keep the computer image files separate from the computer in case it is destroyed or stolen.

Digital photography is also useful if you need to transfer information. You may, for example, want an expert at the other end of the country to identify a document or object—emailing an image of it is quicker and easier than making the trip yourself or mailing it. And sometimes a quick response can save lives—a doctor giving advice via an email after seeing images sent in from the field by satellite phone, for example. And in some circumstances it is crucial to record the time, date, and a sequential number along with each digital image. This is invaluable for many types of scientific work, such as an archaeological excavation.

The combination of digital photography for making straightforward records and software for managing images makes it very easy to print out lists and notes to accompany images.

Reassembly

This fine sculpture from Sri Lanka is designed to protect a home from illness, but for transportation it needs to be disassembled into numerous

small parts. A series of digital photographs quickly records the positions and orientations of every piece so that eventual reassembly is both easy and accurate.

Color accuracy

If you have to produce an image of an object and maintaining color accuracy is crucial, you should include a color bar along with the subject. Such a bar need be visible only on the edge of the image and does not have to be an expensive, standard type. At its most basic, the colored subject divider tabs of a loose-leaf folder will do. The crucial factor is that you have the color bar on hand to compare with the printed image.

Good working practices

- Carefully preserve your backup copies, and always keep them separate from your working files.
- Lock your archive files to prevent accidental or malicious tampering, especially if the contents are crucial to your work. Nonrewritable optical discs, such as CD-R, DVD-R, DVD+R, or BD-R, are most secure and are also archival. Keep more vulnerable discs physically secure, in different premises from the computer.
- Once your images number more than a few hundred, regularly print out a list of file names with notes about image content. You cannot hope to remember details of them all, and these notes will help.
- Use cataloging software (see pp. 234–5) to keep track of pictures. This software makes it easy to print out indexes of pictures, which are easier to search through than scrolling down long lists of names on a monitor.

Art preview

Digital photography proved to be incredibly useful for the Russian artist of this picture. Being rather isolated in Kazakhstan, he photographed it and emailed the picture file to an expert gallery owner for an opinion on its value before committing to a sale. In this instance, it is not of crucial importance that the flash has lit the painting unevenly.

Identification

Even if jewelry is not very valuable, it may still be precious. One problem police encounter when they recover stolen goods is matching items with their rightful owners. If you have inkjet prints of your possessions, it will be a great help to everybody concerned. But take care to keep the prints separate from the items they depict, to prevent them from being stolen with the items they are recording.

Car for sale

If you are offering an item such as a car for sale, using a digital camera it is a matter of just a few seconds to take a picture of the item and email it to the newspaper, along with a full written description and your details, for inclusion in the paper's next issue.

Flat copying

The purpose of flat copying is to make a record of a print, map, or drawing. The easiest method is to scan the original, provided you have a scanner of sufficient size. If, however, the original is too large, you will have to take a photograph of it instead. There are three main considerations:

- The image must be geometrically undistorted and at a known reproduction ratio.
- Lighting must be even and exposure accurate.
- The color reproduction should match the colors of the original as closely as possible.

For accurate alignment of camera and original, a special copystand is ideal, but a tripod can be used if you can ensure that the camera is exactly parallel to the original being copied. For the best results, use an SLR camera with a 35efl of a 50 or 55 mm macro lens. If using the zoom on a digital camera, set it to the middle of its range, as this is where distortion is likely to be minimal. The lighting should be arranged as shown in the diagram (see right), and to ensure color fidelity, reproduce a color bar or step wedge with the original. It is not necessary to use an expensive type any set of standard colors is more useful than none.

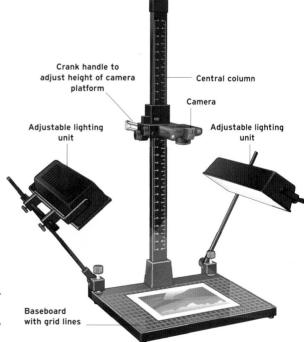

Copying set-up

The copying of flat documents, such as maps, artwork, drawings, and printed material, requires even lighting at a constant level, consistent color temperature, and a steady support for the camera, as shown in the copying set-up here.

Radical conversions

Scanning: The basics

Scanning is the bridge that carries film-based negatives and transparencies or printed images into the digital world. The process converts all color, brightness, and contrast information into digital data for your software to use. The quality of the scanner and the skill with which it is used are the key factors that determine the quality of the digital information and, hence, the quality of the image you have to work with (see pp. 220–1).

Scanning steps

You can think of scanning as a three-stage process:

- Gather together originals for the job. You may have to make prints of family portraits, say, or collect images for your club's website.
- Next is the actual scanning. To do this, the scanner makes a prescan to allow you to check that the original is correctly oriented, or to set the scanner to scan only as much of the original as you want, or to set the final image size and resolution. You then make the real scan and save the result onto the computer's hard disk.
- The final stage is basic "housekeeping"—put your originals somewhere safe, somewhere you

can readily find them again, and, if the work is critical, create a backup copy of the scans.

Basic procedures

To get the most from scanning, it is a good idea to follow some commonsense procedures designed to help streamline your working methods.

- Plan ahead—collect all your originals together before starting.
- If you have a lot of scans to make from a variety of different types of original, sort them out first. If, for example, you scan all black and white originals and then all color transparencies you will save a huge amount of time by not having to alter the scanner settings continually.
- Scan landscape-oriented images separately from portrait-oriented ones. This saves you from having to rotate the scans. And you will minimize visits to dialog boxes if you classify originals by the final file size or resolution you want.
- If you are using a flatbed scanner, clean your scanner's glass plate, or platen, before starting.
- Make sure originals are clean. Blow dust off with compressed air or a rubber puffer. Wipe prints carefully to remove fingerprints, dust, and fibers.

Setting up a scanner

Many scanners give excellent results with practically no adjustment at all. However, it pays to calibrate your scanner carefully right from the outset.

- 1 Obtain a standard target, such as that illustrated opposite. The IT 8.7/1 is intended for use with color transparency film, and the IT 8.7/2 is for color prints. These targets may be supplied with your scanner; if not, a camera store may be able to order them. Alternatively, choose an original for scanning that is correctly exposed and contains a good range of colors and subject detail.
- **2** Make an initial scan using the machine's default settings—those set at the factory.
- **3** Check the image produced by the scan against the original. If necessary, make changes using the

scanner driver's controls so that the scan matches the original. Some scanners require you to make these changes in the preview window. However, be aware that on some scanners, the preview image is not really an accurate representation of the final scan. You need to experiment with your particular equipment. For the best results, you also need to calibrate your monitor (see pp. 232–3).

- 4 Once you have a scan you are happy with, save or note down the settings. Call it by the name of the film used—such as "Kodak Elite 100" or "Fuji Provia."
- **5** Repeat these steps with all the various types of film you scan—color negatives and transparencies use different scanner settings.
- **6** Then, for all subsequent scans, load the relevant saved settings as your starting point.

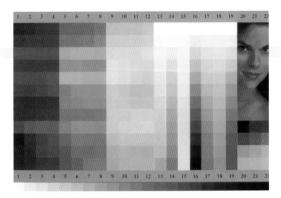

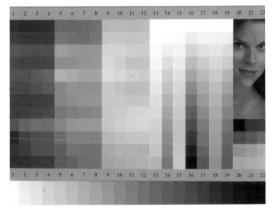

results from an identical standard target image. This demonstrates just how important it is to set up your scanner controls carefully.

- Align originals on the scanner as carefully as you can: realigning afterward may blur fine detail.
- Scan images to the lowest resolution you need. This gives you the smallest practicable file size, which, in turn, makes image manipulation faster, takes up less space on the hard disk or other storage media, and gives quicker screen handling.
- Use file names that are readily understood. A file name you choose today may seem obscure in a few months.
- When scanning, crop as much extraneous image detail as is sensible in order to keep file sizes small, but allow yourself room to maneuver in case you decide to crop further at some later stage.
- You may need to make your output image very slightly larger (say, an extra 5 percent all around) than the final size. This may be essential if, for example, you want your image to "bleed," or extend to the very edge of the paper so that no white border is visible.

Preview window

All scanners show a representation of the image in a preview window (above) prior to the final scan (top). This gives you a chance to make improvements before committing to a final scan. While it will save you time and effort later if you make the preview image as good as you can, bear in mind that it is only a general indication of the final scan. With some scanners, the preview may actually be rather inaccurate: if yours is one of these, you may need to experiment in order to learn how to compensate for its quirks.

Using flatbed scanners

Flatbed scanners are intended primarily for twodimensional artwork and printed material, but you can also use them with small, solid objects (*see pp. 222–3*). For scanning small-format film, such as 35 mm, it is best to use a special film scanner (*see pp. 218–19*): only the larger, costlier flatbed scanners are suitable for these miniature formats. You can satisfactorily scan medium-format and larger films on flatbed scanners, which makes them very versatile pieces of equipment.

Getting the best from your scanner

One way of thinking of what a scanner does is to regard it as a type of camera. Just as being careful when capturing an image via a camera increases your chances of a high-quality image, so careful scanning ensures that you have a good-quality digital image to manipulate—and it also cuts out unnecessary correction time on the computer.

- Keep the scanner's glass bed spotless. If you have a transparency adapter, make sure that is also clean. Lint-free microfiber cloths are available from camera stores or opticians to clean the glass without the risk of scratching it.
- Check that the colors you have seen on the prescan match those of the final scan.
- Be systematic about your filing and the names you give your images.
- Allow the scanner to warm up for at least five minutes before making your best-quality scans.
- If you are scanning, say, a large book, don't damage the hinge of the scanner lid by forcing it down. Use a heavy weight, such as another book, to hold down and flatten the original against the scanner's glass.
- Save your scanned images to the file format that is easiest for your software to access and use. It is a waste of your time to change file formats more than is absolutely necessary.
- Line up any rectangular originals as carefully as you can on the scanner glass. Rotating the image after scanning in order to square it up (to correct a sloping horizon, for example) can significantly degrade image quality—especially of line art, such as black and white artwork.

Scanning photographic prints

There may be times when you get better results by first making a print in the darkroom from a negative, and then scanning the print, rather than scanning the negative directly and working on that in the computer. Certain manipulations, such as the local contrast controls known as burning-in and dodging (*see pp. 246–7*), are often far easier to achieve in the darkroom than by manipulating a scanned image.

If the print intended for scanning has a glossy surface, take care to clean it carefully—every speck of dust, fiber, or loose hair will show up sharply on the resulting scan.

Scanning printed material

There is a wealth of printed material in general circulation, in books, magazines, posters, album covers, and so on, that appears ideal for scanning. But the likelihood is that most of it is protected by copyright restrictions, and you are likely to be in breach of these restrictions if you scan such material without the copyright holder's written consent (*see pp. 374*–5).

However, in general, if you scan for the sole purpose of study or research, or you intend to make no commercial use of the material, then your actions will probably be exempted.

Scanning stamps and coins

Flatbed scanners are ideal pieces of equipment for making records of valuable items, such as stamp collections (*see opposite*) and coins. The main advantage that a scanner has over a conventional camera is that the scanner is capable of making very accurate records of objects with very little distortion. In addition, a scanner will record the real size of items extremely precisely, and this could be a crucially important consideration for some collectors.

Another factor you might want to consider is that the relatively low light-levels needed for scanning are less likely to harm the delicate coloring of, say, stamps than photographic tungsten lamps, which burn very bright and hot.

Hobbyists

Scanners are perfect for many hobbies, including stamp and coin collecting and autograph hunting, as well as for studies such as graphology. Scanners not only make precise 1:1 (life-size) copies, they also make excellent enlargements of, for example, the slight imperfections that can be so important to some collectors. The magnified view of these stamps (left) shows the enlarged "L" that distinguishes this batch.

Starting from a print

Sunlight reflecting off these nurses' white uniforms created a contrasty negative. Working digitally, by scanning the original negative, would have meant losing the attractive graininess of the image. In this example, the negative was first printed conventionally, and the resulting print scanned. The digital equivalent was then worked on-principally by slightly warming up the image tones.

Optical character recognition

If you scan text documents, such as letters or pages from a book, to create image files, you can edit them only as images. However, by using optical character recognition (OCR) software, which is often bundled with scanners, you can scan text documents to create word-processor files. This gives you the option of editing the text directly. For documents that are clearly printed, such as those from a laser printer, inexpensive OCR software is adequate. You will need a small piece of software to bridge the OCR with your scanner, which is usually available free from the scanner manufacturer's website. Once it is installed, operation is normally very simple, and you may be able to fax, print out, or save documents directly from the OCR application.

Using film scanners

Film scanners may seem highly specialized, but if your images are on photographic film—as nearly all are—a scanner designed for film is the best way to transform silver-based records into digital ones. In practice, you need the same organized and orderly approach as using any other scanner (see pp. 214–15 and 216–17).

- Since you will always be enlarging up from a small original, it is more important than ever to keep the system as free from dust as possible. A can of compressed air is invaluable for cleaning films (negatives or slides) before scanning them.
- Make sure you place the film in the scanner the correct way up so you will not have to rotate or flip the scanned image. This procedure can reduce image quality and is best avoided.
- Think what you want to use your scan for. If you print a scan on a letter-size sheet, you will find that it fills only a tiny part. The image scale should be set to, say, 600 percent to give an enlargement with an output height of some 6 in (15 cm).

Oversampling

Some scanners will read an original image more than once—a process called oversampling or multiple scanning—and then combine data so that differences are averaged. The more data samples that are obtained, the better. Oversampling has the effect of retaining genuine, repeatable information and—because unwanted data is random—it helps to create cleaner shadows. However, it does lengthen scanning times.

Even if your scanner does not offer a multiple scanning option, another strategy is available: making separate scans that are optimized for different tonal ranges. First, make a scan that is corrected for subject shadows; then make another, without any changes to cropping or image size, that is tonally optimized for subject highlights. Next, open up both scans and copy one onto the other before experimenting with blending modes and various opacity settings. For example, set the top layer to Screen with an opacity of 30 percent, or try Color Dodge mode with an opacity of

70 percent. Alternatively, try using Blending options, or use a mask to combine the two images.

Preparation

Once you have made a scan, it is good practice to turn your attention to tidying up the image. In most cases, there will be portions of the scan you don't want—parts of the slide mount or film rebate, for example, or an extreme edge that could be removed. Bear in mind that although you may ignore unwanted parts of an image, they will still be taken into the calculations of, say, Levels or Color Balance. However, if you crop off all unwanted portions, you not only reduce the size of the image file, you also remove the extraneous data that may mislead the software.

Next, examine the image very carefully for sharpness and defects. It may be that the scanner failed to focus correctly. If so, rescan now, not after you have started work on the image. Then clean up any dust or particles. If you intend to manipulate the image heavily (*see pp. 260–1*), the best option may be to leave cleaning up to the end, since any even slight carelessness in the cleaning process may become very obvious (*see p. 250*).

Using a pro bureau

Most problems encountered with laboratories or bureaus originate from poor communication between the client and those carrying out the work. To get the best possible results from using a professional bureau, follow these guidelines:

- Give clear, written instructions, particularly if the job is more involved than normal film processing.
- Provide details of how you can be contacted if any problems arise.
- Plan ahead so that you don't pick up work on a Friday—if there is a problem, you may then lose two days over the weekend.
- Allow at least the time that the bureau specifies as the standard turnaround period for the work. If you are in a hurry, you must expect to pay extra for a rapid service.

Original image

The scan of a Kodak Ektachrome transparency is an accurate representation of the original, but as a result it faithfully retains the color inaccuracy recorded by the film, as well as the loss of

contrast, both caused by photographing from an aircraft window-albeit from the cockpit—flying over Tajikistan. In addition, the scan has recorded dust and a scratch on the film.

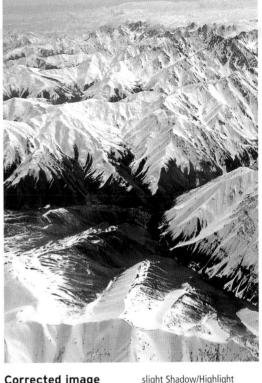

Corrected image

The dust and scratches were removed first. Applying Auto Levels immediately improved the overall balance by removing the blue cast, and increasing the contrast and exposure. By applying

slight Shadow/Highlight adjustment, I was able to open up the darker areas to reveal their detail. Further attention could also be given to reduce the film grain and sharpen details.

Inferior scanner

A high-quality image scanned at 2,000 ppi on a costly but inferior scanner produces results that seem acceptable. There is detail here that can be improved, while overall tone and color can also be brought out.

Superior scanner

The same original scanned on a top-quality scanner, also at 2,000 ppi, shows what can be done. Every detail in the original has been extracted; an enormous print could be made with no post-processing work required (apart from dust removal).

Drum scanners

When you need the best possible image results—for example, if you are making scans for posters or other large-scale reproductions—then there is no substitute for a drum scanner.

This design of scanner uses completely different technology from desktop types. The original must be attached to a glass or acrylic drum, which spins at high speed while a laser beam scans the image. The sensor is a photo-multiplier tube (PMT), which, in principle, works like a night-vision scope to intensify the available light. Drum scanners achieve extremely high resolutions and record over a large dynamic range thanks to this PMT technology. But even at modest resolutions, they capture detail with a sharpness and depth of tone that puts desktop scanners in the shade. But the cost of these machines is high.

Quick fix Scan resolution

Often, one of the most important decisions you have to make when it comes to scanning an image is determining the most appropriate resolution to set.

Problem

When scanning, you may be tempted to set a low resolution in an attempt to keep file sizes as small as possible—especially if your computer has inadequate RAM or hard-disk space is tight. If, however, you set too low a resolution figure, then the resulting image will look unsharp, image detail will be missing, or the image will appear pixelated.

Setting a higher resolution holds out the promise of higher-quality digital output, but if file sizes become too large, then there is a price to pay—images will take longer to scan, the resulting files will need more storage space, they will take longer to load or transmit, and they will need more memory to manipulate on screen. And files can grow very large, very quickly, when you start to work with multiple layers. Yet higher resolutions do not even guarantee better-quality results.

Analysis

Two approaches are possible. First, you could scan every image at the highest resolution you are ever likely to need, producing files of, say, 25–30 MB in size. You can then make copies, adapting image resolution to each task while copying. This saves you from having to scan an image each time you want to use it for a different job. This way of working uses a lot of data capacity, but it is a good solution for, say, a busy studio.

Alternatively, you scan specifically for the task in hand, and if a new use of the image calls for a higher or lower resolution, then you need to make a new scan. This is the most economical method of working if throughput is not particularly great.

Solution

Check image size The simplest method is to work by the size of the image file: use the table here (see opposite) as a guide for color images. For black and white images, use files a third of the size—instead of 1.9 MB for a 3 x 5 in (7.5 x 12.5 cm) print use 0.6 MR When you

make the prescan and crop to the part of the scan that you want (see pp. 214–15), tell the scanner driver the size of the printout required. The driver will then tell you the size of file you will obtain after scanning. If it is not right, simply change the resolution settings until you obtain the approximate file size suggested by the table.

Bear in mind that when you calculate the file size of an image, the size of the original is irrelevant. Whether you reduce a poster to fill a monitor screen or enlarge a postage stamp to fill the same area, the correct file size is exactly the same.

Calculate resolution The more rigorous approach is based on the fact that the number of pixels needed to be input from the scanner equals the total number of pixels needed for output. The calculation is as follows:

input resolution = (size of output x output resolution)/size of original

Ensure that the size of output and size of original are in the same units—both inches or centimeters—then the input and output resolutions will be the same. Another formula giving the same result is the following:

input resolution = percentage increase in size x output resolution

You may take the size of the output and the size of the original as one dimension—say, length. Suppose your original is 2 in long and the print you want is 10 in. If you need an output resolution of 300 lpi (lines per inch), then you need 300 x 10 pixels—a total of 3,000 pixels—for output. The input resolution must, therefore, be 3,000 divided by 2 in (the size of the original), which gives the required scanner resolution of 1,500 ppi (points per inch).

The key is to determine the correct output resolution.

- For inkjets, use anything between 80 and 200 lpi, depending on paper quality.
- For screen-based work, use 72 dpi or 96 dpi.
- For reproduction in print, first determine the screen frequency—it is commonly 166 lpi for good-quality magazines and books but can vary from 96 to 300 lpi. Then multiply the screen frequency by a "quality factor" of 1.5. For example, if the screen frequency used is 150 lpi, the output resolution required is 1.5 x 150 = 225 ppi.

Here are some examples to illustrate these principles. Note that although the final settings are in lines, pixels, or dots per inch, you can work the early parts of the

Screen shot: film scanner

A dialog box for a film scanner may ask for output sizes: the proportion of length to width is often set by cropping the image, or it may be typed in. The resolution setting can also be entered by hand or by setting the scale and letting the software calculate resolution. A useful check is file size: high resolution (2,500 ppi) and a 7 MB file size suggest the image is black and white.

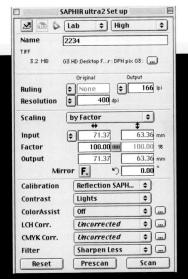

Screen shot: flatbed scanner

Complicated-looking dialog boxes, such as the one here for a flatbed scanner, are usually not that difficult to use. Here, you must set an output ruling (166 lpi in this example) and the scaling is set to "Factor," which is indicated at 100 percent. From the dimensions of the frame for the cropping, the scanner calculates the rest, including the resolution—given here as 400 dpi. The expected file size is shown at the top of the box. These figures show the settings for the feather scan used on page 223.

calculations using metric measurements if you wish:

1 Your original image is 35 mm long, and you want to make a print that is 250 mm long, and the assumption is that you are using an inkjet printer with an output resolution of 120 lpi.

Input resolution = $(120 \times 250)/35$

= 30,000/35

= 857 pixels per inch

Since the original is 35 mm (1.4 in) long, there will be a total of $857 \times 1.4 = 1,200$ pixels on its long side. **2** Your original is 35 mm long and you want a scan of sufficient quality to be suitable for magazine reproduction up to 250 mm long. Working on the assumption that the magazine prints to a 150 lpi line screen, and with a quality factor of 1.5, the output resolution needed, therefore, is

 $150 \times 1.5 = 225 \text{ lpi}.$

Input resolution = $(225 \times 250)/35$

= 56,250/35

= 1,607 pixels per inch or, say, 1,600 ppi

Since the original is 35 mm (1.4 in) long, there will be a total of 1,600 x 1.4 = 2,240 pixels on the long side of the image.

Determining file size

Look up the file size for the output you desire, then make sure the scanned file is about the same size by adjusting the dpi or resolution in the scanner driver.

Inkjet print	3 x 5 in (7.5 x 12.5 cm) 4 x 6 in (10 x 15 cm) 8 x 10 in (20 x 25.5 cm) Letter (A4) Tabloid (A3)	1.9 MB 2.7 MB 5 MB 6.9 MB 12.6 MB
Image for webpage	480 x 320 pixels 600 x 400 pixels 768 x 512 pixels 960 x 640 pixels	0.45 MB 0.7 MB 1.12 MB 1.75 MB
Book/ magazine printing	Letter (A4) 8 x 10 in (20 x 25.5 cm) 5 x 8 in (A5) 5 x 7 in (12.5 x 17.5 cm)	18.6 MB 13.6 MB 9.3 MB 6.7 MB

How to avoid the problem

Experiment with using the lowest resolutions you can manage that do not compromise the quality of the image. The exercise is most valuable when you are using an inkjet printer. Working with the smallest possible files will help to save you both time and

money. Your work is likely to fall into a pattern after a while: keep a note of the settings that produce satisfactory results and reapply them to your new work. If you are outputting using commercial printers ask them for their recommendations

Using scanners as cameras

Since you can think of scanners as being a type of camera—indeed, professional digital cameras used in studios are essentially scanners built into the camera back—they can be used to make records of same-sized or enlarged views of small objects. It is even possible to use a desktop scanner outside, when shooting on location, say, by powering it from a car battery.

Scanning solid objects

You can scan anything that will fit on the scanning glass, but be careful not to scratch or damage it. Ideal subjects for scanning include essentially flat, nearly two-dimensional objects, such as dried leaves or flower petals, embroidery, textiles, textured papers, or wallpaper. But other small objects also scan very well: jewelry, seashells, insects, seeds, or pebbles, for example. Food items such as rice, dry pasta, sugar grains, or cake decoration can also be interesting to try.

Being designed to record two-dimensional objects, flatbed scanners have only a limited depth of field (see pp. 74–7). As a result, only the parts of

objects in contact with the glass will be sharp, but you can still experiment with other subjects-for example, you could try making a portrait by scanning a person's face. Interesting results are also possible if you don't flatten objects-the undulating shape of a leaf, for example, can look intriguing as it goes in and out of focus.

When scanning solid objects, you will have to experiment with backgrounds. If you leave the scanner lid open, objects will be seen against a black background. If you need a white background, cover the object with white paper-but beware, the scanner may then pick up the texture of the paper, and this can be difficult to remove later on. Try shining a light on the paper during the scan. This will brighten the background and so reduce the impact of any texture it may have.

If objects are semitranslucent, such as jewelry or lightweight silks and other fine textiles, you can try scanning them as if they were color transparencies—in other words, use the transparency adapter of the scanner and set the software to scan in transmission mode.

Feather

I first scanned this feather with the lid up, giving a black background. The feather was so flat that covering it with paper would have added texture. I changed the background to white later on in Photoshop.

Shells

Next, I placed these shells on the glass and covered them with handmade paper. I then scanned them at full size with the tones adjusted for soft contrast and subtle color, and blurred the image a little.

First combination

I then manipulated the image by setting the feather layer to Difference. It exaggerated the differences between pixels on the two layers—a white pixel overlaying another white pixel is turned black.

Caring for your scanner

- Do not scan anything that is damp or wet, or water may enter the mechanism and corrode it.
- Take care to avoid damaging the glass bed with acid or grease from your fingers or colored food.
- Be extremely careful if you scan jewelry, pebbles,

seashells, or anything else that may scratch the glass.

• Don't force the scanner lid down on an object in an attempt to flatten it. You will strain the hinges, which are usually not very robust. Flatten objects, if necessary, before placing them on the scanner bed.

Final effect

The feather image, with its white background, was laid over the shells. I then experimented with the various Layer blending modes and found that Color Burn with the shells layer inverted (in other words, with tones reversed) gave the best result. To finish, I made some additional adjustments in Color Balance.

Layer mode

A seemingly complicated image can, in fact, be quite simple: two layers were used but, crucially, the one carrying the feather is smaller. Its layer blending mode was set to Color Burn, which reverses underlying tones. To soften its effect, opacity was reduced a little-from its 100 percent maximum to 87 percent.

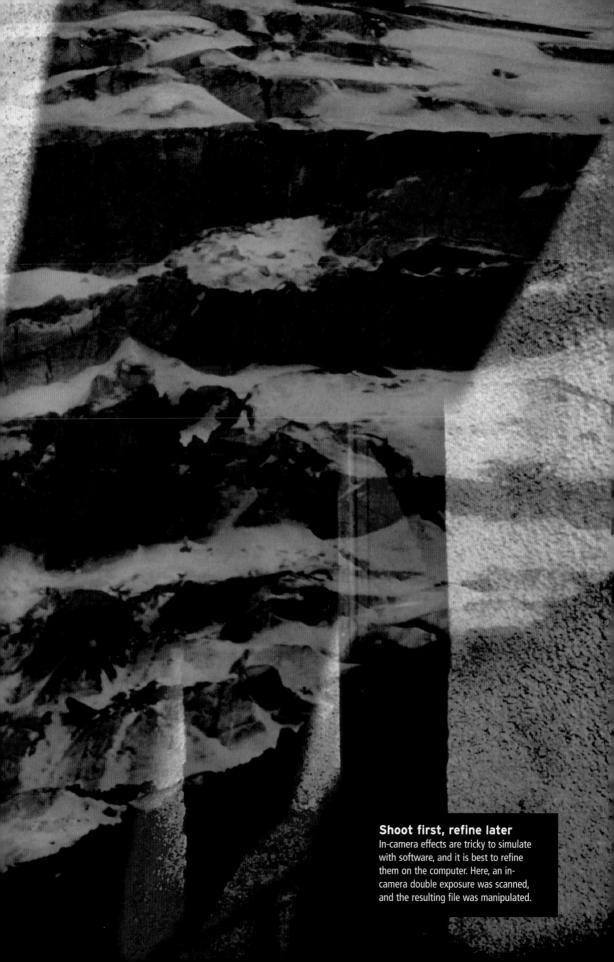

File formats

Most types of data file are produced by application software to be used specifically by that software, so there is only limited potential for interchange with other programs. However, image files are different, since they can be accessed and used by a range of programs. This is achieved by building them in widely recognized data-structures, or formats. The following are commonly supported.

TIFF

The best choice for images used in print reproduction, and widely adopted. A bit-mapped or raster image file format supporting 24-bit color per pixel, with such data as dimensions and color look-up tables stored as a "tag" added to the header of the data file. The variety of tag specifications gives rise to many types of TIFF. The format can be compressed losslessly using LZW compression. This reduces file size by about half on average. It is always safe to compress TIFF files. The suffix is .tif.

"Save as" screen shot

Whenever you save a digital picture file you need to make a decision about which format to save it in. The safest choice is TIFF, which is very commonly recognized, but specific picture needs, perhaps for publication on a website, for example, may demand that you use another type of format. You can use this dialogue box to change from one format to another. To preserve the original, save your new file under another name when choosing a different format.

JPEG

(Joint Photographic Expert Group; pronounced "jay-peg") A format named after its datacompression technique that can reduce file sizes to as little as 10 percent of the original. This is the best choice for photographs intended for use on the internet. JPEG files are saved to different levels of compression or quality. For general use, a middle setting (5 or 6) is sufficient, as it gives very good reductions in file size without noticeable loss in image quality. A high setting of 10–12 is appropriate for high-quality work—loss of quality is all but invisible. The suffix is .jpg. JPEG2000 uses entirely different compression technology for highly efficient compression but is not widely supported.

Photoshop

This is an application-native format that has become so widespread that it is now almost a standard. Photoshop supports color management, 48-bit color, and Photoshop layers. Many scanners will save directly to the Photoshop format, and the format used on other types of scanner may, in fact, be Photoshop, albeit under a different name. The suffix is .psd.

GIF

(Graphic Interchange Format) A compressed file format designed for use over the internet, comprising a standard set of 216 colors. It is best for images with graphics—those with larger areas of even color—but not for photographic images with smooth tone transitions. It can be compressed losslessly using LZW algorithms. The suffix is .gif.

PDF

(Portable Document Format) A format native to Adobe Acrobat based on PostScript. It preserves the document text, typography, graphics, images, and layout. There is no need to embed fonts. It can be read, but not edited, by Acrobat Reader. Very widely used and incorporated into Mac OS X. The suffix is .pdf.

PICT

(Macintosh Picture) A graphics format for Mac OS, it contains raster and vector information but is limited to 72 dpi, being designed for screen images. PICT2 supports color to 24-bit depth.

PNG

(Portable Network Graphics) A format for losslessly compressed web images. It supports indexed-color, grayscale, and true-color images (up to 48 bits per pixel), plus one alpha channel. It is intended as a replacement for GIF. The suffix is .png.

Raw format

Many digital cameras produce files in what is called, variously, RAW, Raw, or raw format, in addition to JPEG or TIFF files. Raw files save data directly from

the analogue-to-digital converter at the camera sensor, so the data has not received any processing for white balance, levels, sharpness, nor any lossy compression. Each camera manufacturer, even individual models within a range, may produce raw files organized in different ways, leading to numerous raw formats. As a result, raw conversion software such as Adobe Lightroom, Apple Aperture, Adobe Camera Raw, DxO Optics, and Capture One must be updated regularly with new format data.

Raw files are favored for retaining maximum quality and flexibility during manipulation, but their variety and patchy documentation raise doubts for the long term. The DNG (Digital Negative) format has been proposed as an open standard for raw files by providing a open-source "wrapper" to contain the raw data.

JPEGs in detail

JPEG compression is efficient due to the fact that several distinct techniques are all brought to bear on the image file at the same time. Although it sounds complicated, thankfully, modern computers and digital cameras have no problem handling the calculations. The technique, known as "jay-pegging," consists of three steps.

- **1** The Discrete Cosine Transform (DCT) orders data in blocks measuring 8 x 8 pixels, which creates the characteristic "blocky" structure you can see in close-up (see *right*). Blocks are converted from the "spatial domain" to the "frequency domain," which is analogous to presenting a graph of, say, a continuous curve as histograms that plot the frequency of occurrence of each value. This step compresses data, loses no detail, and identifies data that may be removed.
- **2** Matrix multiplication reorders the data for "quantization." It is here that you choose the quality setting of an image, balancing, on the one hand, your desire for small-sized files against, on the other, the loss of image quality.
- **3** In the final stage of jay-pegging, the results of the last manipulation are finally coded, using yet more lossless compression techniques.

JPEG artifacts

This close-up view of a JPEG-compressed image shows the blocks of 64 pixels that are created by the compression feature. This can create false textures and obscure detail, but on areas of even tone, or where image detail is small and patterned, such artifacts are not normally visible—even with very high levels of compression. Note how the pixels within a block are more similar to each other than to those of an adjacent block.

The effect of these compressions is that JPEG files can be reduced by 70 percent (or, reduced to just 30 percent of their original size) with nearly invisible image degradation; you still have a usable image even with a reduction of 90 percent. However, this is not enough for some applications, and so a new technology, known as JPEG2000, based on another way of coding data, offers greater file compression with even less loss of detail.

Quick fix Problems with scans

Scanning puts your film-based work into digital form, which you can work with on your computer. The quality of the digitization is crucial to the quality of everything you subsequently do with your images, so you can see that it is important to

take considerable care at this stage of the process. You do not want to work at an image for days only to discover it was scanned at too low a resolution or that it has defects that are too deep to remove without undoing all your work.

Problem: File size is too small

The most common error is working on a file size that is too small for the intended task (see pp. 220–1 for details on how to calculate the optimum file size). Always check your image's file size before you do any work on it: you want it to be neither too large (as it will slow your work down unnecessarily) nor too small (as output quality will then be too low).

Solution

If you discover that the file size you are working on is too small for what you want to do with it, then you have no option other than rescanning and starting again. The sooner you come to this decision, the less of your work you will have to redo.

Image size screen shot

The settings on this dialog box are something you should never see in reality. They show that a small image of 3.2 MB in size is about to be enlarged to a normal page-size print. For the resolution required, however, the resulting file size will grow to more than 16 MB (shown in the top line)—five times larger than the original. With this level of interpolated enlargement, the result will show broken-up detail. In this case it would be better to rescan the image to the required 16 MB.

Problem: Newton's rings

When you place a film strip directly on the glass surface of your flatbed scanner, although you may not realize it you are also trapping a thin layer of air beneath the film. This layer of air acts like an oil film—of the type you often see on a road surface—that causes the light to split into rainbow-colored patterns, known as "Newton's rings." These colored distortions are extremely troublesome to remove from the image and it is best to prevent them from occurring in the first place.

Solution

Avoid placing film strips directly on the scanner's glass surface. Most scanner manufacturers provide special holders for film strips or individual frames. If this is not the case with your machine, then make certain that the scanner is well warmed up before starting—hot, dry air

Newton's rings

This film (only a portion of which is seen here) was scanned on a flatbed scanner because, having been produced by a panoramic camera, it was too long to fit into a normal film scanner. When held down by the scanner's lid, the trapped air created these tree-ring-like patterns (which have been slightly exaggerated for reproduction purposes). They are extremely difficult to remove as they cover a large area and are also colored

Problem: Jitter and other artifacts

Before starting work on an image, examine it closely for signs of any features that are not part of the original. Even the most expensive scanners can introduce artifacts, or imperfections, such as tiny black dots in light areas. These may be so small that they are invisible at normal size; some other errors, however, such as jitter, or the uneven movement of the scanner head, cause defects that are obvious at normal print sizes (see right)— although they may be invisible at screen resolution. Defects may result from movement of the original during scanning—for example, if your book slips slightly, the image will appear slightly stretched or smeared.

Solution

Rescanning on the same or on a better-quality scanner will solve the problem, unless the defect is due to the movement of the original.

Scanner jitter

A scan from an inexpensive scanner produced these streaks, which are due to the uneven movement of the scan head. The streaks have been exaggerated for reproduction purposes, but would be visible anyway when printed. Small areas could be improved by cloning, but essentially a better scanner is required.

Problem: Moiré from printed material

This problem arises when there is a clash between the regular pattern of the dots on the printed page of a book or magazine, say, and the regular raster pattern of the scanner. This conflict can cause a new pattern—known as a moiré pattern—to be superimposed over the image, usually with unsightly results.

Solution

There are several methods of dealing with moiré. You can rescan the original using a slightly different resolution setting, or you could try aligning the page slightly differently on the scanner's platen—just a small change of angle may be enough to do the trick. Some scanner software offers filters designed to remove, more or less successfully, such moiré patterns, but this is often at the cost of critically sharp image detail. Bear in mind that using sharpening filters (see pp. 252–5) may bring out a moiré pattern.

Moiré patterns

Just a small area of a photograph of a heron printed in a book was scanned for this example. You can readily see that the resulting image has picked up the array of half-tone dots that make up the printed original. The pattern of these dots has clashed with the regular array of pixels, resulting in the creation of another pattern. Seen here, it gives the impression of looking at the scene through an intervening fence of chicken wire.

Quick fix Problems with scans continued

Problem: Noisy shadows

Image "noise," or pixels with random values (see pp. 250–1), are encountered in scanned images most frequently in the shadow regions of the image. In the example shown here (see below), the dark areas should be black with smooth transitions to the lighter areas, but the speckled appearance shows a very noisy scan, which was produced by an inexpensive scanner.

Solution

Scans may be improved by increasing the overall brightness of the image, but that may be at the cost of losing highlight detail. If the shadows are of very high density—for example, those in high-definition transparency film—you may need to scan on a better-quality machine.

Levels screen shot

The numerous gaps between the columns seen here indicate lack of data, while the way they are interspersed between very tall columns points to extremely noisy shadows. At the same time, data-challenged (very short columns) further indicate poor image quality.

Problem: Underexposure

You may have set the brightness level too low—this often occurs as a result of compensating for a previous original that was too bright. You may also have assessed the prescan with the monitor screen incorrectly adjusted. The result is a scan with all the data skewed toward the shadow regions. An underexposed scan can, of course, also result from an underexposed camera original.

Solution

Make a new scan. If the original is underexposed, improve it as far as possible at this stage rather than in post-scanner processing. It may help to scan at the highest bit-depth available (say, 36- or 48-bit), make the tonal corrections, and then convert to normal 24-bit.

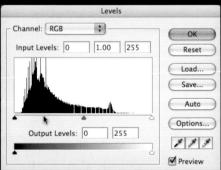

Levels screen shot

The Levels histogram seen here (above) confirms the underexposure seen in the image (top)—subject data is skewed, leaving many empty values.

Quick fix Inaccurate printer color

The basic problem of color reproduction is that monitors produce colors in a very different way from printers. Bearing this in mind will help you avoid harboring unrealistic expectations. You can see from any diagram comparing the color spaces enclosed by printers compared with the color space of monitors (see p. 109) that the deeper blues, greens, and reds seen on a monitor cannot be reproduced in print. These colors are the typical hues that are "out-of-gamut" for printers—in other words, cannot be printed.

Problem: Screen/printer colors don't match

If image colors look correct on the screen but not when they are printed, there is a failure of communication between your software, monitor, or printer. Assuming that your monitor, software, and printer are correctly set up, you may need to alter the printer's advanced settings or options. You can usually change color balance by dragging the sliders provided: change these by small increments, note the settings ("capture," or save, them if the facility is available), and then reprint. Repeat this procedure until you obtain the results you want.

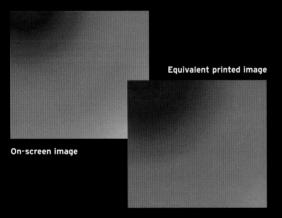

Print brilliance

These images simulate the change you could see when printing out a highly saturated screen image on paper. The loss of depth and richness of color is dramatic when you compare them side by side in this fashion. Fortunately, most people looking at your prints will never see the screen image for comparison—as a result they would accept the print on its own terms.

Problem: Bright colors merge

You have oversaturated colors. Although they appeliatinct on screen, they are out-of-gamut on the p As a result, what were different colors blend into hue. Try to reduce saturation overall by, say, 10 pe at a time until you start to see the separation of c in the print. If this makes the other colors in the p too dull, try selecting the most vivid colors using, example, Photoshop's Replace Color function, and reduce the saturation of a limited range of colors. gamut of printers is usually largest if you use the quality of glossy paper and the manufacturer's over Change the paper if you are not using the best quality of glossy paper.

Problem: Weak colors with patterns

You have chosen a regular dither pattern. "Ditheria method of simulating a wide range of colors fro limited choice. For photographic images, you need random dither pattern, while a regular one is bett business graphics (and it prints much faster, too). random, or diffuse, dither in your printer driver op

Dither patterns

What should be a smooth transition from pale blue to vihere appears banded and patterned. This is not because number of colors was used to simulate what really requihundreds of colors for accurate reproduction, but because colors were ordered into regular patterns. If distribution more random, the gradient would look much smoother.

Color management

After a decade of research and experimentation since the popular rise of digital photography, color technology is now able to get thousands of different screens, printers, and papers—as well as cameras —to work together to produce results with more or less reliable color. Now, the image captured by a camera may appear the same on the camera screen as on the computer monitor, and even the print from a desktop printer will look similar. Nevertheless, precise color matching is elusive, and the limitations of standard management systems such as ColorSync are now hindering progress.

First steps

Your monitor is central to color management. Not only do you view and manipulate your images there, but the monitor is also easily adjusted to meet a standard. That is the process of calibrating. Your computer operating system will allow you, through a control panel or System Preferences, to calibrate the screen using simple visual controls (see your system's Help section). See below for the basic settings required.

Calibration methods based on on-screen controls are inexpensive but rely on subjective judgments. The most objective method is hardware calibration, in which a color sensor is attached to the monitor and communicates with

the video control: it requests standard colors to be displayed, then measures the actual color with the target. The differences are used to calibrate and characterize the monitor's color performance in the form of a profile.

Precautions

Whichever calibration method you use, observe the following precautions. Allow your monitor (even LCD types) to warm up for at least 30 minutes before attempting calibration. Remove any devices that may cause magnetic interference, such as a hard-disc drive or loudspeakers. Calibrate the monitor in the light you normally work in-ideally low enough to make it difficult to read a newspaper. Do not allow desklamps to shine on the screen (see also pp. 62–3).

Color profiles

The way one device handles color is defined by the differences between its own set of colors and that of the profile connection space, which is the set of colors that a "typical" human can see and distinguish. This information, called the ICC (International Color Consortium) profile, is embedded in the image and includes other data about the white point and how to handle out-ofgamut colors (see p. 109). When an image carries

Calibration

Using the most accurate monitor calibrators or using on-screen targets will be of little help if the basic settings for gamma and white point are not carefully chosen to suit the end use of your images. If you supply to third parties such as stock agencies, magazines, or printers, consult them for their preferred monitor settings.

On-screen calibration

On-screen calibration offers prompts such as the above, showing steps for setting luminance response curves and the balance between the three colors. Settings are altered to match targets.

Linear gamma

With the screen set to Linear Gamma, the overall result is very bright, blacks are gray, and colors look washed out. Images adjusted on this screen would look too dark, saturated, and contrasty on normally adjusted screens.

1.8 gamma

The 1.8 gamma was formerly the default setting in Apple Macs and the print industry. It is now regarded as too bright compared to the 2.2 gamma standard on Windows machines. A gamma of 2.0 may be set as a compromise.

a color profile, a piece of equipment compliant with ICC profiles will "know" how to interpret the colors and adjust them, if necessary, for the output, whether it is display or print. There are different types of profile according to the device being used, but the key to color management is that every image you use should carry an appropriate profile. Adobe RGB (1998) is widely used for digital images. (See also pp. 264-7.)

Soft-proofing

Once your monitor is calibrated, you can use it to check how your images will look when printed; this is called soft-proofing. For this, the output profile must be the combination of printer and paper you will use. This profile can be set as the output space or applied to the viewed image directly. Applying an output profile usually makes the image look duller, but it should be a close match to the print.

Profile relationships

This diagram demonstrates how color characteristics of different devices can be translated to each other, using color profiles and a common color space.

An image file may be embedded with a color profile so that it can be accurately reproduced when it enters a different working color space.

most troublesome for avid photographers. But produced accurately and used correctly, they can help maintain reliable,

help the computer system control the monitor, ensuring that colors are produced accurately.

Source profiles are seldom used because the majority of files are processed visually and are only of value with digital images in highly controlled environments, such as studios.

Working color space is your starting point. The sRGB color space is widely used for digital cameras and gives acceptable results. Another standard is Adobe RGB (1998), which gives better results for professional use.

CMYK output profiles are important for professional users and publishers of magazines and books, but they need not concern the majority of photographers.

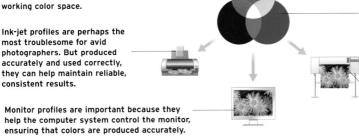

2.2 gamma

The standard on Windows machines, indicating a high level of correction to the monitor's output. Colors are rich, and blacks appear solid while retaining shadow detail but the image quality is a poor match for print quality.

D50 target white

Formerly widely accepted as the standard target white point for a monitor-that is, the monitor attempted to display white according to the definition for D50. The result appears to modern eyes to be creamy or yellowish.

D65 target white

As incadescent lights are used less and more prints are made on bright white paper, the D65 target white has become more widely adopted. It gives a cooler, bluer result than D50 and is a good choice for general digital photography.

9300 target white

Suitable for domestic TV and video, where the final viewing is on TV sets, this white point is generally too blue for digital photography. Using 9300 will result in images that look too red or yellow, and with flattened contrast.

Image management

The problem of managing images has grown exponentially since the beginnings of digital photography. From once taking a few dozen shots per day, photographers now commonly shoot hundreds of images daily: 1,500 images from a single wedding assignment is not unusual, and even a beach vacation can turn in 2,000 or more images. Work methods and specialty software have evolved to ensure the flood of images does not overwhelm the photographer.

Image work-flow

A little forward planning is the key to an efficient work-flow. You can organize your images by date, or assignment or by project—that is, a vacation or trip, or a favorite subject, such as "Urban views" or "Portraits." Within each assignment or project, you can create subfolders by date, by type of image, and so on. Folders on the computer are like their paper counterparts—they are awkward to handle if they get too full but inefficient if you have too many folders with very few items in them.

A good strategy is to organize your folder structure before you shoot, since that helps you to plan your photography and ensures efficiency later, when you want to locate your images. At the same time, plan your backup. Make sure you have sufficient space on another hard disc to create a backup copy as soon as you have downloaded your images.

File naming

Digital cameras automatically give file names to each image, adding a sequential serial number to each new image. Some cameras restart counting whenever you insert a new card. This easily leads to disaster because you can accidentally overwrite images. Always set your camera to series, or sequential, numbering.

When uploading images from your camera to the computer, you may use software (such as Apple Aperture, Adobe Lightroom, or Camera Bits Photo Mechanic) that changes the file name to something useful, like

"Korthi_2010-08-31_123.jpg"—this tells us that it's image number 123 from Korthi, taken on August 31, 2010. Note that the underscores, dashes, and period used in this name are the only recommended marks; do not use marks such as an asterisk (*) or forward slash (/).

Metadata

The most important new contribution to managing images is the now-central role of metadata—data about the image that does not form the image, such as the location, the keywords, the caption, the copyright, and other information. The time to add metadata to your images is when you import them into your system: add the broad caption details, such as "Korthi, Andros Island, Cyclades, Greece," and the keywords: "Andros, Cyclades, olive, tree, terraces, agriculture, sunset." With some cameras, you may even add GPS (Global Positioning System) data to the image to locate it unambiguously.

As your collection grows, the keywords become an immensely powerful tool for locating images. For example, if you have traveled to Spain, Italy, and France over the years, a single search for the keyword "olive" will locate, within seconds, all your pictures of olives and olive trees.

Archiving

Always archive and back up your digital files. Some photographers delete the images they consider worthless before making archives, others reason that storage space is so low-cost that it is better not to risk losing images from a hasty decision to delete. There are many strategies. One way to archive your digital files is to copy them onto DVD or Blu-ray Disc, using a writer. Ensure you keep these backups in a location distant from your other copies of images. Another method is to use online, off-site services such as photo-sharing websites. These can work out to be much less costly than running your own hard-disc "farm" and have the added advantage that you can access your images via the internet from anywhere in the world, though speed of access may be reduced.

You may consider keeping archives of early working or work-in-progress files, not just the original and final files. These can create useful records for historical reasons-in case of litigation over copyright, for example. And sometimes ideas that do not fit one project may be useful for another, though you may not know it until months or years later.

Not only will you produce innumerable digital files in a short time, you may also produce lots of ink-jet prints. You should value all this work after all, you will have put in a great deal of skill and time, so it makes sense to manage these assets properly. An essential part of good practice is to label or number all your work, and certainly the final prints. Make a note of the file name on the back of the print, as well as details such as the printer settings and paper type. Store your successful printouts in archival-quality boxes made from buffered, acid-free cardboard.

CO. CO Carrier TA CO. C. F. selecte C. F. S. acr CC. C. F. LL - CS Dan Co. C. + milbi (1) Test 4

File lists

Image files can be shown in lists that display a thumbnail of the image together with all its associated metadata. Selecting one of the images allows the metadata to be edited. In software such as Apple Aperture (shown here) or Adobe Lightroom, imageenhancement controls are available alongside tools for organizing material for slide shows, web pages, or books.

Management software

One of the best ways to organize your images is by using management software. Applications worth considering include Adobe Lightroom, Apple Aperture, Extensis Portfolio, ACDSee. and Camerabits Photo Mechanic (shown here). Not only do all these programs help you to keep picture files organized, but they can also create "contact prints" and slide shows, as well as publishing picture collections to the web.

All about image manipulation

First steps

The usual way to open a file is to double-click on it: place the cursor over the file's icon and quickly click the mouse twice. The computer's operating system then checks what type of file it is and launches a suitable software application. However, the computer's choice of application may not be yours. A preferred method is to start the application you wish to work with, then open the file from within it via File > Open. This also has a higher opening success rate.

Image sources

Images from specialized sources may need to be opened from within an application recommended by the manufacturer. In particular, raw files from cameras must be opened by software that recognizes the file type, in order for it to interpret the data correctly. If a raw file cannot be opened, you will need to update your software.

Internet downloads

Images from websites are usually in JPEG format (see pp. 226–7). If you expect to work on an image and then save it for extra treatment later on, it is good practice to perform a Save As on the file into Photoshop or TIFF format. Each time you make changes and save and close an image in JPEG, it is taken through the lossy-compression regime. This means that progressively, if subtly, the image quality is degraded.

Copyright and watermarks

Images from picture-agency discs, the web, or CDs and DVDs given away with magazines may show a "watermark"—such as the company's or photographer's name—printed across the image. This prevents piracy and asserts the owner's copyright. Images may also be invisibly marked: although there is no printing overlaying the images, they resist all but the most destructive changes to the files and suitable software can readily detect the invisible identification watermark. The bottom line is, if you are not sure whether you are infringing copyright in an image, do not use it (*see also pp. 374*–5).

Image degradation

This original portrait (top left) was saved several times with maximum JPEG compression (top right). Used small like this, the image is acceptable but, in fact, the original is far better, with smoother tones and more accurate color.

A close-up look at the original image (above left) shows continuous tones and unbroken lines, while the damage to the compressed version (above right) is obvious. A large print made from the JPEG image would simply not be acceptable.

"Choose Application" dialogue

On opening a file that has lost its association with a suitable software application, you will be asked by the system, via a dialogue box such as this, to locate an appropriate program. If your application does not appear, navigate to the folder in which you installed it.

Color mode

The image's color mode is crucial to the success and quality of manipulation. RGB is useful for the majority of image enhancements, but LAB is best for preserving color data to maintain image quality. The initial RGB capture underwater (above) was low-contrast and carried an overall green cast. If it is left in RGB, Auto Levels gives it a bright, colorful, but not accurate result (above right). In LAB mode, automatic Levels correction produces true-to-life colors with accurate tonality.

Adobe Photoshop

Could not open "IMG_5200.JPG" because an invalid SOS, DHT, DQT, or EOI JPEG marker is found before a JPEG SOI marker.

ОК

"Could not open" warning

If you see this warning box on your screen, or one like it, do not worry. You should be able to open the file concerned from within an application. To do this, launch the application first and then try to open the file using the menu options provided.

Checking the image

- Check color mode and bit depth. Files from scanners may be recorded in LAB files. Most imagemanipulation software works in 24-bit RGB color, and if the image is not in the correct mode, many adjustments are unavailable or give odd results.
- Check that the image is clean—that there are no dust spots or, if a scan, scratches or other marks. Increasing the contrast of the image and making it darker usually helps show up faint dust spots.
- Ensure the image has not had too much noise or grain removed.
- Assess image sharpness. If the image has been overly sharpened, further manipulation may cause visible edge artifacts.

- Is exposure accurate? If not, corrections may cause posterization or stepped tonal changes.
- Is the white balance accurate? If the file is not raw format, corrections may cause inaccurate colors and tones.
- Are the colors clear and accurate? If not, corrections may cause posterization, stepped tonal changes, or less accurate hues.
- Check there is no excess border to the image. It may upset calculations for automatic levels or other corrections.
- Check the file size. It should be adequate for your purposes but not much larger. If it is too small, you could work on it for hours only to find it is not suitable for the output size desired. If it is too large, you will waste time as all manipulations take longer than necessary to complete.

Cropping and rotation

Always check that scanned images are correctly oriented—in other words, that left-to-right in the original is still left-to-right after scanning. This is seldom a problem with images taken with digital cameras, but when scanning a film original it is easy to place the negative or transparency the wrong way around-emulsion side either up or down, depending on your scanner—so that the scanned results become "flipped." Getting this right is especially important if there is any writing or numbering in the image to prevent it reversing, as in a mirror image.

Image cropping

The creative importance of cropping, to remove extraneous subject detail, is as crucial in digital photography as it is when working with film. But there is a vital difference, for not only does digital cropping reduce picture content, it also reduces file size. Bear in mind, however, that you should not crop to a specific resolution until the final stages of image processing, as "interpolation" may then be required (see pp. 260-1). This reduces picture quality, usually by causing a slight softening of detail. Image cropping without a change of resolution does not require interpolation.

In general, though, at the very least you will want to remove the border caused by, for example, inaccurate cropping when making the scan. This

area of white or black not only takes up valuable machine memory, it can also greatly distort tonal calculations, such as Levels (see pp. 244-5). If a border to the image is needed, you can always add it at a later stage using a range of different applications (see p. 262).

Image rotation

The horizon in an image is normally expected to run parallel with the top and bottom edges of the image. Any slight mistakes in aiming the camera, which is not an uncommon error when you are working quickly or your concentration slips, can be corrected by rotating the image before printing. With film-based photography, this correction is carried out in the darkroom during the printing stage. But since it is a strictly manual process, you should not expect this type of correction to be an option available from the fully automatic printers found in minilabs.

In digital photography, however, rotation is a straightforward transformation, and in some software applications you can carry out the correction as part of the image-cropping process.

Note that any rotation that is not 90°, or a multiple of 90°, will need interpolation. Repeated rotation may cause image detail to blur, so it is best to decide exactly how much rotation is required, and then perform it all in a single step.

Fixed-size cropping

Some manipulation software, such as Photoshop, allows you to crop to a specific image size and to a specific output resolution—for example, 5 x 7 in (13 x 18 cm) at 225 dpi. This is useful since

it combines two operations in one and is very convenient if you know the exact size of image neededperhaps a picture for a newsletter. If so, enter the details in the boxes, together with the resolution. The crop area will then have the correct proportions, allowing you to adjust

the overall size and position of the image for the crop you require. Cropping to a fixed size is useful for working rapidly through a batch of scans.

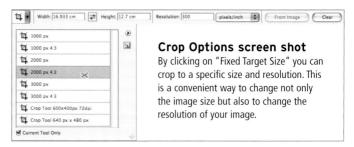

Creative cropping

Cropping can help rescue an image that was not correctly framed or composed. By removing elements that are not required or are extraneous to what you intended, you can create a more visually coherent final image. Be aware that crops to one side of a wide-angle image may appear to distort perspective, since the center of the image will not correspond to the center of perspective. Cropping decreases the size of the image file and calls on the image's data reserves to maintain image quality.

Sloping horizon

A snatched shot taken with a wide-angle lens left the horizon with a slight but noticeable tilt, disturbing the serenity of the image. But by rotating a crop it is possible to correct the horizon, although, as you can see from the masked-off area (above left), you do have to sacrifice the marginal areas of the image. Some software allows

you to give a precise figure. for the rotation; others require you to do it by eye. Some scanner software gives you the facility to rotate the image while scanning.

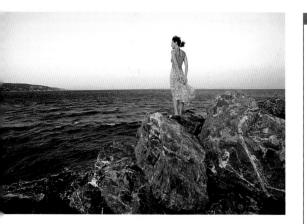

Saving as you go

Adopt the habit of saving your working file as you proceed: press Control + S (PC) or Command + S (Mac) at regular intervals. It is easy to forget in the heat of the creative moment that the image on the monitor is only virtual—it exists just as long as the computer is on and functioning properly. If your file is large and what you are doing is complicated, the risks that the copmuter will crash are increased (and the resulting loss of the work more grievous). A good rule to remember is that if your file is so large that making frequent saves is an inconvenient interruption, then you definitely should be doing it, inconvenient or not.

Quick fix Poor subject detail

Although in most picture-taking situations the aim is to produce the sharpest possible image, there are situations where blur is desirable.

Problem

Images lack overall "bite" and sharpness and subject detail is soft or low in contrast overall.

Analysis

Unsharp subject detail and low contrast can have many causes: a poor-quality lens; inaccurate focusing; subject movement; camera movement; dust or scratches on the lens; an intervening surface, such as a window; and overmagnification of the image.

Solution

One of the great advantages digital photography has over film-based photography is that unsharpness can, to varying extents, be reduced using image-processing techniques. The main one is unsharp masking (USM). This can be found on nearly all image-manipulation software: in Photoshop it is a filter; it is provided by plug-in software such as Extensis Intellihance; and the software drivers for many scanners also provide it. Some digital cameras also apply USM to images as they are being recorded (see pp. 252–5).

However, while USM can improve the appearance of an image, there are limits to how much subject information it can retrieve. In particular, unsharpness caused by movement usually shows little or no improvement with USM. At times, a simple increase in image contrast and color saturation can help to improve the appearance of image sharpness.

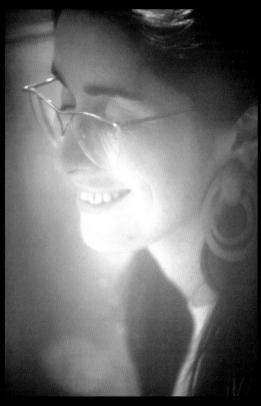

Turning the tables Blurred, low-contrast images are not necessarily failures. This portrait was taken through a dusty, smeary window. The diffusion has not only softened all image contours, it has also reduced contrast and introduced some

flare into the shadow areas. These are usually fatal image flaws, but if they appear in association with the right subject they can add a degree of character and atmosphere, rather than detract from picture content.

How to avoid the problem

- Keep the front surface of your lens and any lens filters clean. Replace scratched filters if necessary.
- Focus as precisely and carefully as possible.
- Release the shutter smoothly, in a single action. For longer handheld exposures, take the picture as
- For long exposures, use a tripod or support the camera on some sort of informal, stable support, such as a table, window ledge, wall, or a pile of books, to prevent camera movement.
- Experiment with your lens—some produce unsharp results when they are used very close-up, or at the extreme telephoto end of the zoom range

Quick fix Poor subject color

If, despite your best efforts, subject color is disappointing, there is still a range of imagemanipulation options to improve results.

Problem

Digital images are low in contrast, lack color brilliance, or are too dark. Problems most often occur in pictures taken in overcast or dull lighting conditions.

Analysis

Just like film-based cameras, digital cameras can get the exposure wrong. Digital "film" is, if anything, more difficult to expose correctly, and any slight error leads to poor subject color. Furthermore, high digital sensitivities are gained at the expense of poor color saturation; so, if the camera's sensitivity is increased to cope with low light levels, color results are, again, likely to be poor.

Overcast light tends to have a high blue content, and the resulting bluish color cast can give dull, cold images.

Solution

An easy solution is to open the image in your imagemanipulation software and apply Auto Levels (see pp. 244-5). This ensures that your image uses the full range of color values available and makes some corrections to color casts. Although quick, this can overbrighten an image or make it too contrasty.

Some software, such as Digital Darkroom and Extensis Intellihance, will analyze an image and apply automatic enhancement to, for example, concentrate on increasing the color content or correcting a color cast.

The handiest single control is the universally available Saturation (see pp. 258-9 and 264-7).

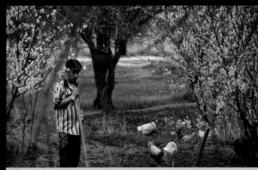

Problem...

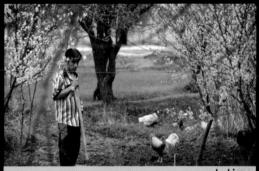

...solution

Manipulation options

The original scan (top) is not only dull, it is also not an accurate representation of the original scene. However, Auto Levels has generally

brightened up the image (above). Color saturation was increased using the Hue and Saturation control, and, finally, the USM filter was applied to help improve the definition of subject detail.

How to avoid the problem

- In bright, contrasty lighting conditions it may help to underexpose by a small amount: set the camera override to -1/2 of a stop or -1/2 of a stop, depending on what the controls permit.
- · Avoid taking pictures in dull and dark conditions. However, bright but partly overcast days usually provide the hest color saturation. On overcast days

consider using a warm-up filter (a very light orange or pink color) over the camera lens.

 Avoid setting the camera to very high sensitivities—for example, film-speed equivalents of ISO 800 or above. And avoid using high-speed color film of any type in a conventional camera if color accuracy is crucial

Levels

The Levels control shows a representation, in the form of a histogram, of the distribution of tone values of an image. Levels offers several powerful options for changing global tone distribution. The easiest thing to do is to click on the Auto Level button. This, however, works effectively in very few cases. What it does is take the darkest pixel to maximum black and the brightest pixel to maximum white, and spreads everything else evenly between them. This, however, may change the overall density of the image.

Another control that may be available is Output Level. This sets the maximum black or white points that can be produced by, say, a printer. Generally, by setting the white point to at least 5 less than the maximum (in other words, to about 250) you prevent the highlight areas in your output image from appearing totally blank. Setting the black point to at least 5 more than the minimum (in other words, to about 5) you will help to avoid the shadow areas looking overly heavy in your output image.

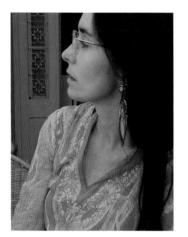

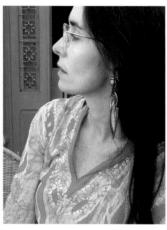

Auto Level

An underexposed image contains dark tones with few high-value ones (far left), confirmed in the Levels display (bottom far left). The gap on the right of the histogram indicates an absence of values lighter than three-quarter tone, with peak values falling in deep shadow. Applying Auto Level (left) spreads all available pixel values across the whole dynamic range. The new Levels display (bottom left) has a characteristic comblike structure, showing gaps in the color data. Auto Level not only brightens colors and increases contrast, it also causes a slight overall color shift.

How to read Levels

The Levels histogram gives an instant check on image quality—perhaps warning of a need to rescan.

- If all values across the range are filled with gentle peaks, the image is well exposed or well scanned.
- If the histogram shows mostly low values (weighted to the left), the image is overall low-key or dark; if values are mostly high (weighted to the right), the image is high-key or bright. These results are not necessarily undesirable.
- If you have a sharp peak toward one or other extreme, with few other values, you probably have an image that is over- or underexposed.
- If the histogram has several narrow vertical bars, the image is very deficient in color data or it is an indexed color file. Corrections may lead to unpredictable results.
- A comblike histogram indicates a poor image with many missing values and too many pixels of the same value. Such an image looks posterized (see p. 268).

Well-distributed tones

As you can see from this Levels histogram, a bright, well-exposed image fills all the available range of pixels, with no gaps. Since the image contains many light tones, there are more pixels lighter than midtone, so the peak of the histogram lies to the right of center. This image would tolerate a lot of manipulation thanks to the richness of color data it contains.

Deficient color data

An image with only a limited color range, such as this still-life composition, can be turned into a very small file by saving it as an indexed color file (*p. 274*). In fact, just 55 colors were sufficient to represent this scene with hardly any loss of subject information. However, the

comblike Levels histogram associated with it indicates just how sparse the available color data was. Any work on the image to alter its colors or tonality, or the application of filter effects that alter its color data, would certainly show up artifacts and produce unpredictable results.

Histogram display

The histogram for this image shows midtones dominated by yellow and blue with large amounts of red in mid- to light tones, consistent with the strong orange color of the shirt. This display is from the FotoStation application, which displays histograms for each RGB separation in the corresponding color.

Two techniques used in film-based and digital photography for manipulating the local density of an image are known as burning-in and dodging.

Controlling density

Burning-in increases the density in the area of the image being worked on, while dodging reduces it. Both techniques have the effect of changing the tonal reproduction of the original either to correct errors in the initial exposure or to create a visual effect. For example, the highlights and shadows of both film and digital images are low in contrast, and to counteract this you can burn in and dodge

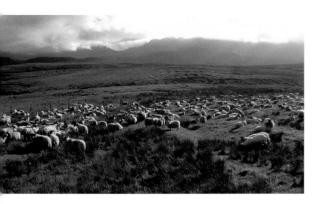

to bring out what shadow and highlight detail does exist by increasing local image contrast.

The same techniques can be used in order to reduce contrast—to darken highlight areas, for example—to bring them tonally closer to image midtones. An often-used application of this in conventional photography is burning in areas of sky when printing to darken them. Increasing the exposure of the sky (while shading, or dodging, the rest of the print) not only helps differentiate sky and cloud tonally, it also helps to match the sky tones to those of the foreground.

Digital techniques

In digital photography, burning-in and dodging are easily achieved using the tools available in all image-manipulation software. Working digitally, you can be as precise as you like—down to the individual pixel, if necessary. And the area treated can be between 1 and 100 percent of the image area, nominated by the Marquee or Lasso tool.

A drawback of working digitally, however, is that when manipulating large areas, results are often patchy and uneven, while working on large areas in the darkroom is easy.

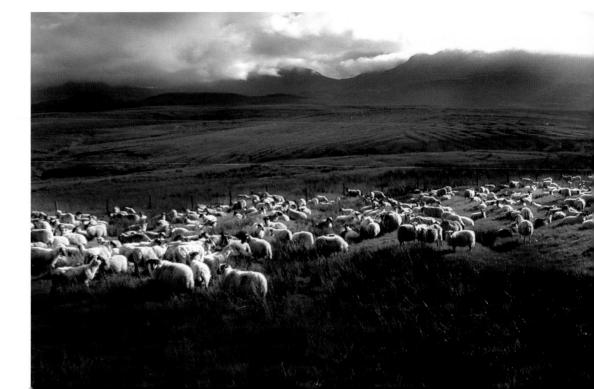

Working digitally, some applications allow you to set the tool for the shadows, midtones, or highlights alone. Carefully choosing the tonal range to be manipulated helps avoid telltale signs of clumsy burning-in and dodging. Corresponding techniques, available in Photoshop and some other professional software packages, are known as Color Dodge and Color Burn painting modes.

Color Dodge is not only able to brighten up the image, but also pushes up image contrast as you apply the "paint." In addition, if you set a color other than white, you simultaneously tint the areas being brightened. Color Burn has similar effects—darkening and increasing image contrast.

Correcting exposure

Taken on a bright winter afternoon, the camera's meter was fooled by the sudden appearance of the sun within the picture area, causing it to underexpose the scene (above left). This situation can be rescued using the Dodging tool set to work on the highlights areas alone. However, to produce the corrected image shown here

(above right), the Paintbrush tool was chosen and set to Color Dodge. By using the brush in this mode, set to a mid-gray color and with lowered opacity (for example, 50 percent), you will obtain more rapid results with less tendency to burn out subject details. As an optional way of working, paint onto a new layer set to Color Dodge mode.

Correcting color balance

Looking at the original image (above left), the temptation to burn in the foreground and some of the background in order to "bring out" the sheep is irresistible. Brief applications of the Burn tool on the foreground (set to mid-tone at 10 percent) and background hills, plus the Dodge tool on the sheep (set to highlight at 5 percent) produced an image (left) that was very similar to the scene as it appeared at the actual time of shooting.

HINTS AND TIPS

- Apply dodging and burning-in techniques with a light touch. Start off by using a light pressure or a low strength of effect—say, 10 percent or less—and then build up to the strength the image requires.
- When burning in image highlights or bright areas, set the tool to burn in the shadows or midtones. Do not set it to burn in the highlights.
- When burning in midtones or shadows, set the tool at a very light pressure to burn in the highlights or midtones. Do not set it to burn in the shadows.
- When dodging midtones, set the tool at very light pressure to dodge the highlights or midtones. Do not set it to dodge the shadows.
- When dodging shadows, set the tool to dodge the highlights. Do not set it to dodge the shadows.
- Use soft-edged or feathered Brush tools to achieve more realistic tonal results.

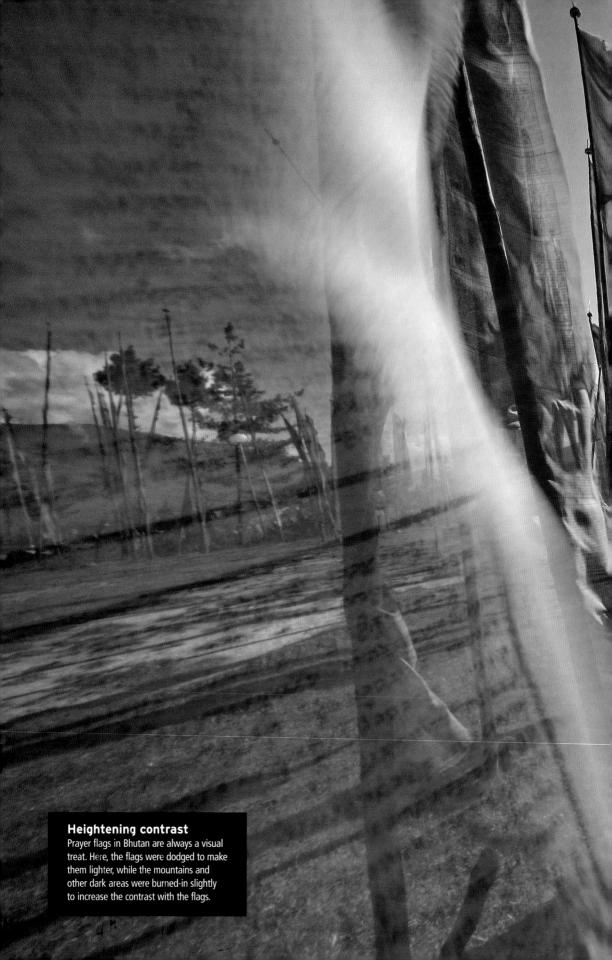

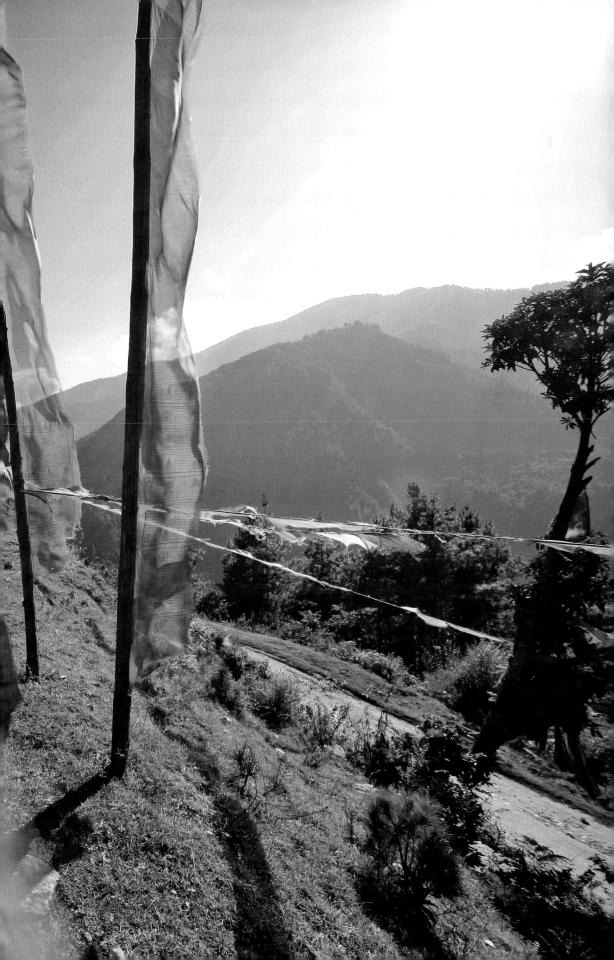

Dust and noise

Two factors are the "forever enemies" of image quality: dust and noise. Dust spots on the image result when material such as dust or pollen lands on the photosensor of a digital camera or on film to be scanned. Dust is a serious problem with dSLRs, since debris on the photosensing surface will be recorded on every single image. Noise usually seen as pixels markedly different from neighboring pixels and not caused by subject features—arises from the electronic properties of the photosensor of a digital camera or scanner.

Noise control

You can reduce noise where the noise has a higher frequency than the image detail itself—in other words, if the specks are much smaller than the detail in the image. This is one advantage of increasing the pixel count of images. In lowresolution images, applying a noise filter smudges image information along with the noise signals. Digital filters such as Noise Ninja are effective at reducing noise only where required, and all

raw converters can reduce noise. DxO Optics stands out by reducing noise before applying color interpolation.

Dust-removal options

Some scanners provide "dust-removal" features to mask the damage caused by dust, and replace the resulting gaps in the image with pixels similar to those adjacent to the problem areas. These can work well, although some may disturb the film's grain structure, while others work only on color film.

Many cameras incorporate mechanisms to reduce dust, using, for example, rapid vibration to shake off particles or antistatic coatings to keep from attracting particles.

Certain digital SLR models offer dust-removal software: you photograph a plain surface, have the result analyzed by the software, which then creates a "mask" that can be applied to images to remove the dust. You may also have to help the camera directly by cleaning the

Dust on sensor

A 300 percent enlargement of the corner of a digital camera capture (above) shows a few faint specks of dust. They are blurred because they lie some distance above the sensor, which "sees" only their shadows. However with manipulation, the pale spots will become more visible.

Dust revealed

The full extent of the dust spots is revealed when we apply an adjustment layer to increase contrast and decrease exposure of the image (left). This presents the worse-case scenario and makes it easy to identify and eliminate the spots.

Dust removed

Use the Spot Healing Brush, Healing Brush or Clone Stamp tool to remove the dust spots. Set the brush to just slightly larger than the average spot, with a sharply defined brush edge, and sweep systematically in one direction.

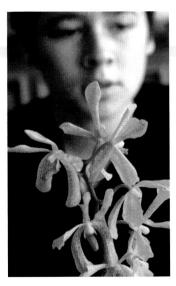

Noisy image

Poor noise-suppression circuitry and an exposure of 1/8 sec gave rise to this "noisy" image. Long exposures increase the chance of stray signals, which increase noise in an image.

Screen shots

Examining the different channels (above) showed that the noisiest was the green one. This was selected and Gaussian Blur applied (top). The radius setting was adjusted to balance blurring of the specks while retaining overall sharpness.

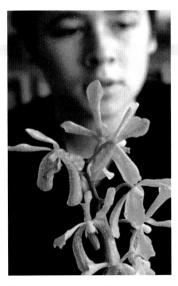

Smoother but softer

The resulting image offers smoother tones—especially skin tones—but the cost is visible in reduced sharpness of the orchids. You could select the red and blue channels to apply Unsharp Masking to improve the appearance of the flowers.

sensor using ultra-soft micro-porous swabs or ultra-fine brushes that sweep up the dust and reduce static charges.

Manual removal

The key image-repair technique is to replace the dust with pixels that blend in with neighboring pixels. Depending on your tool of choice, you either manually select the source for the pixels to cover the dust—this is Cloning—or you let the software sample from around the dust and apply an algorithm that blends local pixels with the dust to hide the spots—in Photoshop, this is called Healing. Where the spots are too numerous, a blurring filter may help, but this will also blur image detail that is the same size as the spots.

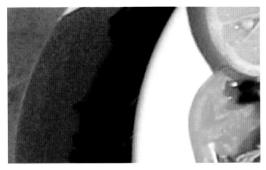

Noise in detail

In this close-up view of an image, it is clear there is more noise, or random pixels (seen as specks and unevenness of tone), in the darker areas than in the brighter ones.

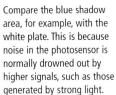

HINTS AND TIPS

- Clone with the tool set to maximum pressure, or 100 percent—as lighter pressure produces a smudged or soft-looking clone.
- In even-toned areas, use a soft-edged or feathered Brush as the cloning tool. In areas with fine detail, use a sharp-edge Brush instead.
- You do not always have to eliminate specks of dust—reducing their size or contrast may be sufficient to disguise them.
- Work systematically from a cleaned area into areas with specks, or you may find yourself cloning dust specks, thereby compounding the problem.
- If cloning gives an overly smoothed look, introduce some noise to make it look more realistic. Select the area for treatment and then apply the Noise filter.

Sharpening

The ease with which modern image-manipulation software can make a soft image appear sharp is almost magical. Although software cannot add to the amount of information contained in an image, it can put whatever information is there to the best possible use. Edges, for example, can be given more clarity and definition by improving local contrast.

Digitally, sharpen effects are true filters, since they hold back some components and selectively let others through. A Sharpen filter is, in reality, a "high-pass" filter—it allows high-frequency image information to pass while holding back low-frequency information.

Unsharp Masking

The most versatile method of image sharpening is Unsharp Masking (USM). This takes a grid of pixels and increases edge definition without introducing too many artifacts. Unsharp Mask has three settings. In Photoshop, they are called Amount, Radius, and Threshold. Amount defines how much sharpening to apply; Radius defines the distance around each pixel to evaluate for a change; Threshold dictates how much change must occur to be acceptable and not be masked.

It is possible to overdo sharpening. In general, assess image sharpness at the actual pixel level, so that each pixel corresponds to a pixel on the monitor. Any other view is interpolated (*see pp. 260–1*) and edges are softened, or antialiased, making sharpness impossible to assess properly.

As a guide, for images intended for print, the screen image should look very slightly oversharpened, so artifacts (such as halos or bright fringes) are just visible. For on-screen use, sharpen images only until they look right on the screen.

Sharpening makes deep image changes that cannot easily be undone, so it is generally best to leave sharpening to last in any sequence of image manipulations, except for combining different layers. However, if you are working on a scan with many dust specks and other similar types of faults, you should expect the final sharpening to reveal more fine defects, so be prepared for another round of dust removal using cloning (*see pp. 250–1*).

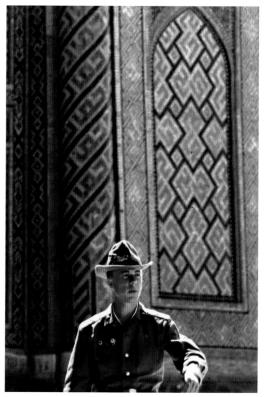

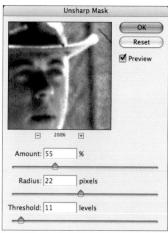

Undersharpening

In images containing large amounts of fine detail, such as this scene taken in Uzbekistan, applying a modest strength of USM filtering (55) and a large radius (22), with a threshold set at 11, does little for the image. There is a modest uplift in sharpness, but this is due more to an overall increase in contrast than to any other effect.

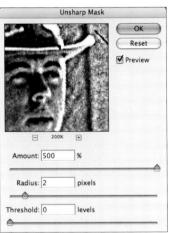

Oversharpening

The maximum strength setting used for this version results in over-sharpeningit is still usable and is arguably a good setting if you intend to print on poorquality paper. The same setting applied to the Kashgar image (pp. 254-5) would simply bring out all the film grain—a technique for increasing noise in the image.

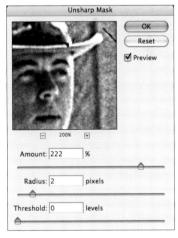

Ideal setting

The best settings for images with fine detail is high strength with a small radius and a very low threshold: here, strength was 222, the radius was 2, and the threshold was kept at 0. Details are all well defined, and if large-size prints are wanted, details are crisper than those obtained with sharpening using a larger radius setting.

Sharpening continued

Original image This photograph of the main town square in Kashgar, Xinjiang, China, has large

areas of smooth tone with little fine detail, and it would clearly benefit from the effects of image sharpening.

HINTS AND TIPS

Using an advanced Photoshop technique for image sharpening, first mask off areas (such as a face) to be protected from oversharpening and any associated increase in defects. Next, produce a duplicate layer of the background and set it to Soft Light mode. This increases contrast overall. Then apply the High-Pass filter (found under the Filter menu in Other > High Pass). Increasing the radius strengthens the effect (passes higher frequencies, or more detail). You can now enter Quick Mask mode or add a layer mask to control which areas of the image will be sharpened by the High-Pass filter. This method is also effective for sharpening an image overall and can be controlled by direct settings and by opacity. However, the preview window in the dialog box does not give an accurate view because it samples only the top layer.

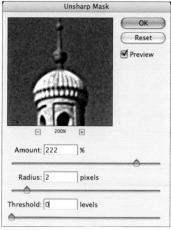

Oversharpening

If you increase the sharpening effect (222 in this version) and reduce the threshold (0), but reduce the radius to 2, virtually everything in the image increases in sharpness. The result is that film grain and fine detail are sharpened to an undesirable extent. Compare the result of these settings with that of an image that contains a mass of fine detail (p. 252).

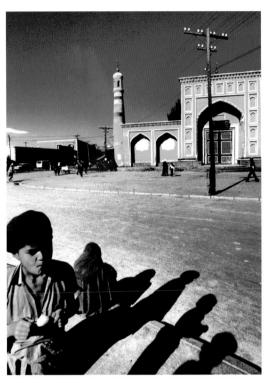

Sharpening areas of tone

A moderate amount of sharpening (55) and a relatively wide radius for the filter to act on (22) improve sharpness where there is subject detail, without bringing out film grain or unwanted information, such as in the subject's skin tones. A threshold setting of 11 prevents the filter from breaking up smooth tonal transitions, as the sharpening effect operates only on pixels differing in brightness by more than 11 units.

Extreme settings

This version results from maximum amount and radius settings. The effect is extreme, but a threshold of 32 controls coloration. Even so, the image has highly saturated colors and brilliant contrast. In addition, film grain is emphasized. The random appearance of film grain gives more attractive results than the regular structure of a digital image, so if you want to use this effect, introduce image noise first.

Blurring

Blur can be introduced by lowering contrast to give boundaries a less-distinct outline. This is the opposite of sharpening (see pp. 252-5). Paradoxically, blurring can make images look sharper, for if you throw a background out of focus, then any detail in front looks sharper in comparison.

Blur options

Blur effects are seldom effective if applied to the whole image, since they often fail to respond to the picture's content and character. The Median and Dust & Scratches filters produce an effect

like looking through clear, moving water. For some subjects this is appropriate, but for blur with some clarity, other methods are better. One approach depends on the data-loss caused by interpolation (see pp. 260-1) when reducing file sizes. First, increase image size by, say, 300 percent, using Resampling, and then reduce it to its original size. Check its appearance and repeat if necessary. This does take time, but it can give welldetailed, softly blurred results. A quicker, though less-adaptive, method is to reduce the file size, and then increase it, repeating this step as necessary.

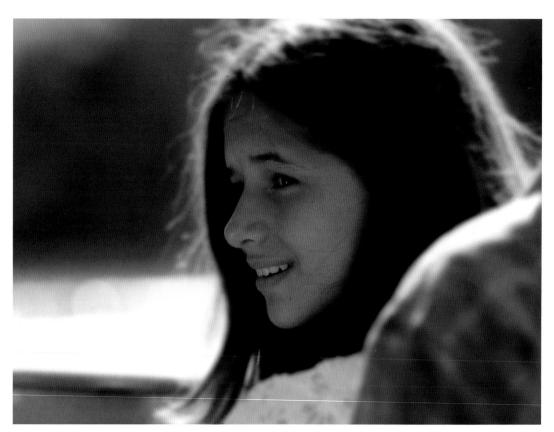

Selective blur

Although you will not often want to blur an image in its entirety, selective blurring, and thus the softening of subject detail, can be extremely useful on occasion. To take one example, the blurred areas of an image could become the perfect background for typography—perhaps on a webpage—since the wording would then be easier to read. Another example could be to introduce digital selective blur to simulate the appearance of

using a special effects, soft-focus lens filter. This type of glass filter is designed to soften all but a central region of the image in order to help concentrate the viewer's attention on a particular feature. In the example shown here—an informal portrait of a traveler on a ferry on the Danube River, Hungary the high-contrast sunlight and the sharpness of background detail were softened to emphasize the girl's features.

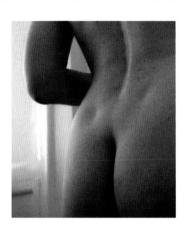

Original image

In this unworked scan (*left*), you can see that the original image was critically sharp, and minor defects, such as freckles on the subject's skin, were very obvious.

The appearance of the subject's skin was softened in this example (*right*) by reducing the file to a quarter of its original size and then increasing it a total of four times.

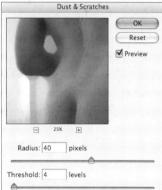

Gaussian Blur filter

This version of the original image is the result of applying a Gaussian Blur filter with a setting of 5. It is, as you can see, fuzzy rather than soft and is, pictorially, not a very convincing result.

Median filter

This option, introducing Median blur, bears a strong family resemblance to the effects of the Dust & Scratches filter (right). As you can see from the dialog box, a radius of 36 pixels was selected, and results are now becoming more useful.

Dust & Scratches filter

This version is the result of applying the Dust & Scratches filter with a radius of 40 pixels and a threshold level of 4.

Quick fix Image distractions

Unless there is a fundamental problem with your image, most minor distractions can be removed, or at least be minimized, using digital techniques.

Problem

While concentrating on your subject, it is easy not to notice distracting objects in the picture area. This could be something minor, such as a discarded food wrapper, but out-of-focus highlights can also be a problem.

Analysis

The small viewfinders of many cameras make it difficult to see much subject detail. Furthermore, though something is distant and looks out of focus, it may still be within the depth of field of your lens (see pp. 74-7). At other times, you simply cannot avoid including, say, telephone lines in the background of a scene.

Solution

You may not need to remove a distraction completely simply reducing the difference between it and adjacent areas may be enough. The usual way to achieve this is with cloning—duplicating part of an image and placing it into another part (see pp. 334-9). For example, blue sky can be easily cloned onto wires crossing it, as long as you are careful to use areas that match in brightness and

hue. If you clone from as close to the distraction as possible, this should not be too much of a problem.

You could also try desaturating the background: select the main subject and invert the selection; or select the background and lower saturation using Color Saturation. You could also paint over the background using the Saturation or Sponge tool set to desaturate.

Another method is to blur the background. Select the main subject and invert the selection, or select the background directly, and apply a Blur filter (see pp. 256-7). Select a narrow feather edge to retain sharpness in the subject's outline. Choose carefully or, when Blur is applied, the selected region will be left with a distinct margin. Try different settings, keeping in mind the image's output size—small images need more blur than large ones.

How to avoid the problem

Check the viewfinder image carefully before shooting. This is easier with an SLR camera, which is why most professionals use them. Long focal length lenses (or zoom settings) reduce depth of field and tend to blur backgrounds. And, if appropriate to the subject, use a lower viewpoint and look upward to increase the amount of non-distracting sky.

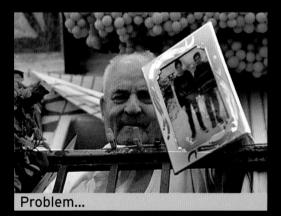

Foreground distraction

An old man photographed in Greece shows me a picture of his sons. As he leans over the balcony, the clothespins in front of his chin prove impossible to avoid

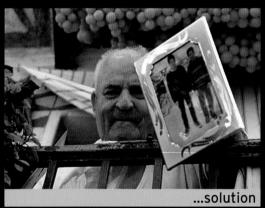

Clonina

Luckily, in this example there was enough of the man's skin tone visible to give a convincing reconstruction. To do this, the skin nart of the image was used to clone areas of color over the

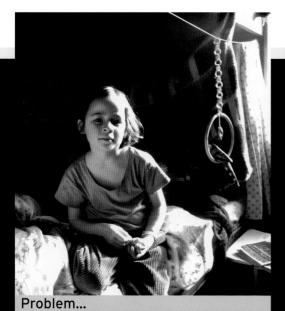

Background distractions

In the chaos of a young child's room, it is neither possible nor desirable to remove all the distractions, but toning them down would help to emphasize the main subject.

Desaturated background

Applying Desaturate to the background, turning all the colors into gray, has helped separate the girl from the numerous objects surrounding her. A large, soft-edged Brush tool was chosen and the printing mode was set to desaturation at 100 percent.

Problem...

Selective blur

Despite using a large aperture, a wide-angle lens setting still produced more depth of field than I wanted in this example (above left). To reduce the intrusive sharpness of the trees, I used the Gaussian Blur filter set to a radius of 9 pixels (right). First, I selected the figure with a feathering of 5 and then inverted this selection in order to apply the Gaussian Blur to the background alone (above right).

Image size and distortion

One of the most common manipulations is to change the output size of the image. There are three classes of change; the first two methods change size uniformly across the entire image, which does not change picture shape. You can change the output size of the image but keep the file size of the image the same: this is resize without resampling (or without changing the number of pixels). You can also resize with sampling, which changes the number of pixels in the image, in turn altering file size. Finally, the size change may be nonuniform that is, you distort the image and change its shape.

Changing image size

In practice, you will likely set only a small range of sizes—from postcard to small poster, say. (For a table comparing the opened file size of an image to the maximum size it can be printed, see p. 221.) In general, you can increase the output size of your image by around 200 percent, but techniques such as spline-based or fractal interpolation can give enlargements of 1,000 percent of acceptable

quality. Note that as print size increases, the assumption is that viewing distance also increases. Files with higher resolution will support greater proportional enlargement than smaller files. All image manipulation can change image size, but specialized software such as Genuine Fractals or Photozoom, may do a better job.

Why distort?

You may distort an image to make it fit a specific area, for humorous effect or for visual impact. Images with irregular-shaped subjects are the best subjects, since the distortion is not too obvious.

The Transform tool can be used to solve a common photographic problem—projection distortion or key-stoning that occurs when the camera is not held square to a building or other geometrically regular subject. The digital solution to this problem is simple: a combination of cropping, allowing for losses at the corners if you have to rotate the image, followed by a controlled distortion of the entire image (see p. 263).

Destructive interpolation

The original landscape-format image of a flower and straplike leaves (above) was contracted on one axis only; so while depth remained the same, width was reduced to a third. This crams all the information into a narrow area and distorts the content of the image (right).

If, however, you decided to restore this image's original shape, it would not be as sharp as it originally was because the distortion is a destructive interpolation and involves the irretrievable loss of image information.

Comic effects

An image already distorted as a result of being shot from a very low camera angle has been taken to comic extremes to emphasize the subject's waving hand (right). Though sometimes amusing, such imagery needs to be used sparingly. The upper part of the image was widened by

about 50 percent and the lower part was reduced by approximately the same amount. The resulting empty areas were then cropped off, as indicated by the white area on the screen (above).

What is interpolation?

Interpolation is a mathematical discipline vital to processes ranging from satellite surveys to machine vision (the recognition of license plates on speeding cars, for example). In digital photography, three methods of interpolation are used to alter image size. "Nearest neighbor" simply takes adjacent values and copies them for new pixels. This gives rough results with continuous-tone images, but it is the best way for bitmap line graphics (those with only black or white pixels).

"Bilinear interpolation" looks at the four pixels to the top, bottom, and sides of the central pixel and calculates new values by averaging the four. This method gives smoother-looking results.

"Bicubic interpolation" looks at all eight neighboring pixels and computes a weighted average to give the best results. However, this method requires more computing power.

Image Size screen shot

If you have the professional image-manipulation software package Photoshop, you have the option of choosing your default interpolation method from the general application

preferences menu, or you can override the default for each resizing operation using the Image Size dialog box (above).

Quick fix Image framing

On't allow your images to become unnecessarily constrained by the sides of the camera viewfinder or the regular borders of your printing paper. There are creative options available to you.

Problem

he precise and clear-cut rectangular outlines around mages can not only become boring, but sometimes they are simply not appropriate—for example, on a website where the rest of the design is informal. What is needed s some sort of controlled way of introducing some ariety to the way you frame your images.

Analysis

n the majority of situations, producing images with clean porders is the most appropriate method of presentation. But with the less-formal space of a webpage, a looser, rignetted frame might be a better option. On occasion, a picture frame can also be used to crop an image without actually losing any crucial subject matter.

Solution

Scan textures and shapes that you would like to use as frames and simply drop them onto the margins of your images. Many software applications offer simple frame types, which you can easily apply to any image and at any size. Special plug-ins, such as Extensis Photoframe, simplify the process of applying frames and provide you with numerous, customizable framing options.

How to avoid the problem

The need to create picture frames usually arises from the desire to improve an image that has not been ideally composed. Nobody thinks about picture frames when looking at a truly arresting photograph. Inspect your pictures carefully, checking the image right to the edges. Tilting the camera when shooting creates a different style of framing, or simply crop off image elements you don't need.

Framing option 1

he first option applies a geometric rame in which it partially reverses the underlying tones of the image. It is effective in hiding unwanted details in he top left of the image, but its outline is perhaps too hard in contrast with the soft ines of the subject's body.

Framing option 2

The simplest frame is often the besthere it is like looking through a cleared area of fogged glass. The color of the frame should be chosen to tone in with the image. However, you should also consider the background color: on this black page, the contrast is too high, whereas against a white page or an on-screen background the nude figure

Framing option 3

Here, a painterly effect is combined with a frame that reverses both hue and tone (a Difference mode). By carefully adjusting the opacity of the frame, the colors were toned down to match that of the main image. Finally, the frame was rotated so that the main axis nude figure runs across the diagonal, leading the eye from the thinh to her just-revealed breast

Quick fix Converging parallels

While the brain largely compensates for visual distortions-so, in effect, you see what you expect to see-the camera faithfully records them all.

Problem

Images showing subjects with prominent straight lines, such as the sides of a building, appear uncomfortable when printed or viewed on screen because the lines appear to converge. Regular shapes may also appear sheared or squashed (see also p. 100).

Analysis

The change in size of different parts of the image is due to changes of magnification—different parts of the recorded scene are being reproduced at different scales. This occurs because of changes in distance between the camera and various parts of the subject. For example, when you look through the viewfinder at a building from street level, its top is farther away than its base—a fact that is emphasized by pointing the camera upward to include the whole structure. As a result, the more distant parts appear to be smaller than the closer parts.

Solution

Select the whole image and, using the Distortion or Transformation tool, pull the image into shape. If there are changes in magnification in two planes, both will converge, and so you will need to compensate for both.

How to avoid the problem

- Choose your shooting position with care and try to compose the image in order to keep any lines that are centrally positioned as vertical as possible. In addition, look to maintain symmetry on either side of the middle of the picture.
- Rather than pointing the camera upward, to include the upper parts of a building or some other tall structure, look for an elevated shooting position. This way, you may be able to keep the camera parallel with the subject and so minimize differences in scale between various parts of the subject as they are recorded by the camera

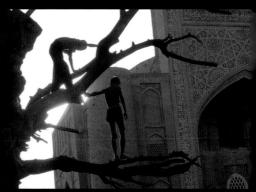

Verticals converge

Shooting from ground level with the camera angled upward caused the scene to appear to tilt backward.

Image manipulation

Stretching the lower left-hand corner of the image using the Distortion tool is the solution to this problem.

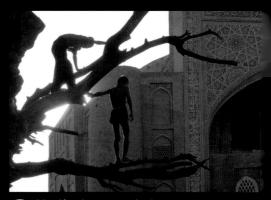

Verticals corrected

The corrected image looks better and corresponds more closely to the way the scene looked in reality

White balance

The basis of accurate color reproduction is neutrality—an equal distribution of colors in the whites, grays, and blacks in the image to help ensure accuracy of hue. The white balance control on digital cameras helps ensure neutral colors on capture. But when we open the image, we may have to take the process further and adjust the brightness and saturation, which are other dimensions of accurate color.

What balance?

An image that is color balanced is one in which the illuminating light offers all hues in equal proportion—in other words, the illumination is white and not tinted with color. Color balance is not to be confused with color harmony (see p. 104). Thus, a scene can be full of blues or greens yet still be color balanced, while another scene that features a well-judged combination of secondary colors may look harmonious, but may not be color balanced at all.

The goal of color balancing is to produce an image that appears as if it were illuminated by white light; this is achieved by adjusting the white point. However, there are different standards for white light, and so there are different white points. For example, it would not look natural to correct an indoor scene lit by domestic lamps in order to make it look like daylight, so a warm-toned white point is called for instead.

Color Balance control

This control makes global changes to the standard primary or secondary hues in an image. In some software, you can restrict the changes to shadows, highlights, or midtones. This is useful for making quick changes to an image that has, for example, been affected by an overall color cast.

Warm white point

The original picture of a simple still-life (above left) has reproduced with the strong orange cast that is characteristic of images lit by domestic incandescent lamps. The corrected image (above right), was produced using Color Balance. It is still warm in tone because a fully corrected image would look cold and unnatural.

Dropper tools

A quick method of working when you wish to color-correct an image is by deciding which part of the picture you want to be neutral—that part you want to be seen as without any tint. Then find the midtone dropper, usually offered in the Color, Levels, or Curves controls in image-manipulation software. Select the dropper, then click on a point in your image that you know should be neutral. This process is made easier if you used a gray card in one of your images—all images shot under the same lighting as the gray card will require the same correction. Clicking on the point samples the color data and adjusts the whole image so that the sampled point is neutral: the dropper maps the color data of all the image pixels around the sampled point.

When working with raw files, the choice of color temperature (blue to red) and of tint (green to magenta) is yours. Usually, you choose color temperature and tint to ensure neutral (achromatic or colorless) colors are truly neutral.

Balancing channels

While the Curves control is most often used to adjust image tonality, by altering the Curves or Levels of the individual color channels, you apply a color balance to the high tones that is different from that of the shadows. This is helpful, for

Original image

This original image has not been corrected in any way, and it accurately reproduces the flat illumination of a solidly cloudy sky.

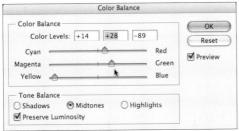

Color Balance control

Strong changes brought about via the Color Balance control, mainly by increasing vellow in the midtoneswhich is the lowest slider in the dialog box heremake the scene look as if it has been lit by an early evening sun.

example, when shadows on a cloudless day are bluish but bright areas are yellowish from the sun. It is easiest to work by eye, adjusting until you see the result you wish for, but for best control you can analyze the color in neutrals and manually put in corrections to the curve. Working in CMYK, using Curves gives a great deal of control and the best results for print. The Color Balance control is essentially a simplified version of using the component RGB channels in Curves.

Channel mixing is effective where a small imbalance in the strengths of the component channels is the cause of color imbalance, due to, for example, using a colored filter or shooting through tinted glass.

The Hue/Saturation control can also be used, since it shifts the entire range of colors en masse. This can be useful when the color imbalance is due to strong coloring of the illuminating light.

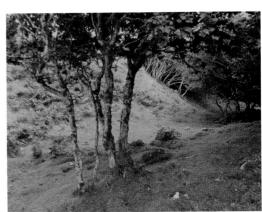

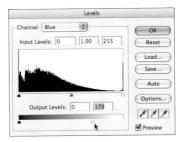

Levels control

A golden tone has been introduced to the image here by forcefully lowering the blue channel in the Levels controlthe middle slider beneath the

histogram—thus allowing red and green to figure more strongly. Red and green additively produce yellow, and this color now dominates the highlights of the image.

Color adjustments

One of the most liberating effects of digital photography is its total control over color: you can control effects from the most subtle tints to the most outrageous color combinations.

Curves

Manipulating Curves, either all at once or as separate channels, is a potent way to make radical changes in color and tone. For best results, work in 16-bit color, as steep curve shapes demand the highest quality and quantity of image data.

Hue/Saturation

This control globally adjusts hues in the image, as well as the color saturation and, less usefully, the brightness. You may also select narrow ranges of colors to change, thus altering the overall color balance. Beware of making colors oversaturated, as they may not print out (*see pp. 109 and 350*).

Replace Color

This replaces one hue, within a "fuzziness" setting or wave-band, with another. Select the colors in the image you wish to change by sampling the

Color temperature

The color temperature of light has, in fact, nothing to do with temperature as we traditionally think of it; rather, color temperature is measured by correlating it to the color changes undergone by an object as it is heated. Experience tells us that cooler objects, such as candles or domestic lights, produce a reddish light, whereas hotter objects, such as tungsten lamps, produce more of a blue/white light.

The color temperature of light is measured in Kelvins, and a white that is relatively yellow in coloration might be around 6,000 K, while a white that is more blue in content might be, say, 9,500 K.

While color slide film must be balanced to a specific white point, digital cameras can vary their white point dynamically, according to changing needs of the situation.

image with the Dropper tool, and then transform that part via the Hue/Saturation dialogue box (*see opposite*). By setting a small fuzziness factor—the top slider in the dialogue box—you select only those pixels very similar in color to the original; a large fuzziness setting selects relatively dissimilar pixels. It is best to accumulate small changes by repeatedly applying this control. Replace Color is good for strengthening colors that printers have trouble with (yellows and purples), or toning down colors they overdo (reds, for example).

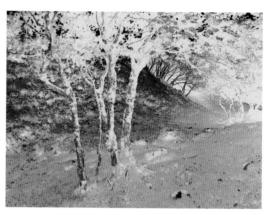

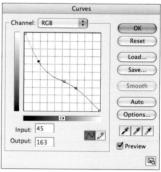

Curves control

A simple inversion of color and tone leaves dark shadows looking empty and blank. Manipulating tonal reproduction via the Curves dialog box, however, gives you more control, allowing you to put color into these otherwise empty deep shadows (the bright areas after inversion). In the

dialog box here you can see how the curve runs top left to bottom right—the reverse of usual—and the other adjustments that were made to improve density in the image's midtones.

Working in RGB

The most intuitive color mode to work in is RGB. It is easy to understand that any color is a mixture of different amounts of red, green, or blue, and that areas of an image where full amounts of all three colors are present give you white. The other modes, such as LAB and CMYK, have their uses, but it is best to avoid using them unless you have a specific effect in mind you want to achieve. When you are producing image files to be printed out on paper, you may think you should supply your images as CMYK, since this is how they will be printed. However, unless you have the specific data or separation tables supplied by the processors, it is preferable to allow the printers to make the conversions themselves. In addition, CMYK files are larger than their RGB equivalents and thus are far less convenient to handle.

Hue/Saturation control

In this dialog box you can see that image hue has been changed to an extreme value, and this change has been supported by improvements in saturation and lightness in order to produce good tonal balance. Smaller changes in image hue may be effective

for adjusting color balance. Bear in mind that colors such as purples look brighter and deeper on a monitor than in print because of limitations in the printer's color gamut (pp. 109 and 348-51).

Replace Color control

Four passes of the Replace Color control were made to create an image that is now very different from that originally captured (p. 265). The dialog box here shows the location of the colors selected in the small preview window, and the controls are the same as those found in the Hue and Saturation dialog box (above left), which allow you to bring about powerful changes of color. However, for Hue and Saturation to have an effect, the selected values must indeed have color. If they are gray, then only the lightness control makes any difference.

Quick fix Manipulation "problems"

For those new to digital photography, there are numerous difficulties to overcome that arise primarily from the nature of the medium in use.

Nhen software will not respond to commands, or example, or when the results are not as you expected them to be, it may seem as if you have

encountered a problem. But, in fact, these could be the result of the software doing exactly what you have asked of it, not realizing that you mean something different. The following are all common examples of DAMNS—Do As I Mean, Not As I Say.

Screen clash

An image that features a fine, regular texture has a raster, or regular array of detail, that can clash with the raster of the monitor on which it is being displayed. This screen clash is seen as inconsistent patterns of dark and light, which appear at some magnifications and disappear or change at others. The printed image, however, is not affected, but the appearance of this pattern on

the screen can be alarming. These two screen images show the same image at different degrees of magnification, and the differences in the appearance of the patterns are readily apparent.

Posterization

As a result of applying a curve (pp. 270-3) that has greatly listorted image tones, the limited color information contained in he image—a gradation from dark to light (see the original image—n p. 264)—has been separated out, or posterized, into an eyeatching composition consisting of distinct bands of colors.

Poor scan

A scan can look too dark with incorrect color balance and yet, after some work, yield an acceptable image if it contains enough data to accommodate the changes. This scan is fine for a newsletter or for publishing on a website, but its weak colors, lack of shadow detail, and poor sharpness all

Curves

The Curves control found in image-manipulation software may remind some photographers of the characteristic curves published for films. This is a graph that shows the density of sensitized material that will result from being exposed to specific intensities of light. In fact, there are similarities, but equally important are the differences. Both are effectively transfer functions: they describe how one variable (the input either of color value or of the amount of light) produces another variable (the output or density of silver in the image).

The principal difference is that when it comes to image-manipulation software, the curve is always a 45° line at the beginning. This shows that the output is exactly the same as the input. However, unlike the film curve, you can manipulate this directly by clicking on and dragging the curve or by redrawing the curve yourself. In this way, you force light tones to become dark, midtones to become light, and with all the other variations in between. In addition, you may change the curve of each color channel separately.

Original image and curve

Since the original negative was slightly underexposed, the image from the scan is tonally rather lifeless. You cannot tell anything about exposure by looking at the curve in the screen shot (above) because it describes how one tone is output as another. As nothing has been changed, when it first

appears the line is a straight 45°, mapping black to black, midtone to midtone, and white to white. It is not like a film characteristic curve, which actually describes how film is responding to light and its processing.

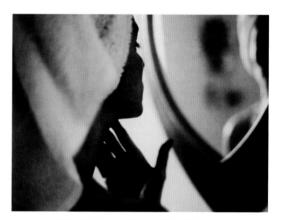

Boosting the midtones

The bow-shaped curve displayed here subtly boosts the midtone range of the image, as you can see in the resulting image (top). But the price paid is evident in the quarter-tones, where details in the shadows and the details in the highlights are both slightly darkened. The result is an image with,

overall, more tonal liveliness; note, too, that the outline of the subject's face has been clarified. With some imagemanipulation software, you have the option of nudging the position of the curve by clicking on the section you want to move and then pressing the arrow keys up or down to alter its shape.

What the Curves control does

The Curves control is a very powerful tool indeed and can produce visual results that are impossible to achieve in any other way. By employing less extreme curves, you can improve tones in, for example, the shadow areas while leaving the midtones and highlights as they were originally recorded. And by altering curves separately by color channel, you have unprecedented control over an image's color balance. More importantly, the color changes brought about via the Curves

control can be so smooth that the new colors blend seamlessly with those of the original.

In general, the subjects that react best to the application of extreme Curve settings are those with simple outlines and large, obvious features. You can try endless experiments with Curves, particularly if you start using different curve shapes in each channel. The following examples (*see pp. 272–3*) show the scope of applying simpler modifications to the master curve, thereby changing all channels at the same time.

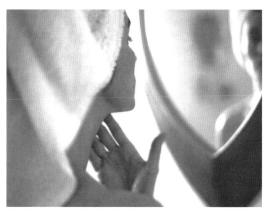

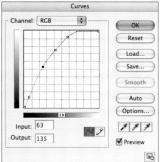

Emphasizing the highlights

The scan's flat, dynamic range suggests that it could make an effective high-key image by changing the curve to remove the black tones (the left-hand end of the curve in the screen shot is not on black but is raised to dark gray) and mapping many highlight tones to white (the top of the curve is level with

the maximum for nearly a third of the tonal range). The result is that the input midtone is set to give highlights with detail. Very small changes to the curve can have a large effect on the image, so if you want to adjust overall brightness, it is easier to commit to the curve and then use Levels to adjust brightness (pp. 244–5).

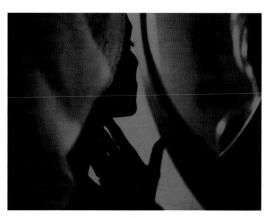

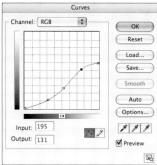

Emphasizing the shadows

The versatility of the original image is evident here, as now it can be seen working as an effective low-key picture. The mood of the picture is heavier and a little brooding, and it has lost its fashion-conscious atmosphere in favor of more filmic overtones. The curve shown in the screen shot has been adjusted not simply to

darken the image overall (the right-hand end has been lowered to the midtone so that the brightest part of the picture is no brighter than normal midtone). In addition, the slight increase in the slope of the curve improves contrast at the lower midtone level to preserve some shadow detail. This is crucial, as too many blank areas would look unattractive.

Curves continued

Original image

The image you select for manipulating Curves does not have to be of the highest quality, but it should offer a simple shape or outline, such as this church. In addition, the

range of colors can be limited—as you can see below, dramatic colors will be created when you apply Curves with unusual or extreme shapes.

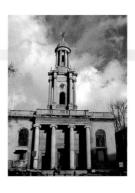

Channel: RGB Input: 121 Output: 249

Reversing dark tones

A U-shaped curve reverses all tones darker than midtone and forces rapid changes to occur—an increase in image contrast, for example. The deep shadows in the church become light areas, giving a

negative type of effect, but the clouds have darkened and greatly increased in color content. The effect of using this shape curve is similar to the darkroom Sabattier effect, when exposed film or paper is briefly reexposed to white light during development.

Reversing light tones

An arc-shaped curve reverses the original's lighter tones, giving the effect shown here. Although it looks unusual, it is not as strange as reversing dark tones (left). Note that the curve's peak does not

reach the top of the range the height of the arc was reduced to avoid creating overbright white areas. The color of the building changes as the red-green color in the normal image was removed by the reversal, allowing the blue range to make its mark.

Tone/color reversal

Applying an M-shaped curve plays havoc with our normal understanding of what a color image should look like. Not only are the tones reversed as a result, but areas with dominant color whose tones have been reversed will also take on a color that is complementary to their own. And since parts of the tonal range are reversed and others are not, the result is a variegated spread of colors.

Channel: RG8 OK Reset Load... Save... Smooth Auto Options... Input: 71 Output: 109 Preview

Using small files

When working on smaller image files, the results on the image of applying extreme curves become increasingly unpredictable due to gaps in the color data the software has to work with. When a W-shaped curve is applied, the

picture becomes rather garish, an effect emphasized by the theatricality of the black sky. You can also see how some picture areas have sharply defined colors while others have smooth transitions, due to variations in the pixel structure of JPEGs (pp. 226–7).

Bit-depth and color

The bit-depth of an image file tells you its tonal resolution—that is, how finely it can distinguish or reproduce tones or shades. A bit-depth of 1 identifies just two tones—black or white; a bit depth of 2 can record four tones; and so on. The number of tones that can be recorded is 2 to the power of the bit-depth, so a typical bit-depth of 8 records 256 tones. When these are applied across the color channels, bit-depth measures the resolution of colors. Thus, 8 bits over three color channels—8 bits x 3 channels—gives 24 bits, the usual bit-depth of digital cameras. This means, in theory, that each color channel is divided into 256 equally spaced steps, which is the minimum requirement for good-quality reproduction.

Number of hues

The total number of hues available to a 24-bit RGB color space, if all combinations could be realized, is in the region of 16.8 million. In practice this is never fully realized, nor is it necessary. A typical high-quality monitor displays around 6 million hues, while a color print can manage fewer than 2 million, and the best digital prints reach a paltry 20,000 different hues at the most. However, the extra capacity is needed at the extreme ends of the tonal and color scale, where small changes require much coding to define, and data is also needed to ensure that subtle tonal transitions such as skin tones and gradations across a sky are smooth and not rendered aliased (also described as stepped or posterized).

Higher resolution

Increasingly, 24-bit is not measuring up to our expectations: tones are not smooth enough and there is insufficient data for dramatic changes in tone or color. This is why, when applying curves with very steep slopes, the image breaks up. Betterquality cameras can record images to a depth of 36 bits or more, but images may be down-sampled to 24-bit for processing. Even so, such images are better than if the images had been recorded in 24-bit. When working in raw format, you may be working in 16-bit space: if you wish to maintain the quality inherent, though not guaranteed, of 16-bit, process and save the file as 16-bit (48 bits RGB).

File size

Once the image is ready for use, you may find that surprisingly few colors are needed to reproduce it. A picture of a lion among sun-dried grass stems on a dusty plain, for example, uses only a few yellows and desaturated reds. Therefore, you may be able to use a small palette of colors and greatly reduce file size. This is particularly useful to remember when optimizing files for the web.

Some software allows images to be stored as "index color." This enables image colors to be mapped onto a limited palette of colors, the advantage being that the change from full 24-bit RGB to an index can reduce the file size by two-thirds or more. Reducing the color palette or bit-depth should be the last change to the image since the information you lose is irrecoverable.

Color bit-depth and image quality

When seen in full color (*left*), this image of colored pens is vibrant and rich, but the next image (*middle*), containing a mere 100 colors, is not significantly poorer in quality. Yet this index color image is only a third of the size of the full-

color original. As the color palette is reduced still further, to just 20 colors (*right*), the image is dramatically inferior. However, since this change does not reduce file size any further, there is no point in limiting the color palette beyond what is necessary.

Original full depth

This image of a church in Greece was recorded as a 12-bit (36-bit RGB) raw image, then processed into an 8-bit file (24-bit RGB). It retains full subtlety of the skies and the transparency and colors of the bunting.

Four levels

With four levels, the sky tones are filled in but they are very patchy and with large jumps in tone and no accuracy of color, simply because the nearest available hue is used. Generally, colors are more saturated than in the original image.

Two levels

With only two levels per color channel, a surprising amount of the original image is retained, with many shapes still well defined. But note the wall in shadow is completely black, and many of the sky tones are blank.

24 levels

With 24 levels, the original image is almost fully reproduced, but the failures are in the sky: note that it remains much darker than in the original, and what was a light area in the lower part of the original is darker than the rest of the sky here.

Limited palette, numerous colors

This image appears to use very few colors. However, the tonal variations of deep cyans, blues, and magentas are so subtle that at least 200 different hues are needed to describe the image without loss of quality. Nonetheless, an indexed color version of the file is a quarter of the size of the RGB version.

Color into black and white

Creating a black and white picture from a color original allows you to change the shot's emphasis. For example, a portrait may be marred by strongly colored objects in view, or your subjects may be wearing clashing colored clothing. Seen in black and white, the emphasis in these pictures is skewed more toward shape and form.

The translation process

A black and white image is not a direct translation of colors into grayscale (a range of neutral tones ranging from white to black) in which all colors are accurately represented—many films favor blues, for example, and record them as being lighter than greens.

When a digital camera or image-manipulation software translates a color image, it refers to a builtin table for the conversion. Professional software assumes you want to print the result and so makes the conversion according to a regimen appropriate for certain types of printing presses and papers. Other software simply turns the three color channels into gray values before combining them—generally giving dull, murky results.

There are, however, better ways of converting to black and white, depending on the software you have. But before you start experimenting, make sure you make a copy of your file and work on that rather than the original. Bear in mind that conversions to black and white loses color data that is impossible to reconstruct.

Before you print

After you have desaturated the image (see box below), and despite its gray appearance, it is still a color picture. So, unless it is to be printed on a four-color press, you should now convert it to grayscale to reduce its file size. If, however, the image is to be printed in a magazine or book, remember to reconvert it to color—either RGB or CMYK. Otherwise it will be printed solely with black ink, giving very poor reproduction.

Four-color black

In color reproduction, if all four inks (cyan, magenta, yellow, and black) are used, the result is a rich, deep black. It is not necessary to lay down full amounts of each ink to achieve this, but a mixture of all four inks (called four-color black) gives excellent results when reproducing photographs on the printed page. Varying the ratio of colors enables subtle shifts of image tone.

Desaturation

All image-manipulation software has a command that increases or decreases color saturation, or intensity. If you completely desaturate a color image, you remove the color data to give just a grayscale. However, despite appearances, it is still a color image and looks gray only because every pixel has its red, green, and blue information in balance. Because of this, the information is self-canceling and the color disappears. If, though, you select different colors to desaturate, you can change the balance of tones. Converting the image to grayscale at this point gives you a different result from a straight conversion, since the colors that you first desaturate become lighter than they otherwise would have been.

Saturation screen shot

With the color image open, you can access the Saturation control and drag the slider to minimum color. This gives a

gray image with full color information. In some software you can desaturate the image using keystrokes instead (such as Shift+Option+U in Photoshop, for example).

Color saturation

While the original color image is full of light and life, the colors could be seen as detracting from the core of the image—the contrasts of the textures of the water, sand,

and stones. This is purely a subjective interpretation, as is often the case when making judgments about images.

Color desaturation

By removing all the colors using the Saturation control to give an image composed of grays, the essentials of the image emerge. The Burn

and Dodge tools (pp. 246-7) were used to bring out tonal contrasts-darkening the lower portion of the picture with the Burn tool, while bringing out the sparkling water with the Dodge tool.

Overcoming distracting color

The strong reds and blues (above left) distract from the friendly faces of these young monks in Gangtok, Sikkim. However, a straight desaturation of the image gives us a tonally unbalanced result. Attempts to desaturate selectively by hue will founder because the faces are a pale version of the red habits. We need

to compensate for the tonally unattractive product of desaturation (middle) by redistributing the tones to bring attention to the boys' faces. This involves reducing the white point to control the sunlit area

in the foreground, plus a little burning-in to darken the light areas of the habit and the hand of the monk behind. Then, to bring some light into the faces (right), we use the Dodging tool set to Highlights.

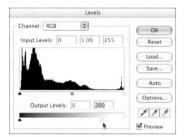

Levels screen shot

With the desaturated image open, move the white point slider in the Levels dialog box to force the brightest pixels to be about a fifth less bright: in other words, to have a value no greater than 200.

Color into black and white continued

Channel extraction

Since a color image consists of three grayscale channels, the easiest way to convert the color to grayscale is to choose, or extract, one of these and abandon the others. This process is known as "channel extraction," but it is available only as part of more professional software packages.

When you view the image normally on the monitor, all three color channels are superimposed on each other. However, if you look at them one channel at a time, your software may display the image as being all one color—perhaps as reds of different brightnesses, or as a range of gray tones, according to the software preferences you have set. If your software gives you the option, choose to view the channels as gray (by selecting this from the preferences or options menu). Then, simply by viewing each channel, you can choose the one you like best. Now, when you convert to gravscale, the software should act on the selected channel alone, converting it to gray.

Some software may allow you to select two channels to convert to gray, thus allowing you a great deal of experimention with the image's appearance. In general, the channels that convert best are the green, especially from digital cameras, because the green channel is effectively the luminance channel, and the red, which often gives bright, eye-catching results.

Another method, available in Photoshop, is to use Split Channels to produce three separate images. With this, you save the image you like and abandon the others. Note, however, that this operation cannot be undone—the extracted file is a true grayscale, and is just a third the size of the original file.

Red-channel extraction

While the colors of the original image are sumptuous (above left), black and white seemed to offer more promise (above right). It is clear that the sky should be dark against the mane and cradling hand, so the green and blue channels (right) were of no help. Neither was the

lightness channel (opposite), since it distributes tonal information too evenly. The red channel, however, presented the blues as dark and the brown of the horse as light. So, with the red channel extracted, no extra work was needed.

Channels screen shot

If your software allows, select color channels one at a time to preview the effects of extraction. Turn off the color if the software shows channels in their corresponding colors.

Blue channel

Red channel

Green channel

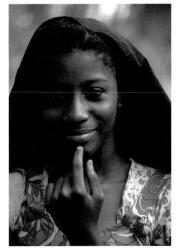

LAB (with Lightness channel extracted)

LAB mode

Comparing channels RGB color images comprise three grayscale images. Here, the B channel is dark while the R is too light, but the green is well balanced, as it carries the detail. This is confirmed by the L channel

in LAB mode (far right).

When you convert an RGB color image image to LAB, or Lab, mode (a shortened form of L*a*b*), the L channel carries the lightness information that contains the main tonal details about the image. The a* channel values represent green when negative and magenta when positive; the b* represents blue when negative, yellow when positive. Using software, such as Photoshop, that displays channels, you can select the L channel individually and manipulate it with Levels or Curves without affecting color balance. With the L channel selected, you can now convert to grayscale and the software will use only the data in that channel. If your software gives you this option, you will come to appreciate the control you have over an image's final appearance, and results are also likely to be sharper and more free of noise than if you had extracted another of the channels to work on. The extracted file is a true grayscale, and so it is only a third of the size of the original color file.

LAB channels

In the Channels palette of Photoshop, you can select individual channels, as shown above. In this example, the screen will display a black-and-white image of the girl (as above, center right).

Color into black and white continued

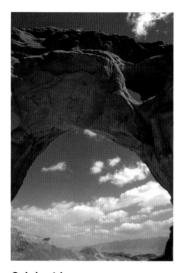

Original image A simple conversion of this image could make colors look lifeless—a problem avoided by using the Channel Mixer

control (below).

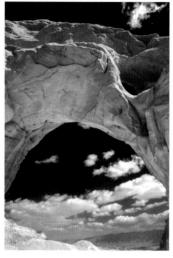

Working in RGB mode In RGB, the blue channel was reduced, making the sky dark, and the red was increased to compensate. Results of using these settings are contrasty and dramatic, but the foreground is too bright.

Working in CMYK mode With the original image translated into CMYK mode, results are noticeably softer than those achieved via the Channel Mixer in RGB mode.

Channel Mixer control

A colored filter used in black and white photography looks a certain color because it transmits only its own color waveband of light. Thus, a yellow filter looks yellow because it blocks non-yellow light. If you then use this filter to take a picture (making the appropriate exposure compensation), yellows in the resulting image are white and the other colors look relatively dark.

Lens filters are limited by the waveband transmissions built into each piece of glass, irrespective of the needs of the subject. But using the Channel Mixer tool you can, in effect, choose from an infinite range of filters until you find the ideal one for each subject.

Using this tool, you can now decide how to convert a color image to grayscale—making greens brighter in preference to reds, for example, or making blues dark relative to greens. Depending on your image software, you may also be able to work in RGB or CMYK (see above), the two methods producing different results.

Channel Mixer screen shot

With the control set to monochrome, the result is gray. If one channel is set to 100 percent, and the others at 0, you are effectively extracting that channel. This is more powerful than channel extraction (pp. 278-9).

If you set the control to Preview, you can see the image change as you alter the settings. For landscapes, increase the green channel by a large margin and correct overall density by decreasing the red and blue channels. Channel mixing is useful for ensuring that reds, which are dominant in color images, are rendered brighter than greens.

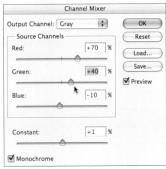

Separating tones

Starting with this color image (top left), a standard grayscale conversion gives acceptable results (middle left), but channel mixing separates out the tones more effectively, particular in shadow areas (bottom left). The settings required were complicated, and arrived at by trial and error (screen shot above). The work done reduces the need for further processing of the image, but if you wish to refine the results further, a channelmixed image makes such techniques as burning-in and dodging (pp. 246-7) easier to apply, since, as you can see, the shadows on the shirts are far more open and susceptible to local density control.

To help learn how to isolate colors using the tools available in your software, start by selecting a bright, multicolored image—perhaps a collection of fruit, a flower stand, or something similar. Working on a copy of the image, now decide which color you wish to emphasize by making it light after conversion to grayscale. Use Color Balance, Replace Color, Hue and

Saturation, or Channel Mixer tools to obtain the required result. If your first try does not work, return to the image and try a series of new settings. When you have a result you are happy with, note the settings. Use this information to replace another color in the image, and see if you can get to the desired result more quickly than the first time.

Duotones

Much of the art of traditional black and white printing lies in making the most of the limited tonal range inherent in printing paper. A common tactic is to imply a wider tonal range than really exists by making the print contrasty. This suggests that shadows are really deep, while highlights are truly bright. The success of this depends on the subtleties of tonal gradation between these extremes. A further technique is to tone the print, adding color to the neutral gray image areas.

Modern digital printers have opened up the possibilities for toning well beyond that possible in the darkroom. The range of hues is virtually unlimited—you can simulate all those that can be created with the four-color (or more) process.

Simple duotones

This view of Prague (left) has been rendered in tones reminiscent of a bygone era. After turning the image to grayscale, two inks were used for the duotone. neither of them black. This gave a light, low-contrast image characteristic of an old postcard.

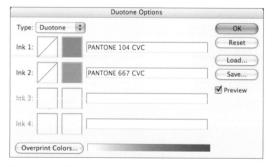

Duotone Options screen shot

The curve for the blue ink (above) was lifted in the highlights in order to put a light bluish tone into the bright parts of the image and also to help increase the density of the shadow areas.

Creating a duotone

Starting with an image, even a color one, first turn the file into a grayscale (see pp. 276-81) using, in Photoshop, the Image > Mode menu. This permanently deletes color information, so you need to work on a copy file. Similar results can be obtained in the Sepia Tone effect, a menu option in almost all image-manipulation applications.

Now that you have a grayscale image, you can enter the Duotone mode, where you have a choice of going it alone or loading one of the preset duotones. If you are not familiar with the process, use the Duotone Presets (usually found in the "Presets" folder of Photoshop). Double-click on any one to see the result.

Clicking on the colored square in the dialog box (see opposite) changes the color of the second "ink." Bright red could give an effect of gold toning; dark brown, a sepia tone. This is a powerful feature—in an instant, you can vary the toning effects on any image without any of the mess and expense of mixing chemicals associated with the darkroom equivalent.

If you click on the lower of the graph symbols, a curve appears that tells you how the second ink is being used, and by manipulating the curve you can change its effect. You could, for example, choose to place a lot of the second ink in the highlights, in which case all the upper tones will be tinted. Or you may decide to create a wavy curve, in which case the result will be an image that looks somewhat posterized (see p. 268).

In Photoshop, you are able to choose to see Previews. This updates the image without changing the file, thereby allowing you to see and evaluate the effects in advance.

You need to bear in mind that a duotone is likely to be saved in the native file format (the software's own format). This means that to print it, you may first have to convert it into a standard RGB or CMYK TIFF file, so that the combination of black and colored inks you specified for the duotone can be simulated by the colored inks of the printer. This is the case whether you output on an inkjet printer or a four-color press.

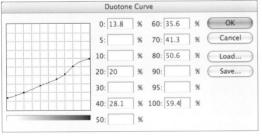

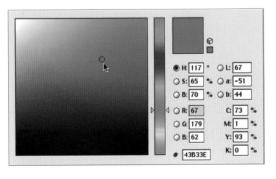

Retaining subject detail

In the original image (above left), there was so much atmosphere it was a pity to lose the color. But the resulting duotone, with a green second ink, offers its own charms (above right). To reduce overall contrast and allow the green ink (chosen via the Color Picker dialogue box, bottom left) to come through, it was necessary to reduce the black ink considerably—as shown by the Duotone Curve dialogue

box (center left). The low position of the end of the curve in the dialogue box (center left) indicates a low density of black, but the kinks in the curve were introduced to increase shadow contrast and retain subject detail. The lifted end of the curve shows that there are no real whites: the lightest part still retains 13.8 percent of ink, as shown in the top box labeled "0:" in the Duotone Curve dialogue box.

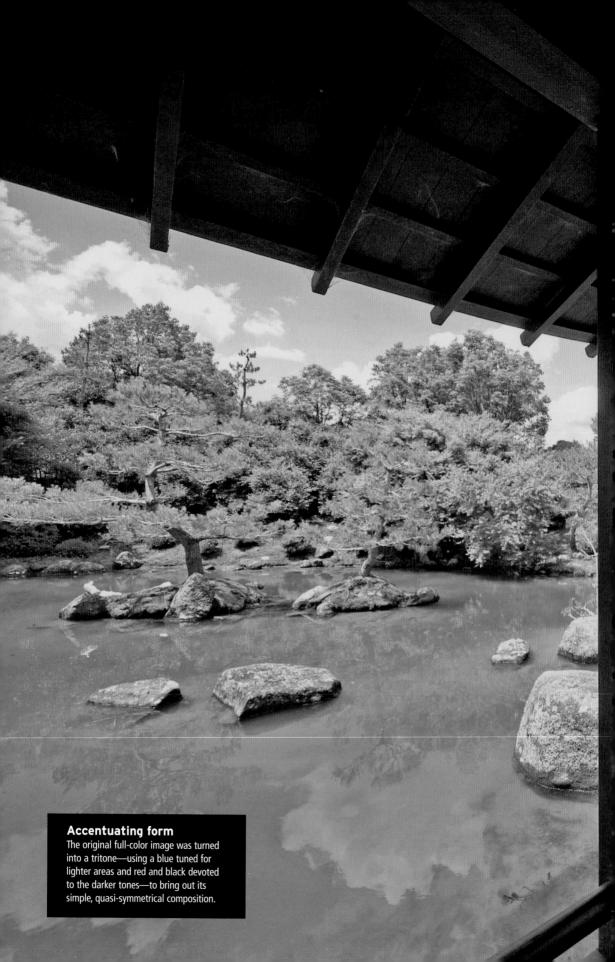

Tritones and quadtones

The addition of one or more inks to a duotone (*see pp. 282–3*) adds extra layers of subtlety to an image. Using most image-manipulation software, you will have tritone or quadtone boxes offering additional inks and curves for you to apply.

Bear in mind that with the extra inks offered, you can produce tinted highlights, or you can hint at colors in the shadows that are not present in the midtones, and in this way create more tonal separation. But there is no substitute for experimenting by applying different curves and colors, since this is the best way to learn how to use this powerful control. As a starting point, try using color contrasts by applying third and fourth inks in small amounts. Or, if you want a graphicarts effect, try curves with sharp peaks.

One technical reason for using a quadtone is to help ensure accurate color reproduction. While not guaranteeing results, the chances of an accurate four-color black are greatly increased by specifying a quadtone in which the colors used are the standard cyan, magenta, yellow, and black of the printing process.

You can save curves and sets of colors and apply them to other grayscale images. When you find a combination that appeals to you, save it for future use in a library of your favorite settings.

Quadtone

For this image, black has been assigned to the dark, featureless shadows, green to those shadows that still retain details, and blue to the lower and midtones. This is shown by the peaks in the graphs next to each color ink in the Duotone Options dialog box (above right). Adjusting the heights of the peaks changes the strength of the colors.

Original image

Starting with this view of the city of Granada, in southern Spain (above), I first made a copy file of the original to

work on. Then, using the copy file, I removed all the color information to make a grayscale, before deciding on which inks to apply.

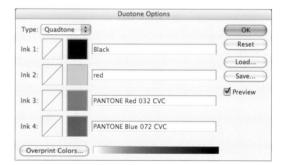

Tritone

Assigning different-colored inks to specific tonal densities in the image produces visual effects that are very difficult to achieve in any other way. In this tritone version of the

scene, the fourth (blue) color has been switched off, and the result is a brighter, lighter image compared with the quadtone (*left*).

Sepia tones

With digital technology, you can bring about image changes with more control than is possible in a darkroom. A prime example of this is the digital equivalent of sepia toning—the low-contrast, nineteenth-century technique that gives warm, brown tones with no blacks or whites.

Old prints lack contrast due to the film's recording properties and the makeup of the print's emulsion. The softness is likely due to the lens, while the brown tone is down to the print's being treated with a thiocarbamide compound.

Many digital cameras produce "sepia-toning," if correctly set, and most image-manipulation applications will also give these effects with just a single command, though with little control. For

greater control, first convert your grayscale image to RGB color mode. Once in RGB, desaturate the image. Use the Levels command (*see pp. 244–5*) to make the image lighter and grayer, and then remove the blacks and whites.

Now you can add color. The easiest way to do this is by using Color Balance (*see p. 264*) to increase the red and yellow. Or use the Variations command (if available) to add red, yellow, and possibly a little blue to produce a brown that you find suits the content of your image.

Another option is to work with a grayscale image in Duotone mode to add a brown or dark orange as the second ink. Using Photoshop, this provides the most subtle effects.

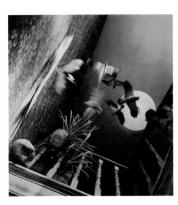

Using Variations

There are several ways to add overall color to the type of interior view shown here. Although subject content is strong, the black and white version (top left) lacks atmosphere. The multi-image Variations dialog box (right), an option

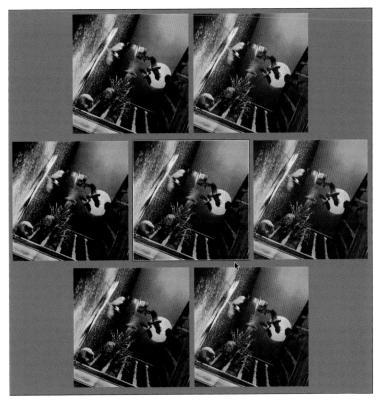

available in most image-manipulation software packages, presents several versions of the toned original from which to choose. By clicking on one (shown outlined in the dialog box above), you turn it into the image of choice, and you can then compare it against the original. To

arrive at the final sepia-toned image (bottom far left), the Levels control was used to reduce shadow density and so produce a flatter contrast.

Sabattier effect

When a partially developed print is briefly reexposed to white light, some of the tone values are reversed. Although developed areas of the print are desensitized to light, partially undeveloped areas are still capable of being fogged. If these are then allowed to develop normally, they will darken. As the doctor and scientist who discovered this effect, Frenchman Armand Sabattier (1834-1910), described this process as "pseudosolarization," it has become incorrectly known as "solarization"—which is, in fact, the reversal of image tones due to extreme overexposure.

Digital advantages

For the traditional darkroom worker, the Sabattier effect is notoriously time-consuming and difficult to control—it is all too easy to spend an entire morning making a dozen or more prints, none of which looks remotely like the one you are trying to create. Using digital imagemanipulation techniques, however, this type of uncertainty is a thing of the past.

The first step is to make a copy of your original image to work on and convert that file to a grayscale (see pp. 276-81). Choose an image that has fairly simple outlines and bold shapesimages with fine or intricate details are not really suitable, since the tone reversal tends to confuse their appearance. You can also work with a desaturated color image if you wish.

There are several ways of simulating the Sabattier effect using Curves and Color Balance. Another method, if you have software that offers Layers and Modes (see pp. 322-7), is to duplicate the lower, original layer into a second layer. You then apply the Exclusion Layer mode, and adjust the tone of the image by altering the Curves or Levels for either layer.

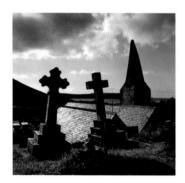

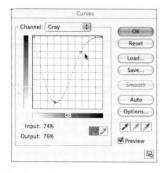

Working in black and white Images with strong shapes (top) are ideal for the Sabattier treatment, since the changing tonal values only obscure images with fine detail. To obtain the

partial reversal of tones shown here (above), a U-shaped curve was applied, which caused the shadows to lighten. The narrow halos on some shapes are a by-product of the Curves, and they

are also reminiscent of the Sabattier effect induced in the darkroom, known as Mackie lines.

Working in color

Working digitally, you can take the Sabattier effect farther than is possible in the darkroom. By starting with a slightly colored image, you will end up with results displaying partially reversed hues. In this landscape, taken in Oxfordshire, England, the grayscale print was warmed using the Color Balance control to add yellow and red. On applying a U-shaped curve to this image, the highlights to midtones remained as they were, but the darker tones reversednot only in tone but also in color, as you can see here (right). An arch-shaped curve would produce the opposite effects.

Using Curves

The most controllable and powerful way of working is to use the Curves control and draw a valley-shaped curve, with a more-or-less pronounced hollow in the middle (top right). By introducing small irregularities in the curve's shape you create surprising tonal changes thus putting back into the process some of the unpredictability and charm of the original darkroom

technique. The advantage of working with Curves is that you can save them and then apply them to any other image you wish. The Sabattier effect will also work with color images but, as with the tones, the colors become reversed as well. If you wish to avoid this, change the image to Lab mode (see p. 279), and then apply the "Sabattier" curve only to the L channel.

Gum dichromates

A gum dichromate is a flat colorization of a grayscale image; in the process, however, the tonal range tends to become compressed. Gum dichromates have had a popular following for most of the history of photography—they are relatively inexpensive and tolerant of processing variations, they are an accessible way to add color to black and white images, and the technique is a rapid route to effects that look painterly. However, the process is also rather messy and results unpredictable, and so most darkroom workers soon tire of it. Fortunately, once you know the look of a typical gum dichromate, you can easily reproduce it digitally without handling dyes and sticky substances.

A clean working method

The digital method is straightforward. Images with clean outlines and subjects without strong "memory colors"—flesh tones or green vegetables, for example, that everybody recognizes—are the easiest to work with. Start by selecting the areas you want to color using the Lasso or Magic Wand tool. Next, choose a color from the Palette or Color Picker and fill vour selection using the Bucket or Fill tool with the Colorize mode set. Working this way ensures that colors are added to the existing pixels, rather than replacing them. The main point to bear in mind is that you should keep colors muted by choosing lighter, more pastel shades rather than deep, saturated hues—it is easy to create too many brilliant colors.

Another approach is to work in Layers, with a top layer filled with color and the mode set to Color or Colorize. This colors the entire image, so you will need to apply some masking (see pp. 328-9) to remove colors from certain areas. Another layer filled with a different color and different masks will apply colors to other parts of the image. If you want to lower the color effect overall, use the opacity setting. In fact, this method is the exact digital counterpart of the darkroom process.

Adding texture

The original picture (above left) shows a place set aside for quiet contemplation in a cemetery in Hong Kong, and it has the clean, strong lines that work so well for dichromatic effects. Areas of the image were roughly selected and colored in to reproduce the inaccuracies that are typical of darkroom-produced dichromates.

After adjusting the colors, a texture was laid on the image to simulate the fibrous nature of a dichromate made the traditional way. The Texturizer filter of Photoshop was used twice at high settings, and then the Blur More filter was applied once in order to soften the texture a little.

Subtle covers

The colors of the room background, the bed itself, and the bed covers that were recorded in the original picture (above left) were each separately selected and then filled with the Colorize

mode set. The resulting image, with its eye-catching blocks of pastel shades (above right) accurately imitates an old-style gum dichromate print.

Color and opacity

This negative print (left) was made from an instant black and white slide film (such as Polapan). It was scanned to RGB and areas roughly selected with the Lasso tool, set to a feather or blended edge of 22. Color was filled into each selection, using the Fill Layer mode set to Color. This colorizes the underlying

layer at differing opacities. Different selections were filled with color and adjusted so that they balanced well to give the final image (below).

Split toning

Toning is a traditional darkroom technique—or workroom technique, as darkness is not essential for the process. Here, the image-forming silver in the processed print is replaced by other metals or compounds to produce a new image tone.

The exact tone resulting from this process depends, in part, on the chemical or metal used and, in part, on the size of the particles produced by the process. Some so-called toners simply divide up the silver particles into tinier fragments in order to produce their effect. Where there is variation in the size of particles, the image takes on variations in tone-from red to brown, for example, or from black to silvery gray. This variation in tone is known as split toning and is caused by the toning process proceeding at

Using the Color Balance control

Images with well-separated tones, such as this misty mountain view, respond best to split toning. To add blue to the blank, white highlights of the mist, an adjustment layer for Color Balance was created. The Highlight Ratio button was clicked and a lot of blue then added. Another adjustment layer was then created, but this time the tone balance was limited to

the shadows. The Preserve Luminosity check-box was left unchecked in order to weaken the strong corrections given: the screen shot (above) shows that maximum yellow and red were set. Further refinement is possible in software packages such as Photoshop (see right).

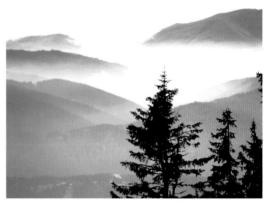

Blending Options

This is part of the Blending Options box from Photoshop. The color bars show which pixels from the lower and which from the upper layer will show in the final image. With the sliders set as here, there is partial showthroughallowing a smooth transition

between the blended and unblended image areas. For this layer, the underlying area shows through the dark blue pixels. In addition, a wide partial blend was indicated for all channels, allowing much of the light blue to show over the dark, reddish tones.

different rates. These rates are dependent on the density of silver in the original image.

This, perhaps, gives you a clue about how the effect can be simulated digitally in the computer—by manipulating duotone or tritone curves (see pp. 282-6) you can lay two or more colors on the image, the effects of which will be taken up according to image density.

Another method is to use Color Balance (see p. 264), which is available in all image-manipulation software. This is easiest to effect in software that allows you to adjust the Color Balance control independently for highlights, midtones, and shadows. If your software does not allow this, you can achieve a similar effect with Curves, working in each color channel separately (see pp. 270–3).

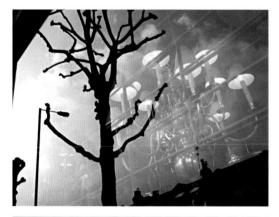

Using Tritone

The Tritone part of the Options dialog box for the final image shows a normal curve for the first, orangebrown, color. The second, blue, color is boosted to darken the midtones, while

the third color, another blue, supports the first blue. Without the addition of this third color, the midtones would look a little too weak and lack visual impact.

Using Color Balance

The aim here was to highlight the similarity in shape between the tree reflected in the store window and the lamps within in the original image (top left). At first, two colors-brown and blue-were used, but it was hard to create sufficient contrast between the dark and light areas. To help overcome this problem, another blue was added to boost the dark areas, as

shown in the Duotone Options dialog box (above left)—the blue plus brown giving deep purple. Color Balance (above right) was shifted to help shadow saturation, and the lamps were also dodged a little, to prevent them from being rendered too dark.

Sun prints

By the end of the eighteenth century, it was known that if objects were placed on specially treated paper and left out in sunshine, a "sun print" of the object could be recorded. Later, prints were made in the same way, by placing negatives in contact with special printing-out paper. This paper did not need developer—the image became visible as a result of the exposure. The image was then fixed or, in later versions, the paper incorporated toning salts so that the image colored as it was exposed.

Typical tonalities were rich and vibrant golden browns and yellows, even oranges and purples.

Developer-incorporated papers today are not intended for printing out: standard fixers erase the image and the low quantity of silver used gives poor image quality.

Fortunately, in the computer you can recreate the tonalities of sun prints easily and conveniently, and you are not limited to using large-format negatives or even black and white originals.

Sun print colors

While the black and white original captures the mood of the scene (top), it loses the golden light so magical at the time. A new layer was applied to the image (scanned from the original) and filled with yellow, with Blending mode set to Color Burn. This had the effect of increasing contrast and color saturation. However, the yellow looked too artificial, so I replaced it with golden orange. Though better, contrast was still too high. To counter this, I lightened it overall by reducing the black output, resulting in the Levels display here (above). The copperred tones of the final image (above right) are typical of toned sun prints.

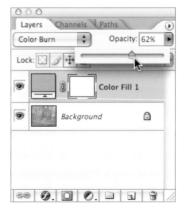

Layers screen shot

The Layers dialogue box (left) shows that the upper layer (scanned from the original black and white image) has been filled with an orange color and that no mask has been applied anywhere to the image. Using these settings, the color is made to extend fully and evenly over the whole of the picture area. The Blending mode selected is Color Burn, which intensifies both the tone and color by darkening tonal values and increasing color saturation. If you want to reduce the intensity of the color effect, then you can simply reduce the opacity from the 100 per cent value that has been set here, seen in the top right-hand panel of the box.

The easiest route is first to take any grayscale image, or desaturate a colored image to grayscale (see pp. 276-81). Then create a layer above the image and fill it with color. Set the Layer mode to Color Burn (to intensify colors) or Color Mode (to add color values to the underlying layer according to its—the receiving layer's brightness). Note that as you do this, images easily fall outside the printer's gamut—the colors seen on the monitor are outside the range that

the printer can reproduce (see p. 109). You can experiment endlessly until you obtain the precise rich, warm tonal response. For a convincing effect, however, it is vital that both the highlights and shadows take on the color cast.

Because this simulated sun-print effect extends evenly over the entire image, you can apply it to virtually any subject. Anything from landscapes to still-lifes, architecture to portraiture, can all benefit from this treatment.

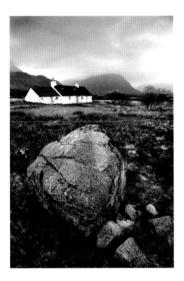

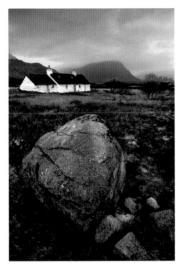

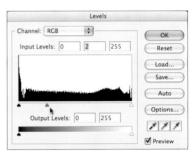

Levels screen shot

The image was lightened, under the top blending layer, in Levels by dragging the central pointer to the left of its default position. This forces a greater proportion of pixels in the image to be brighter than midtone, thus increasing the overall brightness of the picture.

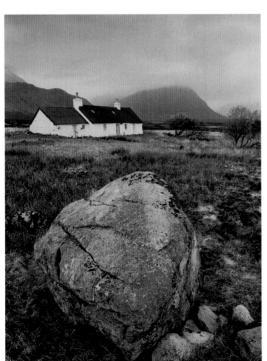

Color and tone

For this view of an attractively located Scottish bothy (a hut or mountain shelter) in a wild and remote region of the Highlands, an even warmer color than that used opposite was applied to the original black and white image (above left) using Color Burn. This mixing mode not only adds strong color, it also greatly increases image contrast. Although the first effort (above) resulted in the correct color, this was simply too intense, and it also had

that heaviness of tone that is characteristics of applying the Color Burn mode. Making a simple adjustment in Levels lightens the image overall (left) without allowing any white areas to appear. It is typical of sun prints in that there is no real white visible anywhere in the image.

Hand-tinting

Hand-coloring in the digital domain is altogether a different proposition from painting directly onto prints. It allows you risk-free experimentation, no commitment to interim results, and freedom from the mess of paints. The core technique is to apply, using a suitable Brush tool, the desired color values to the grayscale values of the image, leaving unchanged the luminance value of the pixels. That is the job of the Color or Colorize mode.

Techniques

The best way to imitate the effect of painting is to use the Brush set to Color mode and then paint directly onto your image. Set a soft edge for the brush, or use one that applies its effects in irregular strokes, like a true brush. You should also set the pressure and the flow to low values, so that application of the brush produces a barely visible change in the image.

Another method is to create a new layer set to Color mode above the image, and paint into this. This makes it possible to erase any errors without damaging the underlying image. You will also find it easier to see where you paint if you use strong colors, and then reduce the opacity afterward. You may make extra layers

To suit the strong shapes of the original (top), equally strong colors were called for. You can work with any combination of colors, and it is worth experimenting—not only will some combinations look better, but some will also print more effectively than others. Bear in mind that

a blank area will not accept color if the Color or Blending mode is set to Colorize. To give white areas density, go to the Levels control and drag the white pointer to eliminate pure white pixels. Once the pixels have some density, they have the ability to pick up color. To give black areas color, reduce the amount of black,

again via Levels control. Although the "paint" is applied liberally (above left), note in the finished print (above) that color does not show up in the totally black areas.

to experiment with different strokes or even blend two or more layers.

Weak colors and pastel shades—that is, those of low saturation, with a lot of white—are often out-of-gamut for color printers and monitors (see p. 109), so you may need to bear in mind the limitations of the printed result while you work. As yet, the porcelainlike textured finish of a highquality, hand-colored print is beyond the capabilities of ink-jet printers. The careful use of papers with tinted bases can help the effect, since the paper's background helps narrow the dynamic range and soften the image contrast.

Graphics tablet

The ideal tool for hand tinting is the graphics tablet, with its pen-shaped stylus. A standard mouse can position the cursor or brush with high precision and is useful if you need to leave the cursor in position, but with a graphics stylus you can vary the pressure with which you apply "paint," thereby affecting both the size of the brush and the flow of color. Some stylus designs also respond to the angle of the stylus. Another advantage of a stylus is that it is less tiring to use than a mouse. The downside is that a large graphics tablet requires far more desk space.

Painting and opacity

When tinting an image, you can apply the paint quite freely—as in this image (above right) of the painted layer that lies above the base image. However, for a realistic final effect, use a range of colors to give variety. The springtime foliage deep within an old wood (above) was emphasized by a lot of dodging (pp. 246-7) to lighten individual leaves. To introduce color, a new layer was created and its Blending mode set to Color, so only areas with density can pick up color (above right). The paint was then applied to this layer. Finally, the layer's opacity was reduced to 40 percent for the final image (right) to allow the foliage to show through the color overlay.

Cross-processing

Of the numerous unorthodox ways to process color film, perhaps the most popular are developing transparencies in chemicals designed for color negatives and processing color negatives in chemicals designed for color transparency film.

Cross-processing techniques make fundamental and irreversible changes to the film, so there is much to be said for simulating the effects using digital image-manipulation techniques. There is a further advantage to working digitally. Color negative film is overlaid with an orange-colored mask whose job it is to correct inherent deficiencies in the color separation or filtering process during exposure. Before the final print can be made, this mask has to be replaced or neutralized.

Color negative film to transparencies

Results from this type of cross-processing have flat tones and muted colors due to the fact that color negative film is low in contrast and transparency processing chemicals compress highlights. Color is also unpredictable, resulting in color balance in the highlights being different from that in the lower midtones and shadows.

Digitally, the Curves control is the best way to simulate this effect, though don't be alarmed if

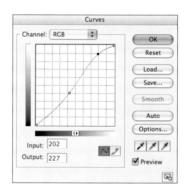

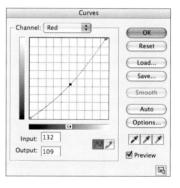

Processing negatives as transparencies

The flattening-out of image contrast and the semblance of color toning that results from processing color negative film in chemicals intended for transparencies can create an interesting portraiture effect. By applying different curves to each color channel (above), the color balance was shifted away from the red (above left) toward the yellow-green coloration that is typical

of this form of cross-processing (left). Note the posterization beginning to become apparent in the shadow areas around the subject's eyes. This is due to the original image being shot on high-speed film. The curves that are given here are for your guidance only: you can start with these, but you are likely to want to adjust them, particularly the master RGB curve, to suit the particular images you are working on.

your image becomes too dark or light—you can adjust overall brightness later. Another possible image outcome is posterization (see p. 268). If you find this effect unattractive, then the quality of the scan may not be good enough. If that is the case, your only option is to rescan the original image, possibly to a higher bit-depth (see pp. 274–5).

From transparencies to color negatives

Results from processing transparencies as color negatives are often contrasty, with color shifts toward cyan. They also have an open tonality, often with highlights reproducing as featureless

white. This occurs because of the need to print inherently high-contrast transparencies on paper meant for the lower contrast of color negatives.

The best way to create this effect digitally is to manipulate the separate channels in the Curves control. When you have a set of curves that work, you can save and reapply them to any image.

If you find it hard to concentrate on the overall lightness of the image while juggling different channels, leave overall density to the end and work just on the colors and contrast. Once you are satisfied with these, call up the Levels control (see pp. 244-5) to adjust overall brightness.

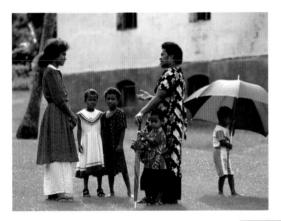

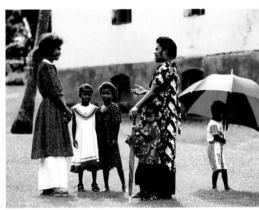

Processing transparencies as negatives

The high-contrast effect that results from crossprocessing color transparency film in color negative chemicals works with subjects that have strong outlines and punchy colors (above left). By applying the set of curves shown here (right), the result is brilliant color and the type of washed-out highlights typical of this form of cross-processing (above right). Since the highlight areas are tonally balanced by the full shadows and strong colors, they are more acceptable than in an image with a normal tonal range. The curves are given here are for your guidance only: you can start with these, but you are likely to want to adjust them, particularly the master RGB curve, to suit your particular images.

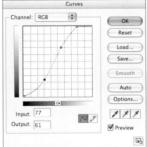

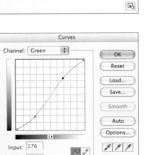

Output: 188

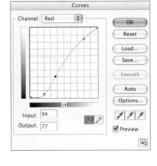

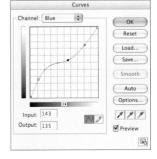

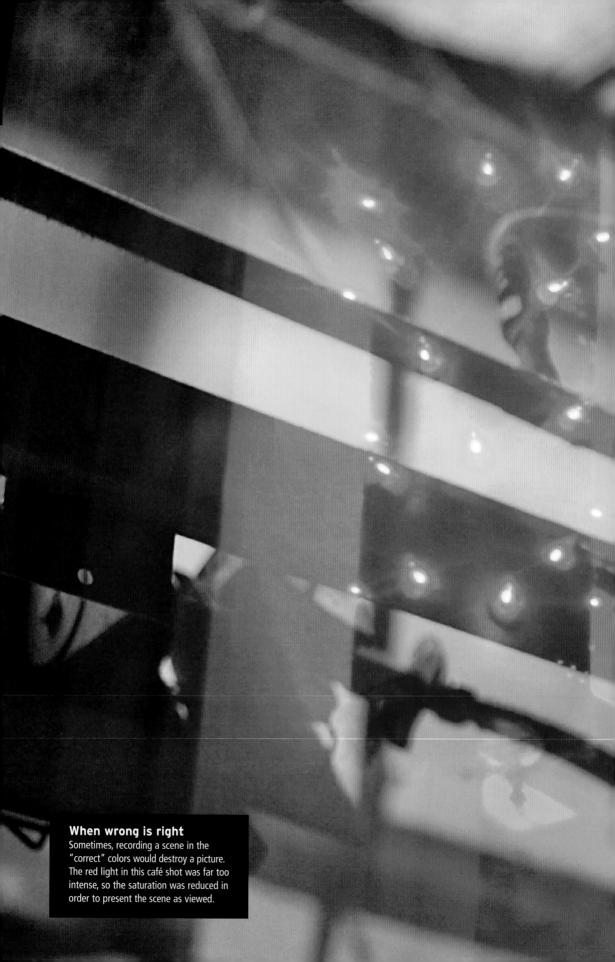

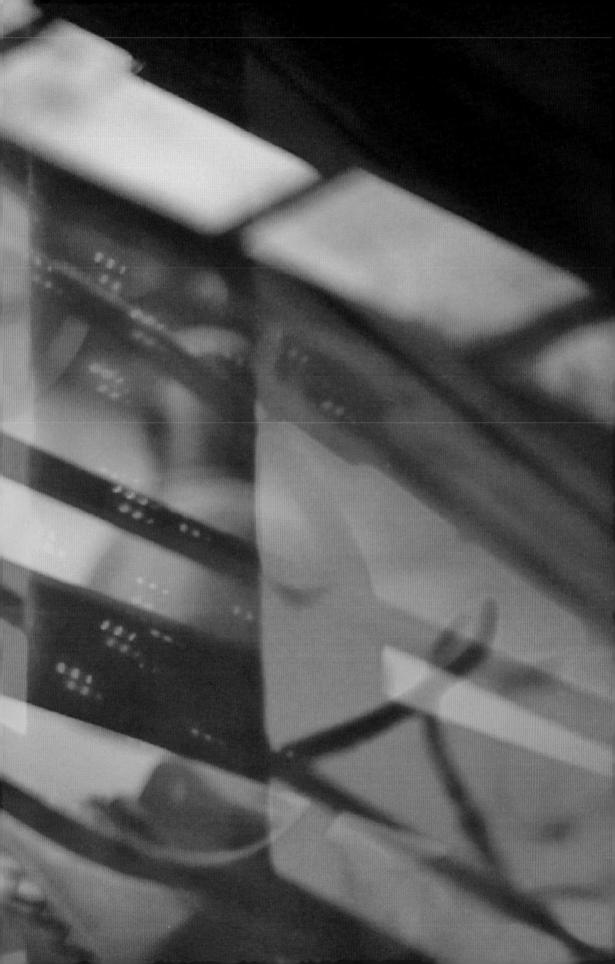

Tints from color originals

It is not necessary for color images to be strongly colored in order to have impact. You can, for example, use desaturated hues—those that contain more gray than actual color—to make more subtle color statements. In addition, selectively removing color from a composition can be a useful device for reducing the impact of unwanted distractions within a scene (see pp. 258–9).

For global reductions in color, you need only turn on the Color Saturation control, often linked with other color controls, such as Hue, in order to reduce saturation or increase gray. By selecting a defined area, you can limit desaturation effects to just that part of the image.

Working procedure

While working, it may be helpful to look away from the screen for each change, since the eye finds it difficult to assess continuous changes in color with any degree of accuracy. If you watch the changes occur, you may overshoot the point that you really want and then have to return to it. The resulting shuffling backward and forward can be confusing. Furthermore, a picture often looks as if it has "died on its feet" when you first remove

the color if you do it suddenly—look at the image again after a second or two, and you may see it in a more objective light.

For extra control, all image-manipulation software has a Desaturation tool. This is a Brush tool, the effect of which is to remove all color evenly as it is "brushed" over the pixels. Work with quite large settings—but not 100 percent—in order to remove color quickly while still retaining some control and finesse.

Another way of obtaining tints of color from your original is to select by color or range of colors. If you increase the saturation of certain colors, leaving the others unchanged, and then desaturate globally, the highly saturated colors will retain more color than the rest of the image, which will appear gray in comparison.

Bear in mind that many pixels will contain some of the color you are working on, even if they appear to be of a different hue. Because of this, it may not be possible to be highly selective and work only over a narrow waveband. Photoshop allows you to make a narrow selection: you can use Replace Color as well as the waveband limiter in Hue/Saturation.

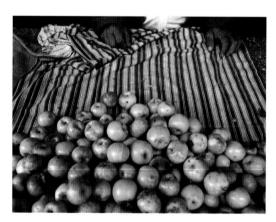

Global desaturation

To produce a selective desaturation of the original (above left), taken in Samarkand, Uzbekistan, the whole image was slightly desaturated, while ensuring that some color was retained in the apples and hands (above right). The process was paused so that the apples and hands could be selected, and then the

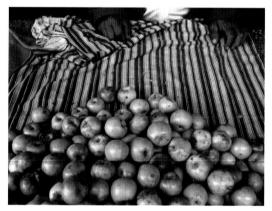

selection was inverted, with a large feathering setting of 22. This was easier to do than selecting everything apart from the hands and apples. Desaturation was again applied, but this time just to the selected area.

Selective color

The original shot of a park in Kyrgyzstan (above left) was too colorful for the mood I wanted to convey. In preparation for a selective desaturation based on colorband, I first increased the blues to maximum saturation in one action by selecting blues in the Saturation submenu. Then I opened Saturation again and boosted yellows (in order to retain some color in the leaves on the ground and the distant trees in the final

image). The result of these two increases in saturation produced a rather gaudy interpretation (above right). Normally, a 40 percent global desaturation would remove practically all visible color, but when that was applied to the prepared image, the strengthened colors can still be seen, while others, such as greens, were removed (right).

Partial desaturation

The best way to desaturate the original image here (above left) was to use the Desaturation tool (also known as Sponge in the Desaturation mode), as it allowed the effects to be built up gradually and for precise strokes to be applied. Although the intention was to desaturate the trees completely, in order to

emphasize the glorious colors of the women's clothes, as the strokes were applied it became clear that just a partial removal and toning down of the green would be more effective (above right). The image was finished off with a little burning-in to tone down the white clothing.

Quick fix Problem skies

A common problem with views taking in both sky and land is accommodating the exposure requirements of both—a correctly exposed sky leads to a dark foreground, or a correctly exposed foreground gives a featureless, burned-out sky.

Problem

Skies in pictures are too bright, with little or no detail and lacking color. This has the effect of disturbing the tonal balance of the image.

Analysis

The luminance range can be enormous outdoors. Even on an overcast day, the sky can be 7 stops brighter than the shadows. This greatly exceeds the capacity of all but the most advanced scanning backs.

Solution

If an area of sky is too light in a scan from a negative (black and white or color), it is best to make a darkroom print and burn the sky in manually (see pp. 246–7). Then you can scan this corrected print if further manipulations are required. Digital solutions will be of no help if the sky presents plain white pixels devoid of subject information. For small overbright areas, you can use the Burn-in tool, set to darken shadows or midtones, at very low pressure.

Don't set it to darken highlights or the result will be unattractive smudges of gray.

Another method is to add a layer, if your software allows, with the Layer mode set to Darken or Luminosity (which preserves colors better). You can then apply dark colors where you want the underlying image darker. The quickest method to cover large areas is to add a Gradient Fill—this is equivalent to using a graduated filter over the camera lens, but it is somewhat indiscriminate.

A more complicated method requires some planning. You take two identically framed images—one exposed for the shadows, the other for the highlights. This is best done in a computer, where it is a simple matter of superimposing the two images with a Gradient Mask.

How to avoid the problem

Graduated filters attached to the camera lens are as useful in digital as traditional photography—their greater density toward the top reduces exposure compared with the lower part of the filter, so helping to even out exposure differences between sky and foreground. It is worth bearing in mind that some exposure difference between the land and sky is visually very acceptable.

1 Areas of overbright highlight, as in the sky of this landscape, can be corrected using Gradient Fill. This mimics the effect of a graduated filter used on the camera lens.

Layers screen shot
First, a new layer was created
and the Layer mode set to Darken.
This darkens lighter pixels but not
those already dark. A graduated dark
blue was then applied to the top
corners with medium opacity.

This digital treatment does not increase graininess, as conventional burning-in would do, but note how local darkening lowers overall image brightness. Further adjustments to brighten the lake are possible.

Masking overlays

The basis of this technique is to take two identically framed images—one exposed for the sky (top), the other exposed for the foreground (above)—and then composite them using a gradient or graduated mask to blend them smoothly. You need image-manipulation software that works with Layers and Masks (pp. 322-9). This is easy for digital photographers, but if you shoot on film, you can scan an original twice (once for highlights, once for shadows), ensuring that the two are the same size, and copy one over to the other.

Making a gradient mask

Next, using Layers control, you have to create a gradient mask, which allows you to blend one image smoothly into the other (top). Notice that this entire image is slightly transparent: in other words, the whole image is masked but there is heavier masking in the lower half, as you can see in the dialog box (above). The overall effect of applying this mask is that the lower image will show through the top layer.

Tinal effect

Blending the two exposures and the mask produces an image that is closer to the visual experience than either original shot. This is because our eyes adjust when viewing a scene, with the pupil opening slightly when we look at darker areas and closing slightly when focusing on bright areas. A camera cannot adjust like this (although certain professional digital cameras can partly compensate). Imagemanipulation techniques can thus help overcome limitations of the camera.

Filter effects

One of the most alluring early advantages of digital photography was the ability to create fantastic visual effects at the touch of a button. These ranged from the visually dazzling to the faintly ridiculous. In time, it has become recognized that many special filter effects are solutions looking for visual problems. Filters are now, rightfully, part of a photographer's repertoire of techniques, but they are best reserved for a definite artistic objective. Therefore, it is important for a digital photographer to be familiar with the range of effects available in the software used.

Sharpness filters

The Sharpness filters are unlike other filters in that they are seldom used for special effects, but rather to enhance the visual quality of the image by bringing out detail. They work by examining the edges of image detail: sharpening filters increase the brightness differences or contrast at these boundaries: the Unsharp Mask (USM) filter is an important tool for increasing image sharpness (see pp. 252-5).

Behind the scenes

Image filters are groups of repeated mathematical operations. Some work by focusing on small parts of an image at a time; others need to "see" the entire image at once. For example, the USM filter looks at blocks of up to 200 pixels square at a time, while Render loads the entire image into memory. A simple filter effect to understand is Mosaic. The filter takes a group of pixels, according to the size you set, and calculates their average value by adding them all and dividing by the number of pixels. It then gives all the pixels in the group the same value, so the pixels appear greatly enlarged. The filter then moves to the next set of pixels and repeats the operation. Most Mosaic filters can work on small image segments at a time, but some need to operate on the entire image for each calculation. These latter types require a great deal of computer memory and calculating power. Add all of these operations together and you obtain the pixelated effect of the Mosaic filter.

Distortion and Pixelate filters

Distortion filters change the shape of the contents of an image—either overall or small portions of it-by

changing the relative positions of pixels, thus retaining overall color and tone. These can be very tricky to control and need to be used with moderation. Blur effects are similar to distortion except, of course, image detail is lost because the pixel data becomes mixed together. Pixelate filters, clumping pixels of similar color values into cells, represent another order of distortion.

Ocean Ripple

This filter adds randomly spaced ripples to the surface of the image so that it appears to be underwater. To make the effect more realistic, you can add surface reflections to separate the "water" from the image below the surface.

Learning to use filters

- Practice on small files when experimenting with filter effects.
- Try the same filter on different styles of image to discover which filters work best on particular types of imagery.
- Filters often work best if applied to selected areas.
- Repeated applications of a filter can lead to unpredictable results.
- You usually need to adjust contrast and brightness after applying a filter.
- Reduce the image to its final size on screen to check the effect of filters.

Polar Coordinates

This extreme distortion is achieved by turning cartesian coordinates into polar coordinates, where positions are defined by their angle from a reference. The "anamorphic" result can produce surprising forms.

Diffuse Glow

The effect of this filter is to render the image as though it were being viewed through a soft diffusion filter. The filter adds transparent white noise, with the glow fading from the center of the image or the center of a selection.

Crystallize

The image is divided into areas, the size of which can be adjusted, then colored with the average of the hues within the area, creating clumps of even color. With limited color palettes, the effect can produce attractive abstracts.

Spherize

This imitates barrel, or pin-cushion, distortion, according to the setting. However, the effect is constrained by the canvas size, so to apply it over the entire image, you must first increase the canvas size, apply the filter, then crop.

Diffuse Glow repeated

A filter can be applied twice to an image for a cumulative effect. If the original effect is too weak, a second application can greatly improve it. Adjustments with Levels or Curves may still be needed, as here, to lighten the shadows.

Mosaic

This classic pixelate filter clumps the average colors together into squares of user-adjustable size. It appears to distort because the image boundaries are shifted when colors fill the large "pixels." This can be used to disguise image detail in a selection.

Filter effects continued

Artistic and Brush Strokes

Artistic filters in Photoshop, similarly to the artist brush

effects in Corel Painter (see pp. 338–9), simulate or replicate artists' materials. Effects such as colored pencils, charcoal drawing, or painting with dry or loaded brush strokes are available. They work by using the image information and combining it with local distortion effects programmed to mimic real artists' materials. Like the Artistic filters, the Brush Strokes filters give a painterly look using different brush- and ink-stroke effects, and the Sketch filters give similar effects but in monochrome.

Sprayed Strokes

This filter quickly reduces an image to its essential shape. The user can set the direction of the strokes, making it very versatile, but it often works best with low-contrast images. Here, the settings were: Stroke Length 6, Spray Radius 24, Left Diagonal.

Paint Daubs-Wide Sharp

Brush Size set to the maximum of 50 and Sharpness set to the minimum of 0 gives this edge-corrected blur, where the outlines of the image are recognized and their sharpness is preserved, but other details are blurred out.

Colored Pencil

In order to simulate a drawing made with colored pencils, the boundaries of the main subject are given a rough crosshatch appearance, and the solid background color shows through the smoother areas with a texture resembling rough paper.

This filter quickly simplifies the image colors and shapes into blocks of uniform color based on averages taken over broad areas. Here, Levels were set to 5, with Edge Simplicity set to a medium 6, and Edge Fidelity to 2.

Paint Daubs-Sparkle

Much more than mere daubing of paint, this filter adds false contour lines partially related to the underlying luminosity. It gives pleasing effects when the Brush Tips is set to Sparkle. Here, the settings were: Brush Size 26, Sharpness 32.

Poster Edges

Giving a passably good imitation of comic-book or cartoon illustration, this filter exaggerates any texture and also outlines the edges of the image. For this result, Edge Thickness was set to 6, Edge Intensity to 5, and Posterization to 1.

Bas Relief

This filter raises a relief pattern on the image according to luminosity values. It can be very useful when combined with the original image, using Layers. Here, the Detail was set to 13, Smoothness to 3, with the Light coming from the left.

Neon Glow

Effective for adding glowing edges to objects, this filter is useful for colorizing an image while softening its look. In Photoshop, the glow color can be selected from the Color Picker that is presented in the Filter Gallery.

Chalk & Charcoal

This filter readily produces images that are very convincing in texture and tonality. It works well even with detailed originals. The Charcoal Area was set to a medium 8, the Chalk Area to a high 15, and the Stroke Pressure to the minimum of 0.

This filter applies a Liquify to the image, guided by local luminosity, so the areas with the greatest number of ripples are those with sharp luminosity gradients. Here, Detail was set to 3, and Smoothness to the maximum of 10.

Charcoal plus Difference mode

This image shows the result of applying the Charcoal filter to the original image, then merging it with a copy of the original, using the blend mode (see p. 325) set to Difference. (See also Multiplying effects, p. 311.)

Filter effects continued

Render, Stylize, and **Texture**

Render and Stylize filters simulate lighting effects in a

scene, while Texture filters appear to raise the surface of an image to give it depth or an organic feel. All the filters in these families make heavy demands on the computer, and you may find large files take longer than usual to render. After using filters such as Find Edges and Trace Contour, which highlight edges, you can apply the Invert command to outline the edges of an image with colored lines or to outline the edges of a grayscale image with white lines.

The Emboss filter can be effective for dramatic transformations of geometric shapes, its gray mask being helpful for further effects. Here, strong settings were used for all parameters: Angle -49°, Height 43 pixels, Amount 98%.

Solarize

This filter reverses tones and colors at the same time. It usually causes a drop in overall contrast and saturation because we prefer our images slightly darker than midtone. After application, it is usual to return contrast and saturation to normal levels.

Craquelure

This filter combines a texture change that replicates the cracks of an old oil painting with a little lighting effect. The image results from setting a low Spacing of 15, an average Crack Depth of 6, and a high setting for Crack Brightness, at 9.

Glowing Edges

While Glowing Edges is most obvious on large-scale boundaries, such as around the rock, it also works on small-scale boundaries, dramatically changing the sea's color. Here, the settings used were: Edge Width 3, Edge Brightness 17, and Smoothness 4.

Find Edges

Filters that define edges work at all scales of the image, so while their effect is predictable with large-scale boundaries, the surprises come with high-frequency, small-scale detail. Here, the sea is textured, while the figures are clearly outlined.

Difference Clouds

Used alone, the Clouds filter randomizes luminance data to completely obscure image detail. The Difference Clouds filter combines Clouds with the Difference blend mode in one step. The results are unpredictable and often surprisingly good.

Grain-Clumped

The Grain filter offers many different effects, or Grain Types, of which perhaps the most useful is Clumped. It appears similar to film grain and is a passable substitute. (For true film-grain simulation, use specific software such as DxO FilmPack.)

Texturizer-Canvas

Another very useful filter is Texturizer. In Photoshop it offers four different textures, plus controls over the scale and relief, as well as the direction of lighting. The Canvas texture gives a good simulation of printing on canvas surfaces.

Extrude

The Extrude filter is worth exploring for the strange effects it produces. You can define the type and size of extrusions and whether their depth is dependent or random. For this, Pyramids were chosen at a Size of 30 pixels, Depth of 30, and Random.

Stained Glass

This filter is useful for defining the scale of important detail, and it also simplifies the color scheme. Adjust the size of the cells until they retain key subject detail. Here, the settings were: Cell Size 10, Border Thickness 4, and Light Intensity 3.

Multiplying effects

To increase further the potential of filters:

- Apply filters to individual layers or several layers to build up the effects, altering blend modes as you go.
- Apply a sequence of different filters, then use the History Brush to blend the results.
- · Apply filters to individual color channels with different settings for each.
- Apply the same filter effect to unrelated images to help make them belong together.
- Create filter effects using Smart Filter to keep the filter effect editable for future alterations.
- Use masks or selections on layers to blend effects.

Multiplying filter effects

Filter effects have the overall effect of obscuring image details and outlines because they add textures or blur details directly (aside from the Sharpen filters, of course). The practical consequence is that the best images for use with filter effects are those with clear, simple shapes and good tonal contrasts—a landscape with trees or the silhouette of a building, for instance, or a leaf with an interesting shape. While the effects of filters on whole images are dramatic, as soon as you apply them selectively, the potential of the technique is multiplied many times.

If you have software, such as Adobe Photoshop, that allows editable filters to be applied, use them. This may slow down your working, but it allows you to adjust the settings to fine-tune results once you have designed the overall scheme of effects. Otherwise, save the various versions of your images as you experiment so that you can return to them if you decide you went too far when applying effects. You can always delete unwanted versions at the end of your project.

You can also work with filters applied to multiple layers and alter their blend modes (see pp. 322-7). This opens up your image-making to an infinite number of effects. To keep from being confused by all the choice, first learn your way around the filter effects, so that you can visualize their impact before applying any of them; then familiarize yourself with layer blend modes.

Original image

In this image of dune lilies the flowers are well outlined, but the leaves are something of a distraction. By using filters, it is possible to separate out the different elements and bring the flowers to the fore.

Chalk & Charcoal and others

Cumulative filter effects are not always gaudy or bold. Here, the combination of Chalk & Charcoal (which reduces contrast and color) with Sumi-e and Spatter (both of which also randomize detail) results in an attractively modern, minimal, high-key look.

Neon Glow

The flowers were first separated from the background using the Color Range control, then the selection was inverted. When Neon Glow was applied to the selected area—the background—a warmly high-key result was produced.

Colored Pencil background

Going for minimal and moderate change, you can select the background and apply an Artistic or Brush Strokes type of filter to retain some original texture without large-scale alteration of color or exposure, as seen here with Colored Pencil applied.

Glowing Edges and Glass Spatter

With the flowers left out of the selection, the background was given two filter treatments. Glowing Edges increased contrast and color, while combining Glass and Spatter broke up the details into irregular clumps of color that contrast with the delicate lily petals.

Original image

This image of a rooster against some fencing was not sharp, but that does not matter, since the image will have filters applied that disrupt detail. To isolate the rooster, it is easier to select it then invert the selection, so that the filter effects apply only to the background.

Three filters together

The rooster was first separated from his background, then three filters—Film Grain, Glass, and Spatter-were applied one on top of the other. The result retains the color but alters the overall texture of the background, and details of the background, to bring out the rooster.

Five filters together

With the rooster separated out, five filters were applied to leave the rooster unaffected. The result of any five-filter combination is hard to predict, but that is part of the fun. This version used Glass, Glowing Edges, Angled Strokes, Sprayed Strokes, and Chalk & Charcoal.

Cumulative filter effects

Original image

Let's suppose we decide to do something radical to this landscape. Taking inspiration from its composition and lighting, we will give the landscape a warm glow and bring some light into the dark area under the bridge.

Neon Glow

First, we duplicate the background layer, then select the new layer and apply Neon Glow. This fills dark areas with the color that is complementary to the purplish glow color. At the same time, it blurs image boundaries.

Soft Light blend mode

Next, we experiment with Overlay group blend modes. We want to blend the luminance of our source layer with the underlying layer. Soft Light looks best, but the landscape is too bright and has lost detail.

We apply a mask to allow the Neon Glow layer to blend only with the underside of the bridge, with just a light effect on the main part of the landscape. We then texture the Neon Glow layer with a canvas surface to give it some "tooth" and adjust the final tonal balance using Levels.

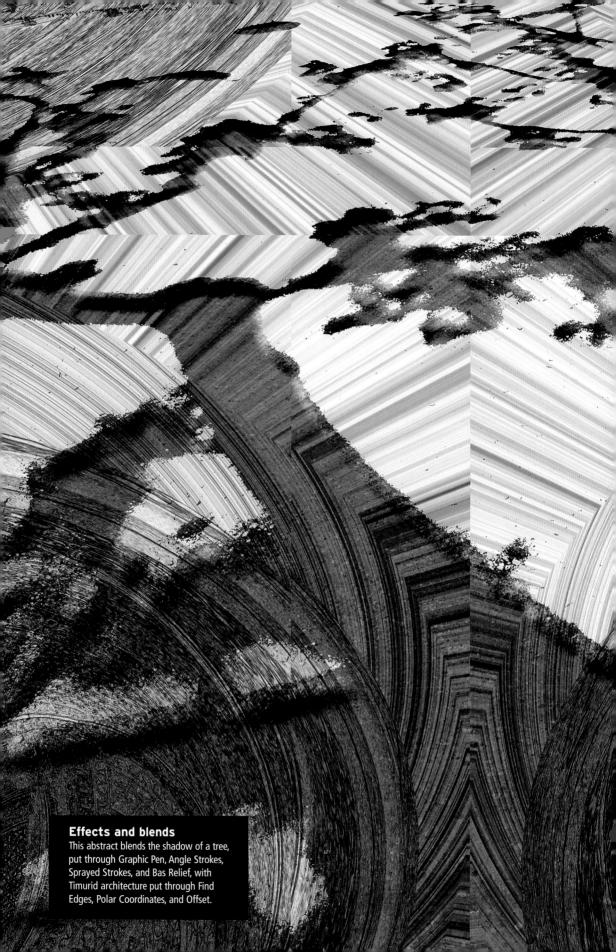

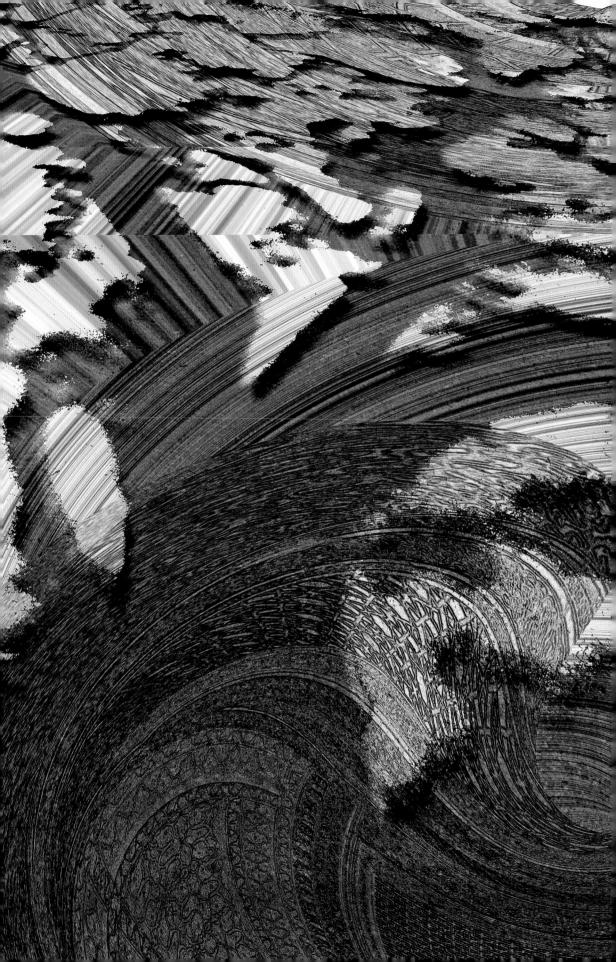

High dynamic range

Dynamic range refers to the difference or ratio between the highest and lowest energy levels in a system. In digital photography, the dynamic range of a scene is the difference between the lightest or brightest part and the darkest or shadow part—essentially its scene luminance range. What makes the range high or not is relative to the recording device we use. High dynamic range means, in practice, that the scene's range of brightness is too large to record all the details we want, given the equipment being used.

Typical dynamic ranges

The practical measure for dynamic range is the number of exposure stops between the darkest area with detail to the lightest area with detail. By this measure, color prints show, at the very best, information for about seven stops from darkest to lightest. Color transparency film records only four stops. Compact digital cameras perform about the same as color print, but dSLR cameras can record ten or more stops of information.

HDR imaging

One way to consider a scene whose dynamic range exceeds the recording capacity of our equipment is that the bright parts need one camera exposure setting, while the darker parts need another. An image that captures a full range of tones can be made by blending two or more different exposures: at least one optimized for the lower midtones and one for the upper high tones.

Highlight/Shadow effect

The use of controls that bring out shadow and highlight details can simulate the appearance of HDR; indeed, they work by compressing an image's tonal range. The effect usually looks unnatural and is further marred by halos around the subject.

Today, we have progressed from exposure blending to more sophisticated versions of blending—often calling themselves HDR, together with a technique called tone mapping. Together, HDR techniques can overcome a camera's dynamic range limitations. HDR compresses the dynamic range in the scene to fit into your image.

How to HDR

To create HDR sequences, you must make bracketing shots with minimal or zero movement between them.

- 1. Set ISO 200, or ISO 400 and the exposure mode to Aperture Priority.
- 2. Set series exposures: three or more shots per second.
- 3. Turn on image stabilization, if available.
- 4. Set the camera to bracket exposures by 1 stop if the sun is to one side, or 2 stops if you are facing the Sun.
- 5. With the camera supported or steady, make the

bracketing exposures. You may also record a single image in raw, create two or more variants at different exposures, and merge these to HDR, but the results are inferior to true variations in exposure.

6. Open the images in software such as Photomatix or Photoshop (File > Automate > Merge to HDR), and blend your images. For superior results, shoot at lower sensitivities, record in raw, make seven bracketing exposures, and use a tripod.

Limits to blending

A raw image of an unlit room taking in the sunny view outside can be darkened to bring color to the window (top left), while another version may be lightened to bring out detail in the

flowers (above left). Blending the images using Blend Options (see p. 292) partially succeeds (above), but transitional midtone areas, such as those around the window, are not well blended.

Merge to HDR

This shot of two friends chatting by the sea originally came out as a silhouette, with poor details in the shadows. I wanted to retain some feeling for the silhouette, but extract shadow detail, too. From the raw file I made some versions that darkened the bright light on the sea, and some that opened up the shadows. In Merge to HDR, the best result was from the Exposure and Gamma option. A little adjustment in Levels improved the overall contrast (see below).

In Photoshop, Merge to HDR offers four different algorithms for combining images: the "best" option depends on the characteristics of your image. In most cases, Exposure and Gamma is the most useful, and it offers fine-tuning controls that are not available in the other methods. Local Adaptations produces highly graphic results and offers radius-based fine-tuning.

Original image

Underexposed 1 stop

Overexposed 1 stop

Underexposed 2 stops

Equalize Histogram

Exposure and Gamma

Highlight Compression

Local Adaptations

Selecting pixels

There are two methods of localizing the action of an image-manipulation effect. The direct way is to use a tool that applies the effect to a limited area, such as the Dodge tool or any Brush. The other method is first to select an area or certain pixels within the image, then apply the effect. This ensures that only the selected pixels will be affected.

Making a selection

When you need to select parts of an image, there are two options. You can select every pixel contained within an area that you define by using, say, the Lasso or Marquee tool. These pixels can be of any value or color. In this case, the pixels are said to be contiguous. Or you can select pixels from across the image that are the same as or similar to a color you specify, using tools such as the Magic Wand or Color Range control. Since there may be gaps between these areas, this type of selection is

Original image

This view of a church in New Zealand shows the original image. I wanted to make the windows lighter in order to reduce the contrast with the bright exterior.

Making a selection

Using Photoshop's Lasso, with a feathering width set to 11 pixels, I selected the dark glass within the window frames. To start a new area to be selected, hold down the the Control key (for PCs) or Command key (for Macs)—the selected area is defined by moving dashes, known as "marching ants." When the Levels command is invoked, settings are applied only to the selections.

called noncontiguous. Magic Wand can be set to Contiguous to select only pixels that are touching each other or are similar in color or tone.

An important option is the ability to partially select a pixel near the edge of a selection. This is called "feathering." It creates a gradual transition across the boundary from pixels that are fully selected through those that are partially selected to those that are unselected, thus smoothing out the effect you apply. A feathering of 0 means that the transition will be abrupt; more than 1 pixel will give a more gradual transition. Note that the effect of increased feathering is to smooth out any sharp angles in the selection.

Selections and masks

The result of selecting a local, defined set of pixels for the changes to work on is related to that of masking (see pp. 328–9), but there are important differences. First, a selection is a temporary mask—it disappears as soon as you click outside a selected area (some programs allow you to save a selection, to reapply later or to use on another image). Second, in software with Layers, the selection applies to any layer that is active. Third, you can copy and move selected pixelssomething that cannot be done with a mask.

Final effect

In some circumstances, the somewhat uneven result of using the Lasso selection can produce more realism than a perfectly clean selection would give. The dark areas remaining toward the bottom of the right-hand windows correspond to the area omitted from the selection in the previous image (above left).

HINTS AND TIPS

- Learn about the different ways of making a selection. Some are obvious, such as the Lasso or Marguee tool, but your software may have other less-obvious methods, such as Color Range in Photoshop, which selects a band of colors according to the sample you choose.
- Use feathered selections unless you are confident you do not need to blur the boundaries. A moderate width of around 10 pixels is a good start for most images. But adjust the feathering to suit the task—for a vignetted effect, use very wide feathering, but if you are trying to separate an object from its background, then very little feathering produces the cleanest results. Set the feathering before making a selection.
- Note that the feathering of a selection tends to smooth out the outline: sudden changes in the direction of the boundary are rounded off. For example, a wide feathering setting to a rectangular selection will give it radiused corners.

- The selected area is marked by a graphic device called "marching ants"—a broken line that looks like a column of ants trekking across your monitor screen: it can be very distracting. On many applications you can turn this off or hide it without losing the selection: it is worth learning how to hide the "ants."
- In most software, after you have made an initial selection, you can add to or subtract from it by using the selection tool and holding down an appropriate key. Learning the method provided by your software will save you the time and effort of having to start the selection process all over again every time you want to make a change.
- Examine your selection at high magnification for any fragments left with unnatural-looking edges. Clean these up using an Eraser or Blur tool.
- Making selections is easier to control with a graphics tablet (see p. 60) than with a mouse.

Original image

The brilliant red leaves of this Japanese maple seem to invite being separated out from their background. However, any selection methods based on outlining with a tool would obviously demand a maddening amount of painstaking effort. You could use the Magic Wand tool, but a control such as the Color Range (right) is far more powerful and adaptable.

Color Range screen shot

In its implementation in Photoshop, you can add to the colors selected via the Eyedropper tool by using the plus sign; or by clicking the Eyedropper tool with a minus sign (beneath the "Save" button), however, you can refine the colors selected. The Fuzziness slider also controls the range of colors selected: a mediumhigh setting, such as that shown, ensures that you take in pixels at the edge of the leaves, which will not be fully red.

Manipulated image

Having set the parameters in the Color Range dialog box (above left), clicking "OK" selects the colors—in this case, just the red leaves. By inverting the selection, you then erase all but the red leaves, leaving you with a result like that shown here. Such an image can be stored in your library to be composited into another image or used as a lively background in another composition.

Quick fix Removing backgrounds

One of the most common image-manipulation tasks is to eliminate a background. There are two main methods: one is to remove the background directly by erasing it (time-consuming); the other is to hide it under a mask.

Problem

The main problem is how to separate a foreground object from its background while retaining fine edge detail, such as hair, or maintain the transparency of a wine glass and retain shadows and blurred edges.

Analysis

Almost all edges in images are slightly soft or fuzzy—it is more the transitions in color and brightness that define edges. If a transition is more sudden and more obvious than other transitions in the locality, it is seen as an edge. If you select the foreground in such a way as to make all its edges sharp and well defined, it will appear artificial and "cut out." However, much depends on the final size of the foreground: if it is to be used small and hidden by a lot of other detail, you can afford a little inaccuracy in the selection. If not, you must work more carefully.

Solution

Make selections with edge transitions that are appropriate to the subject being extracted. The usual selection methods—Lasso or Magic Wand—are sufficient most of the time, but complicated subjects will need special tools, such as Corel KnockOut, Extensis Mask Professional, or the Extract Image command in Photoshop.

How to avoid the problem

With objects you expect to separate out, it is best to work with a plain backdrop. However, while a white or black background is preferable to a varied one, even better is a colored ground. The aim is to choose a color that does not appear anywhere on the subject—if your subject is blond, has tanned skin, and is wearing yellow, a blue backdrop is perfect. Also, avoid using rimlighting, since this imparts a light-colored fringe to the subject. In addition, avoid subject-movement blur and try to keep an extended depth of field so that any detail, such as hair behind the subject's head, is not soft or fuzzy.

Low tolerance

With simple tasks, such as removing the sky from this image, the Magic Wand or similar tool, which selects pixels according to their color and is available in almost all image-manipulation software, is quick to use. It has just one control—the tolerance—which allows you to set the range of colors to be selected. If you set too low a tolerance (here the setting was 22) you obtain a result in which only a part of the sky is selected, seen by the "marching ants" occupying just the right-hand portion of the sky and small, isolated groups.

Removing the sky

Adjusting the tolerance setting in small, incremental steps allows you to see when you have captured just the right area to be removed. Then, pressing "OK" removes your selection. The edges of the selection may be hard to see in a small image, but are clearly visible on a large monitor screen.

High tolerance

If you set too high a tolerance, you will capture parts of the building where it meets the sky. Here, notice the result of setting a large feathering (111 pixels) to the selection—pixels a long way to either side of a target pixel are chosen. As a result, the selection is smoothed out and the boundary is very fuzzy.

Original image

This original image of a young Afghan girl, who is also an expert carpet weaver, shows her taking to the floor to Jance. Unfortunately, the distracting background does not add to the image as a whole.

Defining fore- and background

 Using Corel KnockOut, I first drew inside the girl's outline to define the foreground and then outside her outline to define the background. The region between the two outlines comprises the transition area that allows soft boundaries to be smoothly masked.

Making the mask

Using the information from the previous step, a mask s created. The mask outlines the foreground while hiding he background: the black shows the hidden area and the vhite where the image will be allowed to show through.

Knocking out the background

Now, while the mask hides part of the image on its own layer, it does not affect images on another layer (below left). Therefore, if you place an image behind the mask, you will see that image appear.

Layers screen shot

The Layers dialog box shows the little girl and the associated mask lying over the introduced image. Because the mask was produced by extracting the girl, the original background is gone, waiting for a new ackarpund imaga to be introduced

Masked combination

The background was lightened to tone in with the colors of the girl. The mask has preserved the softness of the girl's outline, and now she appears to be dancing in front of the wall-hanging. An extra refinement would be

Layer blend modes

The "layers" metaphor is fundamental to many software applications, such as desktop publishing, video animation, and digital photography. The idea is that images are "laid" on top of each other, though the order is interchangeable. Think of layers as a stack of acetate sheets with images; where the layer is transparent, you see through to the one below. However, not all software layers have the same resolution, start with the same number of channels, or have the same image mode. The final image depends on how layers blend or merge when "flattened," or combined, for final output. Before then, however, they allow you to make changes without altering the original data, while each remains independent of the others.

Color as layers

A key point to remember is that the basic color image is composed of red, green, and blue layers normally called channels. In essence, the terms "layers" and "channels" are interchangeable. Masks, too, are channels, since they work with a layer to affect the appearance of an underlying layer.

By analogy, if you see a face through a layer of misted glass, it looks soft or diffused. Now, if you

clean off part of the glass, the portion of face lying directly under the cleaned-off area becomes clearly visible, without being obscured as under other parts of the glass. So the glass is a layer over the underlying layer—the face—and by doing something to part of it, but not all, you have applied a mask, which is in effect another layer.

Using layers

The main use for layers (also known as "objects" or "floaters" in some applications) is to arrange composite images—those made up of two or more separately obtained images. You can place images on top of one another, varying the order in which they lie; duplicate smaller images and place them around the canvas to create a new image; or change the size of individual components or distort them at will. At the same time, the ways in which one layer interacts or blends with the underlying layer-known as the blend modesalso be altered. Finally, you can control the transparency or opacity of the layers, too-from high opacity for full effect (or low transparency), to barely visible, when you set a high transparency (or low opacity).

Original 1

The dreamy spires of Cambridge, England, offer the clean clarity of shape and line that are ideal for work with superimposing images. The actively clouded sky also adds variety without too much detail. Prior to use, the image had its colors strengthened by increasing saturation, and the towers were straightened so that they did not lean backward.

Original 2

The outline of wintry trees in France provides fascinatingly complicated silhouettes for the image worker. Taken on an overcast day, the sky was too even to be interesting for this exercise, so a rainbow-colored gradient was applied across the whole image. Finally, colors were strengthened and the outline of the trees sharpened to improve their graphic impact.

Normal

The Normal blend is often ignored, but it is a proper blending mode—provided you lower the opacity of the top layer below 100 percent, the lower layer then becomes progressively more visible. Here, the top layer at 50 percent shows a useful blend is possible—one that cannot be replicated by other blend modes—and it does not matter which is the topmost image.

Screen

Adding together the lightness of corresponding pixels is like projecting one slide from a projector onto the projected image of another slide—the result is always a lighter image. By reducing the opacity of the top layer, you control image darkness. This mode is useful for lightening an overly dark image (the opposite of Multiply). Simply duplicate the image onto another layer and set the top to Screen, then adjust opacity.

Multiply

This mode is the digital equivalent of sandwiching two color slides—densities multiply and the image darkens. Here, the upper layer was reduced to 60 percent opacity to prevent turning the trees black. Multiply mode can be used to recover images that are too light (overexposed slides or underexposed negatives). Duplicate the image into another layer, and set this new layer to Multiply.

Overlay

This mode is able to mix colors evenly from both layers, and is very responsive to changes in opacity. It works by screening light areas in the upper layer onto the lower and by multiplying dark areas of the upper layer onto the lower, which is the opposite effect of Hard Light (p. 324). At lowered opacities, its effect is similar to that of the Normal blend but with more intense colors. It is useful for adding textures to an image.

Layer blend modes continued

Soft Light

Soft Light blending darkens or lightens image colors, depending on the blend color. The effect is similar to shining a diffused spotlight on the image. Now, painting with pure black or white produces a distinctly darker or lighter area but does not result in pure black or white. This is a very effective way of making local tonal adjustments. It is a softer and generally more useful version of the Hard Light blending mode.

Hard Light

This mode is similar to Soft Light: it darkens image color if the blend layer is dark, and lightens it if the blend is light, but with greater contrast. It simulates the contrasty projection of the image onto another image. It is generally less useful than Soft Light but can prove valuable for increasing local contrast—particularly if applied as a painted color at very low pressures and lowered opacity.

Blending modes

Interactions between layers are tricky to learn, since their precise effect depends on the value of a pixel on the source (or blend, or upper) layer compared with the corresponding pixel on the destination (or lower) layer. The most often-used method is simply to try them out one by one (hold the shift key down and press "+" or "-" to step through the menu) until the effect looks attractive. This can distract from your initial vision by offering effects you had not thought of—but that is part of the fun of working with powerful software. With experience, you will get to know the Blend modes that are most pleasing and plan your images with them in mind.

One key point to remember is that the effectiveness of a mode may depend to a great extent on the opacity set on the source layer—sometimes a small change in opacity turns a garish result into one that is visually persuasive. So if you find an effect that does not look quite right, change the opacity to see what effect this has.

Of the many blend modes available in such software as Adobe Photoshop or Corel Painter, some of the most useful are:

- **Soft Light** This offers a useful approach for making tonal adjustments (see *above*).
- **Color** Adds color to the receiving layer without changing its brightness or luminance—useful for coloring in grayscale images (see pp. 330–1).
- **Difference** This produces dramatic effects by reversing tones and colors.
- **Color Burn/Dodge** Useful for greatly increasing contrast and color saturation or, at lower opacities, making global changes in tone and exposure (see *opposite*).

Normal Dissolve Darken Multiply Color Burn Linear Burn Lighten Color Dodge Linear Dodge Overlay Soft Light Hard Light Vivid Light Linear Light Pin Light Difference Exclusion

Interaction modes

The different ways in which layers can interact also apply to other situations, such as painting, fading a command, and cloning. Experience with different effects helps you to previsualize results.

Color Dodge

At first glance, Color Dodge appears like Screen mode (p. 323) in that it brightens the image, but its effect is more dramatic. Black in the upper layer has no effect on the receiving layer, but all other colors will tint the underlying colors as well as increasing color saturation and brightness. This mode is useful when you want to create strong, graphic results. Note that when you change the order of the images, you get markedly different effects.

Darken

The Darken mode applies only darker pixels from the top layer to the bottom layer. Here, the black branches of the trees overshadow anything that lies under them, showing the importance of using clear but interesting shapes. This mode does not strongly change colors. If, for example, there is no difference between the corresponding pixels on the top and bottom layers, there is no change—so this mode cannot be used to darken an image (but see Multiply, p. 323).

Color Burn

This blend mode produces very strong effects as it increases color saturation and contrast. At the same time, it produces darkened images by replacing lighter underlying pixels with darker top pixels. Be aware that both Color Burn and Color Dodge modes often produce colors that are so extreme they cannot be printed—in other words, they are out-of-gamut for printers (see p. 109).

Difference

The Difference mode is one of the most useful for giving dramatic and usable effects, since it reverses tones and colors at the same time—the greater the difference between corresponding pixels, the brighter the result will be. Notice how the dark forms of the trees are rendered in the negative, while the blues of the sky turn to magenta. Therefore, where top and bottom pixels are identical, the result is black, and if one is white and the other black, the result is white.

Layer blend modes continued

Exclusion

A softer version of Difference mode (p. 325), Exclusion returns gray to pixels with medium-strong colors, rather than strengthening the colors. A useful variant is to duplicate the top layer and apply Exclusion to the duplicate layer—now topmost. This creates something similar to the Sabattier effect (pp. 288-9).

Saturation

Here, the saturation of the underlying layer is changed to that of the corresponding pixel in the top, or source, layer. Where saturation is high, the lower image returns a richer color. It is useful where you wish to define a shape using richer or weaker colors: create a top layer with the shape you want and change saturation only within the shape, then apply Saturation mode.

In this mode the colors of the top layer are combined with the saturation and brightness (luminosity) values of the lower layer. The result can be a strong toning effect, as seen here, or it can be weak, depending on the images used. It is worth comparing the effect of this mode with that of the Color mode (below).

Color

Both hue and saturation of the upper layer are transferred to the lower layer, while the luminosity of the receiving layer is retained. This mode simulates the hand-tinting effect of black and white prints. Note that the receiving layer does not have to be turned to a grayscale image for this mode to be effective. Compare this with Hue mode (above).

Luminosity

This blend mode is a variant of Hue and Color: this time, the luminosity of the top layer is retained while the color and saturation of the underlying layer are applied. It is always worth trying the layers in different orders when working with these modes, particularly with this group consisting of Hue, Color, and Luminosity. In this image, reducing the opacity of the top layer produces a soft, appealing image, in contrast to the more highcontrast result when both layers are left at full strength.

Vivid Light

This both burns and dodges: lighter blend colors decrease contrast and lighten the receiving layer (dodges), while darker ones increase contrast and darken the lower color.

Linear Burn

The receiving colors are darkened to match the blend color. This burns or darkens the image without increase in contrast. The strong darkening effect is best tempered through opacity control.

Linear Dodge

Similar to Color Dodge (p. 325), this blend mode brightens the base or receiving layer to match that of the blend layer, thus blends with black produce no change. It is an effective way of brightening an image to a high-key effect but has a tendency to produce too much blank white.

Pin Light

Blend colors lighten or darken the underlying layer according to the blend color and underlying color. The results are tricky to predict, but visually appealing effects are often produced.

Linear Light

Similar to Vivid Light, this burns or dodges in response to the blend color by changing brightness. Its effect is to increase contrast as darker colors are darkened, lighter ones are lightened.

Lighten

This mode chooses the lighter of the two colors being blended as the result of the combination. This blend tends to flatten or reduce contrast, but it is effective for producing pastel tones. Images that originally have subtle tones respond very well to this mode.

Masks

Masks allow you to isolate areas of an image from color changes or filter effects applied to the rest of the image. Unlike real-life masks, digital types are very versatile: you can, for example, alter a mask's opacity so that its effects taper off, allowing you to see more or less clearly through it. Using imagemanipulation software, you can alter a mask until you are satisfied with it and then save it for reuse. When you do so, you create what are known as "alpha channels," which can be converted back to selections. Technically, masks are 8-bit grayscale channels—just like the channels representing the colors—so you can edit them using the usual array of painting and editing tools.

If your software does not offer masks, don't worry—it is possible to carry out a good deal of work by the use of selections. But remember that selections are inclusive—they show what will be included in a change; masks work the opposite way, by excluding pixels from an applied effect.

Software takes two approaches to creating masks. First is Photoshop's Quick-mask, which gives direct control and allows you to see the effect of any transitional zones. Or, you can create a selection that is turned into a mask. This is quick, but transitional zones cannot be assessed.

Quick-mask

In Photoshop and Photoshop Elements, you hit the Q key to enter Quick-mask mode. You then paint on the layer and hit Q again to exit, but in the process, you turn the painted area into a selection. You can also invert your selection (select the pixels you did not first select)—sometimes it is easier to select an area such as bright sky behind a silhouette by selecting the silhouette and then inverting the selection. You then turn the selection into a mask by adding a layer mask.

The layer mask makes all the underlying pixels disappear, unless you tell it to leave some alone. When applying a layer mask, you can choose to mask the selected area or mask all but the selected area. The advantage of Quick-mask is that it is often easier to judge the effect of the painted area than it is to make many selections. It also means that an accidental click of the mouse outside a selection does not cancel your work—it simply adds to the mask. Use Quick-masking when you have many elements to mask out at once.

Turning selections into masks

Some methods of selecting pixels have already been discussed (see pp. 318-19). If you need a

Using Quick-mask

Bottom layer

Quick-mask, or any method where you "paint" the mask, is best when you are not attempting to enclose a clearly defined shape, such as a person's silhouette. It is best first to place the image that will be revealed under the mask—in this example, it is an Islamic painting.

Creating the mask

Next, the mask is applied to the main leaves in this negative image. The red color shows where the freehand masking will be created. When it is turned into a mask, this is the area that will allow the base image to show through.

sharp-edged selection whose scale you can change without losing crispness of line, then you need to create a clipping path.

Although almost anything you can do with masks can be done with selections, it is convenient to turn a selection into a mask, since it is then easier to store and reuse—even for other images. It is good practice to turn any selection you make into a mask (just in case you wish to reuse it), particularly if it took a long time to create.

Alpha channels

Alpha channels are selections stored as masks in the form of grayscale images. The convention is that fully selected areas appear white, nonselected areas are shown black, while partially selected areas appear as proportionate shades of gray. In effect, an alpha channel is just like a color channel, but instead of providing color, it hides some pixels and allows others to be visible. An alpha channel can be turned into a selection by "loading" the selection for that channel. The term "alpha" refers to a variable in an equation defining the blending of one layer with another.

Limiting filter effects

Here (top), the mask has been applied to "protect" the child's face from the effect of the Stylize/Extrude filter. Note that when you turn the painted area into the selection, the mask would be applied only to that selection, so you have to invert the selection to take in everything but the face. When the filter was applied (above), it worked only on the pixels that were not protected.

Quick-mask Layers screen shot
This dialog box shows that the painting forms
the bottom layer (but not the background, since
masks cannot be applied to the background). The top
layer consists of the grass and, to the right, the mask
is also shown.

Final effect
You can move the u

You can move the underlying image around until you are happy with the results—in other words, when the most effective areas are showing through within the areas defined by the masking.

Grayscale and color

There are two ways to obtain grayscale images that is, those with no color information. The best for quality, provided the artwork or photograph fits, is to make a scan of it: even if the original item contains color, you can still scan into grayscale. If the piece is too large for the scanner, you can simply photograph it; for the best quality, use a copystand (see p. 211) and a camera equipped with a macro lens. Some cameras offer a Copy mode, which sharpens details and automatically turns the color image to grayscale. If the original consists of sharp black and white lines, you will need to take extra care if you hope to maintain the crispness of the contours—you will need a high-resolution setting on your camera or scanner.

Should you wish to scan into bit-map (an image in only black or white), then you should set the highest possible resolution. This is because you lose the anti-aliasing effect provided by the intermediate tones (which smooths out the stair-stepping effect of low resolution). The highest resolution may also pick up defects in the paper. Do not be tempted to remove them by raising the contrast of the image, since you will destroy detail. Instead, use cloning tools to remove the defects (see pp. 334-9).

Choosing the color component

When I was considering which color picture to combine with the grayscale image (above right), I looked for a subject that was soft in contrast and contained lots of texture. In order to combine the two images, the grayscale component must be turned to full-color.

HINTS AND TIPS

- Remove dust specks and other defects carefully before combining a grayscale with other images. These defects can be hard to spot, but they can become very evident in certain layer blend modes.
- You can control the effect of certain blends by changing the opacity of either top (blending) or bottom (source) layers—not just of the uppermost layer.
- For best results, avoid increasing the size of a component image by a large amount once it is layered with another image. Rescan if necessary otherwise the mix of sharp and unsharp images that results will look unprofessional.

Output densities

If your image has large, completely black areas, you need to take special care when printing or the paper may become saturated with ink. Reduce the output levels in the Levels control, or equivalent, in your software.

The grayscale component

I scanned the original graphite drawing as a grayscale image with the background kept gray rather than white. This was essential because I intended to add color to the whole image, and pure white would not be colored.

A change of mood Simply by using a different image to add color to the grayscale, as done here, you can very quickly achieve a totally different feel and atmosphere. Since the donor image was pastel in tone, it was placed at 100 percent.

Colored drawing

By laying the colored image over the grayscale and setting the Layer mode to Color, you effectively add color to the drawing without overriding the underlying tones. You will need to adjust both the opacity of the top layer and the tonal quality of both layers to obtain exactly the right effect. If the receiving (lower) layer is darker, it takes on more color; if the donor (top) layer is of higher opacity, it places more color into the lower layer. Here, the opacity was reduced to 85 percent in order to soften the colors.

Difference mode

For a totally different type of toning effect for grayscale images, try applying the top layer in Difference mode (p. 326). This mode, as always, produces dramatic effects. By reducing the opacity, or strength, of the mode in the Layers dialog box to just 35 percent (above right), an intriguingly rich texture has been added to the drawing (above left). The image in the color layer was moved sideways to ensure that any distracting details were not located on the face.

Text effects

Typefaces, also known as letter-forms or fonts, can be treated in many unique ways using imagemanipulation software. Letters can be made to burn up, for example, dissolve into clouds, recede and blur into the distance, or appear transparent over another image—the possibilities are truly unlimited. All image-manipulation applications offer at least a basic range of effects, but if they also accept Photoshop-compliant plug-ins, you can greatly extend your repertoire.

Note, however, that text can sit uncomfortably with image pixels. The reason is that type is best

digitally encoded as "vector graphics," whereas photographic images are best encoded as "bitmap graphics" (see below). Nearly always, the text would have to be turned from vector into a set of bitmapped pixels, resulting in a loss of clarity and sharpness. As a consequence, as you increase the size of an image that incorporates text, the letterforms quickly start to look ragged, with poorly defined outlines. More than anywhere else in image manipulation, if you work with text, always work at the full output size; and avoid altering the image size after applying text to the image.

Bitmap and vector graphics

There are two classes of graphic image. Digital cameras all produce a bitmap type of image, also called a raster image, which is based on a grid of data (the colored pixels). Each pixel is placed in a specific location and given a color value. Image manipulation is all about altering pixels, and so such images are resolution-dependent—that is, they start with a fixed number of pixels and thus a change in image size alters the amount of detail that is available.

Vector graphics, also known as object-oriented images, are described according to their geometrical basics—lines, circles, and so on—with their location, together with operations such as stroke (to draw a line) or fill (to cover an enclosed area with color). Vector graphics are said to be resolution-independent that is, they can be scaled to any size and printed at any resolution without losing sharpness, and so can always use the output device's highest resolution.

Vectors are best for describing text as well as graphics such as company logos, and are created by graphics software such as Macromedia FreeHand, Corel Draw, or Adobe Illustrator. You may discover that the more complicated letter-forms, such as those with scrolls or long loops, may not print properly in your printer: if so, you may need to install special software to interpret the vector information, called a PostScript RIP (Raster Image Processor).

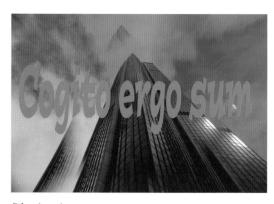

Display type

If you wish to add effects to a typeface, it is advisable to start with a chunky display type such as Postino Italic, shown here, with its vertical scale increased to stretch its height. With a color chosen to contrast with the rest of the image, the effect is unattractive and garish, but it is easy to read at any size.

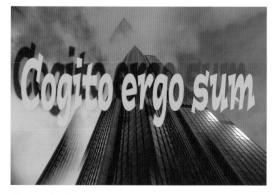

Drop shadow

By asking the image-manipulation software to create a drop shadow, you make the letters appear as if they are floating above the image. The overall effect is of a poster. The color of the type was toned down to that of a tint of white: any light tint of white is likely to be an effective and safe choice of color for type.

HINTS AND TIPS

It is always best to check the typeface at full size by printing it out. Check again if you change the face: even at the same point size, different typefaces vary widely in legibility. Consider, too, the following points:

- Use typefaces with narrow lines where they contrast well with the background; those with broad shapes should be used where the contrast is less obvious.
- You can use typefaces with narrow outlines if you create effects that separate the text from the underlying image, such as drop shadows.
- Use typefaces with broad lines if you want to use them for masking or to allow images to show through.
- Avoid faces with narrow serifs—the little extensions to the end of a stroke in a letter—since these are easily lost into the underlying image. In addition, avoid letterforms with hollow strokes or those made up of double strokes for the same reason.
- Use only small amounts of text when combining it with images—at best a heading and at most a short block of text; but avoid using more than 50 words.

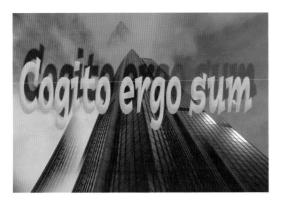

Inner shadow

Here, an inner shadow in pink has been applied with a high level of noise, so creating the appearance of rough texture. Drop shadows have been retained, but note that the "light" can be made to come from different directions.

Text warp

Distortion of text can be effective for drawing the viewer's attention. Here, the text has been warped as if it is a waving flag. In addition, various stroke and inner glow effects were applied to make the type look metallic.

Graduated overlay

Another way of making the type lively is to make the color appear graduated. Here, colors move between yellow and orange. The gradient chosen was sloped so that it runs across the type at an angle. With these effects you can produce comicbook effects that once had to be laboriously hand-painted.

Eye Candy's Fire

Plug-in software can bring very powerful effects to type. Here, with the type area of the image selected, Eye Candy's Fire filter was applied to make the words look as if they are going up in flames. You can adjust all the important parameters of the effect—such as the size of the flames, their angle, and their colors.

Cloning techniques

Cloning is the process of copying, repeating, or duplicating pixels from one part of an image, or taking pixels from another image, and placing them on another part of the image. First, you sample, or select, an area that is to be the source of the clone; second, you apply that selected area where it is needed. This is a basic tool in image manipulation, and you will find yourself constantly turning to it whenever you need, say, to

replace a dust speck in the sky of an image with an adjacent bit of sky, or remove stray hairs from a face by cloning nearby skin texture over them.

This is only the start, however. Such cloning makes an exact copy of the pixels, but you can go much farther. Some applications, such as Corel Painter, allow you to invert, distort, and otherwise transform the cloned image compared with the source you took it from.

Original image

An unsightly tarred area of road left by repairs marred this street scene in Prague. All it will take is a little cloning to bring about a transformation.

History palette

The screen shot of the History palette shows the individual cloning steps that were necessary to bring about the required transformation.

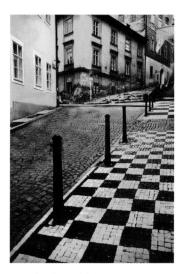

Manipulated image

The result is not perfect—it has none of the careful radial pattern of the original-but it is far preferable to the original image. It was finished off by applying an Unsharp Masking filter plus a few tonal adjustments.

HINTS AND TIPS

The following points may help you avoid some of the more obvious cloning pitfalls:

- Clone with the tool set to maximum (100 percent). Less than this will produce a soft-looking clone.
- In areas with even tones, use a soft-edged or feathered Brush as the cloning tool; in areas of fine detail, use a sharp-edged Brush.
- Work systematically, perhaps from left to right, from a cleaned area into areas with specks—or else you may be cloning dust specks themselves.
- If your cloning produces an unnaturally smoothlooking area, you may need to introduce some noise to

make it look more natural: select the area to be worked on and then apply the Noise filter.

- You can reduce the tendency of cloning to produce smooth areas by reducing the spacing setting. Most digital Brushes are set so that they apply "paint" in overlapping dabs—typically, each dab is separated by a quarter of the diameter of the brush. Your software may allow you to change settings to that of zero spacing.
- If you expect to apply extreme tonal changes to an image using, say, Curves settings, apply the Curves before cloning. Extreme tonalities can reveal cloning by showing boundaries between cloned and uncloned areas.

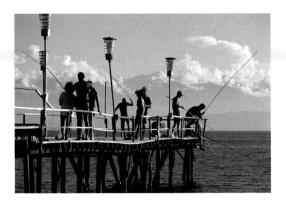

Original image

Suppose you wished to remove the lamp on the far left of this image to show an uninterrupted area of sky. You could use the cloning tool to do this, but it would be a lot of work and there would be a danger of leaving the sky's tones unnaturally smoothed-out in appearance.

Marquee tool The Marquee tool was set to a feather of 10 pixels (to blur its border) and placed near the lamp to be removed to ensure a smooth transition in sky tones.

Removing the lamp By applying the Marquee tool, you can see here how the cloned area of sky is replacing the lamp. Further cloning of sky was needed in order to smooth out differences in tone and make the new sky area look completely natural.

Looking at details The final removal of the lamp was done with a smaller Marquee area, with its feather set to zero (as sharp as possible). Finally, the lamp behind the one removed was restored by carefully cloning from visible parts of the lamp.

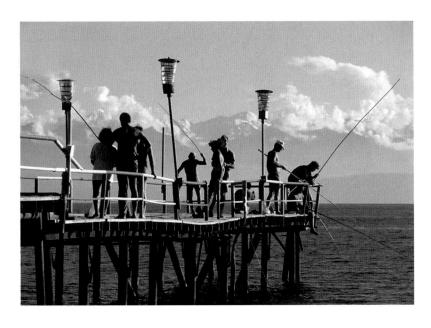

Cleaned-up result

As a finishing touch, a small area of cloud was cloned over the top of the lamp and its lid was darkened to match the others left on the pier.

Cloning techniques continued

Special cloning

In addition to the corrective type of cloning seen on pp. 334-5, it is possible to take the process further and use it creatively.

In most software, there are two main ways of applying a clone. The basic method is what is now known as nonaligned, or normal: the first area you sample is inserted to each new spot the Brush tool is applied to. The other cloning method keeps a constant spatial relationship between the point sampled and the first place the sample is applied to—in other words, an offset is maintained so that the clone is aligned to the source point.

However, software such as Corel Painter offers as many as nine other ways of aligning the clone to the source. You can distort, shear, rotate, mirror, scale

up or down, and so on. The procedure is more complicated than with normal cloning because you need to define the original scale and position prior to applying the clone. You first set the reference points in the source image, then set the transformation points; this can be either in the original image or in a new document. It is this latter feature that gives Painter's cloning tools tremendous power.

One interesting feature is that as your cloned image is being built up, it can itself become the source material for more cloning.

The examples below illustrate just how far it is possible to move away from the source material, as well as how diverse the results can be. Remember, though: with all cloning experiments, you should work on a copy of the original image.

Original images

Both of these originals (left) were taken in New Zealand. Note that images do not have to be the same size or shape for cloning to take place, but look for originals with strong, simple shapes. Sharpness and color were improved prior to the cloning: increasing sharpness after cloning can exaggerate the patches of cloned material.

Manipulated images

The originals were first cloned into a new file, but with added textures and overlaid with several layers. The first image (below) is intended to give a modern feel to the Chinese character "good fortune"; the other (right) has been given a distressed look.

Original image Any original image can be

cloned onto itself to make complexes of line and form. Starting with an image with clear-cut lines and simple

colors, such as this, special cloning techniques can make images that are difficult to produce in any other way.

Rotation and scale

Cloning with rotation and scale calls for two points to be set to define the source, and a corresponding two points to determine the clone.

By experimenting with different positions of the source and clone points, you can create a wide range of effects: here, the boy appears to be spinning into an abyss.

Perspective tiling

Here, the boy was cloned with perspective tiling applied twice to different parts of the image. This requires four points to be set as the source, and four for the clone.

Switching around the positions of the reference points produces wild perspective distortions that could have come from a science-fiction comic.

Natural media cloning

Many image-manipulation filter effects (see pp. 306-13) take photographs into the realm of painting and the textures of fine art materials. Filters operate on the whole of a selected area simultaneously, with overall control possible only over the strength of effect, and no local control at all. Very different effects result, however, if you lay down the strokes yourself using cloning that imitates natural, or art, media.

Don't be afraid if you think you are not artistic: the beauty of working digitally is that if you are not happy with the results, you can step backward to undo the work and start again. Experiment for as long as you like until the result is to your satisfaction. And don't think you are being "amateurish" if it takes hours: some professionals will confess that it can take them days before they achieve results they are content with.

All digital image-manipulation software offers art material effects as special "paints" with which Brushes may be loaded. The difference is that instead of simply loading a Brush with color, it is loaded with instructions: to vary color or intensity as the stroke progresses, to add texture to it or "dilute" the color as if you were mixing water in, and so on. The Brush color can be based on the colors of an underlying or source image, so offering you a shortcut to a radical modification of the original. You can turn a sharp digital image into a soft watercolor, or a colorful abstraction

Jerusalem 1

Once I had settled on an image I wanted to use, I started to experiment with the Curves setting to see what would happen if I set a very distorted value (pp. 270-3). The result that seemed to have the most potential turned the image into a metallic rendering, something like a weathered painting. The trick to this mode of working is knowing when to stop: you can work endlessly trying out different effects. Remember to save promising-looking images as you go so that you can assess them in the cold light of day.

Jerusalem 2

Only those images that have clear outlines and distinct features will survive the detaildestroying aspects caused by applying brushstrokes. Here, Impressionist-like strokes were applied. Taking their color from the original picture, the strokes build up a new image by cloning, or copying, picture information from one image into another. At the same time, the strokes were set to respond to the underlying texture of the paper. You can experiment with different settings and directions of "painting" as often as you like.

into a vibrant "oil painting" with strong strokes of color and the texture of a bristly brush.

The reason for working with a low-resolution file is that it is smaller and the effects you apply will, therefore, appear on screen much faster than with a large file. It makes the whole system much more responsive to your Brush. You will obliterate any fine detail anyway, so it is not necessary to keep all the image data. Reduce the source file resolution to at least half that normal for the output you envision. But when you are happy with your work, change resolution back to normal, in order to avoid pixelation (see pp. 352-3).

Many people prefer using a graphics tablet instead of a mouse for this way of working. The graphics tablet and pen responds to many levels of pressure, speed of stroke, and even to the angle of the pen, thus making for livelier, more naturallooking and varied strokes (see p. 60).

HINTS AND TIPS

For the most effective results when cloning, you will find it easiest to work when the source image:

- offers clear outlines and strong shapes—fine details, such as those of grass or hair or facial features, are generally lost;
- has areas of strong color;
- does not have extensive areas of either black or white:
- is relatively low-resolution.

Applying art effects

Powerful software, such as Painter, offers a bewildering choice of effects to experiment with, but you will probably find that you regularly use only a fraction of the range available. The transformation from the original image of a chest of drawers seen in the screen shot panel

(upper left) to that rendered in Natural Media (lower right) took less than an hour to achieve, yet suggested many other possible treatments on the way.

Image before and after

The shadows in the original (top) were replaced by textures from a drawing on rough-textured paper, which were applied using a Brush tool. Parts of the image were cloned into other areas and tonally adjusted to balance.

Image hose

The normal process of digital painting is to change the values of a group of pixels at once—if you are applying a certain magenta color, then all the pixels lying around the middle of a brush stroke are turned to that shade of magenta. By the same token, you could replace one group of pixels with another group, which could make up an image. This is the principle behind the image hose—as the Brush tool is applied, images are laid down rather than pixels made to change color. The best known example of the implementation is in Corel Painter. In this, the size, orientation, and distribution (whether images are trailed along the brushstroke or scattered around) can all be varied.

Preparations

Unlike other Brush tools, you need to prepare an image hose with a range of images, or you can use a library of images already created. For this, digital photography is ideal, since you can easily capture images—which can be very lowresolution files-for use in the image hose. The next stage involves some calculation and planning, but once done, you have made up tremendously powerful tools for creative work.

The images you "paint" with are without limit—here I have used moths, houses, and ferns. You could even create and apply textures, also known as a texture stamp.

Village original

Ten component images of a village make up this image hose. Each is a small part of a larger whole and at slightly varying scales, so that when applied randomly, the buildings look somewhat jumbled.

Moth original

The component images of this image hose are all the same apart from their orientation, so that when they are randomly applied they appear to be flitting around in different directions.

Ferns original

The components of the ferns Brush used in the final image (opposite) can be seen here. Each fern is an individual image that is held in a collection, or nozzle. As you paint with the ferns Brush, the software selects one fern at a time to lay on the image. Ferns can be set to be chosen at random or according to the speed, direction, or pressure of the stroke. And as the Brush is made larger, so the ferns increase in size.

Adding clouds

To start off the process of manufacturing this fantasy landscape, I first created a gradient of blue to represent the sky against which an image hose loaded with clouds could be applied.

Building elements

As foreground objects overlap those in the background, I first laid down the small buildings to represent the far distance, using a small Brush size for the image hose. By increasing the Brush size, larger "foreground" buildings could then be laid down.

Establishing the middle ground

The trees were applied in the same way as the buildings—with a small Brush for those in the distance and a larger one for those nearer the foreground.

Developing the foreground

A few stones were next deposited in the foreground, then the nearest plants were laid-but I was careful not to use too many examples, to prevent this area from becoming cluttered in appearance.

Moths in the sky

Finally, as a fantasy touch, a stream of moths was createdagain, starting with small ones in the distance, growing larger as they approach the viewer.

Final image

Finally, a few flowers were added to reduce the blankness of the wall in the middle ground.

Photomosaics

Since digital pictures are composed of an array of individual pixels, it is only a short step to making up an image from an array of individual pictures. This is the principle behind photomosaics: you can replace an image's pixels with tiny individual images, like the tiles of a traditional mosaic.

Preparation

As with an image hose (see pp. 340–1) you need to prepare images with which to create the mosaic. The small "mosaic pieces" may be tiny versions of the larger one or different images. Photomosaic software treats individual pictures as if they are pixels, looking for best matches between the density and color of the small images to the pixel of the larger image that is to be replaced.

Specialty stand-alone photomosaic software usually provides libraries of mosaic pieces for you to work with, but it is more fun to create your own. However, the large numbers of images needed mean that this can be a long process. Advanced users can create batch processing sets to automate the process of rendering files into the specific pixel dimensions needed for the mosaic pieces. Other sources are the thumbnails (small files) found in some collections of royalty-free CDs.

Composite photomosaic

The original image was relatively complicated, but its clear lines and shapes, as well as the repeated elements it contained, made it a suitable candidate for photomosaic techniques. By selecting a small size for the mosaic "tiles" the resulting image still, overall, retains many details, but with an added richness of texture that invites closer inspection. The close-up view of the photomosaic (below) shows an intriguing mixture of images. Varying the component images is one way to produce an entirely different feeling to the image, while still retaining the outlines of the originals.

HINTS AND TIPS

If you are thinking of producing a photomosaic, bear the following points in mind.

- Provide a wide range of images from which to make up the mosaic pieces.
- Remember that smaller mosaic pieces produce finer, more detailed photomosaics.
- Use subjects with very clear or recognizable outlines;
- avoid complicated subjects lacking clear outlines, since the process destroys all but the largest details.
- Bear in mind that if you create images in which a high level of detail is replaced with large mosaics, the resulting files will be very large.
- The rendering process that creates the photomosaic can take some time for your machine to carry out.

High-key photomosaic

The large, even spread of tones presents a challenge to photomosaic software, as identical images next to each other must be avoided, or else false patterns are created. However, the photomosaic has superimposed an attractive texture over this image. The close-up view (below) is richly rewarding.

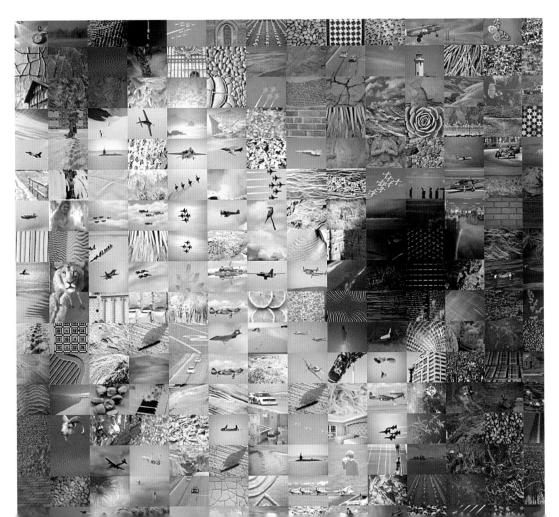

Image stitching

Panoramic views can be created by "stitching," or overlaying, images side by side (see pp. 202-5). Essentially, a sequence of images is taken from one side of the scene to the other (or from the top to the bottom). The individual images are then overlapped to create a seamless composite.

You do not need special software to achieve panoramas if the original shots are taken with care. You simply create a long canvas and drop the images in, overlapping them. However, small errors in framing can make this a slow process, since you must blend the overlaps to hide seams.

Appropriate software

Special panoramic software makes connecting component shots far easier, especially if they

were taken without a tripod. Different software packages offer various approaches. Some try to match overlaps automatically and blend shots together by blurring the overlaps. Results look crude but are effective for low-resolution use. Other software applications recognize if the overlaps do not match and try to accommodate the problem—some by distorting the image, others by trying to correct perspective. Many digital cameras are supplied with panoramacreation software.

For more unusual effects, experiment with placing incongruous images together, or deliberately distort the perspective or overlaps so that the components clash instead of blend. There is a great deal of interesting work still to be done.

Photographs © Louise Ang

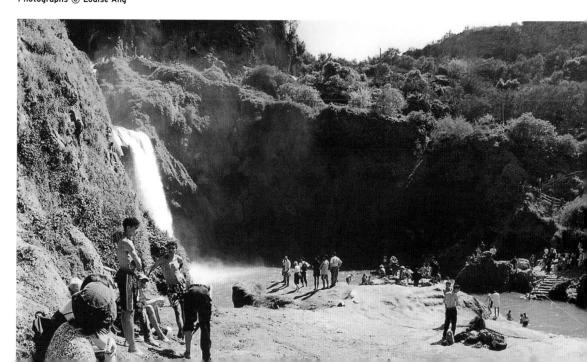

HINTS AND TIPS

- Beware that a panorama resulting from, say, six average-size images will be a very large file: reduce the size of the component images first to avoid overstretching your computer's capacity.
- If you want to create a panorama that covers half the horizon or more, it may be better to stitch it in stages: three or four images at a time, then stitch the resulting panoramas. Keep an eye on the image size.
- Place all the component images together into one folder: some software will not be able to access images if they are in different folders.

Assembly

To start the assembly (left), move the component images into a single folder where the software can access them. With some software, you will be able to move images around to change their order, while in others you will have to open the images in the correct order. To merge the images, the software may need extra instructions, such as the equivalent focal length of the lens used.

Final version

The component images show very generous overlaps, which make it easier for the software to create smooth blends. Once the component images are all combined on one canvas, you can use the facilities offered by the particular software to blend and disguise the overlaps to create a seamless, single image (below). Once you are happy with your work, save the file as a TIFF, not as a JPEG, for best-quality results.

The output adventure

Proofing and printing

It is an exciting moment. You have worked for hours at your computer, using all your know-how to create an image that looks just the way you want it, and now you are ready to print. You take a deep breath and press the button to send the file to the printer. If, then, the printer produces satisfactory results for most images, without any intervention on your part or setting up, you are lucky (make sure you note the settings in the printer driver for future reference). Unfortunately, the experience for many digital photographers is that the results of printing will be disappointing.

An important point is that mismatch between the monitor image and the printer is not, in the first instance, caused by any malfunctioning of your printer or monitor. The basic problem is that the monitor produces colors by emitting a mix of red, green, and blue light, while a print reflects a mix of light to produce the colors you perceive. These fundamentally different ways of producing color lead to a difference in gamut, which is the range of colors which can be produced by a device (*see p. 109*).

There are two main approaches open to you. You can adjust the image to compensate for the differences between what you see on screen and the resulting print, then print again and again, repeating the process until the print is satisfactory. This is not only unscientific, but the adjustments apply only to one image. The best way is to use software, such as Photoshop, that offers colormanagement facilities.

Printing with color management

To use color management for printing, you must first calibrate your monitor (*see pp. 232–3*). Note, too, that for the highest reliability, settings will apply only for the paper and inks with which you make the test. The basic idea is that you will first specify the source color space containing the colors you want to send to your printer—those that typically relate to your monitor. Second, you specify the color space of the printer, usually tied to the material being used. This gives

the software the information it needs in order to make the necessary conversions.

A typical task is to proof an image currently in the monitor RGB space as it will appear on an offset printer (a commercial machine). The source color space uses the soft-proof profile, while your printer profile is the printer space. The following description details the steps to follow in Photoshop.

First choose File > Print Options and select "Show More Options," then "Color Management." For Source Space, select "Document" to reproduce colors as interpreted by the profile currently assigned to the image. Select "Proof" to reproduce document colors as interpreted by the current proof profile. Under Print Space, choose the profile that matches the color space of your

Color settings

The dialog box controlling color settings looks complex, and careful attention is needed to make full sense of it. However, there are many guides—such as those provided in printer and software manuals—that should help you master it. The crucial point to keep in mind

is that, unless you are producing work to be printed by a commercial press for a mass market, you need not worry about these settings. You can get by without touching them: however, if you can control them, it will be far easier to obtain reliably good prints from your desktop printer.

Printer settings

A driver that complies with the ColorSync protocol for color management will offer a dialog such as that shown here. The Source Space is the color space or profile for the image: here, I have specified a commercially defined standard, which defines an RGB space in a way that

is optimized for print. The Print Space is not only that of the printer but of the paper and print quality being set. "Perceptual" has been chosen for the Intent, or preference for color conversions of colors that fall out of gamut, since that is most likely to give a photographically acceptable print.

What is PostScript?

This is the most important of a range of programming languages that describe text and graphics on a page. PostScript breaks the most complex text and graphics into elementary components, such as lines or dots, and into basic operations, such as "stroke" (to draw a line) or "translate" (to turn a component). When a printer receives a PostScript file, it has to interpret it in order to turn these commands into the correct output on the page. This can be done with software in the computer's operating system or through special PostScript RIPs (Raster Image Processors). Using a PostScript RIP is the best way of making sure that complicated graphics and text are properly printed out on the page.

Fantasy colours

When you produce highly manipulated images, even a large error in colour accuracy is unlikely to damage the effectiveness of the image, since most viewers will not ever know what the right colours were supposed to be. Of course, for the sake of

artistic integrity, you will strive to produce the exact colour you have in your mind's eye, but the impact of images such as that shown here, with its artificial colours and fantasy content, does not depend on precise colour reproduction.

Proofing and printing continued

printer to print using that printer space or else select "Same As Source" to print using the original source profile.

If you have an inkjet printer, select "Printer Color Management" to send all the color data that is needed for the printer's driver to manage the colors. (Those using a PostScript printer should follow the instructions that are supplied with their PostScript RIP software.) Finally, under "Print Space," choose a suitable "rendering intent" (see below).

You are now ready to print, but before proceeding any further, make sure that:

- You are using the same type of paper as that intended for the final output.
- You are using the correct side of the paper.
- There is a good supply of ink (check the level using the printer's controls).
- Your image has been sized to the correct output dimensions.

Previewing

The key to efficient printing practice is to employ soft-proofing as much as possible—that is, checking and confirming everything you can on

Textile color

For accurate records of valuable artifacts, such as this piece of textile (above), precise color control is essential. Reds are visually

very important, but deep reds can vary considerably between monitor image and paper output. The subtle variations in deep tone are easily lost if a printout is too dark.

What are rendering intents?

Converting from one color space to another involves an adjustment to accommodate the gamut of the destination color space. The rendering intent determines the rules for adjusting source colors to destination gamut: those that fall outside the gamut may be ignored, or they may be adjusted to preserve the original range of visual relationships. Printers that are ColorSync-compliant will offer a choice of rendering intents that determine the way in which the color is reproduced.

- Perceptual (or image or photorealistic) aims to preserve the visual relationship between colors in a way that appears natural to the human eye, although value (in other words, brightness) may change. It is most suitable for photographic images.
- Saturation (or graphics or vivid) aims to create vivid

color at the expense of color accuracy. It preserves relative saturation, so hues may shift. This is suitable for business graphics, where the presence of bright, saturated colors may be important.

- Absolute Colorimetric leaves colors that fall inside the destination gamut unchanged. This intent aims to maintain color accuracy at the expense of preserving relationships between colors (as two colors different in the source space—usually out-of-gamut—may be mapped to the same color in the destination space).
- Relative Colorimetric is similar to Absolute Colorimetric, but it compares the white or black point of the source color space to that of the destination color space in order to shift all colors in proportion. It is suitable for photographic images, provided that you first select "Use Black Point Compensation."

the monitor screen before committing the image to print. If you have implemented the color management suggested in this book (see pp. 264-7), the on-screen image should be very similar to the print you obtain. If, though, images

Original image

All digital images are virtual and thus have no dimensions until they are sized for output, with a suitable output resolution. Ideally, there are sufficient pixels in the image for the combination of output resolution and output size, otherwise interpolation (pp. 260-1) is needed to increase resolution.

are to be printed on a four-color (CMYK) press, set the destination printer or printer profile to that of a standard to which it conforms.

The first check is the output size: most image applications and print drivers will show a preview of the size and/or position of the image on the page before printing it out. If you are not sure of what you are doing, it is best always to invoke print preview to check—the print preview here (see below), from Photoshop, shows an image that is too large, while the screen shot (see bottom), from an Epson driver, shows an image enlarged 300 percent to make better use of the page. Printer drivers should warn you if the image size is too great to be printed without cropping.

Photoshop print preview

Some software provides a quick way to check the print size in relation to the paper size set for the printer. Here (right) is Photoshop's way of displaying it. The corners of the image fall outside the paper, as can be seen by the diagonals not meeting the corners of the white rectangle, which pops up when you click on a bar at the bottom of the frame: the image is clearly far too large for the paper.

Print Options preview

This screen shot (left), taken from a printer driver, shows how a printer expects to produce a given file. The image has been enlarged by 300 percent to make better use of the paper and has been centered (be sure your image has sufficient data to print at this enlargement). Note how the preview shows the image on paper and that it provides you with handy functions, such as being able to position the image, as well as a choice of units of measurement. Modern printers can place an image with great and repeatable precision.

Output to paper

One great advantage of inkjet printers is that they can print on a wide variety of surfaces. In fact, some desktop models will print on anything from fine paper to thin cardboard.

For the digital photographer, there are three main types of paper available. Most papers are a bright white or a near-white base tint, but some art materials may be closer to cream.

Paper types

Office stationery is suitable for letters, notes, or drafts of designs. Quality is low by photographic standards, and the printed images cannot be high in resolution or color saturation. Inkjet paper that is described as 360 dpi or 720 dpi is a good compromise between quality and cost for many purposes.

Near-photographic quality is suitable for final printouts or proofs for mass printing. These papers range from ultra-glossy or smooth to the slightly textured surface of glossy photographic paper. Paper thickness varies from very thin (suitable for pasting in a presentation album) to the thickness of good-quality photographic paper. Image quality can be the best a printer can deliver

with excellent sharpness and color saturation. However, paper and ink costs may be high.

Art papers are suitable for presentation prints or for special effects and include materials such as handmade papers, watercolor papers, or papers with burlap or canvaslike surfaces. With these papers, it is not necessary to use high-resolution images or large files that are full of detail.

Paper qualities

If you want to experiment with different papers, just ensure that the paper does not easily shred and damage your machine and clog the nozzles of the inkjet cartridge. If using flimsy papers, it is a good idea to support them on thin cardboard or a more rigid piece of paper of the same size or slightly larger. The main problem with paper not designed for inkjets is that the ink either spreads too much on contact, or pools and fails to dry.

Dye-sublimation printers will print only on specially designed paper—indeed, some printers will even refuse to print at all when offered the wrong type of paper. Laser printers are designed only for office stationery and so there is little point in using other types of paper.

Crucial color

Not only does the blue of this scene test the evenness of printing, it also tests color accuracy. Very slight shifts away from blue will make the image look unbalanced in color and distract the viewer's attention from the relaxed, sun-filled scene. In fact, blue ranks with skin tones as the most important of colors that must be correctly printed, or else the foundation of an image will be seen as unsound.

Dark subjects

The blacker a color image, the more ink will be needed to print it. If your subject is full of very dark areas, such as this scene, the paper could easily be overloaded with ink. The ink may then pool if it is not absorbed and the paper

could buckle or become corrugated. To minimize this problem, use the best-quality paper and tone down the maximum of black as much as possible by reducing the black output level in the Levels control.

TRY THIS

To determine the minimum resolution that gives acceptable results on your printer, you need to make a series of test prints with the same image printed to the same size but saved to different resolutions. Start by printing out a good-quality image of about 10 x 8 in (25 x 20 cm) or letter (A4) size at a resolution of 300 dpi-its file size is about 18 MB. Now reduce resolution to 200 dpi (the file size will get smaller but the output size should be the same) and print the file, using the same paper as for the first print. Repeat with resolutions at 100 dpi and 50 dpi. Compare your results and you might be pleasantly surprised: depending on the paper and printer, files with low output resolution can print to virtually the same quality as much higherresolution files. With low-quality or art materials, you can set very low resolutions and obtain results that are indistinguishable from high-resolution files. In fact, low resolutions can sometimes give better results, especially if you want brighter colors.

Even tones

Subjects with large expanses of even and subtly shifting tone present a challenge to inkjet printers in terms of preventing gaps and unevenness in coverage. However, in this image of a frozen lake in a Kazakh winter, the challenge is not so great because the color is nearly gray, which means that the printer will print from all its ink reservoirs. If there is only one color, most often the blues of skies, you are more likely to see uneven ink coverage.

Quick fix Printer problems

A great deal of computation is needed before your printer can translate the image on screen or captured in a digital camera into a print. Not only must the pixel data be translated to individual dots or sets of dots of color, that translation must ensure that the final print is sized correctly for the page and is the right way around. Everybody has problems with printers; the real surprise is that people do not experience more printer problems than they do.

Troubleshooting

The most common causes of problems with the printer are often the easiest to deal with. As a routine response to problems, check that the power cord and printer cable

are securely inserted at both ends, check that your printer has not run out of ink, and make sure that the paper is properly inserted, with nothing jammed inside.

Problem	Cause and solution
Prints show poor quality—dull colors or unsharp results.	If you run the self-check or diagnostic test for the printer and nothing appears to be mechanically at fault, then the cause is a user setting. You may have set an economy or high-speed printing mode. If so, set a high-quality mode. You may be using a low-quality paper or one unsuitable for the printer, or you could be using the wrong side of the paper: change the paper and see what happens. You may be using an uncertified ink cartridge instead of the manufacturer's: use the manufacturer's own brand.
Prints do not match the image seen on the monitor.	Your printer and monitor are not calibrated. Go through the calibration steps (see pp. 232–3). Your image may contain very little color data: check the image using Levels—rescanning may be necessary.
A large file was printed very small.	File size does not alone determine printed size. Change the output dimensions using the Image Size dialog box.
An image does not fully print, with one or more edges missing.	Output size is larger than the printable area of the printer—most printers cannot print to the edge of the paper. Reduce the output or print size of the image in the Image Size dialog box and try again.
The printer works very slowly when it is printing images.	You may have asked the printer to do something complicated. If your graphic has paths, simplify them. If your image has many layers, flatten the image prior to printing. To print landscape-format pictures, rotate the picture in your image-manipulation software prior to printing. If you set the magnification to anything other than 100 percent, the printer must resize the entire image. Change the image size using image-manipulation software before printing.
The print suddenly changes color part of the way through.	Either one of the colors in the ink cartridge has run out or it has become blocked during printing. Clean the nozzles using the driver utilities and try to print again. You may need to repeat the cleaning cycle several times.

paper with the receiving side facing the back of the pack.

resolution and on good paper.

Art printing

It is thrilling to see your images enlarged to poster size and displayed as a work of art. The subject of the poster need not be unusual—sometimes the simplest image is the most effective—and the digital file from which it is output may not even need to be of the highest resolution. This is because large prints tend to be viewed from a distance, so finely rendered detail is not necessarily an issue.

Permanence

The two main factors governing the permanence of photographic images are the characteristics of the materials used and the storage conditions. Both of the main components of the materials the ink that makes up the image and the substrate, or supporting layer—are important.

For the ink to be stable, its colors must be fast and not fade in light or when exposed to the normal range of chemicals in the atmosphere. In general, pigment-based inks—those using solid particles for colorants—are more stable than dye-based inks—those using colored liquids. For the paper to be stable, it should be neutral and "buffered" (able to remain neutral when attacked with a small amount of acidic chemicals), and should not depend on volatile chemicals for its color or physical state. Materials used range from cotton rag to alpha-cellulose and bamboo. The substrate may be a source of impermanence: papers fade or become brittle; papers with a laminated structure are prone to one layer cracking or peeling.

When colors fade, one is likely to fade more rapidly than others, which quickly becomes obvious as a color shift. Black-and-white materials do not suffer from color shift, so they therefore appear more stable.

The careful design of storage conditions can ensure that even highly unstable images are preserved. Ideally, images should be stored in chilled conditions—almost at freezing point—

Faded print With half the print shielded, the exposed half faded after only one week's constant exposure to bright sunlight.

Since some colors are more fast, or resistant to fading. than others, there will be a color shift in addition to an overall loss of density.

Archival storage

Digital photographers have two strategies for the archival storage of images. The first is to store images in the form of prints in the best possible conditions specifically, in total darkness, low humidity, chilled (to temperatures close to freezing point) with slow air circulation in archivally safe containers. These containers—boxes made from museum board should emit no chemicals or radiation, be pH-neutral (neither acidic nor alkaline), and, preferably, incorporate a buffer (a substance that helps maintain

chemical neutrality). These conditions are ideal for any silver-based or gelatin-based film or print.

The alternative strategy is to store images as computer files in archivally safe media. The current preferred option is the MO (magneto-optical) disk, but nobody really knows how long they will last. Next down are media such as CDs or DVDs, which are, in turn, more durable than magnetic media such as tapes or hard disks. But you can never be sure: a fungus found in hot, humid conditions has developed a taste for CDs, rendering them useless.

with low humidity and in total darkness. To ensure the best color stability, exposure to light and chemicals should be kept to a minimum, temperature should be chilled, and humidity low but not zero. In normal room conditions, most materials will last several years, but if kept in a kitchen or bathroom, your prints will have a much-reduced life expectancy.

Large prints

There are two main approaches to outputting prints larger than tabloid size (A3), the maximum that can be easily printed on a desktop printer. The first is to use a large-format printer: these range from self-standing machines to monsters capable of printing advertisements for the side of a bus. If you cannot afford a large-format printer, you need to take your file to a bureau.

Before you prepare your file, ask the bureau for its preferred format (usually RGB TIFF uncompressed), and ask which color profile they expect embedded in the image. Find out which type of removable media is acceptable—all will read from a CD or DVD, and many accept portable hard-discs. You also need to check the resolution the bureau prefers, and you should adjust the file to the output size you require (although some bureaus do that for you).

There are different printers that produce prints appropriate for different markets. The preferred type of printing for the art and fine-art exhibition market uses pigment-based inks for its greater permanence, but dye-based inks may produce subtly superior results. However, bear in mind that the choice of paper is more limited in large sizes than in smaller, cut-sheet sizes. The best of ink-jet printers manufactured by, for example, Mimaki, Epson, Roland, Canon, or Hewlett-Packard can produce extremely high-quality prints suitable for commercial display and trade exhibitions.

The other approach is a hybrid one, based on the digital manipulation of true photographic materials. Your file is used to control a laser that exposes a roll of photographic paper. This is then processed in normal color-processing chemicals to produce a photographic print. Many offline printing services use the same method to produce small photographic prints or books from digital image files. The results can be extremely effective and look very much as if they are traditional photographic images from start to finish. Another advantage to this method is that relatively small image files can produce excellent results: 20 MB of detail may be fine for a poster-size (A2) print.

Tiling a printout

One way to make prints larger than your printer can print is to output the image in sections, or tiles, which you then join. This is straightforward in desktop publishing applications such as QuarkXPress and InDesign: you simply create a large document size, set up the page for the available paper dimensions, and tell the software to print out each section on the paper supplied. You can then trim the prints to remove the overlaps and butt the edges together to produce a seamless, large-size image. For those occasions when economy is important and critical image quality is not required, tiling is worth considering.

Tiling option

Modern printers work with great precision and consistency, so it is possible to combine tiles almost seamlessly. Use heavier-weight papers, plastic, or filmlike material to help retain shape. Then the overlaps need be only sufficient to allow you to trim off the excess and butt the images together before fixing.

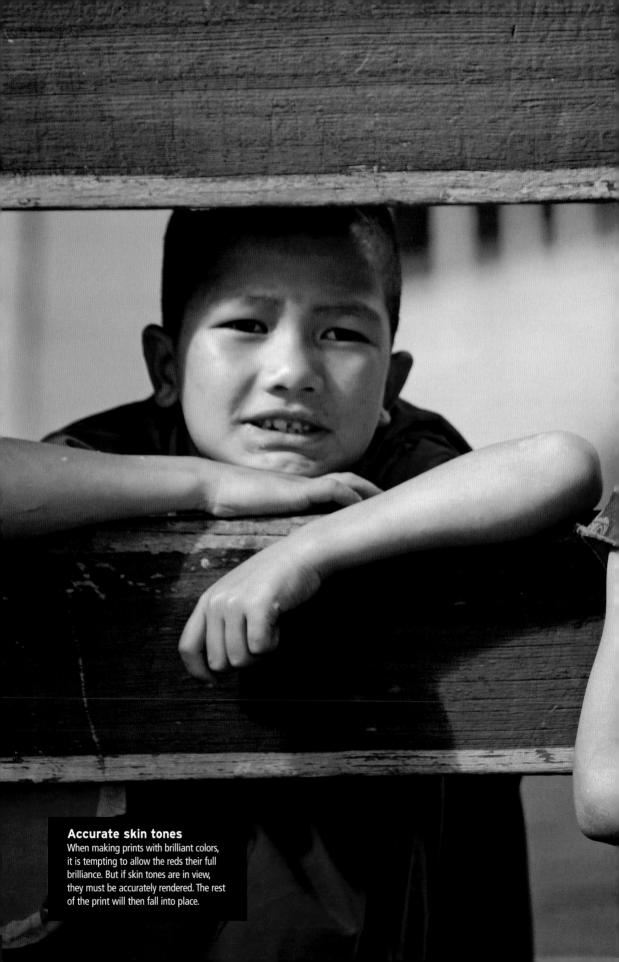

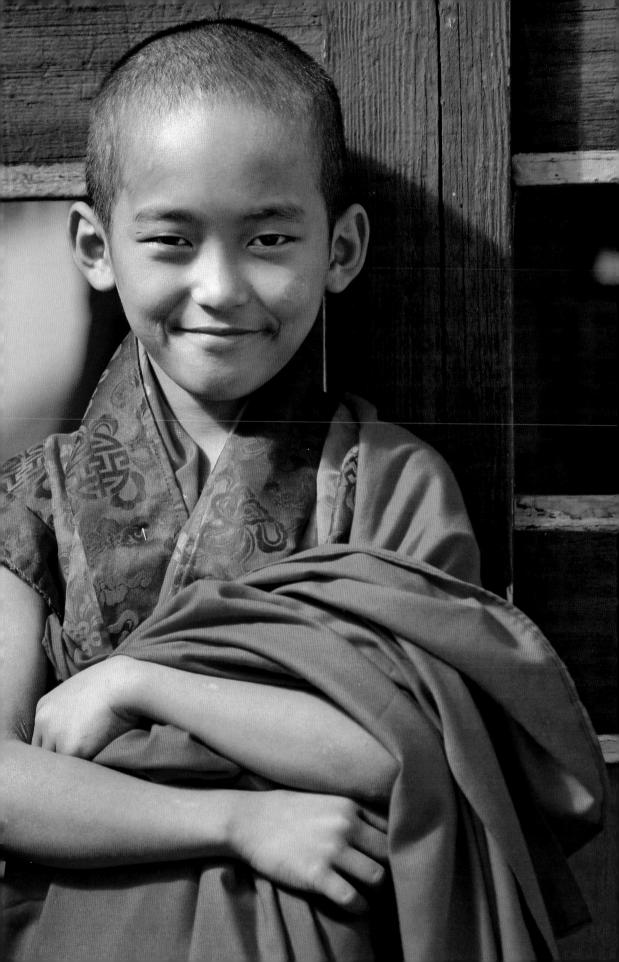

Publishing on the Web

The internet is now the main method of distributing, viewing, and using photographs. This has opened up exciting opportunities for photographers the world over. The number of images on the web is truly astronomical, and by visiting just two of the most popular photo-sharing websites, you have access to more than a billion images.

This situation is due to three factors: the seemingly infinite ability of the web to expand its capacity; powerful new applications for handling images online; and wide access to high bandwidth to allow high-quality images to be downloaded.

Sharing and storage

There are now numerous sites where you can send images to store them, to share them, or to promote your own photography (see p. 394).

Storing your images on a remote hard-disc farm offers security and worldwide access, but the access is slowed down. Picture sharing is good for promoting work or sharing images, but it exposes the image to unscrupulous exploitation. Check the terms and conditions of any website to which you upload: you may be asked to give up rights or provide warranties that you find onerous. It is advisable not to sign up to any service that expects you to give up any rights to your images.

Preparing images

The size of the images you show on a website always depends on balancing quality with the speed of loading the web page. Quality depends

on both the pixel dimension of the image and the level of compression: fewer pixels and higher compression make for smaller files and quicker loading; the downside is compromised image quality. Using high-quality images—measuring 1,024 pixels or more on the long side—may also expose your images to unlicensed use.

There are four main steps in preparing images for use on the web:

- Evaluation Assess the image quality and content. If it is photographic, you can convert it to JPEG; if it is a graphic with few subtle color gradations, you can convert to GIF. Also adjust brightness and color so the image will be acceptable on a wide range of monitors.
- Resizing Change the size of copies of the images (not the original files) to the viewing size intended, so that the file size is no larger than necessary. Images may be tiny, perhaps 10 x 10 pixels (for use as buttons), or large, say 640 pixels on the longest side (for displaying work).
- Conversion Convert photographic images to JPEG. Set a compression slightly greater than you would like (the image is degraded just a little more than you would wish) to optimize loading speed. (See also the box below.)
- Naming Give your files a descriptive name using letters and/or numbers. The only punctuation marks you should use, if desired for clarity, are dashes (-) or underscores (_). Always put a period before the jpg suffix (.jpg).

Optimizing your pictures on the Internet

You will want those who access your site to receive your images quickly and to have the best experience of your images that the system permits. Here are some tips for optimizing your images on the Internet.

- Use Progressive JPEG if you can. This presents a low-resolution image first and gradually improves it as the file is downloaded. The idea is that it gives the viewer something to watch while waiting for the full-resolution image to appear.
- Use the WIDTH and HEIGHT attributes to force a small image to be shown on screen at a larger size than the actual image size.
- Use lower-resolution color—for example, indexedcolor files are much smaller than full-color equivalents. An indexed-color file uses only a limited palette of colors (typically 256 or fewer), and you would be surprised at how acceptable many images look when reproduced even with only 60 or so colors (see p. 274).

JPEG compression

With minimum JPEG compression, you get maximum quality. In fact, at the highest magnification, it is very hard to see any loss in detail, but at the magnification shown here you can make out, with careful examination, a very slight smoothing of detail in the right-hand image compared with the original on the left. The cost, of course, is that the file is compressed from nearly 7 MB to about half the size, 3.7 MB.

Quality setting

At the minimum quality setting, the file size is pared down to an impressive 100 K from 7 MB-to just 2 percent of the original size—a reduction of nearly 50 times, and the download time has dropped to an acceptable 16 seconds. The loss of image quality is more evident: notice how the grain in the original (far left) has been smoothed out and the girl's arm is altered, with slightly exaggerated borders. But when it is used at its normal size on screen, it is a perfectly acceptable image.

Medium quality

With a medium-quality setting, here showing a different part of the same image, there is a substantial and useful reduction in file size—from nearly 7 MB to just 265 K-some 20 times smaller, or 5 percent of the original file size. The download time is accordingly reduced from over 15 minutes to 50 seconds. This latter figure is still uncomfortably long and the image quality is arguably better than needed for viewing on screen, while being just adequate for printing at postcard size.

Creating your own website

Photo-sharing websites such as Flickr, Fotki, and Webshots have removed virtually all obstacles to publishing images for worldwide viewing. However, these are essentially a collection of picture albums: your work is presented on pages identical to millions of others—opportunities to individualize page design are nonexistent or very limited. If you feel this is a constraint, you can create your own website instead.

Hosting

There are thousands of services that will host your site—that is, your files are physically located on their computers, which serve out pages to visitors to your site. And there are hundreds that offer free hosting. Check the terms of service, that you do not have to include advertisements, and that you do not lose any picture rights. You will also want secure ways in which people can communicate to you via the site. Ensure that the host has sufficient capacity to hold your pictures and that the monthly data-transfer limit is sufficient for your photographic needs.

Site design

The advantages of running your own site include: control over the look and feel, no restraints over use of your images (within legal limits), and the ability to organize images however you like. The main disadvantage compared to picture-sharing sites is that you have to do quite a bit more work.

Nonetheless, there is a considerable amount of help available for the design and construction of your website. Free design applications can be downloaded, there are hundreds of web-based tutorials, and some services help you construct sites directly online. In addition, major imagemanipulation (such as Adobe Photoshop) and management software (such as iView, FotoStation, Lightroom, and Apple Aperture) offer templates for design, and publishing the site—that is, uploading the HTML pages and resources to your hosting server—can be virtually a one-click process.

For more sophisticated sites on which you can present Flash or animated content with more features, WYSIWYG ("what you see is what you get," supposedly) web-design software such as Adobe Dreamweaver (Mac OS and Windows), CoffeeCup (Windows), and Serif WebPlus (Windows) will help you get started.

Once you have created a site, don't forget to tell everyone about it: send links to all your friends and colleages, and post announcements on blogs.

Professional sites

Websites such as Digital Railroad, DigiProofs, and Zenfolio provide paid-for picture hosting and different features to suit markets as varied as photojournalism and wedding photography. In return for a fee, you can store large numbers of high-resolution files and you can individualize your own pages. In addition, these sites actively market your work by offering your images as part of the collective inventory of stock photography and may also handle management of the picture rights. However, there are no shortcuts to the work needed to add keywords, captions, and other metadata to images, then uploading them

all to the hosting site.

Digital Railroad

The home page of a photographer features details and links to other pictures in the photo collection. Visitors can click on an image to view an enlargement and search by keywords. If they wish to purchase usage rights, they can select the images and complete the whole transaction online.

Adobe Lightroom templates

While primarily an image-enhancement and management application, Lightroom also offers website-design features. These include a range of templates, plus the ability to choose a color scheme and some other design details as well, including Flash content. Similar but much more limited facilities are offered in Apple Aperture.

Melpen... Vista's ... Vista's ... In Lens Co... | large fo... craq

♥TOMANG.COM

Personal website

A personal site can be simple in appearance yet tricky to update and maintain. This site contains only text and images, but the tendency is to allow it to languish. It depends on whether it is more important to have an up-to-date site that is not individual, or a personal site that is a little dog-eared.

Going further

With the vast quantity of information available, it is relatively easy to find out all you need to know about the many aspects of digital photography. There are numerous sources of information on the web-although these vary in both quality and depth, the best-known sites have excellent, in-depth and up-to-date information on photography, image manipulation and equipment. There are also videos and interactive courses on DVD that guide you step-by-step, and there are also numerous books, some of which you will find listed in Further Reading (see pp. 398-9). The best way to learn from these sources is usually to have a specific task to complete: having a clear direction in mind, rather than just picking up unrelated snippets of information, will greatly speed up your learning.

Another option to help you go further is to attend a training course. Many are available, but the

Taking a course

To help ensure that you get into the program of your choice, consider the following points.

- Plan ahead: most courses recruit and interview only at certain times of the year.
- Prepare a portfolio (see p. 369).
- Read up: if the course contains elements you are not familiar with, such as art history, media theory, and so on, make sure you are interested in them before applying. Further, if you know what the course objectives are, you will then know that what you want to do is in line with what the institution wants to achieve. This is important for you—and it is likely to impress the interviewer.
- Check on any formal requirements: some colleges insist that you have certain minimum educational qualifications before you are considered. You may need to attend an access or refresher course before entering college.
- Plan your finances: attending classes affects your ability to earn and can itself be a financial drain.
 Calculate the course fees, then add the materials, equipment, and travel costs to your living expenses to work out how much you need to put aside.

most cost-effective are usually those offering intensive or residential tuition. These are often run as summer schools in which you immerse yourself in a completely "digital" environment. Such courses will enable you to concentrate on problem-solving, and being able to ask for help from experts at the immediate time that you need clarification can greatly accelerate the learning process. However, if you do not have the equipment to continue at the same level once you return home, you may quickly forget all you have learned. To make the most of immersion teaching, you need to continue using your newly acquired skills. To check if an intensive or residential course is suitable for you, ask these questions when you speak to the administrator or when you read through the prospectus:

- Do the fees include all materials, such as paper, ink, and removable media?
- Will there be printed information to take home and keep?
- Which software, and version, will be taught?
- Which computer platform will be used?
- Do students have individual computers to work on or will you have to share?
- What standard is expected at the start; what standard is to be attained by the end?
- What are the qualifications of instructors? You will gain most from any course if you first thoroughly prepare yourself. Having a project or two in mind to work on prevents your mind from going blank when you are asked what you would like to achieve. And take along some image files or a scrapbook of pictures to use or to scan in. The best way to learn how to use computer software is to have a real task to complete—this might be creating a poster for a community event you are involved in, making a greeting card, or producing a brochure for a company.

Courses and qualifications

If you want more in-depth training and a broader educational approach to the subject of digital photography and image manipulation, then higher or further education courses at college or university are the best route. They are good for meeting other

Going further continued

like-minded individuals: over a period of a few years you can make lasting friends and valuable contacts, and a shared course of study also makes it far easier to share interests and solve problems. A longer period of study also gives you time to figure out future plans and develop in-depth projects.

In some countries you may need a qualification in order to gain a license to work professionally, and so completing a formal course is a necessity. In the English-speaking world, qualifications are seldom a prerequisite for professional practice, unless you wish, for example, to teach digital photography at college level. Indeed, formal qualifications may even be discouraged in some sectors of practice. Don't be afraid to ask local professionals for their advice; most will recall their own initial struggles and will be prepared to help others.

If undertaking a college-based course is not possible, then you may want to consider some type of distance-learning or online study. In these, you communicate with your tutor by mail or email, working with printed materials or from a website. A distance-learning course enables you to be flexible about your rate of progress and when you work, and so is ideal for fitting into a busy schedule, but it can be a lonely process. You may have no contact with fellow students or teaching staff beyond brief summer seminars.

Multi-skilling

Digital photography is just one expression of an enormous growth in employment and career opportunities based on new technologies that has taken place over the last few years. One important feature of these recent developments is that the need to have multiple skills makes it relatively easy for, say, competent digital photographers to transfer to print publication, or for people talented in the field of, for example, page design, to transfer their skills to Internet-based work.

Careers in digital photography

Working as a digital photographer is not solely about the glamorous areas of fashion, advertising, photojournalism, or celebrity portraiture. Many varied and satisfying ways of doing what you enjoy and earning a living are available.

Those, for example, who have some sort of specialized interest—for instance, archeology, architecture, music, or natural history-may find work with institutions relevant to their interests, such as museums, historical societies, humane societies, and so on. In such an environment, a likely job description will require not only photographic skills but also an enthusiasm for and knowledge of the subject. Other career opportunities could take you in the direction of becoming an in-house photographer for specialist magazines—those covering an industry or particular sport, such as sailing, fishing, or biking. If you like working with animals, you might want to consider offering a photographic service to pet owners by taking their animals' portraits in an inventive and creative way (see pp. 186-8).

Those who enjoy photography may also find work in the background to other activities—for example, as technicians in laboratories, factories, or universities. This type of work often has the advantage of letting you do the things you enjoy— perhaps scanning followed by the digital manipulation of pictures—without the stresses associated with working as an independent professional photographer. At the same time, you may enjoy access to equipment that only large organizations can afford—astronomical telescopes or electron microscopes, for example.

Another burgeoning area of photographic interest is in the field of scientific and medical imaging. This ranges from remote satellite sensing to unraveling the secrets of the atom. The work is highly technical but could perfectly suit those with physics or medical degrees who have an interest in both digital photography and aspects of computer technology.

Those with the requisite depth of knowledge and industry experience can also find a welcome in teaching and training institutions: it is widely recognized in many countries that hightechnology industries and service providers are being held back by a skills shortage. If you are an experienced photographer or a designer who has developed a professional grasp of key applications—including Photoshop, Aperture, Lightroom, InDesign, web-authoring applications such as Flash and Dreamweaver, or vector-based graphics software such as Adobe Illustrator—then there are many opportunities for training the thousands of people who need to learn how to use these computer programs.

Finally, the digital photographer is but a step away from working with time-based media, such as animations and video. Indeed, Photoshop was originally invented to clean up images for the film industry, and today the distinction between software for stills images and software for moving images is becoming increasingly blurred, especially with the Internet carrying more and more moving imagery.

Another dimension of time-based media is multimedia production, whether for computer games, websites, or educational presentations. All of these career applications have an enormous appetite for well-taken pictures that display a careful judgment of tonality and color.

Career advice

The key requirement for a career in digital photography is versatility: having a wide range of skills covering diverse fields and the willingness to apply them to different and sometimes untried ends. You need to be competent in photography to understand lighting, exposure, composition, and the nature of the recording medium. You need to be comfortable with computers, to work with varying pieces of hardware to get the most out of them: the more extensive your technical experience, the easier it will be to solve production problems. And you need an understanding of how images work in contemporary society and the wider cultural context in which they operate. A base in visual and contemporary culture with an awareness of art history are great assets.

Needless to say, you have to be competent with

software. This means more than being able to use standard software; rather, you have to be able to obtain the results you want effortlessly and rapidly so that your thinking and creative processes are not hampered by imperfect knowledge or lack of experience. All professional imaging artists use only a fraction of the capabilities of their software—just photographers use a very limited range of films and equipment—but their command of what they use is so fluent that the software becomes almost an extension of their thinking. Much of today's professional work is the creation of a visual solution to a conceptual or communication problem, so it helps to understand how to translate abstract concepts into an attractive, eye-catching image.

And because operating professionally also means working successfully in a commercial environment, you need some business sense, or at least access to good advice, as well as a desire to act professionally—to commit yourself to working to the highest standards, to work honestly, and to take your commitments, such as keeping to agreed deadlines, seriously.

Digital photographers may, therefore, have graphics, illustration, design, or photography backgrounds. While the list of competencies may seem demanding, the good news is that the need is growing much faster than supply. Anybody who offers technical skills combined with artistry, creativity, and business acumen will be kept busy.

Turning professional

Having the right attitude and doing your homework are essential if you are thinking of turning professional. Here is a basic checklist of points to consider before taking the plunge.

- Be positive, decide what you really want to do, and decide that you are going to do it.
- Be prepared to start small, with work you may not want to do long-term, to gain experience, build confidence, and provide the capital reserves to take you in the direction you really want to go.
- Check out the competition: if you want to

Going further continued

be a portrait photographer, you need to know if there are already two others in your community.

- Decide what to charge for particular types of work: it is embarrassing to be asked "How much will it cost?" when you cannot give a quick answer.
- Consider a loan to finance your startup: this means preparing a business plan (*see below*).
- Check any legal and local regulations: do you need to apply for a license; are you allowed to conduct business on your property; do you have to insure against third-party claims?
- Check your supply lines: can you get materials quickly or rent equipment if you need something more specialized than you already own?
- Raise your profile: make sure local newspapers and magazines know you are in business.
- Prepare a portfolio (see opposite)—potential clients will want to see what you can do—and other advertising, such as a website or posters for your local library and meeting places.
- Consider joining a professional organization or Chamber of Commerce to network with others.

Preparing a business plan

A business plan makes you consider whether you have a viable prospect. It makes you think about what you want to do and if you have the means to do it, in terms of money and management skills. Just as important, a business plan demonstrates to your bank or accountant that you should be taken seriously. It is no exaggeration to say that merely possessing a well-presented, clearly argued business plan takes you halfway to the financing your business might need.

The business plan is a report: it summarizes your aims and objectives while honestly presenting your strengths and weaknesses. It should assess the competition and market to arrive at an honest appraisal of your chances of success. The plan also presents a cash-flow forecast of how your business will develop over the first two years or so.

A typical cash flow will show that in the early months, more money will be spent than income is earned. As the business becomes established, income increases while overheads (rent, heating, utilities) remain steady: your business is starting to make money. But at predictable times during the year—when your insurance needs renewing, perhaps—there will be heavy costs, and these might coincide with times when business is slow. By working this out, you know when to expect a few tricky months and can warn the bank in advance. This confirms your financial competence and makes it easier to obtain short-term loans or a line of credit. The cash flow will also show when an injection of extra cash may be needed to take on more people or invest in new equipment.

Many banks give advice or literature on writing a business plan and constructing cash flow forecasts. These may be alien concepts, but you should keep in mind that they are essentially works of fiction—they mix a good deal of fact with the potential and the probable. They should not, however, be works of fantasy, which combine the improbable with the potential. Finally, bear in mind that as your work develops, it may move away from the projected business plan. But with the plan written, at least you know you are changing direction. A business plan is a map—drawn by you—by which to plot your future.

Keeping records

Good records are essential for a well-run business. minimizing the time involved in completing tax returns, dealing with the bank, or setting prices for particular types of work. Get into the habit of keeping all your receipts. Try to make a brief note of the phone calls you make and receive, and keep a book on the projects you work on. In addition, keep track of everything you are paid. Good records keep you on the right side of the law and tax authorities. They also put you in a good position if you are ever involved in litigation—you can refer to your notes and give times and dates on what was discussed and agreed. Good records will also lower your accountancy costs. Accurate financial records enable you to regulate your cash flow, and the resulting soundness of your money affairs will also lower bank and other finance charges.

Creating a portfolio

A portfolio is a selection of your best work brought together to show to a potential client or employer. "Selection" means be selective—only show the type of material that maximizes your chances of getting the work. "Best" obviously means that you select only from the work you are confident in, pleased with, and wish to be known for. And when you present your portfolio, it should be part of a carefully thought-out process. Consider everything—from the way you dress to the words you use, the way you mount your prints to the style of your business cards—so that you make exactly the right impression.

When you create and present your portfolio, bear in mind the following points.

- Show the kind of work that you want to be commissioned to photograph: don't show a range of portraits if you want to shoot gardens.
- Show work that is appropriate: if you know the client is interested in seeing fashion shots, show off your portraiture. A lack of fashion shots in your portfolio may not be too much of a disadvantage—but certainly don't show interiors.

- Show enough to make it clear you are talented and capable, but no more: showing too many images may demonstrate a lack of confidence and poor judgment.
- Talk about your images or explain the thinking behind them only as much as you are invited to: talking too much about your work could, again, suggest a lack of confidence.
- Allow the people reviewing your work to look through it at their own pace. Most professionals sort pictures very rapidly—pausing for perhaps barely a second on each image. This can be very disconcerting if you are not used to it.
- Dress appropriately. If your client is in media you may generally dress more informally than when meeting a financial or industry client. Awareness of dress codes is not about conformity; it is about understanding the needs of clients.
- Be polite. You may be rejected today, but you may want to return another day or approach a different part of the company.
- Leave contact information—preferably a goodquality picture or print, or at least a business card.

Methods of presentation

Unmounted prints

This is the cheapest method but can be recommended only for very informal presentations. Prints easily become damaged when they are handled.

Mounted prints

Still relatively inexpensive, but prints do receive some protection. They may need interleaving or windowmattes (cards with window apertures to reveal the image) for best protection. Being bulky and heavy, oversized mounts (larger than tabloid/A3) are not popular with commissioners. Generally, it is best to mount prints singly rather than arrange them in groups.

Mounted color transparencies

Inexpensive, and you can show many images at once, but you may need a lightbox and magnifier. You could load a selection of transparencies in a slide carousel if you know the client has a projector. This is very convenient and popular in some countries.

Large-format transparencies

This is costly but most impressive: the system makes even small-sized original transparencies look good. Robust (though possibly heavy), and easy to view even without a lightbox, this is a favorite method of presentation in advertising and commercial photography.

A very cheap and reliable medium if you have the right equipment. It allows you to show your images in the best light and is excellent for distribution, since it is easily mailed. The (fairly safe) assumption, though, is that the recipient has a CD player in their computer.

Website

Very inexpensive and relatively easy to set up (see pp. 360-3). Allows anyone 24-hour access anywhere in the world to view your pictures. It assumes that clients have Internet access and are sufficiently interested in your work to look for your site.

Building up your business

Your aim as a photographer is to provide a service for potential clients: in short, people will offer you work if you give them what they want. To that end, you need to bring all your photographic skill, inventiveness, flexibility, and professionalism to bear on the task, as well as honesty and as much charm as you can muster under what will sometimes be very testing circumstances. The qualities that help you attract business in the first place are the same ones that help you retain and build up your client base.

Promotion and marketing

One of the keys to building a successful business is good communication. To start with, clients must be able to find you, and to find you they must first know about you. This is the task of promotion and marketing. Start small—perhaps by placing advertisements locally in community newspapers and magazines, cards or posters on store noticeboards, even pamphleting homes and businesses in your neighborhood. Visit local businesses and leave contact details—preferably a promotional card featuring a picture of yours. If there is any interest, be prepared to show your portfolio (see p. 369): pay particular attention to businesses that are likely to be visually more aware, such as architects, realtors, interior designers, garden architects, and, of course, local publications. Remember, there's no shame in starting by visiting homes to take pictures of babies before making your move on the competitive world of celebrity portraits; hone your skills on interiors of homes for sale or flower arrangements before tackling a multinational's annual report. And, of course, the Web is an increasingly important place for self-promotion, and a natural choice for the digital photographer. A Web presence has to be supported by targeted marketing, however, such as mailings of your photographic calling card or sending out CDs of work.

Once you make contact with potential clients, you then need to enter into discussions with them to help bring about a successful conclusion to the exercise.

What is a contract?

A contract creates legal relations between two parties in which one offers to carry out some work or service and the other party accepts an obligation or liability to pay for that work or service. The contract may not have to be a formal legal document: an exchange of letters, even a conversation, may be sufficient to form a contract and, with it, corresponding legal obligations (depending on local law: ask your lawyer if you are not sure). However, in general, both parties must want to enter into a relationship. This may carry with it conditions that both sides agree. In addition, a contract is generally legally binding only if it is possible to carry it out, is not illegal, and is not frustrated by circumstances beyond the control of either party. Many photographers do not realize that when they are commissioned to carry out work to an agreed specification, they are legally bound to do so: artistic license and freedom of expression do not come into the debate. By the same token, if a client commissions a photographer to take ten portraits, to ask in addition for shots of the building is to vary the contract. It is reasonable for other terms, such as payment, to be renegotiated. An important issue is who retains copyright on a commission: in some countries, national law allows copyright to be assigned from the creator to the commissioner; but in other countries, copyright is held to be an inalienable right of the artist and cannot be assigned to anybody else.

Clarity

Be specific (not "as soon as possible," but "within five working days"); be precise (not "digital images," but "high-resolution, 10 x 8 images at 300 dpi"); be straight (not "of course I can do it" when you don't really know, but "I'll shoot a free test and you can see how it works").

Honesty

Evaluate your skills objectively. Certainly you can take risks and push yourself, but don't let others down—in the end, you only damage yourself. If you don't like something—perhaps an element of the commission is dangerous or unethical—then say so (and the sooner the better).

Repetition

Summarize the conclusions after any discussion has taken place; summarize and confirm the action points; repeat and confirm the schedule with everybody concerned; and repeat and confirm all task allocations and responsibilities.

Follow-up

Construct a paper trail with a written or emailed note after all meetings. Record any phone conversations pertinent to a commission, particularly if detailed changes are being discussed. Keep records of what you do, why you're doing it, and how much it is costing you. If, right from the beginning, you make a habit of keeping good records, even with small jobs, you will be able to cope better with the larger ones.

Legality

Introduce into the discussion anything to do with copyright, licensing, or other legal aspects of the commission that may concern you as soon as they become relevant. Doing this will add to, rather than detract from, the air of professionalism you project. And more often than not, the client will be pleased to know about any possible legal complications at the earliest possible point.

Finances

Talk about money—fees, daily rates, equipment rental charges, and any associated charges that will affect the final bill—early in the negotiations. You will not seem greedy by doing this; you will look more professional. And if you don't think the money is right, then say so. If the money is going to be a deal-breaker, then the sooner you know about, it the better.

Repeat business

Clients will appreciate any sign of your involvement in the project over and above that engendered by the fee. For example, suggesting new approaches to the task, offering additional shots that were not specified, or trying out different angles or a more interesting and creative approach all represent "value-plus" from a client's point of view while, in fact, costing you very little.

Calculating your daily rate

The basic daily rate is your benchmark for survival: it measures the average cash flow (see p. 368) you need to keep going. After all, the fees you charge must at least pay for your survival. If you hit the rate, you can survive, but your profits will be minimal.

The first step is to add up your living expenses, including your rent or mortgage, the cost of any loans or car leases, utilities and groceries, and business overheads, such as insurance, bank charges, loan charges, vehicle and travel expenses, and so on. These are the expenses you must meet before you can move into profit. Don't forget to add depreciation of capital items, such as your camera equipment and car: you will need money to pay for their replacement.

The next step is less objective-you need to evaluate how many billable days you wish for and can reasonably expect to work in a year. Be realistic; allow yourself vacations, days off for illness, and other days on which you may not be earning any money but will still be working—going to meetings, for example, researching new projects, taking your portfolio around. A figure of around 100-150 nonbillable days per year is not an unreasonable figure.

Now, simply divide the figure for total costs by the number of billable days. Many photographers making this calculation arrive at a figure much higher than they expected. To this, of course, must be added your profit element, without which a business cannot grow and improve. An alternative approach, having worked out how much you need per year, is to divide the figure by the daily rate you think the local market will bear: that will tell you how many billable days you need to work.

Mounting an exhibition

After spending some time taking photographs and accumulating images, the urge to show your work to people beyond your immediate circle of family and friends may start to grow and gnaw at you. The first thing you must do is banish from your mind any doubts that your work is not good enough to show to the wider public. An exhibition is exactly that: you make an exhibit of yourself. People will not laugh, but they may admire. If you have the drive and the ambition, then you should start planning now—you cannot start this process too early.

Turning a dream into reality

You may feel that you are not ready to mount an exhibition just yet. If so, then perhaps you had better get on with the task of building up a library of suitable images. At some point in the future you will know you have the right material and that the time is right.

Now try to imagine in your mind's eye what the show will look like: visualize how you would light it, how you will position your images for maximum impact, how to sequence photographs to create a particular atmosphere, and create a flow of meaning or narrative. Picture to yourself the size of the prints, how they will glow in the light.

Selling prints

Remember that silver-based prints will continue, for a long time yet, to sell for higher prices than any digitally produced print. Here are some hints for ensuring good, continuing relations with your buyers.

- Don't make unsubstantiated claims about the permanence of printed images.
- Give people advice about how to care for the prints, such as not storing them in humid conditions or where they will be exposed to bright sunlight.
- Never exceed the run when you offer limitededition prints—produce the specific, guaranteed number, and not one more.
- Print on the best-quality paper you can afford, or that recommended by the printer manufacturer.

This will help to focus your mind and guide your energies as well as act as a spur to your picture- or print-making. Here are some other pointers you might want to consider.

- Choose your venue well in advance, as better-known galleries are under a lot of pressure and have to plan their schedules at least a year ahead. Other galleries may call quarterly or half-yearly committee meetings to decide what to show in the next period. At the other end of the scale, venues such as a local library or a neighborhood community center may be prepared to show work at very short notice. In any event, you will want to give yourself the time necessary for your plans to mature and to give the venue the opportunity to tie something in to the exhibition, such as a concert or lecture (depending on the subject matter of your imagery).
- Choose your venue creatively. Any public space could be a potential exhibition area—indeed, some seemingly improbable spaces may be more suitable for some types of work than a "proper" gallery. Bear in mind that the very presence of your work will transform the space into a "gallery," whether it is on the side of a bus, a shopping mall, or a pedestrian walkway.
- Budget with your brains, not your heart. Put on the best show you can afford, not one that costs more than you can afford. The point of an exhibition is to win a wider audience for your work, not to bankrupt you or to force you to call in financial favors that you might need at some time in the future to further your photographic endeavors.
- Once you have decided on the space you want to use and have received all necessary permissions, produce drawings of the layout of the entire venue. This will also involve you in making little thumbnail sketches of your prints in their correct hanging order: it is much easier to visualize the effectiveness of picture order this way.

Timing

Mounting an exhibition requires very careful planning on many different levels if you want your show to look professional, so don't leave any

Drawing up a budget

When budgeting for the costs of an exhibition, take into account not only your direct photographic expenses but also the range of support services. These include the costs of electricians to light your work, picture-framing, public liability insurance, the building (or renting) of "flats" to break up the exhibition space and provide extra surfaces on which to hang your work. Here are some cost categories to consider.

- Direct photographic costs—including making prints or slide duplication if projected images form part of your show.
- Indirect photographic costs—including retouching, mounting, frame-making, and rental of equipment, such as projectors.
- important carpentry, electrical, picture-framing, or similar work to, say, a long weekend or vacation period when you might not be able to gain access
- to key personnel should something go critically wrong. And you should always count on the fact that something will go wrong.

Looking at sponsorship

One way to offset some of the costs of mounting an exhibition is by sponsorship. The key to success is persuading a potential sponsor that the likely benefits from the relationship will flow both ways. It is obvious that you will benefit from the deal by being offered the use of equipment you might not otherwise be able to afford, perhaps, or complementary or discounted print-making, but what do the other parties get?

The best approach to sponsorship involves persuading potential benefactors that by making equipment or services available to you, they will receive some boost to their business or that their public profile will be somehow enhanced by the association. It could be that, for example, sponsoring individuals, companies, or organizations will receive coverage in trade newspapers or journals as a result of their help.

- Gallery costs—including rental fees, deposits against damage or breakages, and paying for flats or similar.
- Publicity—including the cost of producing and mailing out invitations, advertising in trade or local journals or newspapers, as well as the production of an exhibition catalog.
- Insurance—budget for the costs of insuring your work, public liability, and damage to the venue.
- And don't forget—no matter what your final budget figure is, there will always be out-of pocket expenses you cannot identify beforehand. At the last minute, for example, you might decide you want flowers for the opening night. So, as a precaution, add a 15 percent contingency to the final budget figure.

As a rule, it is always easier to obtain services or products than it is to get cash. Printing materials, exhibition space, scanning, processing, even food and drinks for the opening night are all possible, but cash is unlikely. And remember to make your approach well ahead of time—organizations have budgets to maintain, and once sponsorship allocations have been made, often there may be nothing left until the next financial year.

Finally, even if the answer from a potential sponsor is "no," you can still ask for something that may be even more valuable—information. So ask for suggestions about which other companies or organizations might be interested in helping.

An exhibition is your chance to get your work known by a wider audience, so make full use of the opportunity if it arises by telling everybody you know about it, and encouraging them to spread the word to their contacts.

Finally, mounting a photographic exhibition brings together many different people and skills. They are your sponsors just as much as any commercial contributor, so always take the trouble to acknowledge their invaluable help and contributions, for without them your show might never have gotten off the drawing board.

Copyright concerns

Copyright is a vital subject, since it regulates the intellectual content of digital media and all information. Different traditions of copyright law in different countries lead to variation not only in the detail but also in the entire approach to this subject, but the broad outlines are regulated by international treaty and, for the web, by usage. The following are some frequently asked questions and answers framed to have as wide an applicability as possible. However, always seek professional advice if you are not sure what your rights are or how you should proceed. You may not need to hire a lawyer, since many photographic organizations provide basic copyright advice. Other sources of help can be found on-line (see pp.392–4).

Do I have to register in order to receive copyright protection?

No, you do not. Copyright in works of art—which includes writing, photographs, and digital images—arises as the work is created. In more than 140 countries in the world, no formal registration is needed to receive basic legal protection.

Can I protect copyright of my images once they are on the Web?

Not directly. This is because you cannot control who has access to your website. Make sure you read the small print if you are using free Web space. You may be asked to assign copyright to the Web server or service provider. Do not proceed if you are not happy with this condition.

Do I have to declare copyright by stamping a print or signing a form?

In most countries, no. Copyright protection is not usually subject to any formality, such as registration, deposit, or notice. It helps, however, to assert your ownership of copyright clearly—at least placing "© YOUR NAME"—on the back of a print or discreetly within an image on the Web, such as in the lower-right-hand corner.

What is a "watermark"?

It is information, such as a copyright notice or

your contact details, incorporated deep in the data of an image file. The "watermark" is usually visible but may be designed to be invisible. In either case, watermarks are designed so that they cannot be removed without destroying the image itself.

Can I be prosecuted for any images I place on the Web?

Yes, you can. If your pictures breach local laws—for example, those to do with decency, pornography, or the incitement of religious or racial hatred, or if they feature illegal organizations—and if you live within the jurisdiction of those laws, you may be liable to prosecution. Alternatively, your Internet service provider (ISP) may be ordered to remove them.

Is it wrong to scan images from books and magazines?

Technically, yes, you are in the wrong. Copying copyright material (images or text) by scanning from published sources does place you in breach

Can I prevent my ideas from being stolen?

There is no copyright protection covering ideas to do with picture essays, for example, or magazine features or books. The easiest way to protect your concept is by offering your ideas in strict confidence. That is, your ideas are given to publishers or editors only on the condition that they will not reveal your ideas to any third party without your authorization. Your idea must have the necessary quality of confidentiality—that is, you have not shared the information with more than a few confidants—and the idea is not something that is widely known. The most unambiguous approach to this issue is to require your publisher or the commissioning editor to sign a nondisclosure agreement—a written guarantee. However, this may be an unduly heavy-handed approach. You may preface your discussions with a "this is confidential" statement. If the person does not accept the burden of confidentiality, you should not proceed.

of copyright law in most countries. However, in many countries you are allowed certain exceptions; for example, if you do it for the purposes of study or research, for the purposes of criticism or review, or to provide copy for the visually impaired. Bear in mind, though, that these exceptions vary greatly from country to country.

If I sell a print, is the buyer allowed to reproduce the image?

No-you have sold only the physical item, which is the print itself. By selling a print, you grant no rights apart from the basic property right of ownership of the piece of paper—and an implied right to display it for the buyer's personal, private enjoyment. The buyer should not copy, alter, publish, exhibit, broadcast, or otherwise make use of that image without your permission.

What are "royalty-free" images?

These are images that you pay a fee to obtain in the first instance, but then you do not have to pay any extra if you use them-even for commercial purposes. With some companies, however, certain categories of commercial use, such as advertising or packaging, may attract further payments. Royalty-free images usually come on CDs but they may also be downloaded from a website.

How is it possible for images to be issued completely free?

Free images found on the Internet can be an inexpensive way for companies to attract you to visit their site. You can then download these images for your own use, but if you wish to make money from them, you are expected and trusted to make a payment. This fee is usually relatively small, however, so you are encouraged to behave honestly and not exploit the system.

Does somebody own the copyright of an image if that person pays for the film or the rental of the equipment?

In most countries, no. In some countries, if you are employed as a photographer, it is your employer

who retains copyright in any material you produce; in others, however, it is the photographer who retains the copyright. In any circumstance, the basic position can be overridden by a local contract made between the photographer and the other party prior to the work being carried out.

What is the Creative Commons?

This is a type of license designed to allow a flexible range of protections and freedoms for authors, artists, and educators to encourage wide use of intellectual property while discouraging abuse. Works can be used provided: the author is credited, the use is not for commercial purposes, and no derivative works are made. This allows a widespread sharing of creative and other works without loss to the copyright owners by those who otherwise would not be able to benefit from the works. It is in widespread use in the photo-sharing community. See creativecommons.org.

If I manipulate someone else's image, so that it is completely changed and is all my own work, do I then own the copyright in the new image?

No. You were infringing copyright in the first place by making the copy. And then, altering the image is a further breach of copyright. Besides, the new image is not fully all your work: arguably, it is derived from the copy. If you then claim authorship, you could be guilty of yet another breach—this time, of a moral right to ownership.

Is it okay to copy just a small part of an image—say, part of the sky area or some other minor detail?

The copyright laws in most countries allow for "incidental" or "accidental" copying. If you take an insignificant part of an image, perhaps nobody will object, but it is arguable that your action in choosing that particular part of an image renders it significant. If this is accepted, then it could be argued that you are in breach. If it makes no real difference where you obtain a bit of sky, then try to take it from a free source.

Shopping for equipment

Purchasing all the equipment needed for digital photography can be either bewilderingly off-putting or delightful fun and full of new things to learn. There is undoubtedly a lot to consider, but if you are not lucky enough to have a knowledgeable friend to help, don't worry. A lot of information is available on the web—and all of it is free.

Where to look for help

The web is the prime resource for information about equipment, followed a distant second by printed magazines. Web sources fall into four broad categories: large retail stores such as B&H (bhphotovideo.com); review sites such as dpreview.com; general photographic websites or web versions of printed magazines, such as *What Digital Camera*; and manufacturer's websites.

Large retailers with a web presence are a good starting point for information on photographic equipment. Their websites may even be superior to the manufacturer's own sites for quality and ease of access to information, and you can easily compare specifications of different models. Of course, you can learn about prices, too.

Review sites are numerous. Some do little more than take the camera out of the box and describe it, while others perform exhaustive technical checks. The quality of information, and the depth of knowledge used to produce it, is variable. It is unfortunate but inevitable that only the more glamorous models tend to be reviewed in depth. Obtain a consensus from as many sources as possible.

Other photography websites offer large amounts of information and are constantly updated; they may know more about new products than retailers do. Again, the quality of information is variable, since they may be written by people who are journalists first and photographers second. Added to this, magazines may come under pressure to say good things about a product, so you may have to read between the lines for the criticism.

The manufacturers' websites can offer useful information and other resources such as tips on photographic technique or features on the technology of digital cameras.

Buying online

Online purchases can be safe, efficient, and economical. The sensible precautions for online transactions apply equally for photography. Buy from sites that: guarantee secure transactions; you know about or have been recommended; offer guarantees that cover your purchase, particularly if you are buying abroad. Note that equipment purchased from a foreign website may have instructions in a language other than your own. If possible, use a credit card that protects against fraud. Always print and retain transaction details.

Beware of items that are much cheaper from one source than any others. The importer may not be officially recognized, the guarantee may not cover your region, or the language of the instructions—even on the camera itself—may be foreign to you.

Buying secondhand

The rise of digital photography has helped create a flooded market for secondhand film-based cameras:

Renting equipment

Do you ever need expensive equipment but cannot really afford it or would use it only occasionally? You may, for example, need a super-long telephoto lens for a safari trip, a data projector for a talk, a superior-quality scanner, or a replacement computer while yours is under repair. One answer is to rent items you need—you will save on the purchase price, pay only when the item is really needed, and the rental cost should be fully tax deductible if you are in business. Note the following points.

- Research possible equipment sources and set up account facilities. Some companies will send items if you live far from their warehouse or depot if you are a known customer, while new customers may need to provide a full-value cash deposit.
- Contact the supplier to reserve the item as soon as you think you might need it.
- Try to pick up the item a day or two early so that you can familiarize yourself with it and fully test it.
- Make sure your insurance covers any rented items.

even professional-grade models can be bought at bargain prices. The rapid development of digital cameras has also created a burgeoning supply of low priced digital equipment. Make sure that digital cameras are sold complete with all original software, chargers, and cables, since some use nonstandard items that could be difficult to source.

The world's largest market for secondhand or preowned equipment is eBay, online at ebay.com. This site offers copious help for the uninitiated, but local retailers are likely to offer stocks of equipment that you can examine in person and return easily if found to be faulty.

Shopping for specific interests

Today's photographer is spoiled for choice, thanks to the numerous camera models with features for every occasion. However, it can take a good deal of research to find the right camera for you.

Challenging conditions Cameras should be sealed against dust and rainfall, and have a rugged construction. Cameras with minimal moving parts are best; avoid those with lenses that zoom forward on turning on.

Collections Modern digital cameras offer excellent close-up qualities, but many distort the image. Choose a dSLR with a macro lens, and avoid zoom lenses. For flat objects where precision is essential, such as coins or stamps, use a flat-bed scanner.

Nature Electronic-viewfinder (EVF) or micro 4/3 digital cameras are good for nature photography: some offer focal lengths of 400 mm or more, allowing high-magnification images of distant animals. A tripod will be invaluable.

Low light Fast lenses—that is, those with a large maximum aperture—are limited to costly prime optics for dSLRs. A cheaper solution is to use the highest ISO setting available, and select cameras with image stabilization.

Portraiture Use fast, high-quality lenses. If possible, use full-frame sensors, as digital cameras with small sensors suffer from excessively large depth of field. Sports Rapid response and long lenses are essential. Many EVF cameras give fair results in good lighting. If lighting is poor, you may need a

Shopping checklist

- · Shop with somebody knowledgeable, if you are lucky enough to know such a person.
- · Write down the details of your computer model, operating system, and the details of other equipment that needs to work with the item you need.
- If it is secondhand, check that the equipment appears to have been well treated.
- If it is secondhand, inquire about the history of the equipment—for what purpose was it used, and for how long?
- Check that there is a guarantee period and that it is long enough for any likely faults to appear.
- When buying computer peripherals, make sure they will work with your exact computer model and operating system. You may, nonetheless, still need to test equipment at home with your computer, so if any compatibility problems arise, make sure the store will provide you with free technical support. In case these problems prove to be insurmountable, inquire about the store's policy regarding refunds.
- · Ask about anything that may be causing you confusion. You will not look foolish—the only foolish thing is to pay for equipment that later proves useless.

dSLR and fast, long focal length lenses with large maximum apertures, and a monopod or tripod. Still-life and studio Ensure your digital camera can synchronize with studio flash. Some cameras can be controlled from a computer, and some can even send pictures direct to the computer.

Travel EVF cameras offer a winning combination of compact, lightweight bodies, with extensive versatility and freedom from dust. Cameras that use standard AA batteries free you from worries about power, but try to choose cameras with longlived batteries. For wide-angle views you may need supplementary lenses—awkward on location.

Underwater Housings are available for several models, from entry-level to professional, allowing you to reach all controls. The least expensive are flexible plastic bags but access to controls is limited.

Disabilities

Compared with film-based photography with its chemical processes, many of the features found on modern digital equipment make photography more accessible to people with some forms of disability. The reduced need for darkroom or workroom processes, for example, as well as the greater level of automation of equipment, means that it is altogether easier to produce goodquality, satisfying results.

On the whole, however, any advantages that disabled photographers may enjoy from using digital equipment have been incidental rather than as a result of the industry taking their needs into account at the design stage.

Accessibility is all about accommodating the characteristics a person cannot change by providing options. For example, a person who has impaired dexterity could control equipment via voice commands. The whole subject of photography for disabled people is a complicated one, but some points can be summarized here.

Physical dexterity

Digital cameras could, almost without exception, be designed to make life easier for those with impaired dexterity. In reality, however, buttons are usually tiny, and at times two have to be pressed simultaneously; sockets need connectors that are small and have to be aligned precisely if they are to marry up, and so on. Select cameras with large, chunky controls. Underwater housings created for compact cameras may be helpful, as they provide very large buttons for the controls. In addition, the larger SLR digital cameras, such as those from Nikon, Canon, Sony, Pentax, are in general far easier to handle than compact models. However, on the downside, they are considerably bulkier and heavier.

Some digital cameras allow remote release the camera can be set up on a rig or support while the release is conveniently located some distance away. While the remote controls are usually very small, it should be possible to adapt them by attaching a large hand-grip. Most digital cameras are small and light enough to be easily mounted on a helmet or metal bracket attached to a wheelchair. If so, the mounting should have some type of self-leveling mechanism to keep the camera horizontal even if the chair is tilted out of plumb by an uneven surface.

On the computer side, some software features voice-activated commands, which help to reduce reliance on the the keyboard. With sufficient programming, this software can be used to perform basic image manipulation as well as produce text for captioning or record-keeping notes. There is a wide range of Windows-based software that offers improved access to computing.

Visual ability

The large LCD screens common on compact digital cameras may help the visually impaired. The large LCD screen with touch-screen controls, such as those from Samsung, Sony, and others, allow you to select menu items using any pointing device handled by hand, mouth, or foot.

Back at home, viewing images on a large-sized monitor offers considerable advantages over the traditional prints from most film processors. Selecting a low resolution—say, 640 x 480 dpi, on a 17-in (43-cm) screen—renders palettes and labels very large and far easier to read. Many software applications employ symbols rather than words to indicate options, which can also be an advantage. Software utilities such as KeyStrokes place an easy-to-read keyboard on the monitor screen: mouse clicks on the screen have the effect of typing letters. Keyboards with extra-large keys are also available.

Hearing ability

Most digital cameras give feedback on actions and functions with visual confirmation, so people with hearing difficulties will not be disadvantaged. However, with digital cameras, there is no physical sensation of a traditional shutter release being triggered. It may be important to find a camera that indicates shutter release with some form of visual signal: many do so indirectlyfor example, by using a light to indicate that an image is being written to disc.

Survival guide

The care and preparation for photography are not glamorous, but if you ignore simple precautions, you may find yourself unable to engage in photography at all. The central problem is that every element in digital technology—right down to a battery charger or cable—is mission-critical, and its failure can cripple the system entirely.

Tips for trouble-free photography

Consider these points, whether you are planning a big trip away or preparing for an important event such as a wedding.

- Test all equipment before leaving for a major journey or important assignment. Make sure it all works. Make sure sensors on dSLRs are clean, all batteries are charged, and all memory cards are clear of all material (preferably newly formatted). Shoot some test pictures and check them on the computer; if the trip is really important, do this in time to have any problems corrected.
- Be sure you can continually power your digital camera: always have a spare battery in the camera bag, and always travel with the battery charger. If your travel is international, carry plug and voltage adapters. If your camera can be powered by standard batteries, take these as a backup.
- When you buy a new rechargeable battery, charge it fully and use it until it is completely exhausted before you next charge it, then charge it fully again. This improves battery life.
- Equip yourself with as many memory cards as you can afford. Use the large, fast cards if your camera has a high pixel count.
- Take a portable hard disk or picture storage device that can read memory cards directly. For major trips, take a backup to the storage device.
- If possible, take a laptop computer on long trips, so you can check, review, and even start to catalog and caption images while on the road.
- Take a memory card reader and all the cables you will need if traveling with a laptop. Take spares of all crucial items—for example, FireWire or USB cables and power cords—so there are at least two ways of emptying the camera of its images.

- Cover LCD panels with protective film. These are highly transparent and have a light adhesive covering on one side that should leave no residue when removed. They do not seriously impede the clarity of the LCD display but do a great deal to preserve the screen from scratches and abrasions.
- Obtain insurance to cover all risks while traveling with your equipment.
- Take a small toolkit or universal tool: small screws may need to be tightened (especially after long journeys on rough roads), and small parts may need to be bent back after minor knocks.

While on location

- Do not allow your camera to get too hot—for example, by leaving it in full sunlight or in the glove compartment of a car in the tropics.
- Keep all optical surfaces clean: blow dust off with a blower, and wipe smears off gently. Keep the back of your lenses as clean as you keep the front.
- Check that the batteries are fresh or newly charged every day.
- Keep dust and moisture out of enclosed spaces, such as the memory card and battery compartments and the sockets for connectors. Keep these parts covered when not in use and blow them out with compressed air occasionally.
- Digital cameras are prone to condensation problems because of the electrical contacts inside. A cool camera coming into humid conditions is likely to become misted up. If water forms on electrical contacts, the camera may freeze up, or worse. A camera entering an airconditioned interior on a hot day may also mist up. In both cases, enclose the camera fully before a sudden change in environment, ideally keeping it so until it has partially reached the new temperature.
- In cold weather, keep batteries as warm as possible. Hold the camera close to your body (but not inside your coat, since the exposure to cold will be too sudden). Keep spare batteries inside your coat. To preserve battery power, turn off all functions that aren't absolutely necessary, such as the flash, autofocus, and image stabilization.

Glossary

- **24x speed** The device reads or writes data at 24x the basic rate for the device—for CDs and memory cards, 150 KB per second. DVDs read and write at a basic speed about 9x greater than CDs.
- **24-bit** A measure of the size or resolution of data that a computer, program, or component works with. A color depth of 24 bits produces millions of different colors.
- **2D** Two-dimensional, as in 2-D graphics. Defining a plane or lying on one.
- **3D** Three-dimensional, as in 3-D graphics. Defining a solid or volume, or having the appearance of a solid or volume.
- **35efl** 35-mm equivalent focal length. A digital camera's lens focal length expressed as the equivalent focal length for the 35-mm film format.
- **36-bit** A measure of the size or resolution of data that a computer, program, or component works with. In imaging, it equates to allocating 12 bits to each of the R, G, B (red, green, blue) channels. A color depth of 36 bits gives billions of colors.
- **5,000** The white balance standard for prepress work. Corresponds to warm, white light.
- **6,500** The white balance standard corresponding to normal daylight. It appears to be a warm white compared with 9,300.
- **9,300** The white balance standard close to normal daylight. It is used mainly for visual displays.

A

- **aberration** In optics, a defect in the image caused by a failure of a lens system to form a perfect image.
- aberration, chromatic An image defect that shows up as colored fringes when a subject is illuminated by white light, caused by the dispersion of white light as it passes through the glass lens elements.
- **absolute colorimetric** A method of matching color gamuts that tries to preserve color values as close to the originals as possible.
- **absolute temperature** A measure of thermodynamic state, used to correlate to the color of light. Measured in Kelvins.
- **absorption** Partial loss of light during reflection or transmission. Selective absorption of light causes the phenomenon of color.
- **accelerator** A device that speeds up a computer by, for example, providing special processors optimized for certain software operations.

- **accommodation** An adjustment in vision to keep objects at different distances sharply in focus.
- **achromatic color** Color that is distinguished by differences in lightness but is devoid of hue, such as black, white, or grays.
- **ADC** Analog-to-Digital Conversion. A process of converting or representing a continuously varying signal into a set of digital values or code.
- **additive** A substance added to another, usually to improve its reactivity or its keeping qualities, especially in lengthening the life span of a print.
- **additive color synthesis** Combining or blending two or more colored lights in order to simulate or give the sensation of another color.
- **address** Reference or data that locates or identifies the physical or virtual position of a physical or virtual item: for example, memory in RAM; the sector of hard disk on which data is stored; a dot from an inkiet printer.
- **addressable** The property of a point in space that allows it to be identified and referenced by some device, such as an inkjet printer.
- **algorithm** A set of rules that defines the repeated application of logical or mathematical operations on an object: for example, compressing a file or applying image filters.
- alias A representation or "stand-in" for the continuous original signal: it is the product of sampling and measuring the signal to convert it into a digital form.
- **alpha channel** A normally unused portion of a file format. It is designed so that changing the value of the alpha channel changes the properties—transparency/opacity, for example—of the rest of the file.
- **analog** An effect, representation, or record that is proportionate to some other physical property or change.
- **antialiasing** Smoothing away the stairstepping, or jagged edge, in an image or in computer typesetting.
- **aperture** The size of the hole in the lens that is letting light through. *See* f/numbers.
- **apps** A commonly used abbreviation for application software.
- **array** An arrangement of image sensors. There are two types. *1* A two-dimensional grid, or wide array, in which rows of sensors are laid side by side to cover an area. *2* A one-dimensional or

Glossary continued

linear array, in which a single row of sensors, or set of three rows, is set up, usually to sweep over or scan a flat surface—as in a flatbed scanner. The number of sensors defines the total number of pixels available.

aspect ratio The ratio between width and height (or depth).

attachment A file, such as a PDF or JPEG, that is sent along with an email.

back up To make and store second or further copies of computer files to protect against loss, corruption, or damage of the originals.

bandwidth 1 A range of frequencies transmitted, used, or passed by a device, such as a radio, TV channel, satellite, or loudspeaker. 2 The measure of the range of wavelengths transmitted by a filter.

beam splitter An optical component used to divide rays of light.

bicubic interpolation A type of interpolation in which the value of a new pixel is calculated from the values of its eight near neighbors. It gives superior results to bilinear or nearest-neighbor interpolation, with more contrast to offset the blurring induced by interpolation.

bilinear interpolation A type of interpolation in which the value of a new pixel is calculated from the values of four of its near neighbors: left, right, top, and bottom. It gives results that are less satisfactory than bicubic interpolation, but requires less processing.

bit The fundamental unit of computer information. It has only two possible values-1 or 0 representing, for example, on or off, up or down.

bit-depth Measure of the amount of information that can be registered by a computer component: hence, it is used as a measure of resolution of such variables as color and density. 1-bit registers two states (1 or 0), representing, for example, white or black; 8-bit can register 256 states.

bit-mapped 1 An image defined by the values given to individual picture elements of an array whose extent is equal to that of the image; the image is the map of the bit-values of the individual elements. 2 An image comprising picture elements whose values are only either 1 or 0: the bit-depth of the image is 1.

black 1 Describing a color whose appearance is

due to the absorption of most or all of the light. 2 Denoting the maximum density of a photograph.

bleed 1 A photograph or line that runs off the page when printed. 2 The spread of ink into the fibers of the support material. This effect causes dot gain.

BMP Bitmap. A file format that is native to the Windows platform.

bokeh The subjective quality of an out-of-focus image projected by an optical system—usually a photographic lens.

bracketing To take several photos of the same image at slightly different exposure settings, to ensure at least one picture is correctly exposed.

brightness 1 A quality of visual perception that varies with the amount, or intensity, of light that a given element appears to send out, or transmit. 2 The brilliance of a color, related to hue or color saturation—for example, bright pink as opposed to pale pink.

brightness range The difference between the lightness of the brightest part of a subject and the lightness of the darkest part.

browse To look through a collection of, for example, images or webpages in no particular order or with no strictly defined search routine.

Brush An image-editing tool used to apply effects, such as color, blurring, burn, or dodge, that are limited to the areas the brush is applied to, in imitation of a real brush.

buffer A memory component in an output device, such as printer, CD writer, or digital camera, that stores data temporarily, which it then feeds to the device at a rate the data can be turned into, for example, a printed page.

burning-in 1 A digital image-manipulation technique that mimics the darkroom technique of the same name. 2 A darkroom technique for altering the local contrast and density of a print by giving specific parts extra exposure, while masking off the rest of the print to prevent unwanted exposure in those areas.

byte Unit of digital information: 1 byte = 8 bits. A 32-bit microprocessor, for example, handles four bytes of data at a time.

C An abbreviation for cyan. A secondary color made by combining the two primary colors red and blue.

- **cache** The RAM dedicated to keeping data recently read off a storage device to help speed up the working of a computer.
- **calibration** The process of matching characteristics or behavior of a device to a standard.
- camera exposure The total amount of the light reaching (in a film camera) the light-sensitive film or (in a digital camera) the sensors. It is determined by the effective aperture of the lens and the duration of the exposure to light.
- **capacity** The quantity of data that can be stored in a device, measured in MB or GB.
- **cartridge** A storage or protective device consisting of a shell (a plastic or metal casing, for example) enclosing the delicate parts (film, ink, or magnetic disk, for example).
- catch light A small, localized highlight.
- **CCD** Charge-coupled device. A semiconductor device used as an image detector.
- **CD** Compact disc. A storage device for digital files invented originally for music and now one of the most ubiquitous computer storage systems.
- **characteristic curve** A graph showing how the density of a given film and its development relate to exposure.
- **chroma** The color value of a given light source or patch. It is approximately equivalent to the perceived hue of a color.
- CIE LAB Commission Internationale de l'Éclairage LAB. A color model in which the color space is spherical. The vertical axis is L for lightness (for achromatic colors) with black at the bottom and white at the top. The a axis runs horizontally, from red (positive values) to green (negative values). At right angles to this, the b axis runs from yellow (positive values) to blue (negative values).
- **clipboard** An area of memory reserved for holding items temporarily during the editing process.
- CLUT Color lookup table. The collection of colors used to define colors in indexed color files.

 Usually a maximum of 256 colors can be contained.
- CMYK Cyan—magenta—yellow—key. The first three are the primary colors of subtractive mixing, which is the principle on which inks rely in order to create a sense of color. A mix of all three as solid primaries produces a dark color close to black, but for good-quality blacks, it is necessary to use a separate black, or key, ink.

- codec co(mpression) dec(ompression). A routine or algorithm for compressing and decompressing files; for example, JPEG or MPEG. Image file codecs are usually specific to the format, but video codecs are not tied to a particular video format.
- **cold colors** A subjective term referring to blues and cvans.
- **color** *1* Denoting the quality of the visual perception of things seen, characterized by hue, saturation, and lightness. *2* To add color to an image by hand—using dyes, for example—or in an image-manipulation program.
- **color cast** A tint or hint of a color that evenly covers an image.
- **color gamut** The range of colors that can be reproduced by a device or reproduction system. Reliable color reproduction is hampered by differing color gamuts of devices: color film has the largest gamut, computer monitors have less than color film but more than inkjet printers; the best inkjet printers have a greater color gamut than four-color CMYK printing.
- **color management** The process of controlling the output of all the devices in a production chain to ensure that the final results are reliable and repeatable.
- **color picker** The part of an operating system (OS) or application that enables the user to select a color for use—as in painting, for example.
- **color profile** The way one device—screen, scanner, printer, etc.—handles color as defined by the differences between its own set of colors and that of the profile connection space.
- **color sensitivity** A measure of the variation in the way in which film responds to light of different wavelengths, particularly in reference to black and white films.
- **color space** Defines a range of colors that can be reproduced by a given output device or be seen by the human eye under certain conditions. It is commonly assigned to manage the color capture and reproduction of each photo image.
- **color synthesis** Recreating the original color sensation by combining two or more other colors.
- **color temperature** The measure of color quality of a source of light, expressed in Kelvins.
- **colorize** To add color to a grayscale image without changing the original lightness values.

Glossary continued

- ColorSync A proprietary color-management software system to help ensure, for example, that the colors seen on the screen match those to be reproduced by a printer.
- complementary colors Pairs of colors that produce white when added together as lights. For example, the secondary colors—cyan, magenta, and yellow—are complementary to the primary colors—respectively, red, green, and blue.
- **compliant** A device or software that complies with the specifications or standards of a corresponding device or software to enable them to work together.
- compositing A picture-processing technique that combines one or more images with a basic image. Also known as montaging.
- compression 1 A process by which digital files are reduced in size by changing the way the data is coded. 2 A reduction in tonal range.
- continuous-tone image A record in dyes, pigment, silver, or other metals in which relatively smooth transitions from low to high densities are represented by varying amounts of the substance used to make up the image.
- **contrast** 1 Of ambient light: the brightness range found in a scene. In other words, the difference between the highest and lowest luminance values. High contrast indicates a large range of subject brightnesses. 2 Of a light source or quality of light: the difference in brightness between the deepest shadows and the brightest highlights. Directional light gives high-contrast lighting, with hard shadows, while diffuse light gives lowcontrast lighting, with soft shadows. 3 Of color: colors positioned opposite each other on the color wheel are regarded as contrasting-for example, blue and yellow, green and red.
- **copyright** Rights that subsist in original literary, dramatic, musical, or artistic works to alter, reproduce, publish, or broadcast. Artistic works include photographs—recordings of light or other radiation on any medium on which an image is produced or from which an image may by any means be produced.
- CPU Central processor unit. The part of the computer that receives instructions, evaluates them according to the software applications, and then issues appropriate instructions to other parts of the computer system. It is often referred to as the "chip"—for example, Pentium III or G4.

- crash The sudden and unexpected non-functioning of a computer.
- **crop** 1 To use part of an image for the purpose of, for example, improving composition or fitting an image to the available space or format. 2 To restrict a scan to the required part of an image.
- cross-platform Application software, file, or file format that can be used on more than one computer operating system.
- curve A graph relating input values to output values for a manipulated image.
- cut and paste To remove a selected part of a graphic, image, or section of text from a file and store it temporarily in a clipboard ("cutting") and then to insert it elsewhere ("pasting").
- cyan The color blue-green. It is a primary color of subtractive mixing or a secondary color of additive mixing. Also, the complementary to red.

- D65 The white illuminant standard used to calibrate monitor screens. It is used primarily for domestic television sets. White is correlated to a color temperature of 6,500 K.
- daylight 1 The light that comes directly or indirectly from the sun. 2 As a notional standard, the average mixture of sunlight and skylight with some clouds, typical of temperate latitudes at around midday, and with a color temperature of between 5,400 and 5,900 K. 3 Film whose color balance is correct for light sources with a color temperature between 5,400 and 5,600 K.
 - 4 Artificial light sources, such as light bulbs, whose color-rendering index approximates to that of daylight.
- **definition** The subjective assessment of clarity and the quality of detail that is visible in an image or photograph.
- **delete** 1 To render an electronic file invisible and capable of being overwritten. 2 To remove an item, such as a letter, selected block of words or cells, or a selected part of a graphic or an image.
- density 1 The measure of darkness, blackening, or "strength" of an image in terms of its ability to stop light—in other words, its opacity.
 - 2 The number of dots per unit area produced by a printing process.
- depth 1 The sharpness of an image—loosely synonymous with depth of field. 2 A subjective

- assessment of the richness of the black areas of a print or transparency.
- **depth of field** The measure of the zone or distance over which any object in front of a lens will appear acceptably sharp. It lies both in front of and behind the plane of best focus, and is affected by three factors: lens aperture; lens focal length; and image magnification.
- **depth perception** The perception of the absolute or relative distance of an object from a viewer.
- digital image The image on a computer screen or any other visible medium, such as a print, that has been produced by transforming an image of a subject into a digital record, followed by the reconstruction of that image.
- **digitization** The process of translating values for the brightness or color into electrical pulses representing an alphabetic or a numerical code.
- **direct-vision finder** (or **viewfinder**) A type of viewfinder in which the subject is observed directly—for example, through a hole or another type of optical device.
- **display** A device—such as a monitor screen, LCD projector, or an information panel on a camera—that provides a temporary visual representation of data.
- **distortion, tonal** A property of an image in which the contrast, range of brightness, or colors appear to be markedly different from those of subject.
- **dithering** Simulating many colors or shades by using a smaller number of colors or shades.
- **d-max** *1* The measure of the greatest, or maximum, density of silver or dye image attained by a film or print in a given sample. *2* The point at the top of a characteristic curve of negative film, or the bottom of the curve of positive film.
- **dodging** *I* A digital image-manipulation technique based on the darkroom technique of the same name. *2* A darkroom technique for controlling local contrast when printing a photograph by selectively reducing the amount of light reaching the parts of a print that would otherwise print as too dark.
- **down-sampling** The reduction in file size achieved when a bitmapped image is reduced in size.
- **dpi** Dots per inch. The measure of resolution of an output device as the number of dots or points that can be addressed or printed by that device.
- driver The software used by a computer to control,

- or drive, a peripheral device, such as a scanner, printer, or removable media drive.
- **drop-on-demand** A type of inkjet printer in which the ink leaves the reservoir only when required. Most inkjet printers in use today are of this type.
- **drop shadow** A graphic effect in which an object appears to float above a surface, leaving a fuzzy shadow below it and offset to one side.
- **drum scanner** A type of scanner employing a tightly focused spot of light that shines on a subject that has been stretched over a rotating drum. As the drum rotates, the spot of light traverses the length of the subject, thus scanning its entire area.
- **duotone** *1* A photomechanical printing process in which two inks are used to increase the tonal range. *2* A mode of working in imagemanipulation software that simulates the printing of an image with two inks.
- **DVD-RAM** A DVD (digital versatile disk) variant that carries 4.7 GB or more per side that can be written to and read from many times.
- **dye sublimation** Printer technology based on the rapid heating of dry colorants that are held in close contact with a receiving layer. This turns the colorants to gas, which then solidifies on the receiving layer.
- dynamic range 1 The measure of spread of the lowest to the highest energy levels in a scene.2 The range that can be captured by a device, such as a camera or scanner.

E

- effects filters 1 Lens attachments designed to distort, color, or modify images to produce exaggerated, unusual, or special effects. 2 Digital filters that have effects similar to their lensattachment counterparts, but also giving effects impossible to achieve with these analogue filters.
- **electronic viewfinder (EVF)** An LCD or LCOS screen, viewed under the eyepiece and showing the view through a camera lens.
- **engine** *1* The internal mechanisms that drive devices such as printers and scanners. *2* The core parts of a software application.
- **enhancement** *1* Change in one or more qualities of an image, such as color saturation or sharpness, in order to improve its appearance or alter some other visual property. *2* The effect produced by a

Glossary continued

device or software designed to increase the apparent resolution of a TV monitor screen.

EPS Encapsulated PostScript. A file format that stores an image (graphics, photograph, or page layout) in PostScript page-description language.

erase To remove, or wipe, a recording from a disk, tape, or other recording media (usually magnetic) so that it is impossible to reconstruct the original record.

EV Exposure value. A measure of camera exposure. For any given EV, there is a combination of shutter and aperture settings that gives the same camera exposure.

exposure 1 A process whereby light reaches lightsensitive material or sensor to create a latent image. 2 The amount of light energy that reaches a light-sensitive material.

exposure factor The number indicating the degree by which measured exposure should be corrected or changed in order to give an accurate exposure.

f/numbers Settings of the camera diaphragm that determine the amount of light transmitted by a lens. Each f/number is equal to the focal length of the lens divided by diameter of the entrance pupil.

fade The gradual loss of density in silver, pigment, or dye images over time.

fall-off 1 The loss of light in the corners of an image as projected by a lens system in, for example, a camera or a projector. 2 The loss of light toward the edges of a scene that is illuminated by a light source whose angle of illumination is too small to cover the required view. 3 The loss of image sharpness and density away from the middle of a flatbed scanner whose array of sensors is narrower than the width of the scanned area.

feathering The blurring of a border or boundary by reducing the sharpness or suddenness of the change in value of, for example, color.

file format A method or structure of computer data. It is determined by codes—for example, by indicating the start and end of a portion of data together with any special techniques used, such as compression. File formats may be genericshared by different software—or native to a specific software application.

fill-in 1 To illuminate shadows cast by the main light by using another light source or reflector to bounce light from the main source into the shadows. 2 A light used to brighten or illuminate shadows cast by the main light. 3 In image manipulation, to cover an area with color—as achieved by using a Bucket tool.

filter 1 An optical accessory used to remove a certain waveband of light and transmit others. 2 Part of image-manipulation software written to produce special effects. 3 Part of application software that is used to convert one file format to another. 4 A program or part of an application used to remove or to screen data—for example, to refuse email messages from specified sources.

fingerprint Marking in a digital image file that is invisible and that survives all normal image manipulations, but one that can still be retrieved by using suitable software.

FireWire The standard providing for rapid communication between computers and devices, such as digital cameras and CD writers.

fixed focus A type of lens mounting that fixes a lens at a set distance from the film. This distance is usually the hyperfocal distance. For normal to slightly wide-angle lenses, this is at between 61/2 and 13 ft (2 and 4 m) from the camera.

flare Non-image-forming light in an optical system. **flash** 1 To provide illumination using a very brief burst of light. 2 To reduce contrast in a lightsensitive material by exposing it to a brief, overall burst of light. 3 The equipment used to provide a brief burst, or flash, of light. 4 The type of electronic memory that is used in, for example, digital cameras.

flat 1 Denoting a low-contrast negative or print in which gray tones only are seen. 2 The lighting or other conditions that tend to produce evenly lit or low-contrast image results.

flatbed scanner A type of scanner employing a set of sensors arranged in a line that are focused, via mirrors and lenses, on a subject placed face down on a flat, glass bed facing a light source. As the sensors traverse the subject, they register the varying light levels reflected off the subject.

flatten To combine multiple layers and other elements of a digitally manipulated or composited image into one. This is usually the final step of working with Layers prior to saving an image in

a standard image format; otherwise, the image must be saved in native format.

focal length For a simple lens, the distance between the center of the lens and the sharp image of an object at infinity projected by it.

focus *1* Making an image look sharp by bringing the film or projection plane into coincidence with the focal plane of an optical system. *2* The rear principal focal point. *3* The point or area on which, for example, a viewer's attention is fixed or compositional elements visually converge.

fog Non-image-forming density in a film or other light-sensitive material.

font A computer file describing a set of letter forms for display on a screen or used for printing.

foreground 1 The part of scene or space around an object that appears closest to the camera.2 The features in a photographic composition that are depicted as being nearest the viewer.

format 1 The shape and dimensions of an image on a film as defined by the shape and dimensions of the camera's film gate. 2 The dimensions of paper on which an image is printed. 3 The orientation of an image: for example, in a landscape format, the image is oriented with its long axis running horizontally, while in a portrait format the image is oriented with its long axis running vertically.

fractal A curve or other object whose smaller parts are similar to the larger parts. In practice, a fractal displays increasing complexity as it is viewed more closely and where the details bear a similarity to the whole.

frame 1 A screen's worth of information. 2 An image in a sequence replicating movement.

G

gamma 1 In photography, a measure of the response of a given film, developer, and development regimen to light—for example, a high contrast results in a higher gamma. 2 In monitors, a measure of the correction to the color signal prior to its projection on the screen. A high gamma gives a darker overall screen image.

GIF Graphic interchange format. This is a compressed file format designed for use over the Internet. It uses 216 colors.

grain *1* In film, it is the individual silver (or other metal) particles that make up the image of a fully

developed film. In the case of color film, grain comprises the individual dye-clouds of the image. 2 In a photographic print, it is the appearance of the individual specks comprising the image. 3 In paper, it is the texture of its surface.

graphics tablet An input device allowing fine or variable control of the image appearance in an image-manipulation program. The tablet is an electrostatically charged board connected to the computer. It is operated using a pen, which interacts with the board to provide location information and instructions are issued by providing pressure at the pen tip.

grayscale The measure of the number of distinct steps between black and white that can be recorded or reproduced by a system. A grayscale of two steps permits the recording or reproduction of just black or white. The Zone System uses a grayscale of ten divisions. For normal reproduction, a grayscale of at least 256 steps, including black and white, is required.

greeking The representation of text or images as gray blocks or other approximations.

H

halftone cell The unit used by a halftone printing or reproduction system to simulate a grayscale or continuous-tone reproduction. In off-set lithography, the halftone cell is defined by the screen frequency: continuous tone is simulated by using dots of different sizes within the halftone cell. With desktop printers, the halftone cell consists of groups of individual laser or inkjet dots.

hard copy A visible form of a computer file printed more or less permanently onto a support, such as paper or film.

HDR High Dynamic Range. An image created by blending two or more differing exposures of the same scene in order to enable one image to capture the scene's dynamic range.

highlights The brightest (whitest) values in an image or image file.

hints Artificial intelligence built into outline fonts, which turn elements of a font on or off according to the size of the font. Intended to improve legibility and design.

histogram A statistical, graphical representation showing the relative numbers of variables over a

Glossary continued

range of values. Usually used in imagemanipulation software, histograms are also available to view on some digital cameras

HLS Hue, lightness, saturation. A color model that works well for representing a visual response to colors, but one that is not satisfactory for other color reproduction systems. This model has been largely superseded by the LAB model.

hot-pluggable A connector or interface, such as USB or FireWire, that can be disconnected or connected while the computer and machine are powered up.

hue The name given to the visual perception of a color.

00000000

IEEE 1394 A standard providing for the rapid communication between computers and devices, and between devices without the need for a computer, such as between digital cameras and CD writers. It is also known as FireWire and iLink.

image aspect ratio The comparison of the depth of an image to its width. For example, the nominal 35-mm format in landscape orientation is 24 mm deep by 36 mm wide, so the image aspect ratio is 1:1.5.

indexed color A method of creating color files or defining a color space based on a table of colors chosen from 16 million different colors. A given pixel's color is then defined by its position, or index, in the table (also known as the "color lookup table").

inkjet Printing technology based on the controlled squirting of extremely tiny drops of ink onto a receiving layer.

intensity *1* A measure of energy, usually of light, radiated by a source. *2* A term loosely used to refer to the apparent strength of color, as in inks or the colors of a photograph.

interpolation The insertion of pixels into a digital image based on existing data. It is used to resize an image file, for example, to give an apparent increase in resolution, to rotate an image, or to animate an image.

ISO International Organization for Standardization.

Most exposure indices or film speeds today are described by the ISO system, which uses the same numeric values as the old ASA system—

that is, ISO 100, 400, 800, etc. The slower the film, the lower the number, so ISO 100 is slow film, and ISO 800 or 1600 is fast film. Digital cameras have sensitivity adjustments that are calibrated to be essentially equivalent to ISO film speed.

JK

jaggies The appearance of stair-stepping artifacts. **JPEG** Joint photographic expert group. A data-compression technique that reduces file sizes with loss of information.

k *1* An abbreviation for kilo, a prefix denoting 1,000. *2* A binary thousand: in other words, 1024, as used, for example, when 1024 bytes is abbreviated to KB. *3* Key ink or black—the fourth color separation in the CMYK four-color print reproduction process.

Kelvin (**K**) A unit of temperature that is relative to absolute zero, and is used to express color temperature.

kernel A group of pixels, usually a square from 3 pixels up to 60, that is sampled and mathematically operated on for certain image-processing techniques, such as noise reduction or image sharpening.

key tone *1* The black in a CMYK image. *2* The principal or most important tone in an image, usually the midtone between white and black.

keyboard shortcut Keystrokes that execute a command.

50000

layer mode A picture-processing or imagemanipulation technique that determines the way that a layer, in a multilayer image, combines or interacts with the layer below.

light *1* That part of the electromagnetic spectrum, from about 380–760 nm, that stimulates the receptors of the retina of the human eye, giving rise to normal vision. Light of different wavelengths is perceived as light of different colors. *2* To manipulate light sources to alter the illumination of a subject.

light box A viewing device for transparencies and films consisting of a translucent, light-diffusing top illuminated from beneath by color-corrected fluorescent tubes in order to provide daylight-equivalent lighting.

- **lightness** The amount of white in a color.

 This affects the perceived saturation of a color: the lighter the color, the less saturated it appears to be.
- **line art** Artwork that consists of black lines and black and white areas only, with no intermediate gray tones present.
- **load** To copy enough of the application software into a computer's RAM for it to be able to open and run the application.
- **lossless compression** A computing routine, such as LZW, that reduces the size of a digital file without reducing the information in the file.
- **lossy compression** A computing routine, such as JPEG, that reduces the size of a digital file but also loses information or data.
- **lpi** Lines per inch. A measure of resolution or fineness of photomechanical reproduction.
- **LZW** Lempel-Ziv Welch compression. A widely used computer routine for lossless file compression of, for example, TIFF files.

M

- **Mac** Commonly used term for Apple Macintosh computers and their operating system (OS).
- macro 1 The close-up range giving reproduction ratios within the range of about 1:10 to 1:1 (lifesize). 2 A small routine or program within a larger software program that performs a series of operations. It may also be called "script" or "action."
- **marquee** A selection tool used in imagemanipulation and graphics software.
- **mask** A technique used to obscure selectively or hold back parts of an image while allowing other parts to show.
- master 1 The original or first, and usually unique, incarnation of a photograph, file, or recording: the one from which copies will be made. 2 To make the first copy of a photograph, file, or recording.
- **matrix** The flat, two-dimensional array of CCD sensors.
- matte 1 The surface finish on paper that reflects light in a diffused way. 2 A box-shaped device placed in front of camera lens to hold accessories.
 3 A board whose center is cut out to create a window to display prints. 4 A mask that blanks out an area of an image to allow another image to be superimposed.

- **megapixel** A million pixels. A measure of the resolution of a digital camera's sensor: a 7-megapixel camera has a 7-megapixel sensor.
- **moiré** A pattern of alternating light and dark bands or colors caused by interference between two or more superimposed arrays or patterns, which differ in phase, orientation, or frequency.
- **monochrome** An image made up of black, white, and grays, which may or may not be tinted.

N

- **native** *1* The file format belonging to an application program. *2* An application program written specifically for a certain type of processor.
- **nearest neighbor** The type of interpolation in which the value of the new pixel is copied from the nearest pixel.
- **node** 1 A computer linked to others in a network or on the Internet. 2 A word or short phrase that is linked to other text elsewhere in a hypertext document.
- **noise** Unwanted signals or disturbances in a system that tend to reduce the amount of information being recorded or transmitted.
- Nyquist rate The sampling rate needed to turn an analog signal into an accurate digital representation. This rate is twice the highest frequency found in the analog signal. It is applied to determine the quality factor relating image resolution to output resolution: pixel density should be at least 1.5 times, but not more than 2 times, the screen ruling. For example, for a 133 lpi screen, resolution should be between 200 and 266.

0

- **offline** A mode of working with data or files in which all required files are downloaded or copied from a source to be accessed directly by the user.
- **online** A mode of working or operating with data or files in which the operator maintains continuous connection with a remote source.
- **opacity** The measure of how much can be "seen" through a layer.
- **operating system** The software program, often abbreviated to OS, that underlies the functioning of the computer, allowing applications software to use the computer.
- optical viewfinder A type of viewfinder that shows

Glossary continued

the subject through an optical system, rather than via a monitor screen.

out-of-gamut The color or colors that cannot be reproduced in one color space but are visible or reproducible in another.

output 1 The result of any computer calculation any process or manipulation of data. Depending on the context, output may be in the form of new data, a set of numbers, or be used to control an output device. 2 A hard-copy printout of a digital file, such as an inkjet print or separation films.

PO

paint To apply color, texture, or an effect with a digital Brush or the color itself.

palette 1 A set of tools, colors, or shapes that is presented in a small window of a software application. 2 The range or selection of colors available to a color-reproduction system.

peripheral A device, such as a printer, monitor, scanner, or modem, connected to a computer.

Photo CD A proprietary system of digital-image management based on the storage of image files on CDs playable on most CD players.

photodiode A semiconductor device that responds very quickly and proportionally to the intensity of light falling on it.

photograph A record of physical objects, scenes, or phenomena made with a camera or other device, through the agency of radiant energy, on sensitive material from which a visible image may be obtained.

photomontage A photographic image made from the combination of several other photographic images. Also known as a composite.

PICT A graphic file format used in the Mac OS. **pixel** The smallest unit of digital imaging used or produced by a given device. An abbreviation of "picture element."

pixelated The appearance of a digital image whose individual pixels are clearly discernible.

platform The type of computer system, defined by the operating system used—for example, the Apple Macintosh platform uses the Mac OS.

plug-in Application software that works in conjunction with a host program into which it is "plugged," so that it operates as if part of the program itself.

posterization The representation of an image

using a relatively small number of different tones or colors, which results in a banded appearance in flat areas of color.

PostScript A programming language that specifies the way in which elements are output: it uses the full resolution of the output device.

ppi Points per inch. The number of points seen or resolved by a scanning device per linear inch.

prescan In image acquisition, it is a quick view of the object to be scanned, taken at a low resolution for the purposes of, for example, cropping.

primary color One of the colors (red, green, or blue) to which the human eye has peak sensitivity. prime lens A fixed focal length lens, in contrast to a zoom lens.

process colors Colors that can be reproduced with the standard web offset press (SWOP) inks of cyan, magenta, yellow, and black (CMYK).

proofing The process of checking or confirming the quality of a digital image before final output.

quality factor The multiplication factor—usually between 1.5 and 2 times the screen frequencyused to ensure a file size that is sufficient for good-quality reproduction.

QuickDraw An object-oriented graphics language native to the Mac OS.

RAM Random access memory. The component of a computer in which information can be temporarily stored and rapidly accessed.

raster The regular arrangement of addressable points of any device, such as scanner, digital camera, monitor, printer, or film writer.

read To access or take off information from a storage device, such as a hard disc, CD, or DVD.

refresh rate The rate at which one frame of a computer screen succeeds the next. The more rapid the rate, the more stable the monitor image appears.

res The measure of the resolution of a digital image expressed as the number of pixels per side of a square measuring 1 x 1 mm.

resampling The addition or removal of pixels from an image by sampling or examining the existing pixels and making the necessary calculations.

resize To change a file's resolution or size.

RGB Red–green–blue. A color model that defines colors in terms of the relative amounts of red, green, and blue components they contain.

RIP Raster image processor. Software or hardware dedicated to the conversion of outline fonts and vector graphics into rasterized information—in other words, it turns outline instructions such as "fill" or "linejoin" into an array of dots.

S

scanner An optical-mechanical instrument for the analogue-to-digital conversion, or digitization, of film-based and printed material and artwork.

scanning The process of using a scanner to turn an original into a digital facsimile—in other words, a digital file of specified size.

screengrab An image file of the monitor display or part of it. Also called a screenshot.

scrolling The process of moving to a different portion of a file that is too large for it all to fit onto a monitor screen.

shadows The dark (or black) areas of an image. shutter lag Time between pressing a shutter button fully and the exposure being made: ⁷⁵/_{1,000} sec is just perceptible and acceptable for professional use.

shutter time Duration of exposure of film or sensor to light.

soft proofing The use of a monitor screen to proof or confirm the quality of an image.

stair-stepping A jagged or steplike reproduction of a line or boundary that is, in fact, smooth.

subtractive color synthesis Combining of dyes or pigments to create new colors.

SWOP Standard web offset press. A set of inks used to define the color gamut of CMYK inks used in the print industry.

system requirements The specifications defining the minimum configuration of equipment and operating system needed to run application software or a device. It usually details the type of processor, amount of RAM, free hard disk space, oldest version of the operating system, and, according to the software, any specifically needed device.

thumbnail The representation of an image in a small, low-resolution version.

TIFF A widely used image file format that supports up to 24-bit color per pixel. Tags are used to store such image information as dimensions.

tint 1 Color that is reproducible with process

colors; a process color. 2 An overall, usually light, coloring that tends to affect areas with density but not clear areas.

transparency *1* Film in which the image is seen by illuminating it from behind—color transparency film, for example. Also known as a slide. *2* In image manipulation, the degree to which background color can be seen through the foreground layer.

transparency adapter An accessory light source that enables a scanner to scan transparencies.

TWAIN A standardized software "bridge" used by computers to control scanners via scanner drivers.

UVWZ

undo To reverse an editing or similar action within application software.

upload The transfer of data between computers or from a network to a computer.

USB Universal serial bus. A standard for connecting peripheral devices, such as a digital camera, telecommunications equipment, or a printer, to a computer.

USM UnSharp Mask. An image-processing technique that has the effect of improving the apparent sharpness of an image.

variable contrast A coating formula that mixes emulsions of different speeds and sensitivities to light, with the effect that the midtone contrast can be varied by changing the spectral qualities of the illumination.

vignetting 1 A defect of an optical system in which light at the edges of an image is cut off or reduced by an obstruction in the system's construction.
2 Deliberately darkened corners—used to help frame an image or soften the frame outline.

VRAM Video random access memory. Rapidaccess memory that is dedicated for use by a computer or graphics accelerator to control the image on a monitor.

warm colors A subjective term referring to reds, oranges, and yellows.

watermark 1 A mark left on paper to identify the maker or paper type. 2 An element in a digital image file used to identify the copyright holder.

write To commit or record data onto a storage medium, such as a CD-R or hard disk.

zoom *1* Type of lens that can vary its focal length (field of view) without changing the focus. *2* To change the magnification for onscreen viewing.

Web resources

NEWS, INFORMATION, REVIEWS

www.bjphoto.co.uk

The website of *The British Journal of Photography* has a wide mix of free and subscriber-only content covering news, reviews and feature articles.

www.bobatkins.com

Mixed bag of reviews, technical articles, and links: generally high-quality information and many interesting discussions. Worth dipping into.

www.creativepro.com

One of the best sources for news, techniques, and issues of image manipulation, digital photography, design, and graphics. Also software and hardware reviews. Highly recommended.

www.dcresource.com

Digital Camera Resource is dedicated to thorough reviews of consumer cameras and also features useful comparison charts. An enormous number of cameras is covered. An excellent resource.

www.digicamhelp.com

Full of helpful advice, but particularly useful as a portal for downloading camera manuals.

www.diwa-awards.com

The Digital Imaging Websites Association features camera reviews carried out by 12 (at the time of writing) digital photography sites all over the world, following common formats and shared procedures.

www.dpreview.com

Leading site for camera and lens reviews and industry news. Also hosts lively discussion fora.

www.ephotozine.com

General digital photography website with serious content and useful news, reviews, and help pages.

www.fredmiranda.com

Lively reviews and discussions for the technically inclined, plus illustrated articles.

www.idigitalphotography.com

Beginner-friendly site covering topics on request, with blogs and the most comprehensive and authoritative photography dictionary on the web.

www.informit.com/articles

Extracts from a wide range of information, technology books, many with high-quality content.

www.jackspcs.com

Jack's Photographic and Chemistry Site offers concise information on chemicals, with formulary for developers, toners, and so on, as well as links.

www.lens-reviews.com

Reviews contributed by users—a useful resource for potential buyers.

www.letsgodigital.org

Extensive news and reviews of equipment, as well as a regularly updated picture gallery.

www.lightstalkers.org

Extended and extensive, lively, and broad-ranging debate and exchange in a community site dedicated to photography in all its aspects. Worth regular visits.

www.luminous-landscape.com

High quality of varied content, with some substantial essays on a wide range of photographic topics and detailed, considered reviews. Worth a leisurely visit.

www.normankoren.com

Dedicated to the technically inclined photographer, this site offers much to ponder on: from printing to scanning and digital photography, with good links.

www.pdnonline.com

This online resource from Photo District News magazine offers lively, rich, and wide-ranging news and features. The site complements the print version and is well worth regular visits.

www.photodo.com

News on lenses, as well as reviews—both technical and user-based—of a wide range of lenses.

www.photographydirectory.org

Portal for thousands of sites for photographers, photography agencies, clubs, manufacturers, etc.

www.popphoto.com

The home of venerable and much-respected photography magazines Popular Photography and American Photo. Excellent for news, features, and reviews. Well worth frequent visits.

www.retrophotographic.com

The technical section of this commercial outpost of darkroom practice offers a valuable compendium of data sheets and processing guides.

www.shuttertalk.com

Lively, busy, and extensive photography community with articles, galleries, resources, and news. Worth making regular visits.

www.steves-digicams.com

Well-known site with a large amount of information on many subjects, as well as reviews, technical features, and news. Worth bookmarking.

www.the-digital-picture.com

Content-rich site, with reviews, hints, and tips.

www.travelphotographers.net

Travel Photographers Network is a specialty site offering illustrated travel features, equipment reviews, and technical advice aimed at travel photographers, with image and discussion fora.

SOURCES OF HISTORY AND INSPIRATION

www.colorsmagazine.com

Super collection of powerful, imaginative, emotive imagery of great editorial intelligence. Must visit.

www.foto8.com

Website of the eponymous magazine, which is the leading showcase for contemporary photojournalism and documentary photography. Should be bookmarked by any photography lover.

www.getty.edu

Authoritative references on digital collections, including book-length introduction to digital imaging—highly educational. Also, a collection of marvelous photos and artwork.

www.photography-museum.com

A treasure trove of great images collected thematically with informative historical notes: like any good museum, well worth the occasional visit.

TECHNICAL RESOURCES AND STANDARDS

www.color.org/iccprofile.html

The website of the International Color Consortium explains everything you need to know about color profiles, their applications, and details of software that complies with the specifications.

www.dofmaster.com

This site offers free, easy-to-use calculators for depth of field and hyperfocal distance, useful articles, and software for Windows, Palm, and iPhone.

www.edmundoptics.com

Primarily a corporate site for an optics supplier, but informed with clear FAOs and articles on optics, as well as an excellent list of web links. For those interested in applied photography and optics.

www.hugsan.com/EXIFutils

EXIF Utilities is an application for editing, correcting, and altering the EXIF and IPTC data saved in image files by digital cameras.

www.iptc.org/IPTC4XMP/

The International Press Telecommunications Council's standards for image metadata: technical documentation, tutorials, and samples.

www.photoattorney.com

A valuable blog from an attorney specializing in representing photographers, covering copyright, trademark, contracts, privacy, and other legal issues. Broad relevance despite being US-based, since much contemporary media law is led by US judgments.

www.schneiderkreuznach.com

The Know How section contains valuable and authoritative (technical but approachable) essays on lens coatings and lens design, among other things.

www.schorsch.com

A lighting-design corporate website with a useful knowledge base, offering a range of information for anyone interested in light and lighting.

www.tawbaware.com/maxlyons/calc.htm

Handy calculators for depth of field and angle of view sit alongside a number of other utilities.

Web resources continued

www.updig.org/guidelines

Here you will find the universal photographic digital imaging guidelines for best practice in the creation, supply, and transmission of digital image files. Essential reading.

www.wilhelm-research.com

Essential resource on printing and print permanence, print care, and storage, supported by test data.

SOFTWARE RESOURCES

http://apertureprofessional.com

Blogs, articles, and discussion groups on use and features of Apple Aperture, digital workflow, and image-manipulation software, with news of equipment, software, and other developments.

www.imatest.com

Imatest is used to test all major aspects of lens performance in digital cameras—widely used in the industry. Worth using the evaluation runs on your digital camera. Windows only.

http://photoshopnews.com

A heavyweight site with high-quality material on many issues relating to the Photoshop user, covering not only the software but technical, market, and legal issues, as well as news and web links.

www.photoshopsupport.com

This valuable beginner's resource offers numerous tutorials and free resources such as brushes, fonts, actions, and so on. Also, links to plug-ins, video training, and extracts from Photoshop books. Supports other software, such as Lightroom and Dreamweaver, too.

www.photo-software.com

Douglas Software offers tools for calculating camera and lens details, as well as Sun and Moon positions.

www.pluginsworld.com

Comprehensive and constantly updated listings of plug-ins for Photoshop and other software.

www.versiontracker.com

The best site for keeping your software up-to-date and for trying out new software, with useful user reviews. Essential to bookmark.

PICTURE HOSTING AND SHARING

The internet allows anyone to place hundreds of their images onto photo-sharing websites for friends, family, and prospective clients. These sites operate as online, off-site storage for images, so your images are backed up in secure storage and can be accessed at any time from anywhere in the world.

www.digitalrailroad.net

Picture-hosting stock-photography site with a very wide range of work, including that of top agencies.

www.flickr.com

One of the most popular picture-sharing sites, offering good image management and low prices.

www.fotki.com

One of the largest social networking sites hosting images and videos for sharing.

www.photobucket.com

Offers a hybrid of community and picture-hosting features, catering to popular and social imagery.

http://pa.photoshelter.com

Picture-hosting photography site with a range of contemporary work. Strong North American focus.

http://picasa.google.com

Picasa's software integrates well with Google accounts and offers low-cost picture storage.

www.shutterfly.com

Unlimited uploads and many offers to make prints, books, and so on.

www.smugmug.com

Picture sharing of professional-quality images.

www.webshots.com

Low-cost picture storage on an easy-to-use site.

ONLINE PHOTO EDITING

www.picnik.com www.photoshop.com/express

www.fotoflexer.com

www.phixr.com

These and similar sites allow you to enjoy image manipulation without buying your own software.

Manufacturers

Many of the multinational manufacturers host different websites for each of their sales regions. It may be worth visiting those outside your region, since the quality and information can vary between sites: some, for example, simply present pages of their product catalogs, while others are rich sources of practical tips and technical resources, as well as offering product information. The following is a selection of photographic manufacturers, but inclusion does not imply recommendation.

EQUIPMENT MANUFACTURERS

Apple Computers, displays, software

www.apple.com

Archival Methods Storage solutions for archiving prints and film

www.archivalmethods.com

Canon Cameras, lenses and accessory systems, printers, scanners, data projectors

www.canon.com

Eizo LCD monitors

www.eizo.com

Epson Printers, scanners, picture storage **www.epson.com**

Fujifilm Cameras and accessories, medium-format cameras

www.fujifilm.com

Hasselblad Medium-format cameras, lenses, accessory system, scanners, and software

www.hasselblad.com

Hewlett-Packard Printers, ink-jet papers, scanners, computers

www.hp.com

Jobo Picture storage, digital display, darkroom and other accessories

www.jobo.com

Kodak Cameras, film, papers, printers

www.kodak.com

LaCie Hard-disc drives and media, displays www.lacie.com

Leica Cameras, lenses, accessory systems

www.leica.com

Lexar Memory cards and readers for digital cameras

www.lexar.com

Lexmark Printers

www.lexmark.com

Microtek Scanners

www.microtek.com

Nikon Cameras and lenses and accessory systems, film scanners

www.nikon.com

Olympus Cameras and lenses, printers, removable storage

www.olympus.com

Panasonic Digital cameras, SLRs and lenses, data projectors

www.panasonic.com

Pantone Color control, color-matching systems www.pantone.com

Pentax Cameras and lenses, medium-format cameras and lenses

www.pentax.com

Phase One

Digital backs and medium-format camera systems and software

www.phaseone.com

RH Designs Enlarger timers, densitometers, and other darkroom aids

www.rhdesigns.co.uk

Ricoh Digital cameras

www.ricoh.com

Rollei

Medium-format, specialty, and consumer digital cameras; medium-format film cameras; lenses

www.rollei.com

Samsung Cameras and SLR lenses, projectors

www.samsungcamera.com

Sandisk Memory cards, readers

www.sandisk.com

Sekonic Exposure meters

www.sekonic.com

Sony Digital cameras, SLR systems and accessories, data projectors, computers

www.sony.com

Studioflash Generic studio flash accessories: reflectors, soft-boxes, stands

www.studioflash.co.uk

www.studionasn.co

Tamron

Interchangeable lenses for digital cameras

www.tamron.com

Tokina

Interchangeable lenses for digital cameras

www.tokinalens.com

X-Rite

Color-management solutions: software, hardware, and support

www.xrite.com

Software sources

IMAGE-MANIPULATION SOFTWARE

Despite the dominance of Photoshop, there are many software applications that are capable of excellent results. The simpler programs are better suited to the beginner or those who do not wish to commit a large amount of time to learning how to use the software.

Photoshop

This is the industry-standard software, due to features such as color management and a vast range of elements that can be expanded with the widest range of plug-in software, but it is difficult to master and burdened by some weak features. Mac and Windows.

www.adobe.com

Photoshop Elements

An extremely capable image-manipulation program that is easy to use and comes with many presets and templates. Suitable for the majority of digital photographers. Mac and Windows.

www.adobe.com

GIMP

The GNU Image Manipulation Program is a free, powerful application for image enhancement and compositing. Mac and Windows.

www.gimp.org

Painter

Enormous range of Brush tools (more than 30 categories, with innumerable options), with highly controllable painting effects and powerful cloning tools. An excellent supplement to Photoshop. Mac and Windows.

www.corel.com

Paint Shop Pro

Affordable, powerful software with good Layers features and excellent support for raw formats. It is suitable for most requirements, including web work. Windows only.

www.corel.com

PhotoImpact

Very good range of tools, strong on features for web imagery, in an affordable package. Useful for graphics to video. Includes cut-down version of Corel Painter. Windows only.

www.ulead.com

Photo-Paint

Powerful, comprehensive features, with good Layers and cloning elements. Windows only. Not to be confused with the low-cost image editor Ability Photopaint (www.ability.com).

www.corel.com

PhotoRetouch Pro

With powerful correction tools, this very colormanagement-aware software is designed for professional color-correction work. Highly recommended, but costly. Mac only.

www.binuscan.com

PhotoSuite

Inexpensive, tutorial-based software with a good range of tools and Layers handling, together with good functions for web work and creating slide shows on DVD. Windows only.

www.roxio.com

WORKFLOW SOFTWARE

These applications aim to provide all you need for a digital image workflow—from uploading of images and adding metadata, to image enhancement and management, to output as books, prints, or to web.

ACDSee

This has been refined over the years as an efficient tool for the whole digital image workflow, with excellent support of raw formats and the ability to apply adjustments selectively.

www.acdsee.com

Adobe Lightroom

Powerful raw conversion, with good imagemanagement features and excellent enhancement tools and metadata handling, but the workflow methodology is rigid. Good range of web-page options and controls over printing.

www.adobe.com

Apple Aperture

Powerful raw conversion, with class-leading imagemanagement features, efficient image-enhancement tools, and excellent image viewing and metadatahandling features.

www.apple.com

RAW CONVERTERS

Raw conversion software is a specialty area in which much image craftsmanship is required. Experiment with trial versions before settling on one. Raw converters to consider also include ACDSee, Aperture, and Lightroom (above).

DxO Optics

Excellent raw conversion with superb noise handling, as well as powerful distortion and projection correction features. Highly recommended.

www.dxo.com

Phase One

Widely used by professional photographers, this has excellent batch-processing facilities.

www.phaseone.com

Silkypix

A very well-regarded raw converter, used by many camera manufacturers as the supplied software.

www.isl.co.jp

IMAGE MANAGEMENT

FotoStation

Simple and effective tool for creating sets of pictures and management, with multiple printing and web-page output options. Mac and Windows.

www.fotostation.com

Photo Mechanic

Very speedy picture management, aimed at digital photographers. Easy to use. Mac and Windows.

www.camerabits.com

Portfolio

Powerful tool for the management of picture libraries, with the ability to publish on the internet. It also has search facilities. Suitable for use over networks, but can be slow. Mac and Windows.

www.extensis.com

PLUG-INS

Plug-in software adds functions to the prime software, appearing in its own dialogue box for settings to be made. Many of these will work with applications such as Painter, which accepts Photoshop-compatible plug-ins. Check with the supplier prior to purchase.

Alien Skin

Offering numerous filters effects, as well as plug-ins for enlargement, enhancement, and correction—one of the best collections of Photoshop plug-ins.

www.alienskin.com

Andromeda 3D

Powerful and able to wrap images around basic 3-D objects, but tricky to learn.

www.andromeda.com

Genuine Fractals

Industry-standard image-enlargement software.

www.ononesoftware.com

KPT

Kai's Power Tools offers powerful special-effects filters. It can be tricky to use but is worth exploring.

www.corel.com

NIK

A range of well-regarded tools: Silver Efex for black-and-white images, Color Efex for special effects, Dfine for noise reduction, and Viveza for selective image enhancement.

www.niksoftware.com

Noise Ninja

Powerful and effective reduction of noise, with a high level of control.

www.picturecode.com

DESIGN AND OTHER SOFTWARE

BBEdit

HTML editor with many features invaluable for programming, beloved of web-authoring experts. The Lite version is available as freeware. Mac only.

www.bbedit.com

Canvas

Integrates illustrations with graphics for publishing, supporting a wide range of formats with image-enhancement filters. One version works with GIS (Geographical Information Systems). Windows only.

www.acdsee.com

Dreamweaver

Full-featured WYSIWYG (what you see is what you get) software for designing web pages and managing websites. Mac and Windows.

www.adobe.com

Flash

Software for drawing, animation, and multimedia creation. Flash animation is widely readable on the internet. Mac and Windows.

www.adobe.com

InDesign

Very powerful page-design software with excellent feature set. Mac and Windows.

www.adobe.com

Mask Pro

This software offers highly controllable tools for masking difficult objects such as hair and glass. Mac and Windows.

www.ononesoftware.com

QuarkXPress

Well-established page-design application. Mac and Windows.

www.quark.com

Further reading

TOM ANG:

Digital Photography Masterclass
Dorling Kindersley, London, UK (1 4053 1556 3)
Organized as one-on-one lessons, with practical
assignments, examples from contributing
photographers, and inspirational interviews with
up-and-coming photographers.

How to Photograph Absolutely Everything
Dorling Kindersley, London, UK (1 4053 1985 2)
Step-by-step solutions for numerous picturemaking opportunities and packed with examples.
Designed for beginners, but also being used by
more experienced photographers.

Advanced Digital Photography (second edition)
Mitchell Beazley, London, UK (978 1 8453 3256 3)
A look beyond the basics at more advanced techniques and the background to image manipulation and digital photography.

ROY BERNS:

Principles of Color Technology
John Wiley & Sons, New York, NY (0 4711 9459 X)
Fully illustrated with excellent diagrams, clearly
written, authoritative—ideal for understanding
modern color without going into the fullest detail.

DAN BURCKHOLDER:

Making Digital Negatives for Contact Printing
Bladed Iris Press, Texas (0 9649638 3 3)
Step-by-step guide on the subject—essential for the advanced darkroom worker.

PETER BURIAN:

National Geographic Photography Field Guide National Geographic Society, US (0 7922 7498 9) Concise, clear guide to practical photography, with excellent instruction, examples, and interviews.

STEVE CAPLIN:

How to Cheat in Photoshop CS3
Focal Press, Oxford, UK (0 2405 2062 9)
Clear instructions for elaborate techniques that lay the foundations for a wider range of effects.

BOB COTTON & RICHARD OLIVER:

The Cyberspace Lexicon: An Illustrated Dictionary of Terms

Phaidon, London, UK (0 7148 3267 7)

Numerous illustrations and hyperactive layout make for a restless read, but it's worth dipping into.

MICHAEL FREEMAN:

Mastering High Dynamic Range Photography Ilex, Lewes, UK (1 9058 1424 0) Comprehensive, detailed treatment of HDR photography, with high standard of illustration. Very technical in parts. Overall, recommended.

The Digital SLR Handbook (revised second edition) Ilex, Lewes, UK (1 9058 1417 8)
Sound and accurate advice covering many aspects of digital SLR and software use. Recommended.

MARK GALER & LES HORVAT:

Digital Imaging

Focal Press, Oxford, UK (0 2405 1913 2)

Uneven in quality and coverage, but containing much useful information. Worth a browse.

ROGER HICKS & FRANCES SCHULTZ:

Quality in Photography

David & Charles, Newton Abbott, UK (0 7153 2148 X) Valuable approach to photography, concentrating on technical work, somewhat to the detriment of visual quality, but many tips and advice offered.

SCOTT KELBY:

The Photoshop Channels Book
Peachpit Press, Berkeley, CA (0 3212 6906 3)
This entire book is about just one feature of Adobe Photoshop, yet it is full of practical information.
Essential for the advanced worker.

The Adobe Photoshop Lightroom Book for Digital Photographers

Peachpit Press, Berkeley, CA (0 3214 9216 1) Thorough, clear introduction to efficiency in Adobe Lightroom, which is rapidly becoming an essential item on a digital photographer's computer.

MICHAEL KIERAN:

Photoshop Color Correction
Peachpit Press, Berkeley, CA (0 3211 2401 4)
Excellent, thorough, authoritative coverage of color correction and management. Invaluable.

PETER KROGH:

The DAM Book: Digital Asset Management for Photographers
O'Reilly Media, US (0 5961 0018 3)
Comprehensive coverage of an important field, covering workflows, archiving, and software, but dominated by Adobe Bridge.

MICHAEL LANGFORD:

Basic Photography
Focal Press, Oxford, UK (0 2405 1592 7)
Patchy, and lacking in digital matters, but the coverage of fundamentals and analogue photography is peerless and thorough. For selective reading.

BARBARA LONDON, ET. AL.:

Photography

Pearson Education, New Jersey (0 1318 9609 1) A comprehensive, albeit basic, voluminous introduction to photography—perhaps the best modern treatment. Fully illustrated.

BEN LONG, RICHARD HARRINGTON & ORLANDO LUNA:

Aperture 2

Peachpit Press, Berkeley, CA (0 3214 9662 0) The type of instructional manual that should have been sold with Apple's Aperture software. Excellent.

DAN MARGULIS:

Photoshop LAB Color

Peachpit Press, Berkeley, CA (0 3213 5678 0) Insightful treatise on color correction. A little longwinded, but essential for the advanced worker.

Professional Photoshop

Peachpit Press, Berkeley, CA (0 7645 3695 8) A classic on image manipulation, full of insight on topics such as tone and color correction, color spaces, sharpening, resolution, and blends. A must.

WILLIAM MITCHELL:

The Reconfigured Eye
MIT Press, Cambridge, MA (0 2621 3286 9)
An art-critical approach to image manipulation,
looking at the impact of digital technologies on art.

DAVID OKUEFUNA:

The Wonderful World of Albert Kahn
BBC Books, London, UK (1 8460 7458 4)
A truly inspirational collection of fascinating autochrome images.

SIDNEY F RAY:

Photographic Imaging & Electronic Photography
Focal Press, Oxford, UK (0 2405 1393 2)
More encyclopaedia than dictionary, this book is
strongest on its longer entries.

Photographic Technology & Imaging Science
Focal Press, Oxford, UK (0 2405 1389 4)
Good on photographic technology, but not so hot
on the imaging science.

ANDREW RODNEY:

Colour Management for Photographers
Focal Press, Oxford, UK (0 2408 0649 5)
Comprehensive treatment of color management.
Invaluable for the advanced photographer.

GRAHAM SAXBY:

The Science of Imaging
Institute of Physics, London, UK (0 7503 0734 X)
This is the best modern, all-around introduction to the science of photography.

UWE STEINMUELLER & JUERGEN GULBINS:

Fine Art Printing for Photographers (second edition) Rocky Nook, Santa Barbara, CA (1 9339 5231 8) Sound presentation of color management needed for producing high-quality ink-jet prints.

RON WHITE:

How Digital Photography Works
Que, Indianopolis, IN (0 7897 3309 9)
Clear illustrations of digital camera operations.

Index

A	bags 37	cameras (continued)
Absolute Colorimetric 350	balancing colors 264, 271	large-format 14
abstract imagery 138–40	Color Balance control 264, 265, 292,	medium-format 14
accessories	293	movement 85, 161
cameras 36–7	correcting 247	rangefinder 29
computers 60–1	problem solving 112–13	recording information 198
digital 38–9	ball-and-socket tripod heads 36	see also digital cameras; dSLR cameras;
ACDSee 53, 235	barrel distortion 92	EVF cameras; SLR cameras
Acrobat Reader 226	Bas Relief filter 309	Capture One 53, 227
adaptors 61	batteries 377	careers 366–8
ADC (analogue-to-digital converter) 16	chargers 379	carnivals 192
adjacent colors 104-5	life 67, 146	cataloging software 210, 235
Adobe RGB (1998) color space 233	power 23	cathode-ray tube (CRT) monitors 48
advanced metering 121–4	Bayer pattern 17	CCD (Charge Coupled Device) sensor
aerial photography 144-5, 162, 181	Bibble 53	array 19
Album 53	bicubic interpolation 261	CDs 12, 13, 15, 60, 210, 238, 357
alpha channels, masks 328, 329	bilinear interpolation 261	archiving files 235, 356, 357
alternative views 96	bird's eye views 181–3	portfolios 369
analogous colors 104	bit-depth 274–5	center-weighted metering 114, 115
analogue 15, 16–17	bitmap data 330, 332	Chalk & Charcoal filter 309, 312, 313
analogue-to-digital converter (ADC) 16	black, four-color 276	channel extraction 278
Angled Strokes filter 313	black and white, color into 187, 276-81	Channel Mixer 280
animal photography 186-8, 206-9	Blending Options 292, 317	channels 279, 322-7
"anti-aliasing" filters 26	blend modes, layers 312, 322-7	Charcoal filter 309
aperture 32, 34, 35, 75, 77	Blu-ray Discs (BD) 60-1, 210, 234	children 129, 168-70
optimum 182	blurring 256–7	Chrome filter 309
Aperture 52, 53, 227, 234, 235, 362, 363,	Blur filters 306	chrominance 17
367	lens problems 93	cities 195–7
Apple	poor subject detail 242	clients, building up your business 370-1
Mac computers 49, 59, 226, 232	removing distractions 258, 259	Clone Stamp tool 250
monitors 49	sports photography 190-1	cloning 250-1, 258, 330, 334-9
APS (Advanced Photo System) 80	body tripod 67	close-ups 86-9, 95, 148, 153-7
APS sensors 24, 28, 32, 34, 35	books, scanning 216, 374–5	clouds 144-5
architectural photography 20, 35, 141-3,	bounced flash 40, 127	Clouds filter 311
263	bracketing exposures 121	CMOS sensor array 19
archiving	BreezeBrowser 53	CMYK mode 267, 276, 280
files 210, 234–5, 356	bridge cameras see EVF cameras	CoffeeCup 362
internet 234	bright colors 231	coins, scanning 216
safe media 356	broad lighting 128	Color Balance 264, 265, 292, 293
storing prints 356	Brush Strokes filters 308–9, 312	Color Burn 247, 324, 325
artifacts 227, 229, 330	Brush tool 296	Color Dodge 247, 324, 325
art effects 338–9	budgets, mounting an exhibition 373	Colored Pencil filter 308, 312
Artistic filters 308–9, 312–13	buildings 141–3, 263	Color mode 296, 324, 326
art papers 352, 356–7	burning-in 120, 246–7	Color Range control 312, 318, 319
artwork, grayscale images 330-1	business, starting 365–71	ColorSync compliant printers 350
astronomy 26	business plans 368	colors
autofocusing 18, 24, 76–7	buttons, placement 22, 67	accuracy 123, 210, 233, 264
Auto Levels 219, 239, 243, 244	buying equipment 376–7	adjacent 104–5
automatic indexing 198	C	adjustments 266–7
averaging metering 123		altering 102
В	cables 61	analogous 104
	calibration, monitors 49, 232	Automatic Levels 239
backgrounds	Camera Raw 227	balance 112–13, 247, 264, 271
blurring 256, 258, 259	camera shake 36, 83, 84	bit-depth 274–5
desaturation 258, 259	cameras	into black and white 187, 276–81
removing 320–1	accessories 36–7	bright 231
removing distractions 258, 259	controls 22–3	color bar 210
backlighting 116–17	film cameras 14, 18	color casts 112, 113
backup files 210, 234	handling 66–7	color filter array 17